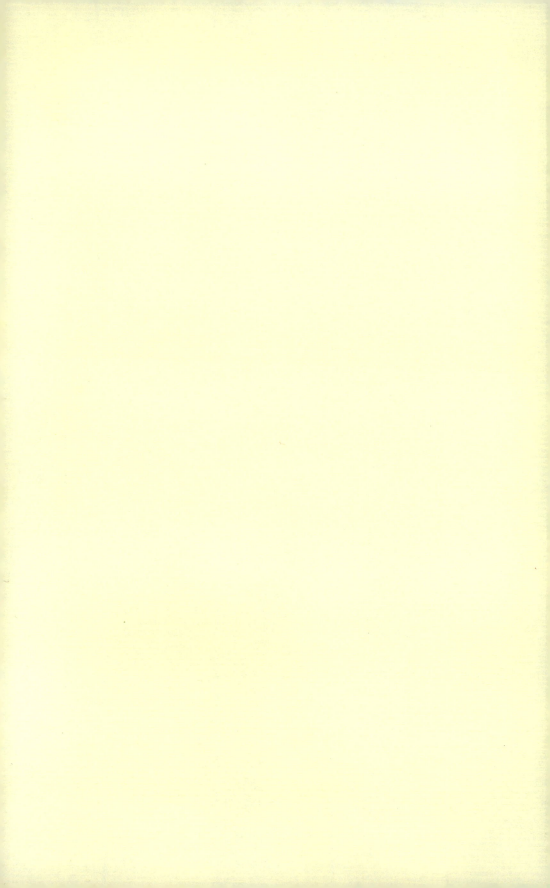

# Albrecht Dürer

Dürer. *Self-Portrait*. Nude. Ca. 1518. Pen and brush,
heightened with white, on green-grounded paper. Weimar,
Schlossmuseum.

# Albrecht Dürer

## A BIOGRAPHY

BY
JANE CAMPBELL
HUTCHISON

PRINCETON

UNIVERSITY

PRESS

Copyright © 1990 by Princeton University Press
Published by Princeton University Press, 41 William Street,
Princeton, New Jersey 08540
In the United Kingdom: Princeton University Press, Oxford

Library of Congress Cataloging-in-Publication Data

Hutchison, Jane Campbell.
Albrecht Dürer: a biography/ Jane Campbell Hutchison.
p.       cm.
Includes bibliographical references.
ISBN 0-691-03978-X (alk. paper)
1. Dürer, Albrecht, 1471–1528. 2. Artists—Germany—Biography.
I. Title.
N6888.D8H88   1990
760'.092—dc20
[B]       89-28971

This book has been composed in Linotron Galliard

Princeton University Press books are printed on acid-free paper,
and meet the guidelines for permanence and durability of the
Committee on Production Guidelines for Book Longevity
of the Council on Library Resources

Printed in the United States of America by
Princeton University Press,
Princeton, New Jersey

3   5   7   9   10   8   6   4

*For James S. Watrous*

# CONTENTS

# LIST OF ILLUSTRATIONS

# PREFACE

ALBRECHT DÜRER was the first artist in history to have a public monument erected in his honor, and the first to have his house and tomb restored in the name of historic preservation. He was an eyewitness to the beginning of the Reformation, and counted most of Germany's leading humanists among his personal friends. He was the first to leave a series of self portraits, as well as a substantial body of autobiographical writing. He was also the first German to publish on artistic theory, one of the first to publish on the physical sciences in the German language, and the first writer in any language to publish a description of artistic genius. He was the first European artist to manifest his appreciation of pre-Columbian art, as well as his abiding concern for the future of German art and art students.

The focus of the present study is Albrecht Dürer's life, rather than his art, and it is based primarily on information to be found in Hans Rupprich's definitive edition of primary documents by and about Dürer, supplemented by information regarding the Hungarian branch of Dürer's family; the last will and testament of his wife, the former Agnes Frey; and evidence about his relationship to both Catholic and Lutheran issues of the Reformation which has been discovered since the publication of Rupprich's work in 1956.

This study has benefitted from the lectures and seminars of my former professors, Wolfgang Stechow, James Watrous, Jan van Gelder, Marvin Becker, and George L. Mosse; and from the interest and encouragement of colleagues in the Department of German at the University of Wisconsin: Max Baeumer, Reinhold Grimm, and Jost Hermand.

Special thanks are due Dr. George Szábo of the Lehman Collection at the Metropolitan Museum; Dr. Margaret Stuffmann of the Städelsches Kunstinstitut, Frankfurt; Professor James Marrow of the University of California at Berkeley; the late Professor Emeritus Jan Bialostocki, University of Warsaw; Dr. Willibald Sauerländer of the Zentralinstitut für Kunstgeschichte, Munich; Mary Kennan, and the late Walter L. Strauss, New York; Professor John Kidwell of the University of Wisconsin Law School; Onno Brouwer and Kathy Chapin of the University of Wisconsin Cartographic Laboratory; William Bunce of the Kohler Library, who located many an arcane item; Jeff Hamm and Jackie Captain of the Department of Art History, Charles Ault, and Molan Chun Goldstein of

Princeton University Press, without whose help the manuscript could not have been prepared.

Last, but by no means least, my seminar students have been a continuing source of inspiration over the years: I wish particularly to acknowledge questions asked and papers written by Karen Breuer, Dorothy Fletcher, Daniel Dryden, Frances Lamont, Karen Pearson, Isabel Gilman, Hans Gustafson, Marvel Griepp, Joanne Moser, Mary Em Kirn, Jill Fisher Kunsmann, Jane Peters, Pamela Decoteau, William Steinke, Pamela Scheingorn, Thomas Dewey, Thomas Gombar, Loni Hayman, Linda Duychak, Suzanne Quigley, Kathryn Casey, Sarah Bingham, Ellen Meyer, Kay Klein, and Gabriele Haberland.

Albrecht Dürer

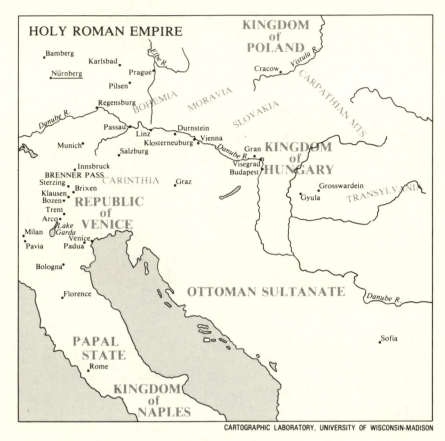

HOLY ROMAN EMPIRE

Bamberg

Karlsbad

Nürnberg

Prague

Pilsen

BOHEMIA

MORAVIA

Regensburg

Danube R.

Passau

Linz

Durnstein

Munich

Klosterneuburg

Vienna

Salzburg

Innsbruck

BRENNER PASS

Sterzing

CARINTHIA

Klausen

Bozen

REPUBLIC

Brixen

Trent

of

Arco

VENICE

Lake
Garda

Milan

Venice

Pavia

Padua

Bologna

Florence

KINGDOM
of
POLAND

Cracow

Vistula R.

CARPATHIAN MTS.

SLOVAKIA

Danube R.

Gran

Visegrad

Budapest

KINGDOM
of
HUNGARY

Graz

Grosswardein

Gyula

TRANSYLVANIA

OTTOMAN SULTANATE

Danube R.

Sofia

PAPAL
STATE

Rome

KINGDOM
of
NAPLES

Elbe R.

Hungary, Poland, and the Republic of Venice.

# I

## DÜRER'S FAMILY
## CHRONICLE

Anno 1524. After Christmas, in Nuremberg.

I, Albrecht Dürer the Younger have put together from my father's papers from whence he came, how he came here, lived here, and came to a blessed end. God be merciful to him, and to us. Amen.

Albrecht Dürer the Elder was born into a family in the Kingdom of Hungary, not far from a little town called Jula [Gyula], eight miles below Wardein [Grosswardein] in a little village by the name of Eytas [Ajtós], and his family made their living by raising horses and cattle. But my father's father, who was named Anthoni Dürer, came into the above-mentioned little town as a boy, to a goldsmith, and learned the craft from him. After that he married a young girl by the name of Elizabeth with whom he had a daughter, Catherina, and three sons. The first son, called Albrecht Dürer, was my dear father, who also became a goldsmith, a pure and skillful man. Another son he named Lasslen [Ladislas]; he was a saddler. His son is my cousin, Niclas Dürer, called Niclas Unger [i.e., "the Hungarian"], who lives in Cologne. He is also a goldsmith, and he learned his craft here in Nuremberg with my father. The third son he named Johannes; he let him go to school. Johannes afterward became a parish priest at Wardein and stayed there thirty years.

I N 1524, four years before his death, Albrecht Dürer wrote a formal history of his family, relying upon notes and documents retained by his father, who had died twenty-two years earlier. This family chronicle, unprecedented in the history of art, was not undertaken for dynastic reasons, or for purposes of determining the limits of consanguinity, as were the genealogical records of the aristocracy, for he had neither children of his own nor any surviving nieces or nephews who were blood relatives. It was, instead, the summary of a dying family, recorded with care by Germany's most brilliant artist in the clear conviction that, as an internationally famous man, the circumstances of his family background were invested with historical importance. He was correct in his assumption, for at least three handwritten copies are known to have

been made of the manuscript, one of which belonged to a key figure in the Dürer "Renaissance" of the late sixteenth century—the Nuremberg goldsmith Hans Petzolt (1551–1633), who worked for a time at the court of the most avid collector of Dürer's work, the Holy Roman Emperor Rudolf II in Prague—prior to its first publication in 1675 by Joachim von Sandrart in the *Teutsche Academie*.[1]

In having made the assumption that his personal affairs were of historic interest, Dürer followed a precedent established, not by painters but by such prominent Nuremberg citizens as his close friend, Lazarus Spengler, and such associates and clients as the Holzschuher, Ebner, Oelhafen, Scheurl, Kress, Haller, and Tucher families, whose original family documents have also survived to the present day.

Albrecht Dürer's father, Albrecht the Elder is a figure of immense historical interest, and to him must go a great deal of the credit for having nurtured the habits of mind and traits of character which made his famous son unique among the artists of his day. It was the elder Dürer who first kept the family records, and it was he who set the example for international travel in search of new professional experiences. In an age when the majority of European artists ventured no more than a few miles from home, he left the Hungarian village of his birth as a teenage journeyman, making his way across the breadth of the Holy Roman Empire and through three language areas to perfect his training in the Burgundian Netherlands, the best education in the world for a goldsmith under the enlightened regime of Philip the Good, whose patronage of jewellers and goldsmiths is legendary. His final decision to settle permanently in the free Imperial city of Nuremberg, then one of the largest and most prosperous cities in Europe, had great importance for the course of his son's career.

The elder Dürer, we now know, was born in 1427. The village of Ajtós, his birthplace, was totally destroyed by the Turks during the siege of Gyula in 1566. The name Dürer, derived from the Hungarian word for "door" (ajtó; "Tür" in German), was adopted as a surname—evidently by Dürer's grandfather, Anthoni, when he left Ajtós for Gyula in order to become a goldsmith's apprentice. Ajtós, apparently, was a country village convenient to the family horse and cattle farm, but neither large nor urban enough to have supported a goldsmith in the early years of the fifteenth century.

Gyula, which lies only a few kilometers from the modern border with Rumania, is the site of the only castle in the region, a fortress built in

the fourteenth century. Thus it seems likely that the goldsmith under whom Anthoni Dürer studied enjoyed aristocratic patronage. Gyula was undergoing a period of prosperity and expanding trade at this time, under the leadership of the Marothy family.

Wardein (Hungarian Nagyvárad, now Oradea in Rumania), where Dürer's uncle Johannes became a priest, was the nearest cathedral city, the seat of a diocese founded by St. Ladislaus in the eleventh century.

Although German scholars at one time assumed that the Dürer family had been of Saxon origin, on the basis of Albrecht the Elder's excellent written German, the Hungarian scholar Emerich Lukinich has established the fact that the area where Ajtós was located—the modern district of Békécs—was entirely settled by Hungarians.[2] It should further be noted that the breeding of horses and cattle are traditionally Hungarian occupations, both requiring the ownership of substantial amounts of land, which also suggests that the family—at least on the father's side—had been indigenous to the area. The baptismal names of Dürer's grandfather—Anthoni (Anton, or Antal)—and uncle Lasslen (Ladislas)—as well as of his cousin Niclas and his own brother, Endres (Andrew) were common ones in Hungarian families, having both dynastic and religious significance, as does Elizabeth, the name of Anthoni Dürer's wife, who was the namesake of St. Elizabeth of Thuringia (b. 1207), daughter of King Andreas II of Hungary.

Research conducted in 1925 suggests that the Hungarian branch of the Dürer family may have survived under the name of Ajtósi. This line of inquiry has brought to light a further document, dated 1461, regarding a priest named Johannes at the Church of the Holy Cross in Wardein who was the guardian or tutor of a young nobleman, Nikolai de Doboka,[3] and who was almost certainly Dürer's uncle. The elder Albrecht Dürer's pride in the achievement of his younger brother, as well as his realization that Johannes would die without issue, is reflected in his later having successively named three of his sons Johannes, or Hanns.

> So Albrecht Dürer, my dear father came to Germany. He had been a long time in the Netherlands with the great artists, and at last he came here to Nuremberg in the year, as one counts from the birth of Christ 1455, on St. Eloy's Day [March 11]. And on the same day Philipp Pirckheimer had his wedding at the Veste, and there was a great dance under the big linden tree. After that my dear father Albrecht Dürer served old Jeronimus Holper, who became my grandfather, for a long time, till the year reckoned 1467 after the birth of Christ. My grandfather then gave him his daughter, a pretty and

honest girl named Barbara, fifteen years old, and he married her eight days
before St. Vitus' [June 8]. It is also known that my grandmother was the
daughter of Oellinger of Weissenberg, and her name was Kunigund.

Albrecht the Elder's decision to leave his Hungarian home for the
west was made when he was sixteen or seventeen years old; thus he had
almost certainly finished his preliminary training as a goldsmith under
his father's tutelage. A document preserved in the Nuremberg Staatsar-
chiv lists his name on the roster of the military unit of volunteer archers
and artillerymen, sons of Nuremberg citizens as well as journeymen like
himself, who were posted from Nuremberg to the fortress of Lichten-
burg on March 8, 1444 (Reminiscere Sunday in Lent), during the war
between Nuremberg and the knights Hans and Fritz von Waldenfels.[4]
Therefore, he must have arrived in Nuremberg at least eleven or twelve
years earlier than his son has indicated in the family chronicle. Since the
Nuremberg trading companies of Landauer and Pirckheimer, among
others, were much involved in the importation of copper from the mines
in Hungary it is quite likely that Albrecht the Elder had traveled east-
ward in the company of merchants bound from Hermannstadt via Gross-
wardein, Vienna, and Regensburg to Nuremberg.[5]

The elder Dürer's reasons for leaving Hungary are not difficult to
guess. In the late 1420s when he was born, the Hussite Wars had in-
flamed Bohemia and the power of the Turks was steadily increasing in
eastern Europe. In 1428, the year after his birth, the future Holy Roman
Emperor Sigismund was defeated at the fortress of Gulambocz. In the
year of his brief military enlistment, 1444, Ladislas I of Hungary was
killed in the disastrous Battle of Varna, on the Black Sea, and Hungary
was thrown into confusion by quarreling nobles. The situation was to
deteriorate still further with the fall of Constantinople in 1453, after
which the Turks were free to turn their full attention to the conquest of
Hungary.

Nuremberg, on the other hand, was approaching a peak of prosperity
and international importance never again to be equalled. Aeneas Silvius
Piccolomini, the future Pope Pius II, who had come to Nuremberg in
the Imperial party in 1444 for the meeting of the Reichstag under the
newly elected Emperor, Friedrich III, was lavish in his praise of the city:
"What a splendid sight this city presents! What brilliance, what lovely
views, what beauties, what culture, what admirable government! . . .
what clean streets, what elegant houses!"[6]

The city, which Martin Luther was later to call "Germany's eye and

ear" and which Regiomontanus proclaimed "the middle point of Europe," lay quite literally at the center of European trade, at the crossing point of the overland routes bringing amber, furs, and salt fish from the Baltic; gold, silver, copper, and horses from Hungary and Bohemia; spices, silks, and luxury goods from Venice; and woollen cloth from the Netherlands. From Nuremberg itself were carried scientific instruments to Portugal, and small metalwares (Nürnberger "Tand") to Poland. Nuremberg's singular rise to prosperity was due not to natural resources (it had virtually none), but to the ingenuity of its citizens and, even more importantly, to the privilege of conducting reciprocal toll-free trade with seventy cities—a policy actually established in Hohenstaufen times, which had been revived and enlarged by Ludwig the Bavarian in 1332 and extended by each successive Holy Roman Emperor. The city had grown up at the foot of the medieval Imperial fortress, acquiring status as a "free" city—subject directly to the authority of the Emperor and immune from taxation by the Bishop of Bamberg, in whose diocese it lay, as well as from the territorial ambitions of neighboring nobility in nearby Rothenburg and elsewhere. Thus, while the city had no navigable waterway (the river Pegnitz is a shallow and slow-moving stream which in English would be better described as a creek or "run"), had no mineral resources, and was sited in soil of the wrong sort for the cultivation either of vineyards or of sheep, its strategic location gave it an initial value which successive Emperors wished to protect. As it became more and more successful as a center of transshipment, international trade, and pilgrimage traffic, of course, the city gained further importance in Imperial eyes as a source of revenue.

Since the Emperors were seldom actually in residence in Nuremberg, it was in effect a city-state, run by its own self-perpetuating City Council of wealthy, upper-middle-class citizens, who regulated city affairs in the best interests of business. Hence, although the medieval castle had come to be regarded as too uncomfortable for winter habitation by fifteenth-century Emperors (who much preferred to be put up in style as houseguests in the homes of Nuremberg's patriciate), the Imperial coronation regalia, crown jewels, and relic collection (*Reichskleinodien*) had been removed from Visegrád and placed on permanent deposit there in 1424, and each new Emperor was required by law to convene his first Imperial Diet in the city. It was such an occasion which had brought Aeneas Silvius Piccolomini to Nuremberg, in the party of the newly elected Friedrich III, and it may also have been the additional attraction of the con-

vening Reichstag with its panoply of visiting noblemen that had drawn the young Hungarian goldsmith, whether or not he had initially intended to remain in the city.

In Nuremberg, with or without the presence of the Emperor and princes of the realm, the elder Dürer could have expected to see on display, on the second Sunday after Easter, the Imperial treasure as it was held up, item by item, for public view: the supposed crown and sword of Charlemagne, together with the sceptre and orb; the coronation robes; the indulgenced relics—the most important of which was the Holy Lance, identified as the one used to pierce Christ's side. Viewers of this and the other religious relics—which included a large piece of wood from the True Cross, mounted in the Ottonian gold reliquary known as the Imperial Cross, as well as a piece of the tablecloth used at the Last Supper, splinters of the manger in Bethlehem, a bone from St. Anne's arm, and a piece of the apron Christ wore when He washed the feet of the Apostles—were assured of release from Purgatory for a minimum of 37 years and 275 days—or, as some said, 230,000 days (632 years).[7]

The elder Dürer seems to have departed for the Netherlands, in any event, after both the Reichstag and the Waldenfels war were over. It is most likely that his journey would have taken him there by way of Mainz, Cologne, Aachen, and Maastricht or Liège—not merely because a large part of the journey could be made more easily on the Main and Rhine, but because the cathedral treasuries in these cities held spectacular medieval goldwork which would have been of interest to him.

We have no reliable information about the city, or cities, in which Dürer's father lived in the Netherlands, only the fact that he had been there "a long time . . . with the great artists." He may have found employment as a journeyman in Brussels or Bruges, two of the principal residences of Philip the Good, or possibly in wealthy but rebellious Ghent. The fact that he was later to be held in high regard by Kaiser Friedrich III suggests the possibility that his days as a journeyman may have been spent in the vicinity either of the Bishop of Liège or of the Burgundian court.

Philip the Good, Duke of Burgundy, was by all odds the most munificent ruler in western Europe. The Czech traveler, Leo of Rozmital, who visited Philip's palace in Brussels in 1465–1466 reported that the treasure of gold and silver vessels and jewelled ornaments was so vast that three days would be required to view them all. The accounts of Philip's travel,

with five cartloads of jewels for himself and another two for the current
Duchess, as well as of his penchant for extravagantly crafted centerpieces
for his banquet tables are justly famous: the table decorations for one
such affair, in 1435, had featured two enormous artificial hawthorn trees
with flowers of gold and silver, and eighteen smaller trees with the ducal
arms. The most fabled of the Duke's soirées, the Feast of the Pheasant,
was staged in Lille in February of 1454, a year before the elder Dürer's
return to Nuremberg. At this affair Philip the Good, literally uphol-
stered in diamonds, rubies, and pearls, presided over a table with an
epergne representing a chapel with a choir singing in it; a figure repre-
senting a nude maiden who stood against a pillar with spiced wine
spraying from her right breast, and other wonders too numerous to
mention here.[8] There was, then, unparalleled opportunity for jewellers,
goldsmiths, and for artists and craftsmen of every sort to be found at or
near Philip's court—for his courtiers and wealthier subjects, too, were
all potential patrons. It is even conceivable that the elder Dürer's return
to Germany might have been made under the auspices of the Burgun-
dian court, for in April of 1454 the Duke and his party traveled across
Swabia and Württemberg to Regensburg by way of Ulm and Günzburg.
Their purpose was to attend the Imperial Diet, a meeting which Kaiser
Friedrich was prevented from attending due to the unrest in Hungary.

The court of the Duke of Burgundy, however, might have been diffi-
cult of access to a young Hungarian journeyman, and its goldsmiths
perhaps unlikely to welcome an outsider. An episcopal city such as Liège
would have been more accessible, geographically as well as socially, and
the elder Dürer could have seen it in its full glory, before it was sacked
by Charles the Bold. The elder Dürer's later use of the term "His Grace"
to refer to the Emperor also suggests that he may have been more accus-
tomed to working for bishops than for sovereigns. In any case, his son's
mention of "the great masters" seems to indicate that his father had been
active in more than one workshop.

Whatever the circumstances of his return to Nuremberg, it was prob-
ably no accident that Albrecht the Elder's arrival was timed for St. Eloy's
Day—the feast day of the patron saint of goldsmiths (March 11). It must
have seemed a doubly auspicious occasion to find Philipp Pirckheimer's
wedding dance in progress, at the old Imperial fortress under the great
linden tree which Henry I's Empress, Kunigund, is said to have planted
in the eleventh century. It was in a house owned by another Pirckheimer
that the elder Dürer and his bride later set up housekeeping, and where

they still lived when their son Albrecht was born in the spring of 1471. The house, which no longer exists, stood behind Dr. Johannes Pirckheimer's residence on the Hauptmarkt, facing the Winklerstrasse. Such "hinter"-houses have been cited in the writings of the Nuremberg humanist Sebald Schreyer: they were quite small, usually only one story high, and sometimes consisted of only a living room, kitchen, and one small bedroom.[9]

The elder Dürer found employment with a local goldsmith, Hieronymus Holper, as the chronicle states, and worked for him for twelve more years before becoming a master. He was twenty-eight years old when he returned to Nuremberg in 1455, and would have been forty when he married his master's fifteen-year-old daughter, Barbara. Since it was customary for journeymen to have room and board in the house of the master craftsman, it is probable that Albrecht the Elder had lived in Holper's house in the Stöpselgasse (purchased by Holper in 1455, the year of his asssistant's arrival), and that he had seen Barbara grow from a three-year-old infant into the "pretty and honest" young girl described in the chronicle.

Hieronymus Holper (d. 1476), his father-in-law, was a man of some stature in the community. Holper's wife, Kunigund, seems to have been a member of one of the most important families in the nearby free city of Weissenburg "am Sand," the Oellingers, for whom the city gate leading to Nuremberg is named. A master goldsmith since 1435, Holper had been selected to design the obverse of the official seal for Ladislaus, King of Bohemia and Hungary, in 1454. He was to become Nuremberg's official silver-weigher in 1460, and its assayer of gold in 1461. Shortly before giving his daughter's hand in marriage to his Hungarian journeyman (June 8, 1467), Holper was able to persuade the City Council to turn over his official assaying duties to his future son-in-law (April 1), a not inconsiderable feat in view of the large number of goldsmiths in the city, many of whom were native-born, and saw him simultaneously granted the necessary Nuremberg citizenship.

The elder Dürer's promotion to master goldsmith was forthcoming the following year (July 7, 1468)—an honor which required the payment of a fee of ten gold gulden and, more importantly, a net worth of one hundred gulden on the part of the candidate. These unusually stringent financial requirements were the result of two factors: first, that Nuremberg had no craftsmen's guilds (they had been suppressed after the abortive revolt in 1348), so that rules for eligibility to mastership were set by

the City Council; and second, that the goldsmith's craft was regulated with particular care because of the high cost of the precious metals involved, which must be purchased at the master's own expense. Although it is difficult to translate the value of fifteenth-century gulden into modern inflated currency, it may be helpful to note that, in 1475 when Albrecht Dürer the Elder bought his house "unter der Vesten," in the city's best residential quarter, he paid two hundred gulden for it. One Rhenish guilder would buy twenty-five bushels of wheat.

The esteem in which the elder Dürer was held may be noted by the fact that, soon after he became a property owner, he was appointed neighborhood warden (*Gassenhauptmann*) for the street on which he lived, "Under the Fortress" (now Burgstrasse), where his neighbors included the publisher Anton Koberger, the humanists Sebald Schreyer and Dr. Hartmann Schedel (later the author of the *Nuremberg Chronicle*), Michael Wolgemut, master of the largest and most successful workshop for painting and woodcut design, and the patrician families of Behaim, Landauer, and Kress von Kressenstein. By the early 1480s Albrecht the Elder had also become the owner of shares in the mine at Goldkronach, owned by the Burggrafen of Nuremberg and the Markgrafen of Ansbach-Kulmbach but operated by a joint-stock company of Nuremberg investors. The very fact that the opportunity for this investment was offered to him is an indication of the high regard in which he was held.

No signed work by the elder Dürer has survived—a situation all too common in the case of even the greatest goldsmiths, for gold objects were a late medieval form of savings account for their owners, and, in cases of financial exigency, even the most cunningly wrought works were not immune from being converted to ready cash by the simple expedient of melting them down for coinage. Documents show that Dürer the Elder was frequently given commissions for the church of St. Sebald—the orders placed by his neighbor, Sebald Schreyer, who was *Kirchenmeister* there—and that he also received commissions from the Emperor in 1489 and 1492. It has been suggested that he may have made one of the most remarkable goldsmith's creations of the period, the famous gilded silver Schlüsselfelder ship model (Nuremberg, Germanisches Nationalmuseum); this is an attractive theory, particularly in view of the influence of the Burgundian goldsmith-engraver, Master W with the Key, whose engraving of a very similar carrack, or galleon, the silver ship closely resembles.[10] However, the date on the ship's presentation

case is 1503—the year after the senior Dürer's death at the age of seventy-five.

Beginning in 1486, Albrecht Dürer the Elder rented a small retail shop, at a cost of five gulden per year, in a prime location near the City Hall. It was probably here that his work came to the attention of Kaiser Friedrich III, who was in Nuremberg for a protracted period during the "Long Reichstag" of 1487. A document dated March 5, 1489, records the commission for a drinking vessel for Friedrich III to be made by Dürer and a colleague, Hans Krug, who is known to have been an engraver of medals.[11]

An autograph letter written by the elder Dürer to his wife and children from the old Kaiser's retirement retreat in the fortress at Linz has survived. It is dated August 24, 1492, the year before Friedrich's death:

> To be delivered to the honorable Frau Barbara Türerin, *goldschmidin* at Nuremberg, my dear wife.
>
> My friendly greeting to my dear Barbara. This is to let you know that, after a hard trip [*mit mü vnd arbet*] I arrived in Linz on Sunday before St. Bartholomew's [August 19], and on Monday my gracious Lord [Kaiser Friedrich III] sent for me and I had to show him the pictures [presumably drawings for gold work under consideration]. His Grace was pleased with them and His Grace spoke with me for a long time. And as I was leaving, His Grace came himself to me put [four] florins in my hand and said to me "My goldsmith, go to the inn and get yourself something good." Since then I have not been with His Grace again, but Steffan and Ret have given me good comfort. So I must wait a while longer, [but] then I hope to be with you again soon. God help me with love to return home. I have no more [news]: so greet the household for me, and tell the apprentices to work fast and I will earn more; and especially recommend me to my children and tell them to be good. Given at Linz on St. Bartholomew's Day, 1492.
>
> <div align="right">Albrecht Dürer.[12]</div>

This direct and loving letter, written in the year of Columbus's discovery of the New World, while Albrecht the Younger was away in Colmar on his *Wanderjahre*, was kept by Barbara Dürer as a family heirloom for its reference to the honor done her husband by the old Emperor. It is said to have been found in 1882 concealed behind paneling in the family home "unter der Vesten."

The elder Dürer's reference to his wife as *Goldschmidin* may be taken for a simple courtesy title, or, alternatively as an indication that Barbara Dürer played a more important role in her husband's workshop than has

previously been assumed. She was, after all, the daughter of a prominent goldsmith, and may very well have been trained to some extent by her father. Merry E. Wiesner's study of working women in Renaissance Germany has called attention to the fact that a surprising number of women were active at specialized tasks within the Nuremberg gold industry, including the spinning of gold thread for ecclesiastical and other luxury embroidery.[13] In any event, as her husband's letter indicates, Barbara Dürer would have been responsible for supervising the apprentices in her husband's absence, and for seeing to their room and board at all times. In Nuremberg, where retail sales were predominantly managed by women, it is possible that she may have clerked in the shop as well, despite her frequent bouts of ill health and her almost perpetual pregnancies.

For Albrecht Dürer the Younger's family chronicle of 1524 continues, recording the births of the eighteen Dürer children, beginning in 1468 when his mother was sixteen, and ending on August 8, 1492, sixteen days before her husband's letter was written, when she was forty:

> And my dear father had by his marriage to my dear mother these following children born—which I set down as he wrote it in his book, word for word:

> "Item: in the year 1468 after Christ's birth, on St. Margaret's Eve [July 12] in the sixth hour of the day [11:00 A.M.] my wife Barbara bore me my first daughter. And old Margaret of Weissenberg was her godmother, and named me the child Barbara after her mother."

Margaret of Weissenberg was probably, according to Hans Rupprich, the authority on Dürer documents, a female relative of Barbara Dürer's mother, Kunigund Oellinger, whose family came from Weissenburg. This seems a likely identification, since it would have been appropriate for such a female relative to be present at the birth of the first child. However, the possibility that "old Margaret of Weissenberg" was the midwife who had served the mother's family cannot be ruled out.

> "Item: in the year 1470 after Christ's birth, on St. Marina's Day in Lent [April 7], two hours before daybreak, my wife Barbara bore me another child, a son, and Fritz Roth of Bayreuth held him over the baptismal font and named my son Johannes."

Albrecht Dürer the Elder's first son was named in honor of his younger brother, the priest in Wardein, a choice which seems to suggest, in addition to respect for the Church and what was evidently a particular fondness for this brother, a special reverence for education: was it Jo-

hannes—a tutor as well as a priest—who had taught Albrecht the Elder
to read and write? The fact that two more male infants were given the
same name is an indication that this Johannes, as well as the second, died
in childhood.

> "Item: in the year 1471 after Christ's birth, in the sixth hour on St. Pruden-
> tius's Day [May 21], a Tuesday in Passion Week, my wife Barbara bore me
> another son. Anton Koberger was godfather to him, and named him Al-
> brecht, after me."

The birth of the future painter and graphic artist was a momentous oc-
casion, first since he was given his father's name, Albrecht, and secondly
because his godfather, Anton Koberger (ca. 1445–1513), was a particu-
larly fortunate choice. The elder Dürer had probably come to know Ko-
berger because he had been a practicing goldsmith until 1470–1471, and
may have asked him to serve as godfather since he was a new bride-
groom at the time. (Koberger married the first of his two wives in 1470,
and was himself to become the father of twenty-five children—twelve of
whom survived childhood.)

During the year of his godson's birth, Anton Koberger gave up the
goldsmith's craft in order to become a publisher. He quickly became the
most important in Germany, owning twenty-four presses, employing
more than one hundred fifty journeymen, and opening branch offices in
Paris, Lyon, and Budapest, as well as in Leipzig, Regensburg, Breslau,
and Frankfurt. He almost surely supplied letters of introduction for the
young Albrecht Dürer when the latter found employment as a book il-
lustrator in Basel as a journeyman, and is known to have placed his type-
faces and printing equipment at his godson's disposal for the publica-
tion of Dürer's first picture book, the *Apocalypse*, published in 1498.

> "Item: in the year 1472 after Christ's birth, in the third hour on St. Felix's
> Day [January 14], my wife Barbara bore me my fourth child. Sebald Holczle
> was his godfather, and named my son Sebald, after him."

Sebald Hölzl, or Höltzl, was to become a member of the Great Council
of Nuremberg in 1478, and would later be related by marriage to the
wealthiest and most influential family in the city—the Imhoffs, who
maintained branch offices and baggage service in Venice that would
later be utilized by Dürer on his travels. Both he and his infant godson
were named for Nuremberg's own local hermit saint, Sebaldus, whose
wonder-working relics were enshrined in the church attended by the
Dürer family and their neighbors—Nuremberg's oldest and finest.

"Item: in the year 1473 after Christ's birth, on St. Rupert's Day [March 27] in the sixth hour, my wife Barbara bore my fifth child. Hans Schreiner, who lives by the Laufertor was his godfather, and named my son Jeronimus after my father-in-law."

Hans Schreiner was a master sword-maker: arms and armor were another Nuremberg specialty. Nothing further is known of the infant Jeronimus, who died young.

"Item: in the year 1474 after Christ's birth, on St. Dominic's Day [i.e., St. Domitian's, May 24] in the first hour, my wife Barbara bore my sixth child. Ulrich Marckh the goldsmith was his godfather, and named my son Anthoni.

"Item: in the year 1476 after Christ's birth, in the first hour on St. Sebastian's Day [January 20], my wife bore my seventh child. The godmother was Miss Agnes Bayr, and she named my daughter Agnes.

"Item: over an hour after that my wife bore me another daughter in great pain, and the child was immediately baptized and named Margaretha.

"Item: in the year 1477 after Christ's birth, on the Wednesday after St. Eloy's Day [July 2], my wife Barbara bore my ninth child, and a young woman was godmother and named my daughter Ursula."

Albrecht Dürer the Elder's sixth child, fifth son, was named for his father, Anthoni, by Ulrich Markh, a fellow goldsmith. The seventh and eighth children, twin girls, were named by a young woman who was perhaps the sister or daughter of the goldsmith Hans Beyer. This was a difficult delivery, and the fact that the second twin was baptized immediately—and was named for St. Margaret, the patroness of women in childbirth (who, it will be recalled, had been swallowed in her entirety by a dragon, and burst out unscathed)—is an indication that death was imminent. Child number nine, Ursula, would seem to have arrived prematurely, since "a young woman"—probably a midwife—was her godmother.

"Item: in the year 1478 after Christ's birth my wife Barbara bore my tenth child, in the third hour of the day after Sts. Peter and Paul [June 30], and Hans Sterger, Schombach's friend, was its godfather and named my son Hanns."

Hans Schompach, whose friend was godfather to the Dürers' tenth child, was Albrecht Dürer the Elder's predecessor as neighborhood warden in the street Unter der Vesten, and was still in office at this time. His friend Hans may well have been chosen primarily for his name, for

the Dürers still wished to have a son named for Johannes Dürer, the priest, their first Johannes having died.

> "Item: in the year 1476 after Christ's birth, three hours before daybreak on a Sunday that was St. Arnulf's Day [July 18], my wife Barbara bore my eleventh child, and the godmother was Agnes Fricz Fischer, and named my daughter after her, also Agnes.

> "Item: in the year 1481 after Christ's birth, in the first hour of the day of St. Peter in Chains [August 1], my wife bore me my twelfth child, and Jobst Haller's man, Nicolas by name, was the godfather, and he named my son Peter.

> "Item: in the year 1482 after Christ's birth, in the fourth hour of the Thursday before St. Bartholomew's [August 22], my wife Barbara bore my thirteenth child, and the godmother was the Beinwarts' daughter Catherine, and she named my daughter Catherine also."

Nothing further is known of Agnes Fricz Fischer, or of the office worker named Nicolas who worked for Jobst Haller I (1433–1493), a member of one of Nuremberg's most prolific and influential families. Catherine Beinwart is also untraceable: her name is spelled differently in each of the handwritten manuscripts of the chronicle. She had perhaps been invited to be godmother because her name, Catherine, was that of the elder Dürer's only sister.

> "Item: in the year 1484 after Christ's birth, one hour after midnight on St. Mark's Eve [April 25], my wife bore my fourteenth child, and Endres Stromeyer was his godfather, and named my son Endres, too."

Endres Dürer (1484–1555, Plate 1) one of the three children who lived to adulthood, became a goldsmith like his father, with whom he must have served his apprenticeship. He returned from his bachelor's journey to become a master goldsmith 1514, and sold his interest in the family home in 1518 to Albrecht—perhaps in connection with the expense involved in becoming a master craftsman, for he apparently continued to live in the house. He married a woman named Ursula, who had two daughters, Constantia and Anna Hirnhofer by a previous marriage, but had no children of his own. He worked for a short time in Crakow (1532–1534), and returned to Poland in 1538 to settle the estate of the third brother, Hans III. The last of the Dürer brothers to die, Endres had inherited Albrecht Dürer's workshop materials and family items from both Albrecht and Agnes Dürer (d. 1539). His own heirs were his widow and stepdaughters, and the great Wenzel Jamnitzer (1508–1585), goldsmith to four

Hapsburg emperors, who had become a naturalized citizen of Nuremberg in 1534 and was living a few doors away from the Dürer house in the Zisselgasse. Jamnitzer, whose elaborately wrought goldwork has survived in an unusual number of examples,[14] shared Dürer's own interests in both nature and the Antique, and was, like Dürer, the author of a scientific treatise on perspective (1568). When he died in 1585, he was buried a few graves away from Dürer's tomb in Nuremberg's Cemetery of St. John.

> "Item: in the year 1486 after Christ's birth, at midday on Tuesday before St. George's [April 18], my wife Barbara bore my fifteenth child, and Sebald von Lochheim was the godfather, and named my son Sebald, so there is another Sebald.

> "Item: in the year 1488 after Christ's birth, at noon on the Friday before Our Lord's Ascension [May 9], my wife Barbara bore my sixteenth child, and Bernhard Walther's wife was the godmother, and named my daughter Christina after her."

The first infant christened Sebaldus (b. 1472) apparently having died, Sebald von Lochheim, a neighbor in the street Unter der Vesten named the second for himself and for Nuremberg's own patron, the recently canonized St. Sebaldus. The Dürers' daughter Christina was fortunate to have as a godmother Christina Walther, the wife of the famous astronomer, whose large house, now known as the Albrecht Dürer House, was later to be acquired by the painter from her husband's estate. Christina Walther was a person of consequence in her own right, and was the subject of a funeral eulogy by the Imperial poet laureate, Konrad Celtis, when she died.[15]

> "Item: in the year 1490 after Christ's birth, in Our Lord's Fast Night [February 21], two hours after midnight on Sunday, my wife Barbara bore my seventeenth child, and Herr Georg, the Vicar of St. Sebald's, was godfather and named my son Hanns. That is my third son who was named Hanns.

> "Item: in the year 1492 after Christ's birth, on St. Cyriacus's Day [August 8], two hours before night, my wife bore my eighteenth child, and the godfather was Hanns Carl of Ochsenfurth, and he named my son Carl, too."

Now all these, my brothers and sisters, my dear father's children, are dead, some in their childhood, others as they were growing up. Only we three brothers are still living, so long as God wills, namely: I, Albrecht, and my brother Endres, and my brother Hanns, the third of that name, of my father's children.

Hanns Carl of Ochsenfurth, who was godfather to the last of the Dürer
children, was a member of the Great Council of Nuremberg and the
owner of several houses and gardens. Carl Dürer, who was born while
his brother Albrecht, now aged twenty-one, was away on his bachelor's
journey, was never mentioned again and presumably died young, like
most of his brothers and all of his sisters. Indeed, since there is no spe-
cific mention of him in the elder Dürer's letter to his wife, written from
Linz only a fortnight after the birth, it is possible that this child had
already died before his father's departure for the Imperial court.

Hanns III (1490–1538, Plate 2), the eighteenth child, was sponsored
by Georg Plödl, the vicar of the Haller-endowed altar at St. Sebald's,
who had come from Würzburg in 1482. This Hanns, who lived to be
forty-eight years old, and apparently never married, was a painter and
graphic artist like his more famous brother, to whom he had been ap-
prenticed. The black sheep of the family, he seems to have given Dürer
some cause for concern as a teenager when, after their father's death, he
was Dürer's ward as well as his apprentice: this is reflected both in the
letters from Venice (see chapter VIII) and in the city archives, which
record a lawsuit brought by Albrecht Dürer on Hanns's behalf against
another young man who had stabbed him with a knife during a fight.[16]
Hanns, who had assisted Dürer with the Heller Altar in 1508, left Nurem-
berg for Poland in 1527, becoming court painter to King Sigismund I in
Crakow in 1529. Murals by his hand (now heavily restored) are in the
Deputies' Room in Wawel Castle.[17]

The high mortality rate among the Dürer children was not unique to
their family. The price paid by Nuremberg, as the commercial center of
the Empire, was its unique vulnerability to epidemic disease. To the
modern reader, however, it may seem strange that, in copying the above
litany of births and godparents from his father's notes, Dürer neglected
to record the deaths or funerals of the brothers and sisters who had pre-
deceased him. Indeed, it is possible that his father's original notes may
have contained such information since, in at least some of the cases,
ongoing expenditures for annual memorial masses may have been
involved.

For Dürer's purposes, however, the most significant information was
his father's careful notation of the hour and date of each birth—the raw
data necessary for the casting of horoscopes. Both Dürer and his father,
like the majority of people born in the fifteenth century—popes, emper-
ors, and peasants alike—believed in the power of the planets to affect

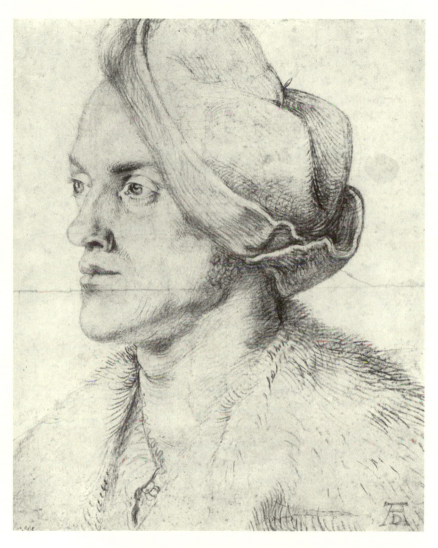

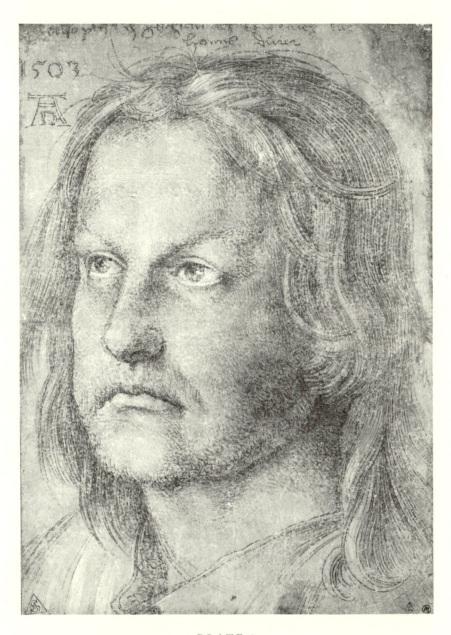

Dürer. *Portrait of Hanns (III) Dürer*. Ca. 1510. Silverpoint. Washington, D.C.,
National Gallery of Art, Rosenwald Collection.

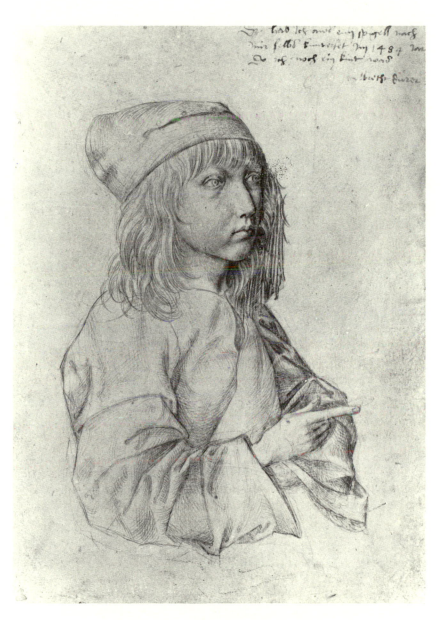

—— PLATE 3 ——

Dürer. *Self-Portrait at the Age of Thirteen*. 1484. Silverpoint. Vienna, Albertina.

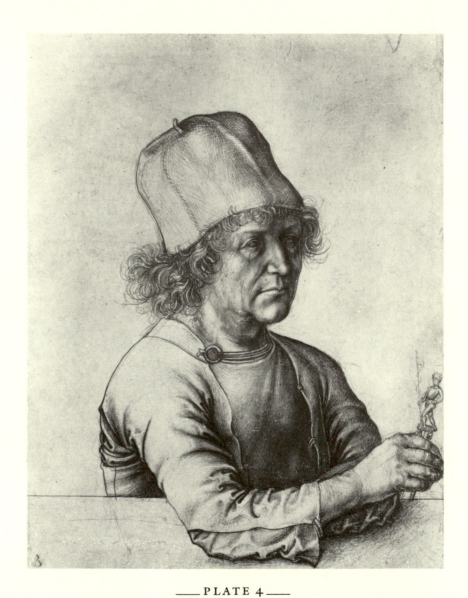

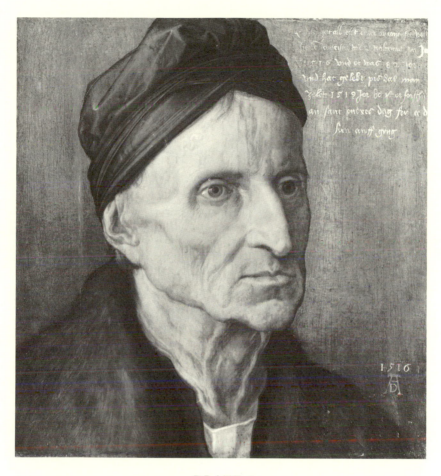

———— PLATE 5 ————

Dürer. *Portrait of Michael Wolgemut*. 1516. Oil on panel. Nuremberg,
Germanisches Nationalmuseum (on extended loan from the Bayerische
Staatsgemäldesammlungen, Munich).

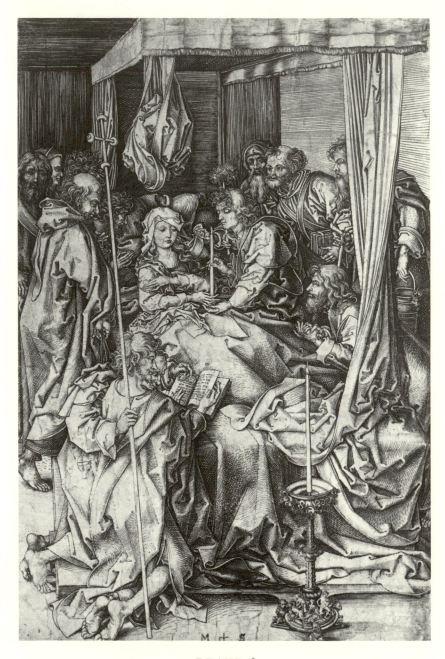

—— PLATE 6 ——

Martin Schongauer. *Death of the Virgin Mary*. Before 1481. Engraving.

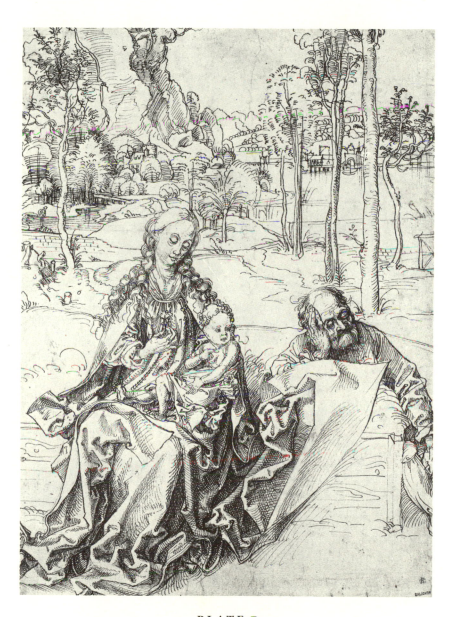

—— PLATE 7 ——

Dürer. *The Holy Family.* 1492–1493. Pen and ink. Berlin, Staatliche Museen
Preussischer Kulturbesitz, Kupferstichkabinett.

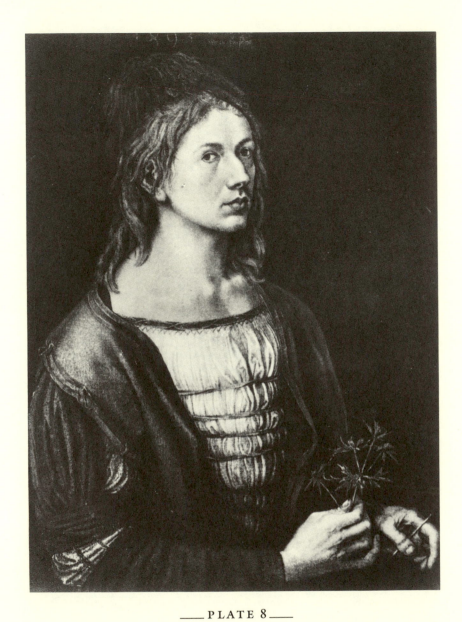

_____ PLATE 8 _____

Dürer. *Self-Portrait with Eryngium.* 1493. Oil, transferred from vellum to linen.
Paris, Louvre.

the physical, mental, and professional development of "their" children. When Kaiser Friedrich's only son, Maximilian, was born in 1459, a complete horoscope was cast for him by the Imperial astrologer. In the Dürer household there may have been recourse to such less expensive sources of astrological information as the popular *Planetenkinder* blockbooks of the day. In any event, the elder Dürer had thoughtfully provided each child with the basic information necessary for determining the position of his or her planet's "house" at the hour of birth—data which was subject to change every two hours.

Albrecht Dürer the Younger, the eldest of the children to survive, can scarcely have failed to be affected by the deaths of so many of his brothers and sisters—saddened, of course, yet perhaps at the same time acquiring something of the sense of his own uniqueness and importance which modern pyschologists have observed in children who have outlived siblings. He may have intended this information to be contrasted with his own horoscope, cast in 1507 by his friend Lorenz Beheim, a canon of the Bamberg Cathedral, who had circulated it in the humanist circle of Nuremberg by sending a copy to Willibald Pirckheimer: Beheim had predicted financial success, travel, and many loves for "our Albrecht," justifying both his slender physique and his artistic genius on astrological grounds, and marveling that he had married only once. His letter, in Latin, is in the Nuremberg Stadtbibliothek.[18] Having dutifully recorded the birth information of his brothers and sisters, Dürer went on in his family history to characterize his father, and to describe his own early life:

> Item: this above-described Albrecht Dürer the Elder passed his life with great toil and hard work, having nothing for his support but what he earned with his hand for himself, his wife, and children; so that he had little enough. He had also much grief, many temptations and annoyances. But he won just praise from all who knew him, for he lived an honorable Christian life, was a man patient of spirit, mild and peaceable to all, and very thankful toward God. For himself he had little need of company and worldly pleasures; he was also of few words and was a God-fearing man.

Dürer has painted an unnecessarily grim picture of his father's circumstances, for, as we have seen, Albrecht the Elder was considered one of the most trustworthy goldmiths in the city, fulfilling the important office of official assayer of precious metals. While by no means a wealthy man, he was nevertheless able to maintain both a house and a separate shop in two of the most desireable locations in Nuremberg, and had

received important commendations and commissions, both Imperial and ecclesiastical. It is evident that Dürer expected this memoir to be read, not by his own family, but by present and future humanists. Consequently, he has used the classical "modesty topos" to compare his own background to that of the upper classes. In emphasizing the fact that the senior Dürer "had nothing for his support but what he earned with his hand," he was making the point that there had been no inherited wealth and no financial windfalls of the sort that merchant families were privileged to enjoy. It was, moreover, considered only prudent in Dürer's day for artists and other craftsmen, as well as peasants, to underestimate their actual worth, as we know from numerous cases in Italy where substantial understatements were routinely made for tax purposes.

The fact that the elder Dürer "endured much grief" is self-explanatory in light of the above-going record of his eighteen children, fifteen of whom he evidently outlived, and may have nothing whatever to do with his professional life. It is certainly true, however, that as a goldsmith, and as public assayer in litigious Nuremberg, he must have undergone "annoyances and temptations" almost daily. The public record shows an alarming number of accusations brought against individual Nuremberg goldsmiths for handling allegedly stolen goods and for other types of malfeasance. In fact, Dürer's future father-in-law, Hans Frey, was convicted and sentenced to jail on May 29, 1488, for having in his possession goods stolen by one Werlein Weissprot—a fact which may well have damaged his daughter Agnes's chances for a marriage within the merchant class, to which Agnes's mother's family belonged. However, the sentence was twice postponed and eventually seems to have been commuted, suggesting that Frey had acquired the stolen goods in good faith. Albrecht Dürer the Elder's name, however, was mentioned in the city's archives only with respect.[19]

> This man, my dear father, was very careful of his children to bring them up to honor God. For it was his highest wish to train them well, that they might be pleasing in the sight of both God and man. Wherefore his daily speech to us was that we should love God and deal truly with our neighbors.

# II

## THE EARLY YEARS

And my father took special pleasure in me because he saw that I was diligent in striving to learn. So he sent me to the school, and when I had learned to read and write he took me away from it and taught me the goldsmith's craft. But when I could work neatly, my liking drew me more to painting than to goldsmith's work. So I put it to my father. But he was troubled, for he regretted the time lost while I had been learning to be a goldsmith. Still, he let me have my way, and in 1486, as one counts from the birth of Christ, on St. Andrew's Day [November 30], my father bound me apprentice to Michael Wolgemut, to serve him three years long. During that time God gave me diligence so that I learned well, but I had to endure much from his apprentices.

D ÜRER'S sympathetic portrayal of his father, and his largely positive memories of his childhood are in remarkable contrast to Martin Luther's recital of brutal beatings at home and at school, as Matthias Mende has noted. There can be little doubt that Albrecht Dürer must have been a more agreeable child than the great Reformer, and even less doubt that in both cases their memories were selective. However, the differences are nonetheless real, and they have to do in large measure not with the relative merits of the boys themselves but with their situations. Luther, a miner's son living in the remote Thuringian village of Mansfeld, was sent to Latin school, and later to the University of Erfurt, in order to be trained for a career as a jurist; hence, although he was actually a dozen years younger than Dürer, the education he received was essentially a more medieval one. Young Dürer was privileged to attend school in the metropolis of Nuremberg (population 50,000) which, in the fifteenth century, was at the forefront of progressive education. Four thousand schoolchildren serenaded Kaiser Friedrich III with folksongs under the great linden tree when he visited Nuremberg in 1487, and His Majesty is said to have rewarded each with a gold florin on this occasion (which the teachers prudently collected

again afterward), and at other times to have dispensed the spicy Nurem-
berg cookies named in his honor, *Kaiserlein*.

In 1475, when Dürer was four years old, and when six children had
been born to the family, his father purchased the house "unter der Ves-
ten," in Nuremberg's Latin Quarter. No documents identify the school
young Albrecht attended: although he lived in the parish of St. Sebald
and would have been eligible to attend the Latin school there, Klaus
Leder has presented important evidence suggesting that like the sons
(fifteenth-century daughters were educated by tutors or in convents) of
most of Nuremberg's merchant-patriciate, he probably was sent to one
of the small, privately run schools in the city where business German,
penmanship, and arithmetic were emphasized. The arithmetic text writ-
ten by one such Nuremberg schoolmaster, Ulrich Wagner, the first to be
printed (1482) in the German language,[1] which survives only in a few
fragments, contains problems dealing with the measurement and sale of
tin, grain, pepper, wine, saffron, and other products traded by Nurem-
berg merchants, as well as problems in foreign exchange. Dürer's later
publications detailing the comparative construction of Roman and
Gothic lettering, the geometry of the human body, and the theory of
fortifications, although they go far beyond the sort of material presented
in Nuremberg's "German" schools, are nevertheless more closely related
to such practical concerns than they are to those of the traditional Latin
school. At St. Sebald's, for example, he would have been taught the ru-
diments of Latin grammar (not German), logic, rhetoric, Gregorian
chant, and would have begun the study of Latin literature. Dürer's abil-
ity as an adult to write a clearer and more forceful German than his uni-
versity-educated friends may be in some measure a function of this early
training.

In Nuremberg, even the parish Latin schools were administered
jointly by both the Church and the City Council—a situation unique in
Germany before the Reformation. Unlike the state of affairs in other
cities, in Nuremberg the Church was responsible only for funding,
while the City Council held control of curriculum and discipline, as well
as of faculty appointments. Consequently the study of the works of sec-
ular authors such as Terence, Aesop, and even the modern humanist,
Aeneas Silvius Piccolomini, had been introduced in Nuremberg by 1485,
at about the time Dürer left school to learn the goldsmith's trade.

Although St. Sebald's Latin school was convenient to his home, its
curriculum was still essentially a preparation for the priesthood or for

the law, which presupposed that a university education would follow. Albrecht Dürer's writings show that, although he had a smattering of Latin vocabulary, he had not mastered the language sufficiently to be able to read the Latin edition of Euclid which he bought in Venice in 1505, and had to wait for the publication of the German edition. He also requested in 1520 that Martin Luther's new pamphlets be sent to him in their German editions, rather than in Latin,[2] and is known to have been dependent upon his humanist friends to compose Latin or Greek inscriptions for his works. His publications demonstrate, however, that his knowledge of mathematics was quite sophisticated, and his written German relatively so. Joachim Camerarius, who was headmaster of the Nuremberg Gymnasium after 1526 and who knew the artist well, comments that Dürer had never studied literature, but had command of mathematics and natural science.[3] Dürer's later friendships with the poet laureate, Konrad Celtis, his involvement with the short-lived "School for Poets," and with Johannes Neudorfer, headmaster of the "German school" in Nuremberg also indicate that his interest in modern education continued to grow long after his own formal learning had been interrupted.

"When I had learned to read and write," then, Dürer says—presumably after three or four years, or about as long as Leonardo da Vinci spent at school—his father withdrew him from the school in order to train him in the goldsmith's craft, probably at the customary age of ten or twelve. As Panofsky noted, this period of his development was more important for Dürer than is generally supposed, for during this time he would have learned the rudiments of drawing, as well the demanding art of handling the engraver's burin—the techniques which were to form the very foundation and uniqueness of his art.

It was during this period of study with his father that young Dürer drew the famous self portrait in silverpoint (Plate 3)—a precocious work in a most demanding medium. Silverpoint, a medieval drawing technique developed first by scribes, is done with a silver stylus on paper, parchment, or vellum which must first be coated with a preparatory ground—often a mixture of glue-water and lead white—and then burnished before use. The faint line which results from the contact between the silver tip of the stylus and the prepared ground is the product of a chemical change, not unlike the tarnishing of table silver, which must take place over a long period of time. When fully "ripe," it yields a delicate and precise, brownish line drawing, ideally suited for the recording

of small details. However, it cannot be erased: the paper must either be washed or recoated with ground in order to obliterate any error.[4] Dürer's drawing of his own reflection in a mirror was done when he was a boy of thirteen, as the inscription in the artist's own hand indicates: "I drew this myself from a mirror in the year 1484, when I was still a child. Albrecht Dürer." The work is a tour de force and a clear indication of the type of inborn talent for drawing which has rarely been seen in the history of art. This was evidently recognized as such by his father, who must have taken the first responsibility for the preservation of the drawing, despite his later misgivings about Dürer's wish to undergo a second apprenticeship as a painter. Another drawing in silverpoint (Plate 4) portrays Albrecht Dürer the Elder with a small statuette, presumably of precious metal, in his hand: it is attributed by many modern authorities to the elder Dürer himself,[5] and is thought to have been a model done by the father for his son's instruction. The concealment of the drawing hand suggests a self portrait, and the style of drawing suggests the influence of the workshop of Dirk Bouts, which is fully in keeping with Dürer's remark that his father had "been a long time in the Netherlands with the great artists" in the early 1450s.

In November of 1486, against his own better judgment, the senior Dürer granted his son's wish to study painting and apprenticed the boy, now fifteen years old, to his neighbor, the painter and entrepreneur Michael Wolgemut (1434/7–1519). Wolgemut, son of a minor Nuremberg painter, had been trained in Munich in the workshop of Gabriel Mäleskircher. Failing in his attempt to wed Mäleskircher's daughter, whom he very ungallantly sued for breach of promise, he had returned to Nuremberg in 1472, to console himself by marrying the newly widowed Barbara Pleydenwurff. Hans Pleydenwurff (ca. 1420–1472), her late husband, a native of Bamberg who settled in Nuremberg in 1457, had been the Imperial city's most able but least successful painter, introducing the Netherlandish manner of Rogier van der Weyden and Dirk Bouts to Nuremberg's painters as Albrecht Dürer the Elder had imported the latest Netherlandish fashions for the local goldsmiths. Wolgemut is thought by some to have collaborated with Pleydenwurff on the painted panels of the altar for the Church of St. Michael in Hof.[6] By 1479, Wolgemut was able to repurchase the workshop that Pleydenwurff had been forced to sell, in the street "unter der Vesten oberhalb der schiltoren" (Burgstrasse No. 16—two doors away from the Dürers), and, in 1493, to purchase an additional house to accommodate his expanding enterprise.

Wolgemut's style is not easily distinguished from that of the workshop he had inherited, which included his stepson, Wilhelm Pleydenwurff (d. 1494), a young man who must have been only slightly older than Dürer, nor from that of the elder Pleydenwurff, whose drawings he had inherited. On the whole, Wolgemut was less remarkable as a painter than as an organizational genius, accepting commissions for sculpture, stained glass, and woodcut illustration as well as for paintings, and making liberal use of subcontractors to orchestrate his more ambitious projects. These included the large transforming altar for the Church of St. Mary in Zwickau (1479), which cost the astronomical sum of 1,400 gulden, including transportation and installation—a fee many times larger than any earned later by Dürer, whose altars did not include sculptured shrines. Wolgemut, who died only nine years before Dürer, continued to operate the largest workshop in the city even during Dürer's most active years. It was Wolgemut whom Dürer asked to give temporary employment to his teenage brother, Hans III, during his own protracted absence in Italy in 1506. Dürer painted the old man's portrait in 1516 (Plate 5), keeping one version of it in his own collection, where he later carefully recorded on it the date of Wolgemut's death, as he had done with the charcoal drawing of his own mother a few years earlier.

Since Dürer at fifteen was already a good deal older than Wolgemut's other apprentices, who can be assumed to have begun their training at the proper age, and since he was already a better draftsman than Wolgemut himself, it is difficult to imagine what unpleasantness, other than mindless teasing, he might have "endured from Wolgemut's apprentices (*Knechten*)." His most valuable experiences in this workshop would have included the basic training in the preparation of panels, mixing of colors and drawing inks, and composing works in the large scale required for the great altarpiece and stained glass commissions which were among the Wolgemut studio's most characteristic products. He would have developed, among other things, a predisposition for the "factual" landscape backgrounds featuring half-timbered Franconian buildings which were popular with fifteenth-century Nuremberg painters.

Even more importantly, Dürer would have learned the art of woodcut design from Wolgemut, who was the first major German painter to contract directly with a publisher, and to employ his own block-cutters to execute his draftsmen's designs for book illustrations. The woodcuts which his workshop produced for printed books were technically among the best to be had in Europe at the time, utilizing previously

unheard-of effects of modeling and spacious and detailed landscape set-
tings. Albrecht Dürer, before his departure in the late spring of 1490,
would probably have witnessed the execution of some of the drawings
made by Wolgemut and Pleydenwurff on woodblocks to be cut for the
illustrations for Stephen Fridolin's *Schatzbehalter* (Treasure Chest),
published in 1491 by Dürer's godfather, Anton Koberger, and even some
of the 645 woodcuts for Hartmann Schedel's *Weltchronik* of 1493 (the so-
called Nuremberg Chronicle). Young Dürer may even himself have
worked on some of the illustrations for Koberger's *Heiligenleben* (Lives
of the Saints), published in 1488 (although the major designer for this
work is thought to have been trained in Ulm, on the basis of his style,
which was simpler than that used by Wolgemut). Other illustrated Nu-
remberg books from the late 1480s which have won acceptance as con-
taining possible works of Dürer's apprentice years include Nikolaus von
der Flühe's *Bruder Claus* (Marx Ayrer, 1488); Philipp Frankfurter's *Die
Geschichte des Pfarrers von Kalenberg* (The Story of the Vicar of Kalen-
berg, Peter Wagner, ca. 1489–1490); Bertholdus's *Horologium Devotionis*
(Devotional Clock, Friedrich Gessner, 1489); the second volume of Jo-
hannes Gerson's collected works (*Secunda pars operum*, Georg Stuchs,
1489) and others. Although each of these, as well as other works of the
period contain certain illustrations which are seemingly prophetic of ef-
fects later utilized by Dürer, it is impossible to prove his participation
beyond reasonable doubt in any particular case.[7]

The most convincing argument in favor of Dürer's precocious in-
volvement in Nuremberg woodcut illustration is the fact that book il-
lustration later proved to be the chief source of his income as a journey-
man, and that it also formed a major part of his professional life after his
return to Nüremberg. It was in the area of woodcut design, in fact, that
he was to make the most revolutionary of his contributions to European
art.

# III

## THE BACHELOR'S
## JOURNEY

When I had finished my service, my father sent me off, and I stayed away four years till he called me back again. As I had gone away in the year 1490 after Easter, then I came back again in 1494, as it is reckoned, after Whitsuntide.

I N EARLY April of 1490, shortly before his nineteenth birthday, Dürer's father sent him off on a bachelor's journey which was to last four years. At the time of his departure, his youngest brother, Hans III was less than two months old. While he was away, the eighteenth and last of the Dürer children was born—Carl (August 8, 1492), who may perhaps have died even before his return.

Before leaving, he painted companion portraits of his parents.[1] Both sitters are shown in three-quarter view, cut slightly short of the waist and each holding prayer beads, and were posed against the neutral background favored by both Wolgemut and Hans Pleydenwurff for portraiture—essentially an extended version of Rogier van der Weyden's formula, which had been popular in the Burgundian Netherlands at mid-century.

No written record of Dürer's bachelor's journey has survived; however, a portion of his travel can be reconstructed from the works of art that remain from these years, and from comments written later by his humanist friends. Christoph Scheurl (1481–1542), a Nuremberg lawyer, in his biography of Anton Kress corrects Jakob Wimpfeling's statement that "our Albrecht" had studied with Martin Schongauer in Colmar.[2] Dürer, Scheurl says, had often told him, both orally and in writing, that his father had wanted to apprentice him to Schongauer at the age of thirteen, and had written Schongauer a letter to that effect, but that he was prevented from carrying out his intention by Schongauer's untimely death. It was after that, Scheurl claims, that Dürer was apprenticed to Wolgemut. Scheurl, who was a fairly close friend of Dürer's, correctly identified Schongauer as one of the most outstanding artists of his time,

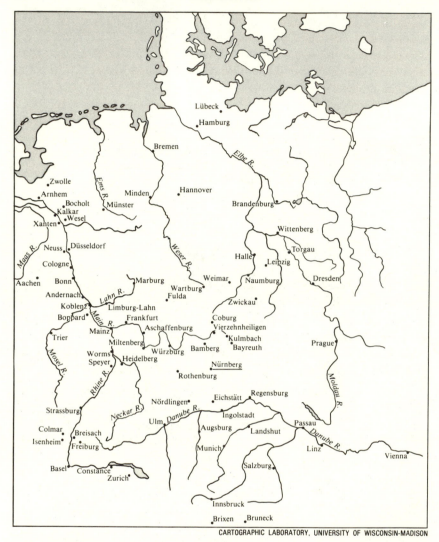

Germany, Austria, Alsace, and Northern Switzerland.

and also identified the elder Dürer correctly as a native of "Cula, near
the Hungarian city of Voradium" (Wardein). He placed the father's de-
cision in the very year of Dürer's silverpoint self portrait—which lends
further authority to his statement, although we know that Schongauer
died on February 2, 1491, rather than in 1484, and that Dürer, unaware
of the great engraver's demise, actually went to his Colmar studio early
in 1492.

That the elder Dürer had thought immediately of Schongauer as an appropriate teacher for his son is not only possible but probable, for Martin Schongauer was the son of the well-known goldsmith, Caspar Schongauer, a member of the City Council of Colmar (Alsace), whose family had previously been prominent in Augsburg. Internationally famous as an engraver, Schongauer was the first major German graphic artist known to have been trained as a painter rather than as a goldsmith. His engravings (Plate 6 is one example) were widely admired in the Netherlands and Germany, and were assiduously used as models for altarpieces by Spanish, Netherlandish, and German painters of the late fifteenth century. In Italy, Vasari alleges, even the youthful Michelangelo copied an engraving by Schongauer—his *Temptation of St. Anthony* (L.54). If Schongauer indeed visited Augsburg in 1483, as some scholars believe on the basis of the inscription on his portrait by Thoman and/or Hans Burgkmair the Elder in Munich,[3] the elder Dürer may have had more direct knowledge of him than has previously been supposed.

Why, then, did he not send young Albrecht immediately to Colmar in 1486, rather than to Wolgemut? In 1486 his fifteenth child was born, and, although it is clear from the family record that far fewer than fifteen were still alive, it is certainly possible that family finances may have been strained. It is probable, too, that the Dürers were reluctant to send a thirteen-year-old on the long journey to Colmar, which is on the left (now French) bank of the upper Rhine nearly opposite Freiburg. Also, they may have known, and disapproved of, the fact that Martin Schongauer was a bachelor—and one whose nickname, moreover, was "Pretty Martin"—for it was customary for young apprentices, most of whom were still children, to be housed and fed in their masters' homes. Another possibility is, of course, that Schongauer was simply unable or unwilling to take on any more apprentices in 1486, for, judging from the number of his imitators, and from the fact that he was co-tenant of a group of houses in the Schedelgasse in addition to his residence, the large house "zum Schwann" in the Augustinergässlein, his workshop must have been unusually large already.[4]

In any case, if Dürer had been apprenticed to Schongauer, his father would have had to pay his fees. If, on the other hand, Dürer were to wait and go to Schongauer as a journeyman, he would be earning his own expenses and would be capable of fending for himself. Scheurl's apparent garbling of the facts may simply mean that the elder Dürer had made a tentative arrangement with Schongauer when his son was still a boy, but that his intention all along had been to have Dürer go to Col-

mar as a journeyman, and that Schongauer's death prevented the fulfill-
ment of this plan.

In Nuremberg, with Wolgemut, Dürer had more than mastered the
rudiments of panel painting and woodcut design, as his portraits of his
parents show. From his father he had already learned to draw and to
handle the burin to some extent, probably enough to make engraved
ornaments. There was, however, no major pictorial engraver resident in
Nuremberg in the 1480s and 1490s, and so one definite goal of Dürer's
bachelor's journey must surely have been to seek further instruction in
the engraving and printing of intaglio plates. From his work with Wol-
gemut he would have been familiar with the two processes for printing
woodcuts—by hand, which requires virtually no equipment, and by Gu-
tenberg press, where type-high woodblocks were locked into the press
bed with the columns of text set in movable type. Engravings, done on
plates of rolled copper, and executed with a steel-shafted tool sharpened
sufficiently to cut grooves into the copper, are much more difficult to
print satisfactorily, since they must be carefully inked and then wiped
before being subjected to tremendous pressure in order to force the
dampened paper down into the incisions on the plate to pick up the
printer's ink.

Schongauer, who practiced and seems to have taught both painting
and engraving, is remarkable for the high quality of his printed impres-
sions. He probably maintained two studios in order to use one for paint-
ing, with easel and workbench for grinding colored pigments, and the
other for his bulky printing equipment and workbench for mixing and
applying printer's ink, and the taut lines for drying finished engravings,
which are still damp when pulled from the press bed.

Dürer reached Colmar too late to meet Schongauer, who had died on
or before February 2, 1491, probably of the plague. At the time of his
death Schongauer was a citizen of Breisach, directly across the Rhine,
where he had been commissioned to create a huge mural of the Last
Judgment on the entrance wall of the Minister of St. Stephen. This
fresco, with its larger-than-life figures, was the most ambitious wall
painting north of the Alps, and it would fully have occupied his time
and that of two or three assistants during the warmer months of the
years 1489 and 1490. Schongauer had evidently left his Colmar work-
shop intact and in the care of one or more of his brothers, perhaps in-
tending to work there during the winter months when fresco work be-
came impossible in the unheated church of Breisach.[5] His printing
equipment, in any event, would have been inconvient if not impossible

to transport. Dürer seems to have been welcomed by Schongauer's brothers and permitted to make a careful study of the older master's engravings, which he continued to admire and to use as sources of inspiration throughout his life.

Since Dürer is known to have left Nuremberg in April of 1490, and not to have reached Colmar—according to Scheurl—until early 1492, a year and a half of his travel time is unaccounted for. This missing period has been the subject of much art-historical speculation. According to Carel van Mander (1604, Haarlem) and Joachim von Sandrart (1675, Nuremberg),[6] he traveled to the Netherlands where, van Mander insists, he inordinately admired the work of the youthful Haarlem painter, Geertgen tot Sint Jans (active ca. 1480–1490). While van Mander is justly famous for having overstated the importance of his adopted city of Haarlem from time to time, it is true that one of Dürer's drawings from this period, the *Holy Family* in Berlin (Plate 7),[7] shows the influence of the modern Netherlandish construction of landscape as perfected by Geertgen. Hans Gerhard Evers (1972) has proposed a trip to Bruges to the studio of the German-born Hans Memling (active ca. 1465–1494), who was the most famous painter in the Netherlands in 1490, and who would have been working on the Greverade altarpiece for shipment to Lübeck at the time. Dürer's detailed description of Bruges written in 1520, however, strikes the reader as having been done by a man who had not seen the city before. Furthermore, we must ask why, if Dürer did become a journeyman painter, there are no fully authenticated paintings attributable to him which date from this period.

No documents survive to reveal Dürer's activities during the missing year and a half. If he kept a journal, as he did on his later trip to the Netherlands in 1520, it has been lost. It is possible that a portion of the time was spent quite near Nuremberg, for two capable engravers trained by Schongauer were active in Dürer's native Franconia in 1490: one was Master LCz, probably to be identified with Lorenz Katzheimer of Bamberg, whose engraving of *The Flight into Egypt* was to be one of the sources, together with Schongauer's print of the same subject, for the corresponding woodcut in Dürer's Life of Mary series of 1502–1505. The other engraver was the Master A.G., employed by the Bishop of Würzburg to illustrate his diocesan publications. Master A.G., who is probably to be identified as Anton Gerbel of Pforzheim,[8] was the first printmaker to create copperplate engravings specifically for use as book illustrations—an idea which proved not yet commercially practical due to the differing pressure requirements for printing engraved plates and

lines of Gutenberg type. Albrecht Dürer's drawing of the Crucifixion with Mary and John of 1490 or 1491 (Paris, Louvre 18.995) is set in a rocky river valley very reminiscent of a landscape setting by Master A.G.—and, indeed, of the natural setting of Würzburg itself. In the late 1490s when Dürer designed the woodcuts for his Large Passion he consulted Master A.G.'s engraved Passion series for prototypes of events not included in the one by Schongauer.

We can be assured, in any case, that Albrecht Dürer did not leave Nuremberg without letters of recommendation from both his father and his godfather, the publisher Anton Koberger. The myth of the wandering apprentice who strolls blithely from one town to the next, whistling a merry tune as he knocks on doors to ask for work, is a nineteenth-century fabrication, as Evers rightly observed. It is virtually a certainty that Dürer's entire trip was laid out with some care by his father and godfather, who would have written in advance to prospective employers such as Schongauer, and, in an age as yet innocent of passport photographs and other official means of identification, would have provided him as well with letters of introduction to carry on his person.

He probably left Nuremberg with one of Koberger's book-delivery convoys bound for the warehouse in Frankfurt—a relatively safe means of transport, since it would have been led by a *Fuhrmann* and escorted by armed guards. In Dürer's day, solitary travelers were highly vulnerable to robbery and personal injury perpetrated by renegade knights and bandits in the forests and countryside to the west of Nuremberg, and even the most idealistic young journeyman would have hesitated to travel alone. Since Koberger's convoys traveled at regularly scheduled intervals, it would even have been possible for his godson to make one or more lengthy stops en route, resuming his westward journey after several months at the time of a later shipment. It is entirely possible that he may have been accompanied part of the way by Koberger himself, for the redoubtable publisher is reported to have ridden horseback "ins Ausland" until he was very old.

The free city of Frankfurt am Main, seat of every Imperial election since Hohenstaufen times, and then as now the locus of western Germany's most resplendent trade fairs, would surely have been on young Dürer's itinerary, if only because Koberger's baggage service halted there. In later years he seems to have depended heavily on the Frankfurt market as an important sales outlet for his prints (see chapters IX and X). In the diary of his 1520 journey to the Netherlands, Dürer was to record overnight stops and entertainment by friends in Frankfurt and in

the nearby archiepiscopal city of Mainz, where he appears to have known several goldsmiths by name, but he failed to comment on any of the principal buildings or tourist attractions, suggesting that both cities were quite well known to him.

Since Dürer's father would surely have been informed by Schongauer of the latter's plans to be absent from Colmar from late 1488 until 1491, Mainz may actually have been one of young Albrecht's primary goals. Birthplace of the printing industry, which had been launched only thirty-five years before with Johannes Gutenberg's invention of printing from movable type, Mainz in 1490 was famous as the adopted home of the Dutch-born painter, and designer for woodcut and stained glass, Erhard Reuwich—the first artist who is also documented as a publisher. Reuwich's best-seller of the 1480s was the travel book describing a pilgrimage to the Holy Land written by Bernhard von Breydenbach, a canon of Mainz Cathedral, the *Peregrinationes in Terram Sanctam* (Mainz, February 11, 1486). The book was liberally illustrated with woodcuts by Reuwich, who had been taken along on the pilgrimage by the author and his patron, all expenses paid, in order to sketch the architecture and topography, costumes, and exotic animals seen on the tour. The book, which Reuwich himself had printed with the aid of typefaces belonging to the Mainz publisher, Peter Schöffer, was an instant success, and rapidly went through German and Dutch editions as well as the original Latin one. Reuwich's illustrations, allegedly done from nature (although, to be sure, a unicorn was depicted), offer an important precedent for Dürer's own nature studies. The *Peregrinationes* was already known and imitated in the Wolgemut studio, where Reuwich's city views and figure studies had formed the inspiration for woodcuts in both the *Schatzbehälter* and the *Nuremberg Chronicle*. Dürer himself was particularly struck by Reuwich's "string-of-pearls" convention for depicting groves of faraway trees by overlapping a neat series of rounded shapes, a device which he used forever afterward in both his paintings and his woodcuts.

Reuwich's assumption of the role of publisher—which netted him, of course, a handsome share of the book's profits rather than a simple artist's piecework fee—must also have given young Dürer food for thought, for he followed Reuwich's example in 1498 as publisher of the great illustrated book of the Apocalypse, using Anton Koberger's typefaces. Reuwich had also done a series of botanical illustrations for Schöffer's herbal, the *Gart der Gesundheit* (The Garden of Health, Mainz, 1485), which prefigure Dürer's later plant studies done from nature.

Reuwich, who had spent a month in Venice while waiting to take ship for the Holy Land, had mastered linear perspective as well—an Italian innovation which was imperfectly understood in the Wolgemut studio, but one which Dürer used to increasingly good effect after 1490. Reuwich, who was born in the Dutch episcopal city of Utrecht and trained there as a painter, may also have had in his possession drawings or other works of art reflecting the Haarlem style of smoothly receding landscape practiced by Geertgen.

In Mainz in the early 1490s, or even in Frankfurt, through the engraver known as Master bxg, Dürer would also have had access to prints by the mysterious Master of the Housebook (also known as the Master of the Amsterdam Cabinet, from the principal collection of his rare drypoint engravings—the Rijksprentenkabinet in Amsterdam).[9] The Housebook Master, who many scholars believe can actually be identified with Reuwich, created spirited and worldly compositions in the highly ephemeral medium of drypoint. He was, in fact, the inventor of the process, which is essentially a lazy man's engraving, done with a round-pointed, icepick-shaped tool to incise the lines, rather than the traditional engraver's burin with its diamond-shaped blade. Drypoint is a great deal easier to master than copperplate engraving, but is impractical for commercial purposes because so few clear prints can be taken from each plate. The Housebook/Amsterdam Cabinet Master, most of whose prints survive today only in single impressions, seems to have pulled only a few prints from many of his small plates of soft metal (zinc or pewter) but was quickly imitated by such other printmakers as Wenzel von Olmütz and Israhel van Meckenem in long-lasting copperplate.

It is not always possible to determine whether Dürer had seen the original drypoint or an engraved copy after it in each case, but he was demonstrably impressed by the Housebook Master's costume studies, depictions of mounted courtiers and ladies, and pairs of lovers. He had already seen work of this nature while still in the Wolgemut studio, as his 1489 drawings, *The Cavalcade*[10] and *Knights Fighting on Horseback*[11] suggest.

While on his travels, Dürer did two drawings of the Holy Family[12] which strongly recall a drypoint of the same subject by the Housebook Master (L.11–28, Amsterdam), a theme which he would carry further in his early engraving of the *Madonna with a Butterfly* (B.44) of about 1495, and in his later drypoint of the *Holy Kinship* of 1512 (B.43). The Housebook Master's satirical coats-of-arms he emulated in a drawing of an imaginary coat-of-arms[13] featuring a pelican as crest and a barefoot peas-

ant lurking behind a tiled stove as the motif on the escutcheon. The Housebook Master's elegant "court" style, developed at the court of the Pfalzgraf Philipp at Heidelberg in the early 1480s inspired Dürer's beautiful drawing, *A Young Couple Walking* (W. 56: Hamburg, Kunsthalle). He even dressed and combed his hair in the manner of the Housebook Master's elegant young gallants, as his *Self-Portrait* of 1493 shows (Plate 8). The Housebook Master's famous *Bulldog Scratching Himself* (L–11.72, Amsterdam), an amusing nature study from about 1475, is an important forerunner of Dürer's later studies of individual animals. In fact, almost the only theme popularized by the Housebook Master which did *not* appeal to Dürer seems to have been that of the Ill-assorted Lovers—depictions of venal love featuring partners wildly mismatched in age. This struck, perhaps, too close to home: although he later engraved the theme of "love for sale" (*The Offer of Love*, 1495, B.93), the man and woman depicted are not caricatured and are much closer in age than is usual for this subject.

Another artist important for the young Dürer who was active in Mainz during the 1480s and early 1490s was the Master W.B., whose painted portraits of an unknown man and woman, dating from about 1484,[14] greatly influenced Dürer's portraits of the late 1490s, including those of the Tucher family, and his own *Self-Portrait* done in 1498 (Madrid, Prado). These, unlike Dürer's portraits of his parents, show the sitters in fully developed architectural settings featuring windows opening into landscapes and elegant brocaded wall-hangings. Fedja Anzelewsky has made the intriguing suggestion that Master W.B. may have been Wolfgang Peurer—for the letters *B* and *P* were quite interchangeable in south Germany in the fifteenth century. Peurer's name and the date 1484 appear in Dürer's handwriting on a pen drawing, *The Courier*, now in Gdansk (Muzeum Pomorskie).[15]

On leaving Mainz, where the river Main joins the Rhine, Dürer would have had two possibilities: one, to go downstream toward Cologne, Xanten, Wesel, and the Netherlands; or, alternatively, to turn southward toward Speyer and Strassburg, which lay on his way to the Schongauer workshop in Colmar. We know that he eventually did go to the south; did he first go north and west as well?

As we have seen, the cities of Frankfurt and Mainz held much that would have been of interest to Dürer, and the fact that his Netherlandish diary of 1520 contains no descriptive passages in reference to his stops of several days in these cities suggests that they contained old friends but few surprises. Much the same can be said of Cologne, which Dürer vis-

ited three times during his "sabbatical" year 1520–1521. Although his diary does contain references to two noteworthy sights in the city—namely, the remarkable sacristy of St. Ursula's Church, with its bones of the 11,000 virgin martyrs, and the great Altarpiece of the Patron Saints by Stephan Lochner in the City Hall—these are by no means the most obvious of the city's attractions. His failure to mention either the unfinished Cathedral, the enormous golden Shrine of the Three Magi designed by Nicolas of Verdun, or any of the works by Rogier van der Weyden and Dirk Bouts in the city's numerous churches indicates that, at least by 1520, he was on relatively familiar territory—although, of course, it is impossible to say how old he may have been when he first went there. In 1490–1491 his goldsmith cousin Niclas "Unger" had not yet moved to Cologne; but the fame of the city, its past and its treasures, and its relative ease of access by water from Mainz must have exerted a powerful attraction for Dürer, who would surely have heard much about Cologne from his father.

A case, then, can be made for a probable trip downstream at least as far as Cologne. It is conceivable that from there he could have visited Xanten, Wesel, Kalkar, or perhaps Bocholt, the home of the engraver-goldsmith Israhel van Meckenem (ca. 1450–1503). His account of his brief excursion on the lower Rhine and Waal from Cologne to Nijmegen in 1520, however, and his description of the latter city suggest that he had not traveled this way before 1520, as he should have done if he were going to Utrecht, Haarlem, or Leyden. It should be borne in mind, too, that although Dutch painters' guilds were on the whole more receptive to foreign journeymen than were the Flemish ones, there was no Nuremberg baggage service or banking connection upon which Dürer could depend in this area. When Dürer traveled, he normally stayed within this network of support services. Haarlem was not only forbiddingly far away, but difficult of access in the fifteenth century, since it was still isolated from the world by the Harlemmer Meer—the great shallow and dangerous lake which was filled in a land reclamation project in the 1840s. In 1490, it was still a well-to-do but quiet and contemplative city best known for its many convents and monasteries and for the sometime residence of the Counts of Holland. Geertgen tot Sint Jans, who was servant and painter to the Commandery of the Knights of St. John, was evidently still alive in 1490, but it seems doubtful that his living situation, "at St. John's," could have allowed for a workshop incorporating a training program for young German journeymen. Geertgen is also an unlikely source for the very sophisticated portrait style that Dürer had developed by 1493, as shown in the self-portrait

drawings in Erlangen and New York of 1491 and the painting in Paris of 1493.

An added complication in 1490 was the political situation in the Netherlands, which had deteriorated dramatically since the palmy days when Dürer's father and Hans Pleydenwurff were journeymen. The reigning Duke of Burgundy, Charles the Bold, had been slain before the walls of Nancy in battle against the Swiss in 1477, his army destroyed and his treasure looted. His only child and heir, the nineteen-year-old Mary of Burgundy, was killed in a riding accident in 1482 at the age of twenty-four. She and her consort, Kaiser Friedrich's son Maximilian, were subjected to the territorial ambitions of Louis XI of France, who saw a golden opportunity for a takeover. Maximilian, after his wife's death, had also to contend with the fractious citizens of Bruges, who seized and imprisoned him in 1488, and with the rebellious Duke of Cleves—through whose territory young Dürer would have had to pass in order to visit the northern Netherlands.

It seems more logical that Dürer would have turned southward on the Rhine, either from Mainz or from Cologne, and traveled against the current toward Colmar, arriving there too late to meet Martin Schongauer:

> Then, when he had traveled to and fro in Germany he came to Colmar in the year 1492, and there Caspar and Paulus, goldsmiths, and the painter Ludwig, and similarly in Basel, Georg, all four of whom were brothers of "Schön Merten," kept him good company. But, not only did he not study with [Martin Schongauer], he never saw him in all his life, although he had greatly wished to do so.
>
> (Christoph Scheurl, *Vita reverendi patris domini Antonii Kressen*, Nuremberg, July 24, 1515)

Scheurl, who received his information from Dürer himself, and who published it during the artist's lifetime, made no mention of a trip to the Netherlands. In view of the fact that he saw fit to include even the names and occupations of Schongauer's brothers, it is certainly curious that he neglected to mention such a major event as a Netherlandish journey—if, indeed, there had been one.

Scheurl's passage is of greatest interest, however, for the information it contains about Dürer's next move, which was to go to Basel. Here he was befriended by Schongauer's brother, Georg, who had become a naturalized citizen of Basel on June 28, 1485. A goldsmith like his father, Georg was apparently doing well, for he had bought property in Basel in 1492—the Haus zum Tanz, which was later to become famous for its

painted facade by Hans Holbein the Younger. It is possible that he of-
fered Dürer lodgings in this fine house; in any case, he surely would
have added his own recommendation to that of Anton Koberger in
helping young Dürer find employment for the coming year. His age is
not known—no birth records exist for any of the Schongauers—but
since he is known to have married Apollonia, the daughter of the influ-
ential Netherlandish sculptor Nikolaus Gerhaert von Leyden (active
1462–1473), whom he may have met in Strassburg when her father
worked there between 1463 and 1467, he may have been born in the
1440s.

Dürer's stay in Basel is documented, not only by Scheurl's statement,
but more importantly by his signature, "Albrecht Dürer von Nör-
mergk," on the back of the woodblock (Basel, Kupfestichkabinett)
which was used for the frontispiece to the new edition of the letters of
St. Jerome (*Epistilare beati Hieronymi*, Basel, Nikolaus Kessler, August
2, 1492). The woodcut, which was crudely cut from Dürer's drawing by
a professional *Formschneider* less skilled than the ones employed by Wol-
gemut, depicts St. Jerome in a late-medieval efficiency apartment, ex-
tracting the thorn from the lion's foot. The background combines the
canopied bed of Martin Schongauer's *Death of the Virgin* with a city-
view seen through the open doorway in the style of the long-dead Basel
painter, Konrad Witz, while the group of Saint, lion, and lectern in the
foreground echo the less ambitious settings of the many anonymous
woodcuts of St. Jerome dating from the third quarter of the century.

During his stay in Basel, Durer made 147 drawings on woodblocks for
woodcut illustrations for a new edition of the *Comedies* of Terence. Only
eight of the blocks were actually cut; of the others, Dürer's original
drawings survive intact (Basel, Kupferstichkabinett). The projected se-
ries was to have opened with an author's "portrait" of the Roman play-
wright himself, looking very like Martin Schongauer's *St. John the Evan-
gelist on Patmos* but wearing a somewhat weedy wreath of laurels. The
book never appeared, probably because the publisher had been upstaged
by Johann Trechsel of Lyons, whose own edition of Terence came out
in 1493. Dürer's drawings, however, are remarkable for their skillfully
depicted architectural settings in correct perspective.

Other Basel publications with which Dürer seems to have been in-
volved to some extent were the German edition of the Chevalier Geof-
froy de la Tour Landry's book of advice for his daughters, *Der Ritter
vom Turn, von exempeln der gotzforcht vn erberkeit* (Examples of the Fear
of God and of Respectability), published by Johann Bergmann von
Olpe in 1493; and the best-selling *Ship of Fools* by Professor Sebastian

Brant of the University of Basel, also published by Bergmann von Olpe, which appeared on Carnival Day (February 11) in 1494. It has recently been discovered that Dürer also illustrated a broadsheet for von Olpe illustrating a Latin poem composed by Brant in honor of his name saint, St. Sebastian, also published in 1494 shortly after Dürer had left the city.

The inventory of Willibald Imhoff, grandson of Dürer's closest friend, Willibald Pirckheimer, lists a pair of portraits (now lost), painted on parchment, of a man and a woman said to have represented Dürer's Strassburg master and his wife—hence his visit to that city is established rather securely. The fact that he was there in 1493 is further determined by the Strassburg dialect used in the inscription on his own *Self Portrait* (Plate 8) dating from that year: "1493. My sach die gat / Als es oben schtat" (My affairs will go as it stands [i.e., is written] above)— a cryptic couplet which could be taken to refer either to Christian humility, as Ludwig Grote thought,[16] or to astrology, or both. The sprig of eryngium (*Männertreu*) which Dürer holds loosely in his hand, together with the fact that the self-portrait was originally painted on parchment (now transferred to canvas), and thus suitable for mailing or carrying rolled, suggest that the occasion for the portrait may have been Dürer's impending engagement. Eryngium, like the carnation which was the favored betrothal symbol in Flemish portraiture, is a symbol of Christ's Passion, and therefore a suitable emblem of the plighting of one's troth, as one used to say.

The Paris portrait is Dürer's most successful painting to date, and is closely related to the drawings in Erlangen[17] and New York (Plate 9), also done in 1493, and showing the first tentative half-dozen hairs of what was soon to become Europe's most famous and anachronistic beard. (Beards were not normally worn by young, or even by middle-age men in Dürer's day—even the majority of elderly men, as Mark Zucker has shown[18], were clean-shaven.)

Dürer's concentration on portraiture seems to suggest postgraduate work, as it were, in a branch of painting which was to stand him in good stead as a source of income in the years to come. The dramatic improvement over the portraits of his parents done in 1490 indicates that Dürer's Strassburg teacher, whoever he may have been, was a gifted artist indeed—but the technique used is another argument against a sojourn in the Netherlands. The major artist whose work it most nearly approaches is, again, the Master of the Housebook, whose elegant *Pair of Lovers* (Plate 10) has a comparable command of the human form and psyche.

# IV

## THE BRIDEGROOM
## IN ITALY

> . . . And when I returned home, Hans Frey made a deal with my
> father and gave me his daughter, Miss Agnes by name, and with her
> he gave me 200 florins, and held the wedding—it was on Monday
> before Margaret's Day [July 7] in the year 1494.

DÜRER'S self-portrait of 1493, with its somewhat fatalistic in-
scription, "My affairs will go as it stands above," or, "as writ-
ten in the stars," seems to hint that the negotiations for his
impending wedding had been under way for six or eight months before
his actual return to Nuremberg. Neither the bride nor the groom had a
great deal to say about their marriage, which was arranged, as was
proper in the fifteenth century, by the two sets of parents to suit their
own purposes. Such businesslike arrangements may often have been
loveless, at least to begin with, but were in the long run at least as satis-
factory in most respects, and a good deal more permanent, than those
contracted by more modern methods. Dürer's marriage would be re-
garded as a failure by today's standards, for it was both intellectually
unsatisfying and childless, as well as unromantic. However, it seems to
have fulfilled his expectations, and, to the astonishment of Canon Lo-
renz Beheim, who characterized Dürer as an *ingeniosus amator*, pos-
sessed of *multas appetit* when he cast the artist's horoscope in 1507, it was
the only one he ever had.[1]

Hans Frey (1450–1523), Dürer's new father-in-law, was a master crafts-
man who worked in brass and hammered copper, specializing in me-
chanical devices and fountains for banquet tables. Much younger than
Dürer's own father, he came from an old Nuremberg family whose sim-
ple black-and-silver coat of arms suggests that they had originally been
in the service of the Burggraves at the Imperial fortress. Frey, who is
reported to have been a clever and charming man and the best harp
player in town, as well as a good singer, had formerly been the city's
official gauger of honey and nuts. In 1494 he became the building man-

ager of the City Hall, and two years later he was to be appointed to the
Great Council. After 1515 he was superintendent of the beggars' stocks in
the debtors' prison. His wife, Anna Rummel (d. 1521) was the descen-
dant of what in former years had been Nuremberg's wealthiest and most
important family, and her own dowry had been 800 florins when she
married Frey in 1472. The Rummels, originally merchants, were best
known for their ancestor, Wilhelm Rummel "the Rich" (d. 1425), an in-
ternationally respected financier who made loans to emperors and con-
ducted business regularly in Bologna, Milan, Venice, in Florence with
the Medici, and in Rome with the Curia in the early years of the century.
Anna Frey's mother was Kunigunde Haller, the daughter of another im-
portant patrician family, whose coat of arms can be seen on Dürer's early
and hopefully Bellini-like *Madonna and Child* now in Washington (The
Haller Madonna: National Gallery of Art).

So Dürer's father had chosen well: although Agnes Frey's dowry was
less grandiose than her mother's, it was still the price of a comfortable
house like his own. The bridal couple, however, did not immediately
acquire a house, but seem to have lived, as was customary for new-
lyweds, in one of the parental households—it is not known which, al-
though there was surely greater luxury and less congestion at the Freys'
than at the Dürers', for Agnes had only one sister and her family owned
two adjoining houses on the Hauptmarkt.

The bride herself, who is thought to have been about nineteen at the
time, is first known to us from the small, brilliant, and apparently un-
posed pen drawing of 1494 (Plate 11), inscribed "Mein Agnes." Still
wearing her hair in a virginal braid down her back, she appears heavy-
eyed, slightly sullen, and very young, and is seen in much the same pos-
ture that Dürer was later to use for the personification of Melancholy
(cf. *Melencolia I*, Plate 24). A less radiant bride has seldom been recorded
for posterity: it is perhaps not a complete coincidence that one of Dü-
rer's earliest engravings, *The Ravisher* (B.92, 1495) shows a young mar-
ried woman attacked by a rapist who is Death himself.

The bridegroom, however, had just come into the first really substan-
tial amount of money he had ever handled in his life, and he probably
used a portion of it to finance the trip to Italy which he seems to have
taken very soon after the wedding. With the benefit of hindsight this
can be seen to have been not only a legitimate business trip but an essen-
tial one from the point of view of the development of Dürer's unique

importance as the translator of the Renaissance into German. However, it may also have been one of the first of several things about her husband that Agnes Dürer found difficult to understand.

Dürer, in leaving the city for a " bachelor's journey" immediately after completing his apprenticeship, and in going *peregrata Germania*, had already fulfilled his obligation to his craft; indeed, he had exceeded the normal expectation in this respect by remaining away for a full four years rather than for the usual one or two. His decision to leave again within only a few months, and above all, to go to Italy, was, for a Franconian artist, unprecedented. Although occasional German and Netherlandish artists, beginning with Master Bertram of Hamburg, had gone to Rome as religious pilgrims, there had been no concerted attempt to study Italian art for its own sake. Only the Austrian Michael Pacher (ca. 1435–1498), who actually lived in what after World War I became the Italian portion of the Tyrol, had benefitted substantially from his contact with North Italian art to master one-point perspective and to explore the use of life models.

Dürer's immediate reasons for undertaking the trip remain unknown, as does his itinerary within Italy. A severe outbreak of the plague in Nuremberg in September 1494 has sometimes been cited as the most compelling reason for his precipitous departure; a total of 805 citizens of Nuremberg died between September 8 and October 9.[2] Dürer seems, however, to have left his bride to take her chances with it, although it is possible that he may have taken her along as far as Innsbruck, where she had relatives.

Dürer had surely been exposed, if not to the plague or to the discomforts of married life, then surely to some works of Italian art, including the engravings of Andrea Mantegna—the artist to whom Pacher also was most indebted—for they were already being collected in Basel and probably in Nuremberg as well. He would have had the opportunity to hear about Venice from Erhard Reuwich, as well as from any number of Nuremberg scholars and businessmen, for Nuremberg merchants made frequent business trips to Venice and Verona, and Nuremberg's humanists were beginning to be aware of the new publishing house of Aldus Manutius, which employed German printers and specialized in scholarly editions of the Greek and Latin classics. The news of the marriage of the Emperor Maximilian to Bianca Maria Sforza in 1493 would also have served to turn Dürer's attention toward things Italian, and may have kindled his desire to see the palace at Innsbruck as well.

In making this trip to Italy, and in leaving Nuremberg to escape the plague, as in many of his future decisions, Albrecht Dürer departed from the norms established by German artists in order to adopt practices which were more typical of the scholars and merchant-politicians who were to become his clients and friends. In this respect, as in so many others, he was fortunate to have been a citizen of Nuremberg, which had no painters' guild. Painters' guilds in other cities afforded their members a kind of collective political power which Nuremberg's artists did not possess; gave them forms of unemployment insurance and death benefits, and assured them of an active social life among their brothers in the craft. This more secure existence, however, had its negative side in limiting the members' intellectual and social aspirations. If the security of the guild system was unavailable to Dürer, so was its more stultifying effect of standardization. He was free to adopt whatever modern business methods he found appropriate, and to seek a new inspiration or a new market wherever he chose. In the case of his first trip to Italy, he may have intended to do both.

Unlike his second Italian journey of 1505, the first is documented only by Dürer's drawings and watercolors of north Italian motifs; by his remark in a letter to his friend, Willibald Pirckheimer, datelined Venice, February 7, 1506, stating that "those works of art which so pleased me eleven years ago please me no longer"; and by Christoph Scheurl, who in a publication of 1508 quoted Dürer as having spoken of his own "return to Italy" in 1505.[3]

Although the Brenner Pass remained open in 1494, winter travel in the Alps was ill-advised, and could be both dangerous and uncomfortable even in autumn rains. Therefore it is assumed that Dürer must have left Nuremberg by early October at the latest—more probably by late August—and that he remained in Italy at least until the mountain roads were clear again in the spring of 1495. He probably traveled with one of the convoys of Nuremberg messengers and businessmen which frequently made the trip down to the Hansa headquarters in Venice—the Fondaco dei Tedeschi, where Agnes Dürer's Rummel ancestors had held trading privileges since 1412. Venice was the end of the German baggage train, and possessed not only the obvious artistic advantages, but offered German-speaking innkeepers, bankers, and information services as well. The trip itself, at a comfortable pace, took about two weeks; a messenger riding hard and changing horses frequently could do it in four days.

It is clear that Dürer remained for some time in Venice. His drawings include renderings of a live crab and a lobster—both tremendous novelties for someone who came from the part of Germany which is farthest from any access to the sea. He also drew studies of Venetian women and their fashions, one of which[4] contrasts in an amusing way both the line and the character of the wearer to that of her Nuremberg counterpart. His model for the Nuremberg costume must have been one of the wives of Nuremberg businessmen who not infrequently accompanied their husbands to Venice.

For his knowledge of Venetian women, Dürer seems to have relied on the prostitutes for which Venice, like many great ports, was justly famous. In addition to the male population of the city, their customers included the sailors, and the traveling salesmen from Germany, and even occasional pilgrims in search of something to repent of in the Holy Land. One of Dürer's Venetian ladies of the evening (W.69, Vienna, Albertina) was later to make her appearance as the Harlot of Babylon (B.73) in Dürer's Apocalypse series, which would seem to offer evidence that her profession was, indeed, the world's oldest.

However, it should be noted that, by northern European standards and those of other parts of Italy, even "respectable" Venetian women were considered both brazen and egregiously overdressed. The German knight Arnold von Harff found Venetian ladies no match for the beauties of Milan; he took particular exception to their heavy make-up, which created a distressing spectacle when the incumbent became overheated, although he declared their jewelry to be the richest in the world. The Milanese Canon Pietro Casola, who came to Venice in 1494, ridiculed their high heels and curled false hair (which they bought from the displays hung from poles in the Piazza San Marco), as well as their diamonds, rubies, painted faces, and bare shoulders ("They are not afraid of the flies biting them," he marveled). When he visited a noble Venetian home, the Canon discovered to his horror twenty-five young girls, each showing "not less than four or six fingers' width of bare skin below their shoulders before and behind."[5] Brother Paul the Franciscan was appalled to find that Venetian women were permitted to "go about shamelessly, their shoulders naked as low as to their breasts—and as for other sins. . . .[!]"[6]

Above all, however, the Italian trip provided Dürer with his first serious opportunity to begin the study of mythological subject matter, classical nudity, and antique drapery which would continue to preoc-

cupy him until shortly after the turn of the century. He traced, in pen and ink, one of the sheets of Mantegna's two-page engraving, *The Battle of the Sea Gods* (W.60), as well as his ludicrous *Bacchanale with Silenus* (W.59, both Vienna, Albertina), substituting his cursive, Germanic modeling system for the strict parallel lines of the original. He studied Antonio Pollaiuolo's *Ten Fighting Nudes*, improvising a drawing of *The Abduction of the Sabine Women* (W.82, Bayonne, Musée Bonnat) in the same size and exaggerated musculature. He made a beautiful, Mantegna-inspired drawing of *The Death of Orpheus*, labeled "Orpheus, der Erst Puseran" (Orpheus, the First Pederast; W.58, Hamburg, Kunsthalle), as well as a marvelous sheet of studies containing a fully worked-out composition of the *Abduction of Europa* together with small sketches of several Venetian motifs, one of which is a turbaned oriental in the style of Gentile Bellini (W.87, Vienna, Albertina). He drew ten naked, *Dancing Putti* (W.83, Moscow, Pushkin Museum), on a sheet with Roman funereal armor, and copied a naked infant from a drawing of the Christ Child by Lorenzo di Credi (W.84, Paris, Louvre).

It is not known whether Dürer's winter in Italy included study visits to cities other than Venice: to Padua, perhaps, which lay within the jurisdiction of the Venetian Republic, and where still greater works of Mantegna's were to be seen. The route of his travel between Italy and Austria, however, can be reconstructed from his series of brilliant topographical watercolors, which are among the first pure landscape paintings of modern times. It is for these that his first journey to Italy is best known today.

It has already been mentioned that views of local architecture had become popular as backgrounds for Nuremberg altarpieces in the generation preceding Durer's: the Krell altar in St. Lorenz (ca. 1480) contains the first "vedute" of Nuremberg itself. This trend gained further momentum with the publication of Bernhard von Breydenbach's *Peregrinationes* in the mid 1480s, and with Hartmann Schedel's *World Chronicle* in 1493, both of which provided convenient prototypes for views of other cities. There was also in Germany an accelerating interest in descriptive geography, spearheaded by Konrad Celtis, which should be seen as having provided further motivation for Dürer's souvenir watercolors of his travel route.

Architectural renderings of the Episcopal Palace, the Curia buildings of the Cathedral, and the Cloister of Michelsberg in Bamberg had already been done by Wolfgang Katzheimer before 1485 in a combination

of pen with gouache and watercolor.[7] It is not unlikely that Dürer may have known about these or other such studies, since Bamberg was the cathedral city for his diocese and the Episcopal Chancery the place where travel passes could be obtained. In any case, he had begun to experiment with landscape watercolors featuring some of the outlying meadows and picturesque "industrial" buildings, such as the *Wire-Drawing Mill* (W.61, Berlin, KdZ.4) on the outskirts of Nuremberg, during the early summer of 1494. Using these works as a standard, scholars have theorized that the majority of watercolor views made on the Italian journey, since they are more freely painted and less controlled by contour, were probably done on the way home, after Dürer's exposure to Venetian light and color. The view of Nuremberg itself, seen from the west,[8] was the one most completely free of contour lines.

The northernmost point depicted in the travel watercolors is Innsbruck, through which travelers still normally pass on their way to and from the Brenner Pass. On his way south Dürer did two architectural renderings of the former Gothic courtyard of the Imperial castle.[9] A distant view of the entire city as seen from the north, which has a lower horizon and greater sense of atmosphere, is thought to have been done on the return journey (W.66, Vienna). Since in other cases only one watercolor seems to have sufficed, it is possible that he spent several days here, both going and returning, perhaps living as the guest of his wife's relative, Peter Rummel.

From Innsbruck southward his way would have lain through the Brenner, the lowest crossing point of the Alps, and down through Sterzing on the other side. When Friar Felix Fabbri and his party made this journey in the 1480s, they stopped at Sterzing and Brixen, then proceeded through the Austrian toll stop where the road had been widened by blasting with gunpowder to make the way less perilous, and then followed the Adige valley to Trent. Passing through Feltre they came to Treviso, where it was customary for pilgrims either to sell their horses or have them stabled for the return journey, while the travelers themselves went on to Mestre on rented horses, and took a boat from there into Venice. Essentially the same route was taken by Friedrich the Wise of Saxony and his retinue in 1493, and was probably taken by Dürer as he traveled southward in the early autumn. His watercolors of the castle[10] and valley of Trent,[11] and of the Dosso di Trento with the Church of Sant'Apollinare in the foreground,[12] are thought to have been done on the return journey, as are the most brilliant of the watercolors, the

*View of Arco*[13] and the unfinished *Welsch Pirg* or "Italian Mountain," possibly a view in the Val di Cembra.[14] Spring foliage is to be seen on these last, as well as the more mature manner of handling the pigment so as to take advantage of the paper itself as one of the colors modifying the watercolor washes.

In order to reach Arco, which lies at the northern tip of Lake Garda, and well to the south of Trent, Dürer is thought to have left Venice by the more leisurely southern route, via Padua and Verona, traveling northward along the lakeshore (or possibly by boat on the lake itself) for some distance. There is reason to believe that he may have traveled in the company of the man who was to become his best friend, Willibald Pirckheimer of Nuremberg (Plate 12).

# V

## WILLIBALD PIRCKHEIMER

WITHOUT Pirckheimer's friendship, it has been said, there would probably have been a different Albrecht Dürer, for Pirckheimer bore much of the responsibility for having exposed the artist to the literature and the ideals of the Italian Renaissance, as well as to those of the ancient world. It was Willibald Pirckheimer and his friend Konrad Celtis, with their fluent command of ancient Greek, Latin, and modern Italian, who made literary sources available to Dürer which the artist could not have read for himself, and whose close friendship offered Dürer entry into a level of society which he could not have penetrated on his own. It was their thorough knowledge of the history, philosophy, poetry, and travel literature of the Ancients that permitted Dürer to widen his own professional horizons to include not only the depiction of classical subject matter, but the scientific study of human proportion. Their dream of a new German culture became his as well.

Dürer and Pirckheimer's mutual friendship with Celtis, the "arch-humanist," stimulated Dürer to play a far more essential role in history than that of Michael Wolgemut; he became not only the most famous artist in Nuremberg, but one of the foremost artists and theoreticians in Europe.

Pirckheimer was to be one of Germany's most influential humanists, with a lengthy bibliography to his credit and the finest private library in Germany which, in his lifetime, was always open to the community of scholars. He introduced the study of geography into the curriculum of German middle schools and is still revered as the translator of the writings of such essential Greek authors as Xenophon, Lucian, Isocrates, Plutarch, and Plato from Greek into Latin and German, and of the Roman historian Sallust from Latin to German. His translations from Greek into Latin were made for the benefit of other humanists (for German universities did not yet offer courses in Greek), while those into German were apparently done with the needs of the public and the convent in mind. Pirckheimer's translations, which are

excellent ones following the sense rather than the literal meaning of the originals, were read by every German schoolboy until the classics were de-emphasized for the benefit of the present generation, and they were made for the most Utopian of reasons. The Swiss edition of the original *Utopia*, in fact, was dedicated to Pirckheimer by its author, Sir Thomas More.

Pirckheimer took up the challenge issued by Konrad Celtis in his inaugural address made at the University of Ingolstadt in 1492; namely, to write the history of the Germans and to contribute materially to the education of his countrymen by making the classics available to them. His histories of early Germany and of the Swiss War of 1499 (which the Swiss, of course, prefer to think of as the Swabian War) posthumously earned him the title of "the German Xenophon."

It was the dream of Pirckheimer and of Celtis, who was the first German to be named Poet Laureate of the Empire, to cultivate the study of the humanities in Germany so as to mediate the unfortunate impression of the Germans as drunkards and savages which had figured so prominently in Italian writings—even, alas, those of Tacitus (though he praised the Germans for their valor and integrity) and Aeneas Sylvius Piccolomini. Celtis in particular had been highly offended by the remarks of Italian university lecturers in the late 1480s regarding the general level of civilization, or lack of it, north of the Alps. As the Renaissance awareness of the existence of "the middle ages" progressed, the Germans had come to be perceived both as the destroyers of ancient Rome and as the perpetrators of a substantial amount of the needless theological niggling, couched in bad Latin, which characterized the dreariest of medieval writing. Petrarch, in the fourteenth century had been the "discoverer" of the Dark Ages, and chief among the scoffers. In *De viris illustribus* (ca. 1338), however, he had pointed to the imitation of the men of antiquity as the only hope for progress in the modern world, and had called for the establishment of a cult of literary men—a new breed, whose loyalty would be only to letters. More than a century later, the Poet Laureate, Konrad Celtis, and his friend Pirckheimer were determined to create such an intellectual elite—in Germany. Pirckheimer was to be the field marshal of the Nuremberg contingent.

Pirckheimer, who enjoyed an almost princely income of 750 florins per year, was a generous host at whose comfortable home on the *Herrenmarkt* (now *Hauptmarkt*, at *Augustinerstrasse*) the most important visiting humanists would stay when they came to Nuremberg, and the resi-

dent ones were also invited to foregather: Celtis celebrated it in his *Norimberga* as the meeting place of scholars and artists.[1] At Pirckheimer's evening gatherings, Albrecht Dürer was always *persona grata*.

Pirckheimer provided important contacts for Dürer among the humanists of other cities—Konrad Peutinger in Augsburg, for example, and Erasmus of Rotterdam in Antwerp. He is known to have been a ready source of financial support, as well as encouragement, on the occasion of Dürer's second trip to Italy as the correspondence shows, and quite possibly may have been his companion and guide during part of the first Italian trip as well. Like his father and grandfather, he collected fine editions of the classics—his own specialty being the newly printed editions of ancient Greek authors which were beginning to be published in Venice and Pavia; in some cases he had his friend Dürer decorate their title pages with charming miniatures, each containing Pirckheimer's coat-of-arms—a tree on a field of scarlet. His copy of the Aldus Manutius edition of the idyllic poetry of Theocritus, published in Venice in February of 1495 or 1496,[2] also bears the arms of the Rieters, Pirckheimer's wife's family—a mermaid with two tails—indicating that it must have been illuminated before Crescentia's death in 1504. Dürer's miniature, closely related to the Greek text, shows a scene of pastoral music making: Thyrsus plays the fiddle while another shepherd performs on the pipes of Pan. As Erwin Rosenthal has noted, both the figure of Thyrsus and the delicate painting technique were done by Dürer in accordance with Italian Renaissance prototypes.[3] Fourteen such books illustrated by Dürer were sold from the Pirckheimer library in the seventeenth century to a collector in Leyden, and a number of others have since been identified.

One ancestor of the Pirckheimer family, which seems to have originated in Lauingen, had settled in Nuremberg and become a wealthy landowner by 1356, acquiring trading privileges in Venice and Crakow and holdings of sixty rental properties. This Pirckheimer—Hans I—was the first of three generations to be elected to the exclusive Inner Council of Nuremberg, an honor for which only members of the highest level of patrician society were eligible. Willibald himself was to serve, with mixed results, in this capacity, beginning with the Easter election of 1496, in which a humanist majority was swept into office. He was later instrumental in the establishment of Celtis's interesting educational experiment, the School for Poets. However, he was also a member of the Council when, in 1498, it petitioned the Emperor Maximilian for per-

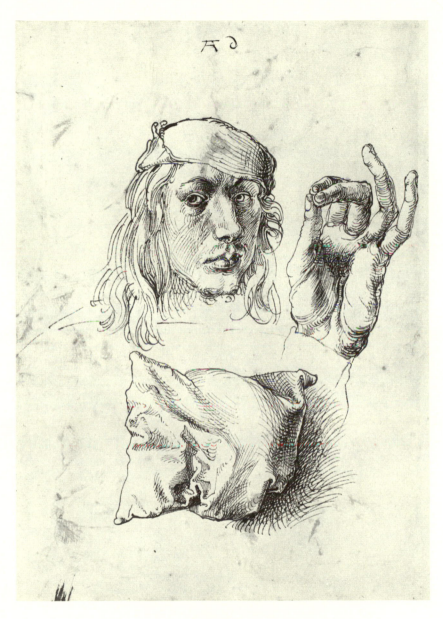

———— PLATE 9 ————

Dürer. *Self-Portrait at the Age of Twenty-two*. 1493. Pen and ink. New York,
The Metropolitan Museum of Art, Robert Lehman Collection.

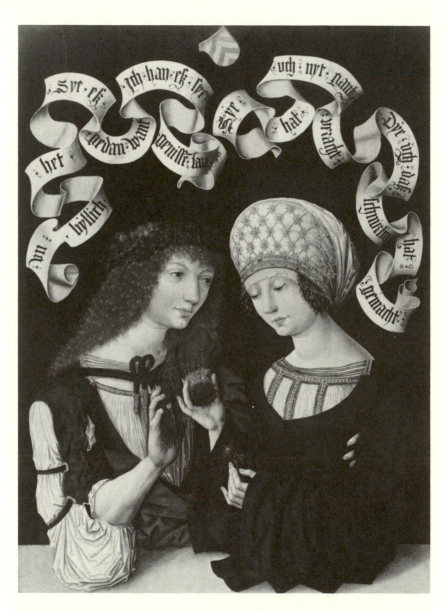

Master of the Housebook. *Pair of Lovers*. Ca. 1484. Oil and tempera(?)
on lindenwood panel. Gotha, Museum Schloss Friedenstein.

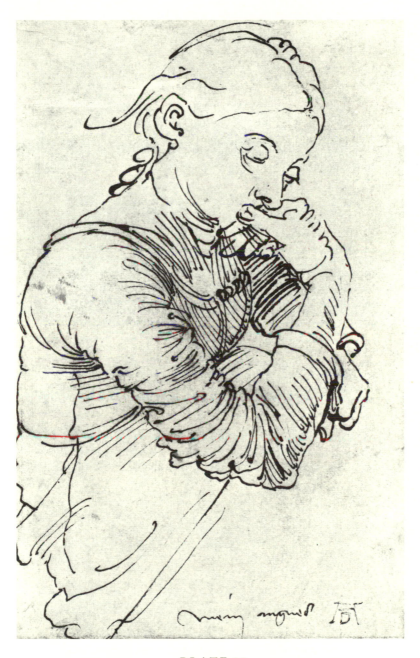

—— PLATE II ——

Dürer. *Portrait of Agnes Frey Dürer* ("Mein Agnes"). 1494.
Pen and ink. Vienna, Albertina.

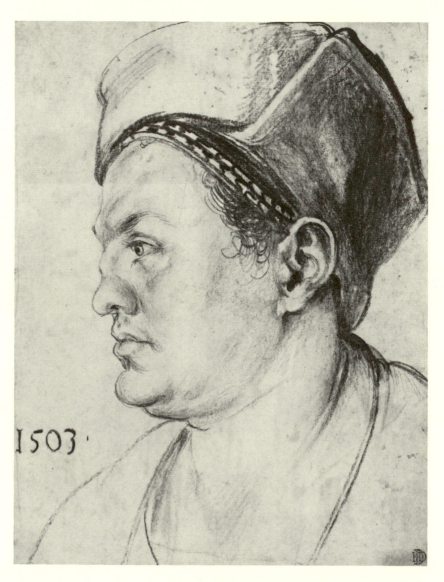

1503

——— PLATE 12 ———

Dürer. *Portrait of Willibald Pirckheimer*. 1503. Charcoal. Berlin, Staatliche
Museen Preussischer Kulturbesitz, Kupferstichkabinett.

Dürer. *Hercules Defending Virtue against Vice* (The Large Hercules). Ca. 1498.
Engraving. Berlin, Statliche Museen Preussischer Kulturbesitz,
Kupferstichkabinett.

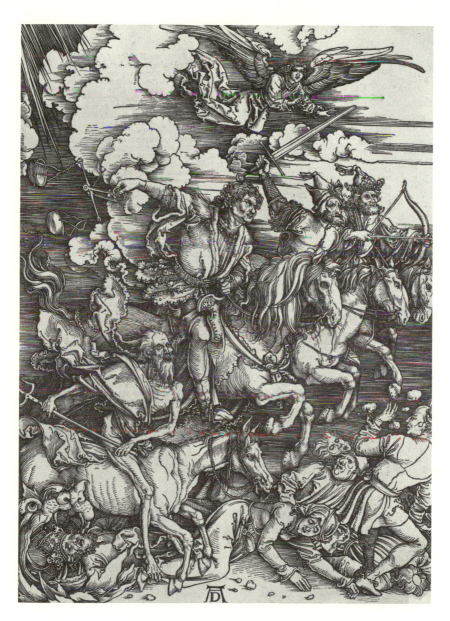

Dürer. *The Four Horsemen of the Apocalypse*. Ca. 1498. Woodcut. Berlin, Staatliche Museen Preussischer Kulturbesitz, Kupferstichkabinett.

mission to expel Nuremberg's Jewish community. The expulsion itself took place on Laetare Sunday, March 10, 1499, on the eve of his departure for the Swiss War.[4] Pirckheimer was successful in obtaining an armed escort for the refugees, to prevent their being attacked on the road. But this same escort, of course, might be interpreted by some as a deterrent to their attempting to remain in the city. (Anton Koberger thoughtfully bought their property for resale, including the community buildings, and Veit Stoss, the great sculptor, newly returned from the Polish court, acquired one of the finest houses.[5])

Willibald Pirckheimer's father, Johannes—a classmate of Dr. Hartmann Schedel, author of the *Nuremberg Chronicle*—had attended the University of Padua, taking his doctoral degree in law in 1465.[6] On returning to Nuremberg to claim his fiancée, he had found to his dismay that the lady in question, Barbara Löffelholz, grown impatient with waiting, had married another—one Sigmund Stromer von der Rosen—and that *copula carnalis* had taken place. Exhibiting remarkable presence of mind under the circumstances, Dr. Pirckheimer won back the lady with his humanist poetry and filed a lawsuit against Stromer. The case was adjudicated in the diocesan court by the Bishop of Bamberg, who could only come to the conclusion that, since the alleged wedding had been a private and unwitnessed oath-taking (of the sort depicted in Jan van Eyck's *Arnolfini Wedding*—a not uncommon procedure before the Council of Trent) it was impossible for him to determine whether or not there had been any nuptials.[7] Custody of the bride was therefore awarded to Dr. Pirckheimer, who married her on April 19, 1466, and immediately bore her away to Eichstätt, where he became first legal counsel to the new Bishop, Wilhelm II von Reichenau (served 1464–1496). It was the Bishop of Eichstätt who later stood godfather to their only son, and named him Willibald, after the famous Benedictine missionary to the Bavarians, founder and patron saint of the diocese.

Due perhaps to the scandal surrounding the youthful indiscretion of Dr. Johannes Pirckheimer's wayward bride, whose family also belonged to the upper echelons of Nuremberg society, the Pirckheimers continued to live in Eichstätt and later in Munich until Barbara's death in 1488, when the widower and his youngest daughter Juliana moved back to Nuremberg (her six surviving sisters were already in convents), and Willibald was sent to the University of Padua in the autumn. Hence, although Dürer and Willibald Pirckheimer could, in theory, have seen one another briefly either as infants or as adolescents, it is unlikely that they

had known one another well. They belonged to separate levels of society, and there would have been few times, if any, when both were in Nuremberg, since the Pirckheimers never actually lived in their main house while the Dürers were tenants in the cottage behind it. It is entirely possible, however, that the Elder Dürer, who as the city assayer of precious metals was known to be a person of exceptional honesty, might have been entrusted by his absent landlord with certain caretaking responsibilities connected with both houses, and that he might for that reason have had written or personal contact with the senior Pirckheimer during a few of the Eichstätt years.

Dr. Pirckheimer had become legal counsel to Duke Albrecht IV of Bavaria and to Duke Sigmund of Tirol as his son was growing up, and had taken the boy twice to Italy (1481 and 1484), beginning at ages eleven and fourteen—"as soon as [I] was old and strong enough to follow [my] father on horseback," as Willibald notes in his autobiography, written two years after Dürer's (1526 ff.)[8] Willibald studied in Italy from the fall of 1488 until the summer of 1495, spending the first three years at his father's alma mater. Padua, as the university serving the Republic of Venice, was strongly slanted toward Aristotelian philosophy—some fastidious folk called it Averroist—and had what at the time was Europe's leading department of the Greek language and literature, staffed by Greek professors from Crete. In Padua, too, young Pirckheimer soon fell under the spell of the flamboyant Giovanni Pico della Mirandola (1463–1494), whose nephew and namesake became his friend. Newly exonerated of charges of heresy, the elder Pico was soon to bring out his *Oration on the Dignity of Man*. Pirckheimer is known to have acquired a copy of Marsilio Ficino's commentary on Plato's *Symposium* at this time as well as Pico's work.

Having been sent to Padua to study law, he was instead taking courses in natural science, astrology, mathematics, geography, medicine, and Greek literature. Then suddenly in 1491 he decided to transfer to the University of Pavia, apparently because of a disagreement with Padua's Rector. He may perhaps have chosen Pavia because it, too, offered Greek studies, and had just initiated a course in Hebrew, taught by Benedetto di Spagna.

Dr. Pirckheimer seems to have become impatient with Willibald's academic progress after the transfer and to have taken over the plotting of his course of study, with the result that Willibald spent his remaining three years dutifully attending lectures on the law. He also followed his

father's wishes in leaving law school before receiving his degree, in order that he might be eligible to join the Nuremberg City Council, where excessive university education was considered grounds for disqualification.

In Pavia, which was the university serving Milan, Pirckheimer made the acquaintance of two members of the Sforza court, Galeazzo Visconti, leader of the Ghibelline party in Milan, and Galeazzo di Sanseverino, one of Leonardo da Vinci's patrons. Sanseverino in particular is thought to have provided an indirect link between Leonardo and Albrecht Dürer,[9] since he was to be Pirckheimer's houseguest in Nuremberg in 1502. As Franz Winzinger noted, this goes far to explain some of the parallel interests of the two artists in various aspects of science and human physiognomy which have often been remarked upon. Leonardo, who was nearly twenty years older than Dürer but had had a similarly limited formal education, and an even more overweening interest in the sciences, still lived in Milan, and was at work on the ill-fated Sforza equestrian monument at this time. Pirckheimer's letters to his father from Pavia reported the rejoicing at the Sforza court over the election of Pope Alexander VI (Rodrigo Borgia); and, in the fall of 1494, the tumultuous welcome given by Pavia's students to the arriving army of Charles VIII of France. His friend Sanseverino actually accompanied the French army as far as Florence on its march to the south by way of Lucca and Pisa, and Pirckheimer eagerly followed accounts of their progress. (Leonardo, it will be recalled, found employment in 1502 with Cesare Borgia, the Pope's illegitimate son, and finally lived out his last days (1517–1519) in France at the court of Francis I.)

In Pavia it was noted that young Pirckheimer spent his time almost exclusively with Italians, and that, despite his father's precautions, his life was scarcely a case of all work and no play. Eloquent testimony to his extracurricular activities is offered by a fervent letter from a certain Bernardina, a young woman of the lower classes and apparently of easy virtue, whose undying devotion is declared in a love letter posted to Pirckheimer after his departure from Pavia for Nuremberg.

As has been mentioned above, six of Willibald Pirckheimer's seven sisters and, later, two of his daughters entered convents in Munich, Bergen bei Neuburg, and Nuremberg. Katharina was a prioress in Geisenfeld; Sabina and Euphemia became abbesses in Bergen, one after the other; Caritas and Clara succeeded one another in the post of Mistress of Novices in the Franciscan convent of St. Clara in Nuremberg.

The most remarkable of the sisters was the eldest, Caritas (1467–1532: née Barbara), who was unanimously elected Abbess of St. Clara's in 1503. Since she herself was a gifted Latinist, Pirckheimer sent her his Plutarch translation, dedicated his edition of St. Fulgentius to her, and took his visiting scholars to meet her. (Caritas, a member of the Poor Clares, was permitted to speak with but not to be seen by her guests, who might contact her at stated visiting hours by means of the "speaking window" at the convent.) Celtis, for one, was so smitten by her intellect (she also knew Greek) that he wrote an ode in her honor, and dedicated his edition of the newly discovered writings of the medieval Benedictine nun Roswitha von Gandersheim to her. Caritas's charming and self-effacing thank-you letter to Celtis is still preserved.[10]

This close communication between Caritas and her brother's circle assured Dürer of a ready source of information regarding the thoughts, needs, or wishes of the religious community for works of art in general, and of prints in particular. In Dürer's day, before the Reformation, the community of priests, nuns, and friars made up one-tenth of the population of Nuremberg; a number of them were teachers, who would have found both the unusually large size and the superb quality of his religious prints a great attraction for classroom use, as well as for their own private meditations. Dürer's Life of Mary woodcut book was to be dedicated to Caritas.

The seventh of Pirckheimer's sisters, Juliana, was married on July 13, 1495, to a wealthy widower, Martin Geuder, who was a member of the Nuremberg City Council. If, as seems likely, it is true that Pirckheimer made a special effort to reach home in time for the wedding of his only non-cloistered sister, the likelihood that he and Dürer may have traveled together on the way back from Lake Garda is increased, for the foliage development in Dürer's landscape watercolors of Italy has suggested to scholars that he, too, would have returned home in the early summer of 1495.

In choosing a career, Willibald, who had made a study of military tactics before leaving Eichstätt, had once expressed a wish to enter the service of Maximilian. He was dissuaded from this course of action by his father, however, because of the undesirable effects of life at court. He then placed both his military and his legal and diplomatic skills at the service of the city of Nuremberg, serving as Councilman, heading the Nuremberg regiment in the Swiss War of 1499, and acting as Nuremberg's emissary on several later occasions to the local robber barons.

Like Albrecht Dürer, Pirckheimer married the bride of his father's choosing, as soon as his period of study abroad had been completed. His wedding to Crescentia Rieter took place on October 13, 1495; she bore him five daughters and one stillborn son before her death, of child-bed fever, in May of 1504. Pirckheimer never married again since, as Er-win Panofsky has noted, he enjoyed his bereavement too greatly.

In 1498, shortly after Willibald's election as a member of the victori-ous humanist party in the City Council, Dr. Johannes Pirckheimer opened the short-lived (1498–1509) School for Poets in Nuremberg, in the old city Weighing House in the Winklerstrasse, a few steps from the house where Dürer had been born. This, as the name suggests, was not a grammar school in the usual sense, but an academy which would be more nearly comparable to what it is now fashionable to call "continu-ing education," or "community outreach." Poetry, like mathematics, was believed by the humanists to possess almost mystical powers to re-veal divine truths, as well as having a civilizing effect upon those in need of culture: it was recommended, in fact, as a substitute for war. And Dr. Pirckheimer, of course, was his own best witness to its amatory powers as well. In light of Albrecht Dürer's own authorship of quite a large quantity of truly dreadful poetry, all written in the years 1509–1510, he may perhaps have begun to attend this ill-fated institution, which was the distant ancestor of the more famous Nuremberg School for Poets of the seventeenth century.

In any event, the Pirckheimers and especially their friend Celtis, who became Professor of Rhetoric and Poetry at the University of Vienna in 1497, would seem to have kept Dürer abreast of the need for modern illustrations depicting mythological themes and classical allegories. Dürer's works dealing with such subjects were all produced between 1494 and 1505, and involve knowledge of some quite esoteric source material.[11]

These subjects had begun with the sheet of pen drawings containing the *Rape of Europa*, after Ovid's account but with embellishments in-spired by Politian, and a Lysippean *Apollo*, among other motifs, some Bellini-like, indicating that the artist was in Venice when he drew them.[12] The *Death of Orpheus* drawing in the style of Mantegna[13] was also done in Italy in 1494. The single woodcut of the group, *Hercules Slaying the Sons of Molione* (B.127), done in about 1496, depicts an ob-scure subject told by Apollodorus (II. 139) and Philostratus.

The great engraving of 1498 which Dürer later referred to as the *Meer-*

*wunder* (Sea Monster; Plate 13), if it is, as Erika Simon suggested, a representation of *The Abduction of Syme by Glaucus*, is from a story told by Athenaios in *The Symposium of Sophists*. More recently, however, an alternate explanation has been offered—that it represents the rape of the Langobard queen Theudelinde by a sea monster, as told by Kaspar von der Rhön in the *Dresdner Heldenbuch* of 1472.[14] Such a theme would be quite in keeping with Celtis's exhortation to recount the German past.

Dürer's most ambitious engraving of the period, showing Hercules taking up his cudgel to defend Virtue against Vice (Plate 14), known as The Large Hercules, comes from a tale recounted by Xenophon.[15] This print, which was evidently one of his most popular, is, like the *Hercules Slaying the Sons of Molione* (B.127), a representation of the ancient hero best beloved by German humanists.

Tacitus alleges, in Chapter III of the *Germania*, that Hercules had visited Germany personally, and in Chapter IX that the ancient German tribes worshipped him. Some Bavarians claimed descent from Hercules Alemannus, one of the offspring of Noah's son Tuyscon (born after the Flood), who supposedly gave his name, "Teutsch," to the German people.[16] Others pointed with pride to the fact that Noricum—actually the Roman name for a territory corresponding roughly to Austria, but misinterpreted by Arnold von Regensburg ("the Bavarian Livy") to refer to Bavaria—takes its name from Norix, the son of Hercules, who founded Regensburg.[17] Dürer's Hercules, a hero with the exaggerated musculature suggestive of the influence of Pollaiuolo, has been identified as Hercules Gallicus, by virtue of the cock (*gallus*) on his helmet.[18]

The year 1500, which was approaching as Dürer put his first prints on the market, was a critical one. To the circle around Konrad Celtis, it seemed the dawn of a new age and the chance to renovate northern European society through better education. Dürer's classical prints—all but one of them engravings—and his drawings of classical themes were directed toward the interests of this Utopian group of thinkers, the community of scholars.

For another, less educated group, however, the year 1500 issued a call, not for rejoicing, but for repentance and meditation. For them, Dürer's Apocalypse and Large Woodcut Passion series were made.

# VI

## THE PRINTMAKER AS
## PUBLISHER AND
## PAINTER

THE WORKSHOP Dürer opened in the late spring or summer of 1495, when he was twenty-four, was never to grow so large as that of Michael Wolgemut, but the young master quickly began to attract international attention for the astonishingly high quality of his work, as well as for the unprecedented variety of his subject matter. Like his godfather, Anton Koberger, he seems to have given a great deal of thought to the means by which his art might reach the widest possible public.

Rather than produce works of art by Wolgemut's more passsive, medieval method of waiting for orders in all media to come in and then making adjustments in his staff to accommodate them, Dürer immediately began to build up a stock of engravings and woodcuts, the like of which had never been seen. In 1497 he began to employ an agent, Contz Swytzer, who was empowered to handle his foreign print sales "ye von einem land zu dem anndern und von einer stat zu der anndern" (from one land to another and from one city to another). Swytzer's contract, which has been preserved,[1] required him to seek the highest possible prices, remitting the money to Dürer from time to time as collected, and cautioned him not to lie around idle ("nit still liegen") in places where there was no money to be made. In return, Swytzer was guaranteed a salary of one-half a Rhenish florin weekly, plus three *pfund* for expenses.[2] On August 21, 1500, Dürer hired a different salesman, Jakob Arnold, whose brother, the local painter Hans Arnold, vouched for his trustworthiness. His contract, more legalistic than Swytzer's, was witnessed by Anton Koberger and Heinrich Zyner, and made provisions for Dürer to be compensated in the event that his prints should be damaged in transit due to Arnold's carelessness or neglect.[3]

Nuremberg, situated in the geographical center of the Holy Roman Empire, was an ideal location for a graphic artist, whose works are the

most easily transportable of the visual arts. And Nuremberg, once a me-
dieval center of parchment manufacture, now had the added advantage
of a ready supply of fine paper, available in two grades from Germany's
first paper mill, which had been founded on the Pegnitz by Ulman
Stromeir (1329–1407) in 1390. Although Stromeir's original mill had
been burned to the ground during a war in 1449, its replacement con-
tinued to produce the same excellent paper with the bull's head and
starflower watermark which had been popular with German artists for
generations.

Nuremberg had another advantage in the availability of copper, and
of copper workers, for making engraving plates. The city had long been
famous for its metalwares, importing raw copper from the mines of
Hungary and exporting finished metal goods, although until Dürer's
day these metalwares seem not to have included copper engraving
plates. Nuremberg was famed, however, for both the inventiveness of
its citizens and the high quality of its "heavy industry"—it has been aptly
called the Ruhr region of the fifteenth century—and could well have
supplied talented mechanics to aid Dürer in building a printing press
capable of exerting sufficient evenly distributed pressure to handle en-
graved plates successfully. It surely cannot have escaped his notice that
a substantial part of Martin Schongauer's success as a graphic artist had
been due to the fact that he was one of a comparatively small number of
artists whose plates were both elegantly engraved and consistently well
inked and crisply printed.

Nuremberg also had another feature which would work to Dürer's
advantage as a printmaker—namely, the city's frequent fairs, markets,
shooting contests, and religious festivals, which brought in droves of
out-of-town visitors on a regularly scheduled basis. In addition to the
annual *Heiltumsfest* mentioned earlier, when the Imperial relic collection
and coronation regalia were displayed, there were the fairs, in continu-
ous operation since their original institution in the eleventh century by
the Emperor Henry III, which were a traditional marketing outlet for
inexpensive novelties of all sorts. By the fifteenth century, these included
prints. It may safely be assumed that a number of Dürer's religious
prints, particularly the less expensive woodcuts, were made with these
traditional, medieval markets in mind.

The woodcuts which he began to bring out in the late 1490s, how-
ever—in particular the so-called Large Passion and the Apocalypse—
although traditional as to subject matter, were revolutionary in style and

technique. By using enormous blocks of plank-grain hardwoods, cut to the size of half-sheets (i.e., full pages) of paper, and thus several times larger than the blocks in normal use, Dürer was able to achieve unprecedented pictorial effects which raised this crudest and most old-fashioned graphic medium to the status of fine art. Several of his largest and finest blocks from this period have survived—the humanist-oriented *Hercules Conquering the Molionides* and the *Martyrdom of the Ten Thousand Christians*, both now in the British Museum; the *Samson Rending the Lion* at the Metropolitan Museum in New York; and the *Holy Family with Three Hares* at the Princeton Art Museum.

The remarkably "sculptural" character of the cutting of these blocks, which in some respects resemble the low-relief woodcarvings of the late fifteenth-century lindenwood sculptors, led William Ivins and many other modern scholars to the conclusion that Dürer must have done the carvings himself.

While the idea that Dürer could have excelled at any chosen undertaking is an appealing one, for sentimental reasons if for no other, Matthias Mende, director of the Dürer Haus, has cast serious doubt upon it by pointing out that there is absolutely no evidence in the city's archives to support the contention that either Albrecht Dürer, or any earlier Nuremberg painter or woodcut designer ever took over the duties normally performed by a professional *Formschneider*, or block-cutter. It is clear, on the other hand, that Michael Wolgemut, Dürer's teacher, employed professional cutters for this purpose—and therefore, presumably, would not have taught this skill to his own apprentices. As Lüdecke has shown, several members of Wolgemut's immediate family, including two women, were cutters. Dürer himself is known to have employed a professional cutter, Hieronymus Andreae, at least after 1515.

The blocks cut by Andreae are inferior in quality to the few which have survived from Dürer's prints of the 1490s, such as the *Samson*; and it is true that the difference in cutting technique is at the root of the matter —Andreae's flat, knifelike incisions have none of the subtly chiseled but literally unprintable gradations of depth that characterize Dürer's early "sculptural" blocks. However, it should be borne in mind that the youthful Dürer had no demonstrable expertise as either sculptor or *Formschneider*, and that his minimal training as goldsmith would have prepared him to make castings, rather than carvings.

If Dürer had wished to achieve the most elegant results with his woodcuts, as was surely the case with his earliest prints, it is likely that

he would have sought the advice or even the assistance of a professional lindenwood sculptor—perhaps one of the many journeymen who, as Michael Baxandall has shown, annually were attracted to Nuremberg's great wealth and lack of guild restrictions. There is proof, for example, that Dürer's younger contemporary, the sculptor Peter Flötner was later active as a *Formschneider*. Of greater interest for Dürer's own work, however, was the return of the great sculptor Veit Stoss from Crakow to Nuremberg in 1496, to set new standards of muscularity, animation, and energetic drapery for the city's woodcarvers in the last years of the century. Soon after Stoss's arrival Dürer must have begun to plan the most ambitious of his woodcuts, the oversized Apocalypse (published 1498) and Large Passion series, which reflect the gravity-defying energy of Stoss's drapery forms. The extraordinary sense of animation and over-abundance of detail seen in these early woodcuts is stylistically quite different from the more restrained and "classical" manner of Dürer's engravings dating from the same few years.

It is also not without interest that Albrecht Dürer the Elder, whose credentials as a goldsmith would have included training in small-scale (though cast) figural sculpture, was newly retired from the practice of his own craft—probably, as Mende as Mathias Mende, suggests, in order to cede the limited workshop space in the family dwelling to his son.

Whatever the circumstances of the cutting of the woodblocks, Dürer's woodcuts of the late 1490s were the most complex and impressive ever to appear in European art, and were an immediate success on both sides of the Rhine and the Alps. His illustrations of the visionary events of the Apocalypse—a document couched in deliberately obscure language by its author for an "underground" early Christian readership, and never intended either to be illustrated or to be intelligible to the man in the street—breathed new life ino the formulaic representations of earlier fifteenth-century blockbooks and printed Bibles, including the Quentell Bible printed in Cologne about 1479, and Anton Koberger's own derivative edition of 1483. Never had the "strong angel with a face radiant as the sun, and with legs like pillars of fire" been so convincingly depicted, nor the even more problematic act of St. John devouring his notebook at the angel's behest.

The influence of the theology of Nicolas of Cusa (1401–1464), the former Bishop of Brixen, has been noted in connection with Dürer's general scheme for this series, as in several later works, and it has been suggested that in planning his series Dürer benefitted from the assistance of

a scholarly adviser such as Dr. Johannes Pirckheimer,[4] on grounds of the latter's retirement to the Franciscan monastery in Nuremberg after the death of his wife in 1488. Dr. Pirckheimer did, indeed, follow the example of earlier widowers in his family by taking Franciscan vows, but not until after May 2, 1500, when the Apocalypse series had been on the market already for two years. His daughter Caritas Pirckheimer, however, was Mistress of Novices in the 1490s in Nuremberg's largest convent, the Franciscan St. Clara's. Before her entry into the convent, she is known to have been educated by her grandfather, Hans Pirckheimer II, who had had personal connections with Nicolas of Cusa. Caritas engaged in a lively correspondence with her brother's circle of humanist friends, as we have seen, and seems to have known Dürer personally, since he was the illustrator of a book dedicated to her—Konrad Celtis's edition of the works of the medieval nun, Roswitha von Gandersheim,[5] and was later to dedicate his own Life of Mary to her. Caritas's best friend, Apollonia Tucher, a member of the important Nuremberg family which commissioned four portraits from Dürer in the late 1490s, was Prioress at St. Clara's, beginning in 1494. Then, too, of course, Dürer's own uncle Johannes had been priest and tutor in Grosswardein, and may still have been living at this time.

By any or all of these means, then, Dürer must have had access to informed theological opinion, and could have been made aware, not only of Nicolas of Cusa's theological justification for the study of nature but also of a public need for a set of modern illustrations for the Apocalypse, to be made available in Latin internationally for teachers and clergy, and in German for the core of the Empire.

The legendary Four Horsemen of the Apocalypse—Pestilence, War, Famine, and Death—have never been more astoundingly portrayed than by Dürer (Plate 15), showing to perfection his newly invented modeling system, which Erwin Panofsky aptly termed "dynamic calligraphy." The carving, in total disregard of the plank grain of the hardwood blocks, translates the billowing linework of this system flawlessly, and supersedes the old-fashioned distinction between outlines and shading lines. The burden of the system, however, still lay in the original drawing on the block, as always, and could readily have been followed by a capable relief-carver to whom Dürer had communicated his wishes, particularly a carver working in the new, large scale.[6]

What was equally as revolutionary as Dürer's enlargement of the format and of the vitality of his imagery, however, was his decision, with

the consent of his godfather, Anton Koberger, to act as his own pub-
lisher for the Apocalypse: his imprimatur is found on the last page of
the rare 1498 edition. In principle his book resembled the thin picture
books of the earlier fifteenth century, such as the Dutch blockbook of
the Apocalypse; but whereas the earlier, entirely handmade books could
offer only brief inscriptions cut in relief into the same woodblocks as the
illustrations, Dürer's featured full-page illustrations on the recto, and
St. John's complete text set in Anton Koberger's typefaces on the reverse
of each sheet. For his German edition, Dürer used Koberger's transla-
tion of the text as well. For the Latin edition he followed, of course, the
familiar text of the Vulgate.

In his first publishing venture, Dürer outdid even Erhard Reuwich,
who had illustrated and published Bernhard von Breydenbach's travel
memoir in the previous decade, for here there could be no doubt in the
buyer's mind but that the illustrations were the primary attraction.

It is probable that at least the text pages of both the German and the
Latin editions were printed in Koberger's shop, where the presswork
was facilitated by trained pressmen, as well as by water diverted from
the Nuremberg city water system. The existence of a number of proof
pages of the woodcuts alone, minus the text on the back, may perhaps
be an indication that the pictorial work was printed by Dürer at home
on his own press.

Dürer's later correspondence with Jacob Heller (see chapter X) offers
proof that he was fully aware that his talent would show to its best ad-
vantage when unencumbered by the limited imagination of a client. He
had not traveled the breadth of Germany and northern Italy in order to
prepare himself simply to take dictation from his customers; he had al-
ready begun to impose upon himself a set of artistic standards far in
advance of any that they might have been capable of imagining.

As a graphic artist, Dürer was free to create plates or woodblocks de-
picting subjects of his own choosing, executed to his own satisfaction,
and could then seek buyers for the individual impressions after the fact.
Unlike a painting, each plate or block bearing one of his designs re-
mained his own property to the end of his life, if he so chose, for well-
cured woodcut blocks are capable of yielding hundreds of good impres-
sions and could be reprinted at will, either by himself or by an assistant,
whenever the need arose to replenish his stock for sale at a fair or for
shipment abroad. Engraved plates generally yield fewer than one hun-
dred impressions of the best quality, but it is worth noting that when

Dürer traveled to the Netherlands in 1520 he took with him for sale a large stock of prints made from plates and blocks cut before 1500, as well as examples of his latest work. He clearly regarded some of the early engravings, such as the large and elaborate *St. Eustace* (B.57, ca. 1500–1501) with its highly detailed forest setting, or the spectacular *Meerwunder*, as ranking among his masterworks, along with the woodcuts of the Apocalypse series of 1498 and the Large Passion.

Dürer followed in the footsteps of Martin Schongauer and such other printmakers as the upper Rhenish engraver, Master E.S., whose work he had copied as an apprentice in the Wolgemut studio, in making one of the staple items in his portfolio a handsome series depicting the Passion of Christ. The demand for such narrative series seems to have developed directly and naturally out of the pre-Gutenberg practice of illustrating each of the Hours of the Passion in handwritten prayer books with one of these scenes. Unlike the engravings of some of his predecessors, however, Dürer's first Passion series, as well as his Apocalypse, was done in giant woodcuts of unexampled vigor and virtuosity, too big to be used as "tipped-in" illustrations in the new prayer books printed with moveable type. He continued to utilize motifs taken over from Martin Schongauer's engravings—the kneeling, barefoot Apostle by the great cathedral candlestick from Schongauer's *Death of the Virgin* (L.16) became Dürer's St. John in the *Vision of the Seven Candlesticks* (B.62); and Schongauer's *Agony in the Garden* (L.19), *Ecce Homo* (L.25), and *Bearing of the Cross* (L.26), suitably amplified with deeper and more detailed and wind-tossed landscapes, were the inspiration for the same scenes in Dürer's Large Passion. But from the beginning, Dürer's animated compositions had a look of authority and a distinctive personal style which ensured their status as collectors' items in their own right. The breathtaking new woodcut technique, moreover, precluded their being copied by others in any medium but engraving, painting, or lindenwood sculpture.

Dürer's fifteen Apocalypse woodcuts had set a new and objective standard for the depiction of visions, and just at the most opportune moment, for the close of the fifteenth century had set off a new wave of speculation about the possible arrival of the Millennium—the end of history and of the world—in the year 1500. It is important to note, however, that Dürer's *Apocalypse*, unlike the contemporary art of more provincial artists such as Hieronymus Bosch, is neither pessimistic nor chiliastic in its tone. Although vengeance is wreaked upon the wicked in

spectacular natural disasters on land and at sea, the monstrous is kept to an absolute minimum (e.g., the monster with seven heads; the Leviathan representing Hell), while no effort was spared in depicting the "Wonder of Heaven," the splendor and majesty, power and dominion of God, and the honor done to the Blessed.

Durer's large sets of woodcuts, the Apocalypse and the first seven scenes for the Large Passion, which were issued first as single sheets, would have figured prominently among the items consigned to his new agent, Jakob Arnold, for sale in 1500, since they were not yet ready for sale in 1497. The fact that Dürer had employed no agent for 1498 or 1499 suggests that his emphasis lay, not on the projected end of the world, but on 1500 as a traditional Holy Year of papal jubilee, when special indugences would be available for those who visited approved pilgrimage shrines in a mood of repentance. The fact that the Pope authorizing the indulgences, Alexander VI (Rodrigo Borgia), was hardly a model of propriety—no more than the most notorious of his four illegitimate children, Lucrezia and Cesare—was scarcely germane.

The call to penitence is graphically illustrated, not only in the Apocalypse and Passion, but in Dürer's highly original engravings of *The Prodigal Son* (Plate 16), and *St. Jerome in Penitence* (B.61, 1496–1497). The penitent St. Jerome, of course, was a theme already popular in Italy due to the mid-century influence of St. Antoninus in Florence, and was one of Dürer's importations to Germany, where Jerome had customarily been shown only in his scholarly role as translator of the Vulgate and healer of the wounded lion. Dürer's handsome engraving, with its finely detailed background based on his watercolor studies of rock quarries, may well have been done specifically to appeal to the Italian market.

Strangely enough, the theme of the Prodigal Son, which is the subject of Christ's parable (Luke 15: 11–12) regarding God's infinite capacity for mercy toward those sinners who show genuine remorse, had never before been put to use as a penitential work of art: far more popular in northern Europe were the recountings of the wayward son's adventures in various bathhouses and brothels—favorite motifs in tapestries from the earlier fifteenth century—or his appearance as the noncommittal swineherd seen in the Basel *Speculum humanae salvationis* of 1476. Dürer's moving scene of the "born again" Prodigal on his knees in a barnyard bounded by Franconian outbuildings became a sensation—particularly in Italy, where it was even more avidly copied by painters of faience than by Italian engravers.[7] Even Vasari, forty years after Dürer's

death, still considered it one of Dürer's most remarkable works, with its "hovels in the German manner—very beautiful."

Dürer's clients for paintings in these earlier years included no less a personage than Friedrich III the Wise (1463–1525), Elector of Saxony, the future employer and protector of Martin Luther. The Elector, who had also recommended Konrad Celtis for the laureate in the 1480s, came to Nuremberg in 1496 for four days (April 14–18) with his brother Johann, and was one of the first patrons to "discover" Dürer. His portrait, painted in tempera on linen[8] is a remarkable if uncomfortable-looking image of authority. Dürer and Leonardo da Vinci were among the first to attempt to render the sitter's state of mind, as exemplified by facial expression, in portraiture. Dürer's painting of Friedrich, like his later portraits of Oswolt Krel (1499, Munich), the irascible Factor of the Great Ravensburg Trading Company, and later Mayor of Lindau; Lorenz Sterk,[9] Margaret of Austria's treasurer; the Portuguese diplomat Rui Fernandes de Almada;[10] the Imperial Herald, Caspar Sturm,[11] and other powerful men, are characterized by a slight frown, which is perhaps the artist's way of imbuing the sitter with the civic virtue of Fortitude. A handsome drawing of an unknown youth (Plate 17) is a "speaking" likeness, while his most daring attempt to capture a full-blown smile is the famous drawing of a Windish peasant woman,[12] an uncommissioned work depicting a naive subject.

While Dürer had used a neutral background for the Elector's portrait, as he had done in the case of his own "portable" self-portrait of 1493 (Paris), he began in 1497 to pose his sitters in the three-dimensional setting featuring an open window, a motif invented in the Netherlands but widely used in southern Germany well before the end of the century (most notably in an earlier portrait of Friedrich the Wise himself, by an unknown artist). Dürer's first of these, also painted in tempera on canvas in 1497, portrayed a young woman of the Fürleger family.[13]

Dürer used the same, waist-length format with an open window in the following year for a new portrait of himself, painted in oil (Plate 18). No longer the star-struck youth with uncombed hair from the days of his *Wanderjahre*, he appears in the new portrait elegantly attired and barbered, fully bearded, and wearing the thin grey doeskin gloves which were a Nuremberg specialty. His dashing black-and-white-striped tailoring, erect posture, and fine architectural surroundings denote a move upward in Nuremberg society. The jaunty inscription under the window reads: "Das malt ich nach meiner gestalt / Ich war sex und zwenzig

Jor alt / Albrecht Dürer" (I painted this from my own appearance; I was twenty-six years old). He used similar settings for the portraits of the brothers Hans (V) and Nikolaus Tucher and their wives in 1499. With the portraits of Elsbeth[14] and her husband, Nikolaus—whose likeness, unfortunately has been lost—Dürer introduced the portrait diptych into high Nuremberg society. An earlier generation of Tuchers (Hans IV) had sat for Michael Wolgemut; a younger one (Anton II) would be the donor of Veit Stoss's famous sculpture of the Annunciation to the Church of St. Lorenz on the eve of the Reformation.

Friedrich the Wise, as he sat for his Dürer portrait in 1496 also requested an elaborate altarpiece, portions of which survive in the museums of Dresden and Munich as *The Seven Sorrows of the Virgin* and the *Mater Dolorosa*. Once the Saxon Elector had broken the ice, religious commissions, too, began to come to Dürer from such leading families as the Hallers and Paumgartners. The Paumgartner Altar,[15] a Nativity with Adoration of the Shepherds, seems to have been commissioned as a result of Stephan Paumgartner's pilgrimage to the Holy Land in 1498, when he traveled with the party of Duke Henry the Pious of Saxony— one of Friedrich's relatives. Stephan, a Nuremberg attorney slightly older than Dürer, who was to become his good friend, is portrayed as St. Eustace on the left wing of the altar; his brother Lukas, dressed as St. George, is on the other. Meanwhile on the foreground of the main panel, seven shrunken Paumgartners and their coats-of-arms appear in the style of medieval donors, in deference to the deceased father of the family. The same slightly incongruous note of tiny medieval donors in a fully developed field of Renaissance perspective was used again by Dürer as late as 1500-1503 in the *Lamentation* painted for a local goldsmith, Albrecht Glimm, also in Munich, a composition closely related to the corresponding woodcut in the Large Passion.

Very shortly afterward, however, in the *Adoration of the Magi* (1504: Florence, Uffizi), painted for Friedrich the Wise, Dürer was able to demonstrate in a traditional religious painting his full command of perspective and of the pyramidal composition favored in Renaissance Italy. This splendid work is highly original, yet strangely evocative of Leonardo's huge, unfinished panel of the same theme begun in 1481 (Florence, Uffizi), almost as though Dürer had heard, but not seen, a description of Leonardo's abandoned underpainting.

# VII

## ALBERTUS DURERUS
## NORICUS

IN THE early months of the year 1500, before his twenty-ninth birth-day, Albrecht Dürer painted his most formal portrait of himself (Plate 19)—a full-face view of the sort used in northern Europe heretofore only for members of the Trinity. His elegant brown coat with a fur collar, cut full in a new fashion for men first worn by such late fifteenth-century noblemen as the handsome Count Palatine, Philipp the Sincere, is an indication that his social status had ascended to new heights: fur-trimmed garments, like dancing, were subject to regulation by the City Council. His hair and beard, at their most lustrous, were painted in a dark and Christ-like brown—particularly striking in view of the fact that his other self-portraits, both before and after, show beyond a doubt that Albrecht Dürer was blond. The symmetrical and schemat-ically idealized arrangement of his serious, handsome face and mass of shoulder-length hair deliberately invite comparison with the image of Christ as popularized in the so-called Lentulus Letter and its progeny, the many artistic reconstructions of the Sudarium, or veil of St. Veron-ica. No architectural setting or gloves appear here, and no flippant rhymes in gothic script: a plain, black background serves as a foil for the painter's monogram and for the carefully centered inscription in the for-mal Antiqua script favored by the humanists: "Albertus Durerus Nori-cus ipsum me propriis sic effingebam coloribus aetatis anno xxviii" (I, Albrecht Dürer of Nuremberg painted myself thus, with undying col-ors, at the age of twenty-eight years).

Dürer's natural resemblance to Christ has been deliberately but rev-erently amplified here,[1] and his use of the Latin term *proprius* to mean not "[my] own" but "undying" or "permanent," as well as his unusual choice of the verb *effingere* (to mold or create) rather than *pingere* (to paint) or *facere* (to make), which would have been normal usage in a painter's signature, implies reliance on the help of a scholarly "librettist," such as Pirckheimer, who commanded advanced Latin. More importantly, it gives clear evidence of Dürer's newly serious inter-

pretation of his role as artist and creator—as designer of works for the future.

In 1965 Dieter Wuttke discovered a previously unknown manuscript written by Konrad Celtis,[2] datable to 1500, which contains five epigrams in praise of Albrecht Dürer, professionally lettered by Celtis's secretary in the same Italianate Antiqua script as was used for Dürer's inscription on the portrait, and also using the verb *effingere* in praise of Dürer's creativity, which he compared to that of Phidias and Apelles. Another of Celtis's epigrams likened Dürer to the medieval philosopher and scientist most revered by the humanists, Albertus Magnus, declaring that God had given both men comparable creative powers.[3] Albertus Magnus (ca. 1206–1280), like Dürer, based his work on *experientia*, or observation of nature.

Scholars have called attention to the fact that, in its particular emphasis on the eyes and the right hand, the Munich portrait was intended to portray Dürer as the "thinking" artist.[4] Dürer's use of the full-face view and almost hypnotic gaze emphasize his belief that the sense of sight is the most noble of the five senses. He was to state this idea verbally in 1512 in an early version of the Introduction to his projected *Painter's Manual* ("For the noblest of man's senses is sight . . . Therefore a thing seen is more believable and long-lasting to us than something we hear"). The strict symmetry of the portrait, too, would have had special meaning as the equivalent of the *symmetria*, or *harmonia*, praised by such ancient writers as Cicero, Vitruvius, and Lucian, and promulgated in Italian Renaissance art and theory by Alberti (whose book on painting was still in manuscript, although its author was long dead) and in Germany by Celtis himself in his praise of Dürer.

The portrait, which would never have left the house in the artist's lifetime, would have been used not only as a display piece to show Dürer's ability to prospective clients, but also as a teaching demonstration for his students. The man in the Munich portrait is Dürer the Humanist—the new and Christianized Apelles. The darkened tone and limited color scheme of the painting may have been selected by the artist in accordance with Pliny's description of the art of Apelles, who was famous both for his four-color palette and his dark and lustrous glaze *atramentum*, reported to have been made of burnt ivory, which enhanced the brilliance of his colors while protecting them from dust.[5]

Celtis's comparison of Dürer to Albertus Magnus is a compliment founded in part upon the coincidence of names, but largely on Dürer's

demonstrated capacity to illustrate the assertion made by Albertus Magnus in *De pulchro et bono* that everything that actually exists participates in the beautiful and the good. Celtis would have based his judgment on Dürer's works done from life, or from nature, before the year 1500, such as the portraits, particularly the self-portraits and the likeness of Friedrich the Wise; the *Prodigal Son* engraving with its fine barnyard animals and view of the outbuildings at Himpelshof; the drawings and prints of male and female nudes, such as the *Men's Bath* woodcut (B.128, ca. 1496); the drawing of a *Nude Woman Seen from the Back* (Paris, Louvre, ca. 1495), as well as the costume studies, the landscape watercolors, and the prints which included landscape settings based on nature studies, such as the engraved *Madonna with the Monkey* (B.42, ca. 1498) with its view of the little pond house owned by the Angerer family at St. Johannis based on the watercolor now in the British Museum. Dürer's further nature studies, such as the famous watercolors of the *Wild Hare* (1502) and *Large Piece of Turf* (1503, both Vienna, Albertina), were the masterworks of this branch of his art. As Dürer himself later put it, "Depart not from Nature . . . for Art is rooted in Nature, and whoever can pull it out, has it." [6]

Such landscape watercolors as the *Wire-Drawing Mill* (Berlin, KdZ.4), or the *View of Nuremberg from the West*,[7] would have held particular interest for Celtis, who had been preparing his volume on Nuremberg's scenery and public life in 1495 for the projected *Germania illustrata*, which was to have been a series of monographs giving parallel descriptions of ancient and modern Germany—a counterpart to Flavio Biondo's *Italia illustrata* (Rome, 1474), in which "the barbarians" stood accused of having caused the near extinction of literature and history, as well as the loss of original Latin topographical place names. One of Celtis's most important sources was Tacitus—who had proclaimed the ancient German tribes to be indigenous, since it seemed clear to him that no one could possibly have wanted to move there deliberately. Most modern Italian writers were scarcely better informed about the geography and the aborigines to be found on the other side of the Alps.

The fact that Celtis had written four poems in praise of Dürer, however, and that Dürer had painted such a manifesto-like portrait of himself at about the same time, strongly suggests that there were still more important plans afoot for Dürer's future. Like Willibald Pirckheimer, Albrecht Dürer had agreed to play a vital role in the cultural campaign that Celtis called "bringing Apollo to Germany."[8]

Dürer's role was absolutely vital to the success of this enterprise,

since, aside from poetry, the visual arts represented the only direct means of access to the aesthetic values of ancient civilization. Celtis, Pirckheimer, and Dürer were relying on the power of Christianized classical education to create a modern Golden Age. Friedrich the Wise of Saxony responded to the call by founding a new university in Wittenberg; Albrecht Dürer determined to fathom the secrets of human proportion in order to publish them for the benefit of future generations of German artists—a project that would occupy him for the rest of his life.

There can be little doubt that Dürer had first come to the attention of Pirckheimer and Celtis as the logical person to undertake the reform of the visual arts because as a boy he had already demonstrated an extraordinary ability to approach the classical standard of the near-perfect imitation of nature (*mimesis*). Sebald Schreyer (1446–1520), the Dürer family's wealthy neighbor in the Burgstrasse and Konrad Celtis's host when the latter first came to Nuremberg, had been in frequent contact with Albrecht Dürer the Elder in regard to commissions for liturgical objects for the Church of St. Sebald, where he was honorary churchwarden. He would surely have known the work of Albrecht the Younger from boyhood on, for he had also had dealings with the Wolgemut studio.

Schreyer and Hartmann Schedel had formed a group of local humanists as early as the 1480s; it was Schreyer and his brother-in-law, Sebastian Kammermeister, who in 1493 had put up the money to have Dürer's godfather, Anton Koberger, publish Schedel's *World Chronicle*, with its illustrations from the Wolgemut workshop. It was likewise Schreyer who encouraged Celtis to publish his *Norimberga*, which Celtis had first presented to the Nuremberg City Council in 1495 as a scholarly paper. Schreyer was also among the first in Nuremberg to "bring Apollo to Germany" when he allowed Celtis to design a decorating scheme consisting of Apollo, the Muses, and classical philosophers, with explanatory captions in Latin verse, to be painted on the walls of a large room on the first floor of his house.[9] This room, which was unveiled at a gala reception for Celtis in June of 1495, would have been decorated while Dürer was away in Italy; it is quite likely that Dürer had known of the commission, however, and was inspired by it to enlarge his knowledge of classical motifs. It is also possible that Dürer and Pirckheimer may both have been in attendance at the reception for Celtis—Dürer as a neighbor, and Pirckheimer as a junior member of Schreyer's circle of humanist friends, all of whom had studied in Italy and were avid stu-

dents of Neoplatonic philosophy.[10] They were also devotees of Marsilio Ficino, who stressed the artist's essential role in making divinely ordained beauty visible.

Dürer's interest in the creation of beauty, as distinct from the simple replication of unedited nature, had begun to show itself in his drawings of classical motifs as early as the Italian journey, and had continued with such engravings as the perplexing *Four Naked Women* (B.75, 1497) which may represent either a scene of witchcraft or a *Judgment of Paris;* The Large Hercules (B.73, ca. 1498–1499); and *The Dream of the Doctor* (B.76, also known as *The Temptation of the Idler*, ca. 1498–1499) and the related drawing of *A Nude Woman with a Herald's Wand* (W.947, Sacramento, Crocker Art Gallery, dated 1498). The Sacramento drawing seems to have been an experiment in the combination of life drawing and classical proportion, rather than the simple and somewhat awkward observation of nature which scholars have previously supposed. The torso, which has both the proportions and the posture of the Aphrodite of Cnidos— and which has neither drapery nor pubic hair—appears to have been inspired by one of the many Roman copies of Praxiteles' most famous work,[11] while the awkwardness of the drawing arises from the attempt to graft onto it the head and arms of a living model. Dürer would have been aware of the extravagant praise lavished on Praxiteles' original, one of the extremely rare female nudes of the fourth century B.C., through his—or Pirckheimer's—reading of Pliny (XXXVI, 20), who alleges that the model was the sculptor's own mistress, Phryne.

Dürer's studies in human proportion began to accelerate after 1500, resulting in the drawings known as "the Apollo group" of about 1500– 1501,[12] and the engraving known as *The Large Fortune*, or *Nemesis* (B.77, ca. 1501), which features a ponderous female figure of the type that Xenophon would have called "a female in the heroic mold." Her proportions are based on a mathematical scheme of measurement similar, but not identical to, the one outlined by Vitruvius. The culmination of his experimentation along these lines was the great engraving of 1504, *The Fall of Man*, in which an Apollo-like Adam conforms to the light and lithe measurements of the Lysippean canon of proportion.[12]

Not the least of Dürer's reasons for taking particular care with his self portrait of 1500, and for his accelerated interest in human proportion, may have been Maximilian's appointment, on April 8, of the Venetian painter and printmaker, known in Italy as Jacopo dei Barbari, as court portraitist and miniature painter for the term of one year. Jacopo's resi-

dence was to be in Nuremberg. At the expiration of his temporary appointment as Imperial court painter, Jacopo was employed by Friedrich the Wise and other members of the Saxon nobility before traveling to the Netherlands, where he died in the service of Margaret of Austria.

Jacopo, who was known in Italy as "Jacob of the Barbarians" because of his seemingly unfathomable decision to go and live among the Germans, was called Jacob Walch, or Wälsch—literally, Jacob "the Italian"—by Dürer and his friends. His real name is not known. He had been "discovered" by the Nuremberg merchant, Anton Kolb, who may have recommended him to the Emperor and who had commissioned him to design a huge woodcut panoramic map of the city of Venice, which was published in Venice in 1500.

Since Dürer reveals in an unpublished draft of his Introduction to the *Four Books of Human Proportion*[14] that Jacopo once "showed me the figures of a man and a woman, which he had drawn according to a canon of proportions," it is assumed that the Italian artist provided an important stimulus for Dürer's own studies of the scientific measurement of the human body, despite the fact the Jacopo "did not want to show his principles to me clearly." It was after this rebuff, when he was still quite young, says Dürer, that "I set to work on my own and read Vitruvius, who writes somewhat about the human figure . . . and thereafter, from day to day, I have followed up my search according to my own design."

Close scrutiny of Jacopo dei Barbari's dough-like nudes by the scholars of several centuries has as yet failed to identify any figures which conform to a known canon of proportion, ancient or modern. Moreover, the Venetian artist's earliest engravings already clearly show the influence of Albrecht Dürer and the German style of modeling; none of them can be dated earlier than 1498.[15] Of much greater interest today, and of genuine influence on both Dürer and Barbari's successor at the Saxon court, Lukas Cranach, was Jacopo's introduction into northern art of the Hellenistic motif of the still life with dead game. These illusionistic hanging arrangements of dead birds were ideally suited to the hunt-oriented culture of the rural Saxon nobility, but were also taken up by the urban Albrecht Dürer in his stunning watercolor studies of brilliantly colored blue-green birds known as rollers dating from 1512 (Vienna, Albertina).

Dürer's ability to rival the ancients in this element of illusionism was to be celebrated in 1508 by Christoph Scheurl and Ricardus Sbrulius in their Latin "Little Book in Praise of Germany" (*Libellus de laudibus Ger-*

*maniae*): Scheurl, referring to Dürer as "the second Apelles," recalls Pliny's tale of the contest of ancient painters (XXXV, 10), wherein the birds were deceived by Zeuxis's painted still life of grapes, but Zeuxis himself was fooled by Parrhasius's painted curtain, which he took to be the covering over his rival's picture. Albrecht Dürer's dog, Scheurl alleges, mistakenly planted a kiss on the painted portrait of his master when the great painter had set his newly finished work outside to dry in the sun, and the mark remains on the portrait "to this very day."

# VIII

## THE DEATH OF
## ALBRECHT DÜRER
## THE ELDER

KONRAD CELTIS spent the Easter holiday of 1502 in Nuremberg
at Pirckheimer's house, probably in connection with the pub-
lication of his new book, *Norimberga*, which was being printed
there for the Sodalitas Celtica, and the three friends were temporarily
reunited.

Galeazzo de Sanseverino arrived a few months later to spend the sum-
mer as Pirckheimer's house guest; it is surely not by accident that his
visit coincided with the need to defend the city against the forces of the
Margrave Casimir of Ansbach, which continued from May through
July. Galeazzo had shared Pirckheimer's interests in military tactics since
their student days in Pavia, and had in the meantime been privy to the
opinions of Leonardo da Vinci on the subject.[1] For his connections with
Leonardo, and with the mathematician Fra Luca Pacioli—who dedi-
cated the manuscript of his *Divina proportione* to Sanseverino—his ar-
rival would have been of particular interest to Dürer, who may have met
Sanseverino in 1495 at Pirckheimer's wedding. Where Celtis had in-
spired Dürer to turn his attention to problems of the reconciliation of
nature with classic form, Galeazzo may have helped to stimulate his
growing interest in mathematics and the theory of perspective—an in-
terest which would grow stronger with the return to Nuremberg of the
great mathematician and astronomer, Johannes Werner (1468–1522),
who became pastor of St. John's Church in 1508. In 1502, the sundial
designed by Werner was being installed on the south side of the Church
of St. Lorenz. Werner was a friend of the astronomer Bernhard Walther,
whose house and observatory Dürer was to purchase in 1509; he had
discovered a comet in 1500 which he and Walther observed together, and
would later cast Pirckheimer's horoscope.

The elaborate perspective constructions of Dürer's Paumgartner Al-
tar,[2] the engraving which he called *Weihnachten* (B.2, 1504), and the ex-

tensive architectural views in his *Adoration of the Magi* for Friedrich the
Wise (Florence, Uffizi) and the Life of Mary series of woodcuts which
he began in 1502 show the results of this deeper concern for the intrica-
cies of perspective, as well as his continuing interest in the reform of
religious imagery.

The Life of Mary series, which Dürer worked on from time to time
until his departure for a second trip to Italy in 1505, must have been
begun soon after his father's death in September of 1502, since only two
blocks had been completed by the end of the year:

> Some time later, my father fell so ill with dysentery that nothing could
> cure it. And when he saw death approaching, he gave himself to it willingly
> and with great patience. He commended my mother to me, and exhorted
> me to live in a manner pleasing to God. He received the Holy Sacraments
> and passed away in a Christian manner in the year 1502, after midnight be-
> fore St. Matthew's [September 19] as I have described in another book.
> After that I took my brother Hanns to live with me, but my brother Endres
> we sent away.
>
> Dürer's *Family Chronicle*

> . . . So the old woman helped him up, and the nightcap on his head became
> suddenly wet with great drops of sweat. Then he asked to drink, and she
> gave him a little Reinfell [Rainfel, a sweet Italian wine from Rivoglio]. He
> took a very little of it and then wanted to get into bed again, and thanked
> her; and when he had gotten into bed again he fell at once into his last
> agony. At once his old wife lit the candle and repeated St. Bernhard's Prayer
> to him:

> ["Lighten mine eyes, lest I sleep the sleep of death;
> Lest mine enemy say, I have prevailed against him;
> Into thine hand I commend my spirit: Thou hast redeemed me, O Lord
>     God of Truth.
> Then spake I with my tongue: Lord, make me to know mine end,
> And the measure of my days, what it is; that I may know how frail I am
>     . . ."]

> . . . and before she had said the third verse he was gone. God be merciful to
> him. And the young maid, when she saw the change, ran quickly to my
> room and woke me, but before I came down he was gone. I looked on the
> dead with great sorrow, because I had not been worthy to be with him at
> his end. And in the night before St. Matthew's eve, my father passed away,
> in the year mentioned above [September 20, 1502]—the merciful God help
> me also to a happy end.

And he left my mother a grieving widow, whom he had always praised so highly to me, saying what a good wife she was. Therefore I intend never to forsake her. O all my friends, I pray you for God's sake, when you read of my pious father's death, remember his soul with an Our Father and Ave Maria, and also for your own soul's sake, that we may so serve God as to attain a happy life, and the blessing of a good end. For it is not possible for one who has lived well to depart ill from this world; for God is full of compassion. Through which may God grant us, after this pitiful life, the joy of everlasting salvation through the Father, the Son, and the Holy Spirit, without beginning and without end an eternal ruler. Amen.

(Dürer's *Gedenkbuch*. Berlin, Kupferstichkabinett)

The brief and rather clinical reference to his father's death which Dürer included in his *Family Chronicle*, written near the end of his own life, is in sharp contrast to the detailed account of his father's last moments that he wrote in his *Gedenkbuch* shortly after the event. This full and immediate description must follow the testimony of his mother, since Dürer, to his great sorrow, did not arrive in time to witness the death.

The most striking difference between the two accounts, other than their length, is the fact that in the earlier of the two a great point is made of the recitation of St. Bernard's prayer, and of the plea to the reader to say The Lord's Prayer and an Ave Maria for the elder Dürer's soul, since he had died before a priest could be summoned. In the account written in 1524, Dürer insisted that his father had received "the Holy Sacraments" and had died "in a Christian manner." This editorializing, which seems to be somewhat at variance with the facts in insisting that Dürer's father had received communion, was written during the final stages of discussion in the City Council which led to Nuremberg's formal break with the papacy. The Lutheran communion, of both bread and wine, was already being administered in several of the city's churches as of Holy Week, 1524, and Requiem Masses had been abolished. Since Dürer was writing his *Family Chronicle* for the ages, he felt obliged to adjust his description of the piety of his parents to bring it into conformity with "modern" Christianity.

The one remaining page of the *Gedenkbuch*, however, gives other evidence of the survival of the "medieval" Dürer, even during the years of his most intense involvement with Nuremberg's humanists:

The greatest miracle that I have seen in all my days, happened in the year 1503, when crosses fell on many people, especially on children more than on

other people. Among them all I once saw one in the shape, which I have drawn here; it fell on the linen blouse of Eyrer's maid, who was in the Pirck-heimers back-house. And she was so upset about it that she cried and wailed; for she thought she was going to die of it.

Also I saw a comet in the heavens . . .

# IX

## THE RETURN TO ITALY

[Venice, January 6, 1506]

To the Honorable, wise Herr Willibald Pirckheimer, burger of Nuremberg, my kind Sir:

Item: I wish you and yours many good, happy New Years. . . . Know that I am in good health; I pray God that you are even better. Item: as you wrote to me to buy some pearls and gems, you must know that I can't find any good ones, or even any worth the price. Everything is snapped up by the Germans. They hang around the Riva [degli Schiavone]. They always want to get four times the value for anything, for they are the most dishonest people alive. No need to expect any honest service from any of them. Some good friends told me to watch out for them—they shit on [cheat] man and beast. You can buy better things for less money in Frankfurt than in Venice. . . .

As soon as God helps me get home, I will repay you honorably with many thanks. For I have a panel to paint for the Germans for which they are to pay me a hundred and ten Rhenish florins—it will cost me less than 5 fl. to make. In eight days I will be finished with the chalk ground and the scraping. Then I will begin to paint right away because it must, God willing, stand on the altar a month after Easter. God willing, I hope to save all the money. I will pay you out of it. For I don't think I need to send money to my mother or my wife so soon. I left 10 fl. with my mother when I rode away; she has in the meantime taken in 9 or 10 fl. from art [sales]. . . . I gave my wife 12 fl., and she took in 13 in Frankfurt. . . . But if she wants anything, my brother-in-law [Martin Zinner] will have to help her till I come home. . . .

Greet Stephan Paumgartner and my other good friends who ask about me.

Albrecht Dürer [Letter 1][1]

I N the late summer of 1505, Dürer made a second journey to Italy. Ten of his letters from Venice to his friend Pirckheimer have survived, and he evidently kept a journal of some sort during his absence from Nuremberg which has been lost, but nowhere in his sur-

viving writings did he explain precisely what his motive for making the trip had been. More likely than not, he had several.

By 1505, Dürer was an internationally famous man, both in the Netherlands, where his prints were an inspiration to the youthful Lucas van Leyden and others, and in Bavaria and the outer Empire with such printmakers and painters as the Master M.Z., Wenzel von Olmütz, Lucas Cranach, and the younger men of the so-called Danube School. He was still more famous in Italy, where he had employed an agent to handle his print sales, and where his compositions of the late 1490s were being widely imitated by the local painters, engravers, and even by decorators of ceramics.[2] His engravings of *The Prodigal Son* and *The Madonna with the Monkey* (B.42) were particular favorites in Italy for their picturesque backgrounds of "exotic" German landscape and architecture, while his rich and varied effects of texture completely revolutionized Italian engraving, as may be seen from the work of Giulio Campagnola, Cristoforo Robetta, and Benedetto Montagna, as well as by less talented copyists such as Zoan Andrea and Giovanni Antonio da Brescia. Dürer appears to have been flattered by all of this attention—up to a point—although he did find it annoying to be criticized by some of his copyists for not being "antique" (classical) enough (letter 11).

Giorgio Vasari in his *Lives of the Artists* reported, many years after Dürer's death, that the German artist had filed suit against Marcantonio Raimondi, who had not only been making exact copies of Dürer's woodcut compositions in engraving, but signing them with Dürer's own initials. Although the case—which would have been the first legal action in defense of copyright in history—was said to have been adjudicated by the Venetian Signoria, Dürer's own letters and later writings are silent on the subject, an indication that this cannot have been his primary reason for going to Venice. Raimondi's copies after the Life of Mary series, in any case, must post-date Dürer's second trip to Italy.

In his letters to Pirckheimer, Dürer stressed several times his feeling of accomplishment at having silenced the Italian painters who had previously called him a good graphic artist but a poor colorist (Letter VIII). And he certainly seems to have felt that he had "arrived" when people began to warn him that he might be poisoned by some jealous Venetian artist (Letter 11):

[Venice, February 7, 1506]

... I wish you were here in Venice! There are so many nice fellows among the Italians who are my companions more and more every day, so

that it warms my heart: intelligent, educated, good lute players, flutists, connoisseurs of painting, and many noble minds. . . . On the other hand, there are also among them some of the most false, lying, thievish rascals, the like of which I wouldn't have believed lived on earth. . . . I have many good friends among the Italians who warn me not to eat and drink with their painters. Many of them are my enemies, and they copy my work in the churches and wherever they find it; and then they sneer at it and say that it is not in the antique style, and therefore not good. But Sambelling [Giovanni Bellini] has highly praised me before many nobles. He wanted to have something of mine, and came himself and asked me to paint him something; he would pay well for it. . . . He is very old, but he is still the best painter of them all.

And that thing that pleased me so much eleven years ago doesn't please me any more. . . . You must know, too, that there are many better painters here than Master Jacob [Jacopo dei Barbari]. . . . The others make fun of him, saying, "If he were any good he would stay here," etc.

I have only begun to sketch my picture, for my hands were so scabby that I couldn't work. But I have cured it. . . . My friend! I want to know if any of your mistresses has died—that one by the river, for instance, or the one like [a rose] or [a brush], or the [dog] girl, so that you need to replace her for another one.

Given at Venice at the 9th hour of the night, on Saturday after Candlemas in the year 1506.

Give my service to Stephan Paumgartner and to Masters Hans Harsdorfer and Volkamer.

                                        Albrecht Dürer [Letter 11]

Dürer had set out, not just for Italy, but specifically for the Republic of Venice, the end of the German trade route and baggage service beyond the Alps. Venice can have held but few surprises for him, since he had apparently spent a substantial portion of the winter of 1494–1495 there. He seems to have held fond memories of certain things he had seen there eleven years earlier. (What were they? He didn't say.) But he commented without disappointment—and with an awareness of his own growth as an artist in the interim—that he no longer found them very pleasing. He now realized that Jacopo dei Barbari was really a second-rater whom other Venetian artists were ridiculing behind his back. He still admired the venerable Giovanni Bellini, but it was Bellini who wished to buy some of Dürer's work. If Bellini whispered any professional secrets to him, Dürer never divulged them. Quite the opposite, in fact, if we can believe the account of Joachim Camerarius in his preface to the Latin edition of Dürer's *Four Books of Human Proportion* (pub-

lished posthumously in 1532), wherein it is alleged that Bellini had begged Dürer to give him "one of those brushes that you draw hair with," and was dumbfounded to find out that they were perfectly ordinary paintbrushes much like his own.

Although he had begun to take the theoretical aspects of art very seriously—both the mathematical foundations of perspective and the various canons of human measurement utilized in Antiquity—and had perhaps already determined to publish this material in German at some future date, Dürer only made mention at the end of his stay in Venice (Letter x) that he intended to ride to Bologna "to learn the secrets of the art of perspective, which a man is willing to teach me." Thus it seems quite unlikely that the sheer acquisition of theoretical knowledge could have been uppermost in his mind when he decided to make the trip to Italy.

Dürer's primary goal, it would seem, was Venice itself, still the wealthiest city in Europe, its palaces brilliant with gold-leaf and bright frescoes and its citizens resplendent with jewels. In its large and prosperous German community, Nuremberg's captains of industry maintained sales outlets, and her merchants bought spices and silks and carpets from the Orient. In Venice, as in other "outlandish" locales, the German tradesmen lived in their own compound, and the center of the Venetian one was the Fondaco dei Tedeschi (German House), the Hansa-owned clubhouse for making deals, communal dining, card playing, drinking un-Italian quantities of alcohol, and on "ladies' nights" practicing the latest scandalous dance steps of the 1500s.[3] (Venetian "ladies" were also available commercially, as Dürer himself had already noted in 1494 with his life study of the one who later emerged as the Harlot of Babylon in his Apocalypse series.)

The German knight Arnold von Harff has left a vivid description of Venice and of the Fondaco dei Tedeschi as it appeared on his visit in 1497:

> Item: at Venice I was taken by the merchants to the German House, which is called in the Lombard speech Fondigo Tudisco. . . . Item: to describe first this trading house. As I stayed there for some time I was able to see daily much traffic in spices, silks, and other merchandise packed and dispatched to all the trading towns, since each merchant has his own countinghouse there—from Cologne, Strassburg, Nuremberg, Augsburg, Lübeck, and other German cities of the Empire. . . . From this German house one goes over a long wooden bridge on the right hand. Then one reaches a small

square called the Rialto. Here the merchants assemble daily about nine or
ten o'clock for their business, so that each one can be found without delay.
This square is built round about and is about as large as [that at] Düren.
Close by the square sit the money-changers who have charge of the mer-
chants' cash, which they keep with money-changers so that they may have
less money to handle. When a merchant buys from another, he refers him
to the bankers. . . . Leading from the Rialto are long streets where the mer-
chants have their shops, such as goldsmiths and jewelers selling pearls and
precious stones. One street contains tailors, cobblers, rope sellers, linen and
cloth dealers, and others trading there without number. Above the shops is
a place like a monastery dormitory, so that each merchant in Venice has his
own store full of merchandise, spices, rare cloths, silk draperies, and many
other goods, so it can be said that the wealth of Venice lies in this squre.[4]

This was the Venice that Dürer would have remembered. Early in
1505, however, word had reached Nuremberg of the disastrous fire in the
German settlement which had destroyed the old Fondaco dei Tedeschi.
Construction of the new building was entrusted to an Augsburg archi-
tect, Master Hieronymus. In view of the fact that Pirckheimer had a
number of influential friends in Augsburg, as well as in Venice, and was
willing to lend Dürer the money to make the trip to Venice—via Augs-
burg, which lay on the way—it may have been that Dürer hoped for a
commission for decorations in the new German House. It is not without
interest that, when the Signoria refused to allow the Germans to use
marble for the facade, the youthful Giorgione was finally employed in
1508 to decorate the facade with frescoes. By that time, Dürer had al-
ready returned to Nuremberg, after having completed the Altarpiece of
the Rose Garlands for San Bartolommeo, the German church in Venice.
A hope of obtaining the commission for either the frescoes or the altar-
piece would have been a strong incentive to lure Dürer once more over
the Alps to Italy. The idea that Dürer would leave in Italy a permanent
testimonial to his artistic genius, and by implication a rebuke to those
Italians who had belittled German culture, would have had enormous
appeal for Celtis and Pirckheimer as the fulfillment of their plan to spon-
sor and publicize German art.

In any event, just as in 1494, Dürer had chosen to leave Nuremberg at
a time when an outbreak of the plague was raging there, so severely that
Anton Koberger had closed his press, and Pirckheimer and most of the
other prominent citizens had left to take refuge in Nördlingen or
Schwäbisch-Gmünd, where no cases of the dread disease had yet been
reported. Dürer's quick and powerful charcoal sketch of 1505 labeled

**———— PLATE 17 ————**

Dürer. *Portrait of a Young Man.* 1503. Metalpoint, pen and brown ink
heightened with white. Williamstown, Mass., The Sterling and Francine
Clark Art Institute.

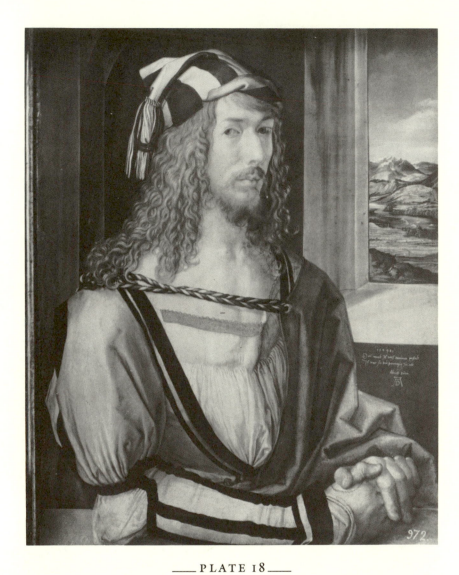

—— PLATE 18 ——

Dürer. *Self-Portrait*. 1498. Oil on panel. Madrid, Prado.

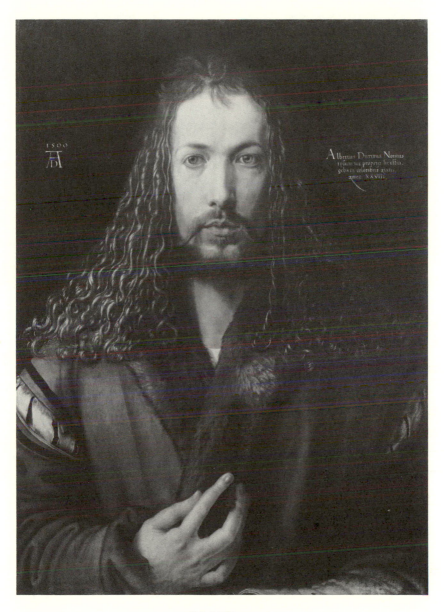

Dürer. *Self-Portrait*. 1500. Oil on lindenwood panel. Munich, Alte Pinakothek.

———— PLATE 20 ————

Dürer. *The Feast of the Rose Garlands* ("The German Picture"). 1506.
Oil on poplar panel. Prague, Narodni Galerie.

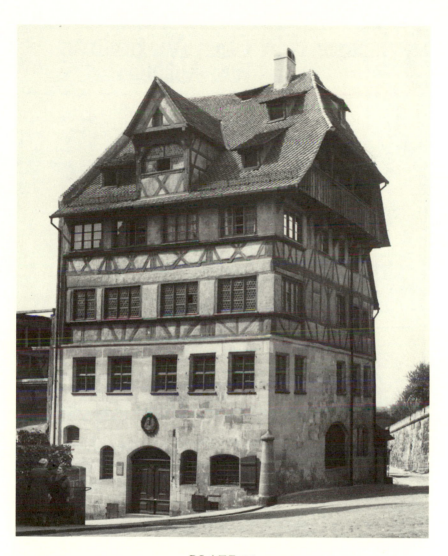

—— PLATE 21 ——

Dürer's house in the Zisselgasse, Nuremberg.
(Pre–World War II photograph.)

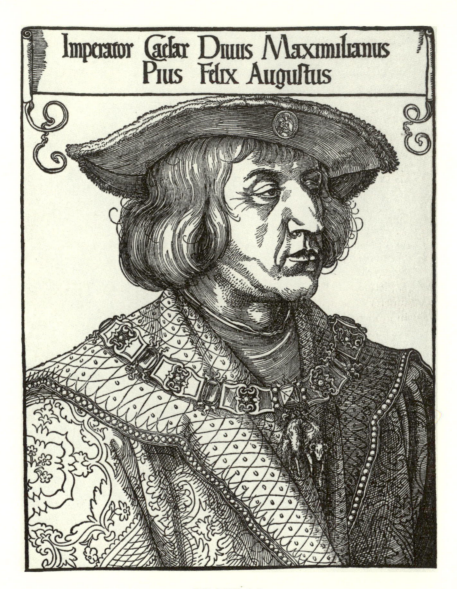

Imperator Caefar Diuus Maximilianus
Pius Felix Auguftus

Dürer. *Portrait of the Emperor Maximilian I.* 1519. Woodcut.

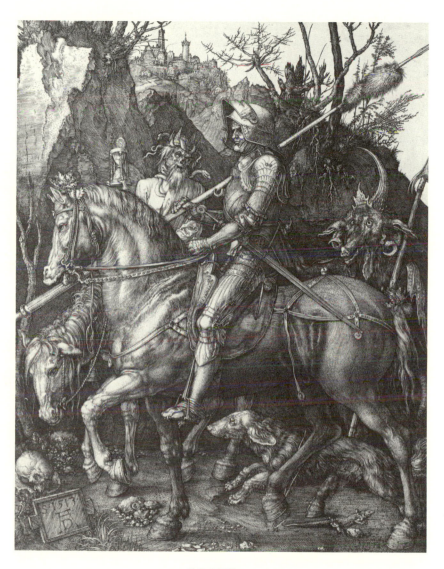

_____ PLATE 23 _____

Dürer. *Knight, Death, and Devil* ("Der Reuter"). 1513. Engraving. Berlin,
Staatliche Museen Preussischer Kulturbesitz, Kupferstichkabinett.

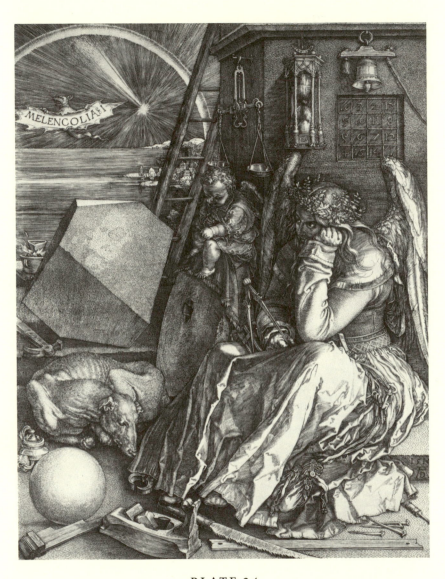

"Memento mei" (Remember me, London, British Museum) is surely a reference to this epidemic, and perhaps to the vicissitudes of travel as well. It shows Death wearing a king's crown, carrying a scythe and riding a cadaverous horse.

As he seems to have done at the time of his first trip to Italy as a new bridegroom, Dürer left Agnes behind. Before he rode away he gave small household allowances to her and to his widowed mother (Letter 1), intending to supplement these funds as necessary with earnings yet to be made in Italy. He made arrangements for Agnes to travel to the Frankfurt fair (August 24) with a selection of his prints for sale. Since it would have been unthinkable for Agnes to travel alone to Frankfurt and back, it is probable that she was accompanied either by her brother-in-law, Martin Zinner, who is mentioned several times in Dürer's correspondence, or by Dürer's godfather, Anton Koberger, who was accustomed to attend the Frankfurt fairs in both spring and fall.

Dürer's mother was expected to sell his prints at the *Heiltumsfest* in Nuremberg, the second Friday after Easter: a large number of potential buyers of prints with sacred subject matter could always be expected to view the Imperial relics, particularly the Holy Lance, which was heavily indulgenced.

Dürer's wife and mother, like other Nuremberg women of their social class, would have been accustomed to handling his sales even when he was at home, since in Nuremberg it was the custom to regard retail sales as women's work. For this reason it was quite common for Nuremberg women to be literate, as both Barbara and Agnes Dürer were: it is clear from his Venetian letters that they had written to Dürer, and he to them, on a continuing basis, although none of the correspondence from either side has been preserved.

Since Dürer's twenty-one-year-old brother Endres, a goldsmith like their father, was apparently still away from the city on his bachelor's journey, the youngest brother, Hanns III, fifteen, seemed destined to be "lost among the women," as Dürer put it. He had offered to take the boy along with him to Italy, to learn Italian and to continue his training as Dürer's assistant, but their mother "was afraid the sky might fall on him" (Letter v). By April of 1506 Dürer was urging Pirckheimer to have a fatherly talk with the boy, and to ask his mother to try to get Hanns some employment in Wolgemut's workshop. Later Nuremberg court records (June 17, 18, 1510) report that Hanns was stabbed during a fight with another apprentice, an indication that Dürer's worries on his brother's behalf may have been well-founded.

Dürer's path to Italy, just as in 1494, would have taken him directly south through the Imperial city of Augsburg. Once an ancient Roman trading post at the northern end of the Via Claudia Augusta, Augsburg was still the major German center of trade with Italy. In 1505 it was one of the wealthiest cities in Europe, the home of the millionaire Fugger and Welser families, and in contrast to Gothic Nuremberg a veritable fairyland of painted house facades, tumescent Renaissance columns and Italianate cherubs—all as modern as Augsburg finance.

The Fugger banking house was headed by Jacob, affectionately nick-named "the Rich," who personally funded the beginnings of German Renaissance architecture, and whose gold and silver dishes the impecunious Maximilian had to borrow for state occasions, who provided the dowries for the Emperor's grandchildren, and who would later finance both Maximilian's war with Venice and bribe the Imperial electors to choose Maximilian's grandson, Charles V, as Holy Roman Emperor instead of Francis I of France. Dürer's portrait of Jacob Fugger, now in the Augsburg Staatsgalerie, is based on a life drawing made when the Imperial Diet met in Augsburg in 1518, but it is possible that Dürer may have drawn the portrait of Fugger's brother Georg at this time. Anzelewsky has suggested that Georg Fugger, who died in 1506 after having lived in Nuremberg for a number of years, may be one of the men depicted standing next to Dürer in the Altarpiece of the Rose Garlands. The fact that the seventeenth-century art historian Joachim von Sandrart, who lived in Nuremberg and was an authority on Dürer's life and work, owned a life-size drawing in black chalk (now lost) which he listed as a portrait of Georg Fugger lends credibility to the idea that the latter had sat for Dürer in 1505 when the artist was on his way south.

Jacob Fugger's attorney, Dr. Konrad Peutinger, Municipal Secretary of Augsburg, knew Dürer well enough by 1515 to refer to him as "mein guter frund Dyrer," and it is tempting to speculate that he and Dürer may already have known each other by this time. In 1505, at the suggestion of the Emperor Maximilian, Peutinger had published a catalogue of his extensive collection of ancient Roman inscriptions, all of which had been unearthed in the Augsburg area. Dürer, who later wrote a treatise on Roman lettering, *On the Just Shaping of Letters*, would surely have been interested in these. Peutinger may also have drawn Dürer's attention to the life-size Roman bronze of a nude youth, turned up by a farmer's plow in 1502 in the province of Carinthia (Kärnten) in southeastern Austria.[5] The piece, now in the Vienna Museum, is thought to

be a Roman copy of a work from the circle of Polykleitos. Dürer had already demonstrated an interest in Greek canons of measurement in his remarkable engraving of 1504, *The Fall of Man*, and it is certainly possible that he had already seen a drawing of the Roman bronze and may have wished to see the original.

On his first journey to Italy, Dürer seems to have taken the direct route south from Augsburg over the Brenner Pass. If he took the longer route through the province of Kärnten this time, it would have added only another 100 kilometers (about four days' travel) and would have brought him to Venice by way of Klagenfurt.[6] A trip through Kärnten is also a logical way to explain the existence of Dürer's two life drawings of Windish peasant women. The pen and wash drawing in London,[7] an unprecedented depiction of a woman laughing, is inscribed "una vilana windisch—1505" in the mixture of Italian and Slavic which is still spoken in this region.[8]

Kärnten (ancient Noricum—the name which Dürer had wrongly cited as his own address in the *Fall of Man* engraving) was the repository of the largest number of Roman remains to be found in Austria, and the area near Zollfeld where the statue had been unearthed was formerly the Roman city of Virunum, founded by the Emperor Claudius. From here an excellent Roman road runs south to Italy, as the Visigoths already found out.

Dürer's ten letters from Venice to his friend, and now creditor, Willibald Pirckheimer, are priceless documents. Unlike the family chronicle and the diary of his journey to the Netherlands, which exist today only in faithful copies dating from the seventeenth century, the Venetian letters are the originals written in Dürer's own hand. Eight of them were discovered in 1748 during the remodeling of the grand house on the Egidienplatz which had belonged to the heirs of Pirckheimer's son-in-law, Hans (II) Imhoff (1488–1526), whose father is mentioned in the letter of April 25, 1506 (No. VI). The bundle of letters had been hidden away in a hollow wall in the family chapel together with other personal papers belonging to Pirckheimer—probably to safeguard them from harm during the Thirty Years' War when Nuremberg served for a time as headquarters for the Swedish King Gustavus Adolphus on his victorious march from Pomerania to the Rhine in 1631.

Dürer's letters are doubly valuable because they are the first truly personal letters written by an artist to a friend which have survived. Original documents pertaining to northern European art and artists in Dü-

rer's time and even later are extremely rare and are limited mostly to official contracts. There are no letters from either Matthias Grünewald or Hans Holbein, for example, and only six from Rembrandt—all of them written to the Secretary to the Prince of Orange (who maintained a filing system) in regard to a commission for a series of paintings. Only Rubens, who was at once a classicist, an ambassador without portfolio, and a man determined to spark a renaissance in seventeenth-century Antwerp, left a larger body of correspondence.

A precedent of sorts for Dürer was set, as we have seen, by the brief but loving letter written by Albrecht the Elder to his wife and family from the Imperial court in Linz in August of 1492, which seems to have been saved as a family heirloom because of the great compliment paid to Dürer's father by Kaiser Friedrich III. The exchange of letters between Dürer and Pirckheimer, however, can be seen to be of quite a different sort, despite the fact that only Dürer's half of the correspondence has survived. There are clear references to other letters both written and received by Dürer, many of them to or from his wife and mother, and even one to another woman; none of those has been preserved.

We owe the survival of these ten letters entirely to the fact that their recipient was Pirckheimer, who had loaned Dürer the money for the trip. Pirckheimer believed in the existence of genius, and sought to nurture it wherever he found it. He had recognized it in Dürer early on, and more importantly, had enabled Dürer to recognize it in himself. The two friends, therefore, were mutually delighted with one another's steadily increasing fame, viewing it as the just reward for extraordinary achievement (Letters VII, VIII, IX, X).

Pirckheimer's increasing activity as diplomatic representative of the Nuremberg City Council before the Margrave of Brandenburg, as well as with such local robber barons as Kunz Schott, is a source of real pleasure to Dürer, just as the news that the Venetian Doge (Leonardo Loredano, whom we know from the magnificent portrait by Giovanni Bellini) and the Patriarch Antonius Surianus have seen his altarpiece for the German church (Letter VIII), or that the venerable Giovanni Bellini has praised his work to the Venetian nobility (Letter II) and wishes to buy something of his, is sure to have pleased his friend.

The first letter, dated January 6, 1506 (see epigraph to this chapter), contains a progress report (not encouraging) on Dürer's efforts to carry out his friend's request to buy jewels for him—a not unreasonable

errand, since Venice was a well-known center of trade for such items (which at home were subject to control by the City Council) and since Dürer, by virtue of his brief apprenticeship to his goldsmith father, could be expected to have some expertise in such matters. In the course of his explanation, Dürer has some unflattering things to say about "the Germans" as unscrupulous businessmen. Then, without pausing for breath, he goes on to say that he has received what looks like a lucrative commission from "the Germans" to paint the altarpiece for which they are prepared to pay him 110 (gold) Rhenish florins. As he discusses the development of "the German picture" in later letters it becomes clear that he is talking about the painting now in Prague known as the *Feast of the Rose Garlands* (Plate 20). He continues to use "the German picture" as the short title for this altarpiece, not merely because San Bartolommeo's is the national church of the Germans in Venice, but because the painting is explicitly German in its subject matter.[9] Its iconography is directed specifically toward Rosary devotion (the German word for Rosary, *Rosenkranz*, literally means "garland of roses"), a devotion invented in Cologne in the 1470s and spread immediately by the Dominicans across Germany and Holland, but not yet popular in Italy.

The specifically German character of Dürer's altarpiece is further emphasized by his inclusion of a portrait of the Emperor Maximilian kneeling in the foreground at the Madonna's left, equal in status to Pope Julius II. Maximilian, as Dürer reveals in Letter VIII, was highly unpopular in Venice at this time—in point of fact, he was soon to launch an attack on the Most Serene Republic (1507), his expeditionary force underwritten by Jacob Fugger.

Dürer's altar is a brilliant blend of the Germanic and the Italianate, its echoes of Bellini's rich color, light, and adolescent musical angels counterbalanced by reflections of Stephan Lochner's great Altar of the Patron Saints of Cologne (Cologne, Cathedral) and its reference to the legend of the foundation of the Rosary by St. Dominic. The two symmetrical communities of the sacred and the secular contain many portrait heads which undoubtedly represent specific members of the German colony in Venice, although few can be identified with certainty—Burkhard von Speyer and Hieronymus the architect, and perhaps Georg Fugger.

At the rear of the painting, however, there is no mistaking the most Germanic of all Albrecht Dürers, standing under a tree set off against an

Alpine snow field, near the view of Nuremberg on the horizon. Daz-
zlingly blond (unlike his Christ-like self of 1500), and splendidly uphol-
stered in ginger-colored fur, he points discreetly to the parchment in his
hand signed "Exegit quinquemestri spatio" (Painted in the space of five
months) "Albertus Dürer Germanus." Since his letters have shown that
the altarpiece actually took him six months and a half Dürer seems to
have counted only the time spent in actual brushwork on the prepared
panel, discounting the preparatory studies.[10]

His "German picture" finished at last, and duly admired by the Doge
and the Patriarch—who, one would suppose, may have been invited to
participate in the dedication ceremony—Dürer allowed himself four
more weeks to conclude his business in Italy, telling Pirckheimer that he
had refused over two thousand ducats' worth of commissions which had
come pouring in since the unveiling of his altarpiece (Letter IX, Septem-
ber 23, 1506), since he feels obliged to return home. He has finished an-
other painting, "the like of which I have never painted before," and has
agreed to "make the portraits of some people I have promised."

The picture unlike any he had ever done before may have been the
*Madonna with the Siskin* (Berlin), with its Italianate theme of the Ma-
donna and Child with the infant St. John the Baptist—a subject which,
despite its popularity in Italy in the wake of the moralizing treatises by
Cardinal Giovanni Dominici and Leon Battista Alberti on the family
and the rearing of small children as a theme suitable for viewing by
young children, had been virtually ignored in the north.[11] The painting
soon had its own following in Italy when Dürer's golden-haired St.
John was copied almost line for line by the young Titian in his *Madonna
with the Cherries* (Vienna).[12]

To the modern mind, however, a more innovative painting than the
*Madonna with the Siskin*, which has many features in common with the
"German picture," is the strangely truncated *Christ among the Doctors*
(Lugano, Thyssen-Bornemisza Collection). Dated 1506 and inscribed
"Opus quinque dierum" (The work of five days), it features several gro-
tesque heads reminiscent of Leonardo da Vinci—or of Hieronymus
Bosch, whose work was also to be seen in Venice—and has brilliant
shot-silk drapery which seems to prefigure Italian mannerism.[13] Unlike
Dürer's recent compositions utilizing deep space, this small picture has
only a wreath of heads and hands set off against a plain, dark back-
ground. Drapery of changeable color had been painted before, particu-
larly in the Rhine valley where Dürer had spent what is known of his

bachelor's journey in the early 1490s, but it was destined to reach its greatest popularity in Italy, shortly after Dürer's departure, and after the unveiling of Michelangelo's Sistine Ceiling, where very similar effects are to be found.

Fedja Anzelewsky has presented evidence in the form of a drawing and an early painted copy of Dürer's picture which shows that the inscription originally read "A.D. F(ecit), ROMAE" (Made by Albrecht Dürer in Rome). Did Dürer go to Rome, as he had told Pirckheimer he wanted to do "if the King comes to Italy" (Letter VII, August 18)?

Maximilian did, indeed, plan a trip to Italy for his coronation as Holy Roman Emperor by the Pope. In the early summer of 1506 he was in Hungary at the head of his army, attempting to assert the Hapsburg claim of succession to the Hungarian crown. He had been unable to suppress the rebellious Magyar nobles, but had finally reached a settlement of sorts with them by July 19, after which he intended to march to Rome for the coronation and revival of the Empire in Italy. He never reached Rome, however, for he found his access to the Italian peninsula blocked by French troops in league with the Venetians. Maximilian, ever short of cash, had to retreat to the Reichstag at Constance (May, 1507) to try to raise money for troops and supplies. The delegates proved unwilling to fund a full-scale invasion of Lombardy and Venice, and voted only enough funds for a token force. So it was 1508 before Maximilian got even so far as Trent where, in the cathedral with the Pope's consent, he settled for the provisional title of "Emperor-elect"—which left him exactly where he had been all along.

Dürer must still have been hopeful of joining the Imperial party bound for Rome when he wrote to his father-in-law on September 8 (Letter VIII), for Hans Frey had been chosen to serve in the Nuremberg contingent for the coronation trip—perhaps because he was known to be the best harp player in town, as well as an ingenious maker of banquet-table fountains. Having informed both Pirckheimer, who was a member of the city's elite Inner Council, and Hans Frey, who was a member of the larger and less powerful Great Council, Dürer would have had an excellent chance of being included.

Rome in 1506 was slightly smaller than Nuremberg, and was, at the moment, filled with piles of rubble. While the destruction of medieval Rome was proceeding splendidly, and Julius II's plan for the renovation of the city, casting the papacy in the role of successors to the ancient Roman emperors (a role which, incidentally, Maximilian rather fancied

for himself) was well into the planning stages, Bramante's new St. Peter's remained a diagram and none of the splendid frescoes of Raphael and Michelangelo had yet been painted. Dürer's attention, if indeed he went to Rome, would perhaps have been directed toward the paintings of Botticelli and Perugino from the late fifteenth century, but most assuredly toward such famous pieces of ancient sculpture as the great bronze equestrian monument of Marcus Aurelius, which had remained on public view all during the Middle Ages wrongly identified as a statue of Constantine, and certainly toward the Laocoön group, newly unearthed in January of 1506 and already being celebrated by poets and scholars.

A more pressing reason to go to Rome, other than to see the coronation and to bring himself to the attention of Maximilian, may have had to do with the untimely death of Dürer's sales agent. In the undated fragment of his *Gedenkbuch* Dürer later wrote, "Also someone died in Rome with the loss of my goods. That is why, when I was in the 13th year of my marriage (i.e., between July 1506 and July 1507) I paid a large debt that I incurred in Venice." Scholars have discovered that there was an outbreak of the plague in Rome in the summer of 1506, in which a number of Germans died, possibly including Dürer's agent. The loss of his stock through theft in such a case could have created serious financial difficulties for Dürer if he had been living beyond his means in Venice in the expectation of receiving profits from Rome. If, however, Dürer's original reason for leaving Nuremberg had been to escape the plague, he would have been unlikely to expose himself to it deliberately by going to Rome at this time.

In the last three of his Venetian letters, Dürer revealed that he was beginning to invest rather heavily in new clothes—a brown French mantle and a Hungarian *husseck*—and had even taken a couple of experimental dancing lessons. In addition to repaying Pirckheimer for the loan, which he intended to do from the proceeds of "the German picture," Dürer had readily agreed to do quite a lot of shopping for Pirckheimer, buying the items out of the funds he had with him and being reimbursed later by his friend. These purchases ran from pearls (forbidden in Nuremberg) and emeralds to junk jewelry (the latter perhaps intended for servants, or for some of Nuremberg's numerous ladies of the evening), from crane feathers—to wear in one's hat—to oriental rugs. Dürer had also been asked to enquire at the publishing houses as to whether any new (classical) texts in Greek had come out, since Pirckheimer was al-

ways desirous of adding to his library and, as a translator, felt a sense of urgency about making the classics available to the German public.

Dürer felt secure enough in his friendship with Pirckheimer not only to ask his friend to admonish his younger brother Hanns when he needed it (Letters V, VI), but also to lie to his wife for him about the projected date of his return (Letter V):

> . . . Tell my mother to speak to Wolgemut about my brother [Hanns] and to ask him whether he can make use of him and give him work till I come, or whether he can place him with someone else. I would gladly have brought him to Venice, and that would have been useful both to me and to him, and he could have learned the language. But my mother was afraid the sky might fall on him or something. Please keep an eye on him yourself— he is lost among the women. Tell the boy, as you so well can, that he should learn, and be honest, and not be a trouble to his mother. . . .

> . . . Tell my mother to be ready to sell [my prints] at the Heiligthumbsfest [about April 24]. I am arranging for my wife to have come home [from the Frankfurt Easter Fair] by then; I have written to her, too, about everything. . . .

> . . . I don't think I will be able to come home until next fall, when what I earned for the picture, which was to have been ready by Whitsunday, will be all used up on living expenses, purchases, and payments; however, what- ever I earn afterwards I hope to save. If you think it best, don't mention this further, and I will keep putting off my leaving from day to day and writing as though I were just coming. . . .

> Letter V: April 2, 1506

Pirckheimer was also a friend he could ask to approach an Augustin- ian friar about special prayers as a safeguard against "the French disease" (or, as the French called it, "the Spanish disease"— i.e., syphilis), "be- cause nearly everybody here has it" (Letter VII).

Dürer's fear of contracting syphilis was very real, in view of the out- break of scabs on his hands which had temporarily prevented him from working (Letter II), but his concern should not be misinterpreted as an admission of sexual promiscuity, for in 1505 the true nature and method of transmission of the disease were not yet known. It was, in fact, Pirck- heimer's friend Ulrich von Hutten who deduced the method of trans- mission in 1519, shortly before he died of syphilis himself. A broadsheet published by Anton Koberger in 1496 with a woodcut illustration of a syphilitic man, often attributed to Dürer (St. 30), alleges that the disease was caused by an unfortunate conjunction of the stars. (Henry VIII of

England, as everyone knows, contracted it when he was breathed upon
by Cardinal Wolsey. We can only speculate as to where Pope Alexander
VI and Charles VIII of France got it.) At any rate, modern medical
opinion holds that, in light of the extreme severity of the first epidemic
in Europe in the late 1490s, it is quite possible that the initial form of
the disease may have been spread by casual contact or by common eating
or drinking utensils, as well as by the more customary method.

Whether or not Dürer's fears of contracting "the French disease" were
groundless, the letters offer ample evidence that his marriage to Agnes
Frey had remained essentially limited to the simple business arrange-
ment envisioned by their two fathers when they were first paired off
together in 1494. We should probably take with a grain of salt the relay-
ing of various greetings back and forth to Dürer from "whores and hon-
est women alike" in Nuremberg (Letter x), as well as at least some of
the talk both about Pirckheimer's numerous girlfriends and the latter's
penchant for handsome Italian soldiers. Pirckheimer's generous offer to
clyster Dürer's wife if he doesn't come home soon, and Dürer's reply to
it ("Don't try it—you'll kill her") are all too explicit indications of the
developing hostility between Pirckheimer and Agnes Dürer which was
eventually to culminate in his famous indictment of her as a virago, writ-
ten to Johann Tschertte a month before his death in 1530.[14] This is sur-
passed in its tastelessness only by Dürer's own enquiries as to whether
any of Pirckheimer's mistresses or children has yet died (see extract of
Letter 11, above); Pirckheimer's wife, Crescentia Rieter, *had* died in
childbirth, together with her infant son, in 1504. (Pirckheimer was plen-
tifully supplied with daughters, but fathered only one other son—an
illegitimate one born in 1525, apparently to an Austrian servant girl.)

Jokes as crude as these are scarcely comprehensible today, but seem to
have been received in the spirit of fun by the two correspondents. Most
of Dürer's other witticisms, however, are as fresh and funny as the day
they were written: Dürer's remark, for instance, about Venetian fiddlers
"who play so beautifully they cry over it themselves" (Letter VIII), or
his advice to Pirckheimer to stick swan-feather pens in his hat as a sub-
stitute for the unobtainable crane feathers the latter had ordered, or his
remark that "when God helps me home, however, I don't know how I'll
be able to stand you with your great wisdom" (Letter IX).

The preserving of letters like these in memory of a friendship tran-
scending the boundaries of social class is a phenomenon not met with
in northern Europe before the end of the fifteenth century. And where

the writing and preserving of letters, even among social equals, is involved, the motivation is nearly always traceable to the influence of Cicero. It will be recalled that Cicero was the author of an important treatise on friendship (*De amicitia*), and was himself a not inconsiderable correspondent, since upwards of nine hundred letters written to or from him have survived. Cicero's letters are studded with wit and irony, as well as with observations on the daily life around him, and were among the most important sources of knowledge of ancient Roman civilization before the recovery of Pompeii and Herculaneum in the eighteenth century. Willibald Pirckheimer, as both classicist and historian, would have been keenly aware of the precedent. It would seem that this firmly worldly, blatantly non-medieval friendship, and the correspondence it generated when friends were apart, was rooted as firmly in the study of the classics as that of another famous pair of Ciceronians, Sir Thomas More and Erasmus of Rotterdam, both of whom were also in correspondence with Pirckheimer.

By late September, as Dürer wrote to Pirckheimer, the "German Picture" was finished:

> ... My picture [the Rose Garland Altar] if you must know, says it would give a ducat for you to see it; it is well painted and beautifully colored. I have earned much praise but little profit by it. In the time it took to paint it I could easily have earned two hundred ducats, and now I have declined much work so that I can come home. And I have stopped the mouths of all the painters who used to say that I was good at engraving but, as to painting, I didn't know how to handle my colors. Now everyone says they have never seen more beautiful colors.
>
> Item: my French mantle greets you, and my Italian overcoat too.
>
> Item: you stink so much of whores that it seems to me I can smell it from here! When you go courting, they tell me here, you pretend to be no more than 25 years old. Ocha! Double that and I'll believe it. God's body! there are so many Italians here who look exactly like you; I don't know how that happens![15]
>
> Item: the Doge [Leonardo Loredano] and the Patriarch [Antonius Surianus] have also seen my picture. Herewith let me commend myself to you as your servant. I must really go to sleep as it is striking the seventh hour of the night, and I have already written to the Prior of the Augustinians; to my father-in-law; to the Dietrich woman, and my wife, and they are all whole sheets full. So I have to hurry over this letter; read it according to the sense. You would doubtless do better if you were writing to a lot of princes. Many good nights, and days too. Given at Venice on Our Lady's Day in September (Sept. 8, 1506).

Item: you need not lend my wife and mother anything; they have got money enough.

<div align="right">Albrecht Dürer [Letter VIII][16]</div>

. . . Your letter telling me of the praise you get to overflowing from princes and nobles gave me great delight. You must have completely reversed yourself to have become so gentle: I'll hardly know you when I come home.

Know also that my painting is finished, and another quadro [painting] as well, the like of which I have never painted before.[17] And since you are so pleased with yourself, let me tell you that there is no better Madonna picture in the land than mine, for all the artists praise it, as the nobles praise you. They say they have never seen a nobler, more charming painting. . . . Also know that I will be ready to leave in 4 weeks at the latest, but I must first make the portraits of some people I have promised.[18] But in order to come home as soon as possible I have, since my picture was finished, refused over 2000 ducats' worth of work. Everybody knows that who lives around me here.

Herewith let me recommend myself to you. I had much more to write but the messenger is ready to start. I hope moreover to be with you myself very soon and to learn new wisdom from you. Bernhard Holzbock has told me great things about you, though I think he does it because you are his brother-in-law. But nothing makes me angrier than when they say you are good-looking, since [if that is true] I must be really ugly. That would drive me crazy. I have found a grey hair on myself; it is the result of so much purifying poverty and worry. I think I must have been born to have a hard time.

My French mantle, my Hungarian *husseck*[19] and my brown coat send you a hearty greeting. But I would be glad to see what your *Herrenstube* knows, that they are so boastful. Given on the Wednesday after St. Matthew's Day [Sept. 23, 1506].

<div align="right">Albrecht Dürer [Letter IX][20]</div>

. . . Knowing that you are aware of my devotion to your service, there is no need for me to write about it to you, but I do urgently need to tell you of the great pleasure it gives me to hear of the great honor and fame which your manly wisdom and learning have brought you, the more to be wondered at, for seldom or never in a young body can the like be found. It comes to you, however, as it does to me, by a special grace of God. How pleased we both are with ourselves, I with my painting and you with your wisdom! When any man glorifies us, we hold up our heads and believe him. Yet perhaps he is only some toady who is making fun of us. Therefore, don't believe it when anybody praises you, for you have no idea how completely disreputable you are!

I can just see you standing before the Margrave and speaking so charmingly—behaving exactly as if you were courting Mistress Rosenthaler, bending as you do. I also noticed that when you wrote your last letter you were quite full of the joy of whoring. You ought to be ashamed of yourself, an old man like you pretending to be so good-looking. Courting pleases you in the same way that a big, shaggy dog plays with a little kitten. If you were only as fine and gentle a man as I am I could understand it. If I become burgomaster I'll have you disgraced and thrown into the Luginsland [jail], as you do to the pious Zamasser[21] and me. I will have you locked up there once with your girlfriends the Rechenmeisterin, the Gartnerin, and the Schutzin and Porstin, and many others who for the sake of brevity I won't mention. They must castrate you. But people ask more after me than you, as you yourself write how whores and honest women both ask after me. It is a sign of my virtue.

. . . However, now that you are thought so much of at home, you won't dare talk to a poor painter in the street any more; it will disgrace you to be seen with a poor poltroon of a painter.

. . . As for your threat that, unless I come home soon you will clyster my wife, don't try it—you'll kill her.

Item: know also that I set to work to learn dancing and went twice to the school. There I had to pay the master a ducat. Nobody could make me go there again. I would have to pay out all that I have earned, and at the end I still wouldn't know how to dance!

. . . Item: in reply to your question when I shall come home, I tell you, so that my lords [of the Nuremberg Senate] may also make their arrangements, that I shall have finished here in ten days. After that I want to ride to Bologna to learn the secrets of the art of perspective, which a man is willing to teach me. I will stay there about eight or ten days and then return to Venice. After that I will come with the next messenger. Oh, how I shall long for the sun! Here I am a gentleman; at home only a parasite.

Item: let me know how Old Lady Kormer is as a bride and that you will not begrudge her to me.

I had much more to write to you, but I will soon be home myself. Given at Venice, I don't know what day of the month but about 14 days after Michaelmas in the year 1506.

<div align="right">Albrecht Dürer [Letter X][22]</div>

By his own admission, Dürer did not leave Italy until after the turn of the new year, 1507—which Germans in his day reckoned from Christmas Day rather than from January 1. On the flyleaf of his copy of the new edition of Euclid edited by Bartolommeo Zamberti (Venice, Johannes Tacuinus, 1505), now in the library at Wolfenbüttel, is the following in-

scription in Dürer's handwriting: "I bought this book at Venice for one ducat in the year 1507—Albrecht Dürer."

If he went to Bologna for eight or ten days after the date of his last letter in mid-October, and if he left the city before November 10—as would have been prudent, since both the French army and that of the Papal States, headed by Pope Julius II himself, were approaching the city from opposite sides—it would leave ample time for Dürer to have made a brief trip to Florence and perhaps to Rome. His productivity as a painter in this period seems not to account fully for the time elapsed. And in any case, he was already beginning to grow nostalgic for Italy, as he has told us himself: "Oh, how I shall long for the sun! Here I am a gentlemen, at home only a parasite" (Schmarotzer).

# X

## THE HELLER AND
## LANDAUER ALTARS

**D**ÜRER had returned to Nuremberg in early February of 1507, as
is proven by letters from several of Pirckheimer's correspon-
dents including Canon Lorenz Beheim (1457–1521), who had
settled in Bamberg in 1504;

[Bamberg, February 21, 1507][1]

> I understand from some that you have been debauching yourselves during
> carnival time with foreign spectacles, such as Italian ballets and countless
> other entertainments that are still going on. I like that! . . . If I had known
> about these bacchanalia I wouldn't have missed them. . . . Give my regards
> to our Bearded One, I mean Albrecht Dürer.

Beheim, who had formerly been chamberlain and master of fortifica-
tion to both the late Pope Alexander VI, Rodrigo Borgia, and his ille-
gitimate son Cesare, certainly knew a good debauch when he saw one.
He never tired of teasing Dürer about his famous beard, which he al-
leged would frighten the artist's pupils, and wrote later to reveal that he
had cast Dürer's horoscope. Since Leo is in the ascendant, he declared,
Dürer is lean. Because the Wheel of Fortune is at the end, he will make
money, and because Mercury is in the house of Venus his painting is
elegant. Since, on the other hand, Venus is in the house of Mercury, he
is a talented lover. Because Mars is in Aries, he is fond of weapons; and
because Mars is in the ninth house, he loves to travel. Because Jupiter is
in the House of Possessions, he will never be poor, but he will have
nothing left over. Since Jupiter declines in the sign of Virgo, he will
have only one wife. Because the Moon inclines toward none of the plan-
ets, Beheim opined, "it is surprising that he has taken a wife at all. What
else can I say? If he were here I would tell him more." On the back of
the sheet he went on to predict, on the basis of Ptolemy's *Centiloquio 49*,
that Dürer was destined to become Pirckheimer's master. If by this he
meant that Dürer had become more assertive since his latest Italian so-

journ, and that both his fame and fortune were on the rise, he was quite correct.

On May 8, presumably after having settled his debt to Pirckheimer, Dürer paid 116 florins to Sebald Pfinzing the Elder to cancel the mortgage on his father's house. Two years later, on June 15, 1509, he was to purchase the large house in the Zisselgasse near the city wall and Imperial castle which, much restored since its near-destruction in World War II, is known as the Dürer House (Plate 21). With its large rooms and third-floor balcony, this mid-fifteenth-century house had, at the time of Dürer's birth, been the home of Regiomontanus (a.k.a. Johannes Müller of Königsberg, 1436–1476), the most important astronomer and mathematician of the late Middle Ages. After his departure for Rome and early death in 1476, it had become the home and laboratory of Regiomontanus's pupil, the wealthy merchant-astronomer Bernhard Walther (1430–1504), whose wife had been godmother to Dürer's sister Christina and whose library, mechanical workshop, printing equipment, and original observatory it still contained, with Pirckheimer as custodian. Dürer purchased the "corner dwelling and court . . . near the Tiergärtnertor, the front facing the rising of the sun," for 275 florins in cash from Walther's estate.

Later in 1509, on August 25, Dürer paid another 78 florins, 1 pound, 4 schillings for a certificate of deposit issued by the City Council, the interest to be paid annually on St. Walpurga's Day for the support of the St. Erhart's Altar in the Church of St. Sebald. (This tax-free donation was the City Council's creative replacement for the older form of small donation made directly to the clergy on an annual basis.)

In the same year, perhaps in recognition of his having become a property-owner as well as in token of his professional standing, Dürer was made a member of Nuremberg's Great Council.

Word of Dürer's success with the altarpiece for the German church in Venice had speedily gotten around, prompting a number of important clients to order paintings. The voluptuous, life-size nude *Adam* and *Eve* panels (Madrid, Prado), which he painted early in 1507, would soon set the stage for similar works by Lucas Cranach the Elder and Hans Baldung, and were acquired by no less a person than the Bishop of Breslau, Johann V Thurzo, a distant relation of the Fugger family. Friedrich the Wise of Saxony was quick to request a new painting for his relic chamber, *The Martrydom of the Ten Thousand Christians* (now in Vienna), a complicated and retardataire work based on Dürer's earlier woodcut

of the same subject but featuring at its center the full-length likenesses
of the recently deceased Poet Laureate Konrad Celtis and of Dürer
himself.

Still more importantly, however, an opportunity presented itself for
Dürer to paint a large altarpiece for placement in the Dominican church
in Frankfurt am Main—a location which Dürer considered strategic in-
deed. His client was the wealthy Frankfurt cloth merchant, Jacob Heller
(ca. 1460–1522), owner of the "Nürnberger Hof"—the inn to which Nu-
remberg's own elite businessmen repaired when they came to attend the
Frankfurt fairs. Heller, a former alderman and mayor of Frankfurt, was
already well-known both for his piety and his patronage of the arts. Due
to Heller's sound business instincts, nine invaluable letters from Al-
brecht Dürer have been preserved which reveal a great deal about both
his post-Italian painting methods and his newly enlarged sense of his
own worth.

The original letters have been lost, but are known from two old cop-
ies, one set of which was made in the seventeenth century for the Arch-
duke Maximilian of Bavaria, who had acquired the Heller Altar, com-
missioning the Jobst Harrich copy to replace it, and wanted to have the
related correspondence as well:[2]

[August 28, 1507]

I am at your service, dear Herr Heller! I was happy to receive your kind
letter. But please know that I have been suffering from the fever for a long
time, which has delayed my work for Duke Friedrich of Saxony [*The Mar-
tyrdom of the Ten Thousand*] by several weeks, and has caused me great loss.
But now I mean to finish my work for him quickly, for it is more than half
done. So be patient with me about your picture, which, when I have com-
pleted the work for the above mentioned Prince, I will immediately set to
work on and paint diligently as I promised you [when you were] here. And
although I have not yet begun your painting, I have bought the panel from
the joiner and paid for it with the money you gave me. He would not lower
the price for it, though I thought he didn't deserve so much. And I have
given it to a preparer, who has gessoed it and will put on the gilding next
week. I don't want to take any money in advance on it until I begin to paint
it, which, God willing, shall be the next thing after the Prince's work. For I
don't like to begin too many things at once, so that I won't tire myself out.
So then the Prince won't be kept waiting either, as he would be if I were to
paint your picture and his at the same time, as I had first planned to do. But
have confidence in me, for, as much as God permits, I will still make some-

thing that not many men can make. Now many good nights to you. Given at Nuremberg on St. Augustine's Day, 1507.

Albrecht Dürer

Seven months later, on March 19, 1508, Albrecht Dürer wrote again to Heller, alleging that in two more weeks he would have finished Duke Friedrich's picture, and would not undertake anything else until he had finished Heller's altar, promising in particular to paint the middle panel of it himself. He reported that the wing panels were already sketched in—presumably by his youngest brother Hanns III, who later received a tip from Heller—and that they could be painted in "stone color" (i.e., grisaille) if that would be satisfactory. He reported that the underpainting for the middle panel had also been done. Then he went on to say that, although he had spent an entire year on Friedrich the Wise's painting, he was only being paid 280 Rhenish gulden for it—all of which had already been spent—and was therefore inclined never to set a price in advance again, "for I neglect better chances that way." He was, however, prepared to make an exception for Heller on the basis of their previous arrangement.

On August 24, 1508—five months later—he wrote again:

[Nuremberg, August 24, 1508]

Dear Herr Heller,

I have safely received your last letter, and I gather from it that you wish me to execute your panel well, which is just what I myself have in mind to do. In addition, you shall know how far it has progressed; the wings have been painted in stone colors on the outside, but they are not yet varnished; inside they are completely underpainted, so that one can begin to carry them out.

The middle panel I have outlined with the greatest care and at the cost of much time; it is also coated with very good colors upon which I can begin to underpaint it. For I intend, as soon as I hear that you approve, to underpaint it some four, five, or six times over, for the sake of clearness and durability, and to use the very best ultramarine for the painting that I can get. And no one shall paint a stroke on it except myself, wherefore I shall spend much time on it. I therefore assume that you will not mind, and have decided to write you my proposed plan of work, [but I must add] that I cannot without loss carry out said work [in such elaborate fashion] for the fee of 130 Rhenish florins; for I must spend much money and lose time over it. However, what I have promised you I will honorably perform; if you don't want the picture to cost more than the price agreed, I will paint it in such a way that it will still be worth much more than you paid for it. If, however,

you will give me two hundred florins I will follow out my plan of work. Though if hereafter somebody were to offer me 400 florins I would not paint another, for I shall not make a penny on it, as a long time is spent on it. So let me know your intention, and when I have heard it I will go to the Imhoffs for 50 florins, for I have as yet received no money on the work.

Now I commend myself to you. I want you also to know that in all my days I have never begun any work that pleased me better than this picture of yours which I am painting. Till I finish it I will not do any other work; I am only sorry that the winter will so soon come upon us. The days grow so short that one cannot do much.

I have still one thing to ask you: it is about the Madonna that you saw at my house; if you know of anyone near you who wants a picture, pray offer it to him. If a proper frame was put to it, it would be a beautiful picture, and you know that it is nicely done. I will let you have it cheap. If I had to paint it for someone [on commission] I would not take less than fifty florins. But as it is already done it might be damaged in the house. So I would give you full power to sell it for me cheap for thirty florins; indeed, rather than that it should not be sold, I would even let it go for twenty-five florins. I have certainly lost much food over it.

Many good nights. Given at Nuremberg on Bartholomew's Day, 1508.

Albrecht Dürer

Heller evidently misunderstood Dürer's proposal as a simple breach of contract, and complained angrily about it to one of Dürer's in-laws—perhaps Hans Frey, or Martin Zinner, who was married to Agnes's sister—also sending a sharply worded letter to the artist himself. Dürer replied heatedly in a letter dated November 4 that the picture would be worth at least 300 florins, and that he would not paint another one like it for three times the price:

... For I neglect myself for it, suffer loss, and earn anything but thanks from you.

I am using, let me tell you, quite the finest colors I can get. I will need twenty ducats for the ultramarine alone, not counting the other expenses. Once the picture is finished, I am quite sure that you yourself will say that you have never seen anything more beautiful. And I dare not expect to finish the middle panel from beginning to end in less than thirteen months. I shall not begin any other work till it is finished, though it will be much to my hurt. Then what do you suppose my expenses will be when I am working at it? You would not take less than 200 florins to keep me for that time. Think what you have repeatedly written about the materials! If you wanted to buy a pound of ultramarine you could hardly get it for 100 florins, for I cannot buy an ounce of it good for less than ten or twelve ducats.

And so, dear Mr. Jacob Heller, my writing is not so utterly unreasonable as you think, and I have not broken my promise in this matter.

You further reproach me with having promised you that I would paint your picture with the greatest possible care that I ever could. That I certainly never said unless I was out of my mind. For in my whole lifetime I could hardly finish it. For with the greatest care I can hardly finish a face in half a year. Now your picture contains fully one hundred faces, not counting the drapery and landscape and other things in it. Besides, who ever heard of making such a work for an altarpiece? No one could see it. But I believe that what I wrote to you was: to make the painting with great or more than ordinary pains because of the time you spent waiting for me.

Besides, knowing you, as I do, I feel sure that if I had promised you to do something which you yourself saw to be to my loss, you would not want it done. But nevertheless, do as you wish, I will still hold to what I promised you. For as far as I ever can I will be honest with every man. However, if I had not made you a promise, I know what I would do. And therefore I had to answer you, so that you might not think I hadn't read your letter. But I hope that, once the picture is finished and you have seen it, everything will be better. So be patient, for the days are short, and this thing, as you know, cannot be hurried. Since there is much work in it and I will not make it less, I place my hope in the promise you made my in-law at Frankfurt.

Item: you need not look around for a buyer for my Madonna, for the Bishop of Breslau has given me 72 florins for it. So I have sold it well. I commend myself to you. Given at Nuremberg in the year 1508 on the Sunday after All Saints' Day.

Albrecht Dürer

By March 21, 1509, Dürer, who reported that he had been painting steadily on the picture since Easter and could hardly expect to have it finished before Whitsuntide, declared that he wouldn't make another painting like it for less than 400 florins, taking into account both his time and his living expenses:

> . . . But I won't let such a thing put an end to our agreement, for your honor and mine, as it will be seen by many artists who perhaps will tell you whether it is masterly or bad. So have patience for a short while, for the lower part of the painting is finished and only needs to be varnished. And in the upper part there are still some cherubs to be painted. And it is my great hope that you will be pleased with it. I believe, though, it may not please some art critics who would take it for a peasant picture [i.e., a picture for a village church]. But I don't try to please such people. I only paint for the intelligent. And so, if Martin Hess praises it to you it may make you feel better about it. You might also ask some of your friends who have seen it.

They will tell you how it is done. And if you do not like the picture when you see it, I will keep it for myself, for someone has begged me to sell it and to make you another. But far be it from me! I will right honorably hold with you to what I have promised. I also take you for an honorable man, and I have hope in your letter and feel sure that the great pains I am taking will please you. And so I am ready to serve you whenever I can. Nuremberg 1509 on Wednesday after Laetare.

<div align="right">Albrecht Dürer</div>

On July 10, Dürer wrote again to Jacob Heller. It had come to his ears that Heller had complained to Hans Imhoff about the lengthy wait for delivery of his picture, saying that if he had it to do all over again he would never have ordered it in the first place, and that Dürer was welcome to keep it. Dürer, who had still been working daily on the altarpiece, and had accepted no other work in the meanwhile, replied tartly that he would be glad to keep it, because he knew where he could sell it for 100 florins above Heller's price. He reported that he had tried to return Heller's deposit to Hans Imhoff, but that the latter would not take it without authorization from Frankfurt.

Dürer wrote again four days later when he had received a personal letter from Heller, saying that at Hans Imhoff's persuasion and "because I would prefer it to find a place at Frankfurt rather than anywhere else, I have consented to send it to you for 100 florins less than it might well have brought me." Realizing now that Heller had originally wanted something "for about 130 florins," Dürer stated that he wished he had painted a picture of that value, for he would have been able to finish it in six months. He offered to send the painting at once, on approval, at the price of 200 florins, giving Heller the prerogative of selling it for Dürer on the Frankfurt market if he still felt the work to be overpriced.

A month later, on August 26, Dürer wrote to report that he had handed the altarpiece over to Hans Imhoff for delivery to Frankfurt, and had received another payment of 100 florins:

> . . . I have painted it with great care, as you will see, using none but the best colors I could get. It is painted with good ultramarine under and over, about 5 or 6 times. And then after it was finished I overpainted it twice more so that it may last a long time. I know that if you keep it clean it will remain bright and fresh 500 years. For it is not made as one usually paints. So have it kept clean and don't let it be touched or sprinkled with holy water. I feel sure it will not be criticized, unless for the purpose of annoying me. And I am sure it will please you well.

No one could ever pay me to paint a picture again with so much labor. Herr Georg Tausy himself wanted me to paint him a Madonna in a landscape with the same care and in the same size as this picture, and he would have given me 400 florins for it. I flatly refused to do it, for it would have made a beggar out of me. Of ordinary pictures, I will in a year paint a pile which no one would believe it possible for one man to do in the time. With such things one can earn something. But very careful nicety does not pay. Therefore I shall stick to my engraving, and if I had done so before I should today have been a richer man by 1000 florins.

I may tell you also that, at my own expense I have had a new frame made for the middle panel which has cost me more than 6 florins. I have broken the old one off, for the joiner had made it roughly. But I have not had the other fastened on, for you wanted it not to be. And it would be good if you had the rims screwed on so that the picture doesn't split.

And place the painting so that it hangs forward two or three finger-breadths, so that it can be seen without glare. And when I come to you in a year or two, or three, if the picture is properly dry, it must be taken down, and I will varnish it again with some excellent varnish that no one else can make, so it will then last 100 years longer than it would before. But don't let anyone else varnish it, for all other varnishes are yellow, and the picture would be ruined for you. And if a thing on which I have spent more than a year's work were ruined, it would be grief to me. When you have it set up, be present yourself to see that it is not damaged. Deal carefully with it, for you will hear from your own and from foreign painters how it is done.

Give my greeting to your painter Martin Hess. My wife asks you for a *Trinkgeld*, but that is as you please, I screw you no higher, etc. And now I commend myself to you. Read by the sense, for I write in haste. Given at Nuremberg on Sunday after Bartholomew's, 1509.

                                                            Albrecht Dürer

On October 12, 1509, Dürer wrote a final letter to Jacob Heller:

. . . I am glad to hear that my picture pleases you, so that my labor has not been invested in vain. I am also happy that you are content with the payment—and rightly so, for I could have gotten 100 more florins for it than you have given me. But I wouldn't take it, for I would then have had to let you down. For I hope thereby to retain your friendship over there [in the Frankfurt area]. My wife thanks you very much. She will wear your gift in your honor. Also my younger brother thanks you for the two florins you sent him for a *Trinkgeld*. Herewith I thank you myself for all the honor, etc.

As you have asked me how the picture should be framed, I enclose a little

drawing of what I would do if it were mine. But you must do whatever you like. Now, many happy times to you. Given on Friday before St. Gall's 1509.

<div align="right">Albrecht Dürer</div>

Although he had failed to win from Jacob Heller the 300 to 400 guilders he felt the work was worth, he had scored an important point in removing from his client the prerogative of paying the artist whatever Heller thought would be a just price. Dürer had learned more in Italy than the secrets of perspective.

JACOB HELLER, in accordance with the terms of his last will and testament, was buried in the St. Thomas Chapel of the Dominican church, beneath Dürer's brilliant painting of the Assumption and Coronation of the Virgin. In its dual depiction of the Virgin's empty tomb surrounded by the Apostles, and her final coronation by the Trinity in a heavenly vision, it was the very paradigm of an epitaph, and the most dramatic of illustrations of St. Thomas Aquinas's views, expressed in the *De anima*, on the immortality of the soul and its corollary demand that the body be resurrected and reunited with it.

Although the theme of the Virgin's Assumption and Coronation arose from the dual nature of the most important feast day of the church year devoted to the Virgin Mary, and had been treated by such earlier German artists as the Nuremberg Master of the Imhoff Altar (ca. 1450), the Cologne Master of the Holy Kinship (1480), Veit Stoss in the Crakow Altar (1477–1489), and more recently in Italy by the twenty-year-old Raphael (1503), no previous altarpiece can have compared with Dürer's, to judge from the high quality of his chiaroscuro preparatory drawings—including the famous *Praying Hands* (Vienna, Albertina)—as well as from the copy in near-original size made by Jobst Harrich in 1614, now in Frankfurt am Main. Dürer's original, despite the artist's 500-year guarantee on the workmanship, was destroyed by fire in 1729 in the Munich Residenz.

While Harrich's copy seems to correspond reasonably well to the surviving drawings, and to subsequent works influenced by Dürer's Heller Altar, such as Hans Baldung's high altar for the Freiburg Minster, a better idea of Dürer's color and painting technique is given by his slightly later altarpiece painted for Matthäus Landauer, *The Adoration of the Trinity* (Vienna, Kunsthistorisches Museum). It is possible, indeed, that Landauer may have been the client who had begged to buy the Heller Altar. A representation of the Augustinian Company of the Blessed, the Landauer Altar was painted for the All Saints' Chapel of Landauer's retirement home for

twelve old men (twelve, because there were twelve Apostles). Landauer himself, aged and frail, is seen prematurely elevated to the heavens at left, while a minuscule Albrecht Dürer stands alone in the landscape below, grandly arrayed in a full-length, fur-lined cloak and pointing with justifiable pride to a huge tablet bearing the inscription "ALBERTVS. DVRER. NORICVS. FACIEBAT. ANNO. A. VIRGINIS. PARTV. 1511." The original frame, built to Dürer's own specifications from the drawing done in 1508, now in the Musée Condé at Chantilly, is in the Nuremberg Museum. Unlike the nearly contemporary forest of pinnacles carved by Tilmann Riemenschneider for the Herrgottskirche altar now in Creglingen (ca. 1505–1510), Dürer's is a pure and simple Renaissance frame with a semicircular lunette resting on two classical columns.

Dürer's post-Italian graphic works, like his paintings, show a compositional grandeur and heightened lighting scheme, as well as a predilection for visionary subject matter. The largest and most complicated of his woodcuts, *The Trinity*, of 1511 (B.114), a "Throne of Grace" surrounded by angels, is an abbreviated version of the Landauer Altar, destined to serve as inspiration for altarpieces by such later artists as Tintoretto and El Greco. His additions to the Life of Mary series included both a *Death of Mary* (B.93) and an *Assumption and Coronation of the Virgin* (B.94) which show a new sophistication in the handling of chiaroscuro as well as compositional reflections of the lost Heller Altar.

For the Large Passion he designed a luminous *Last Supper* (B.5), as well as a visionary *Resurrection* (B.15) which, like the Grünewald it later inspired, depicts the moment of Christ's rising from the tomb as the fulfillment of the mystery of the Transfiguration (Matt. 17: 1–17), when "His face did shine as the sun," and "a bright cloud overshadowed them," after which the Apostles were charged to "tell the vision to no man, until the Son of Man be risen again from the dead."[3] For his three large woodcut books, the Apocalypse, Large Passion, and Life of Mary (dedicated to Caritas Pirckheimer), he designed new title pages, each a vision enclosed in a cloud of light, and re-issued them as bound volumes with Latin texts (there was no German edition this time). New verses for the title pages of these books, as well as for the new Small Woodcut Passion (1508–1511), were composed in Latin by Pirckheimer's friend Benedictus Chelidonius (real name Schwalbe), a Benedictine theologian from the nearby monastery church of St. Egidius. All were published for Dürer by Hieronymus Höltzel, a printer from Traunstein who had settled in Nuremberg in 1500 and was currently employed by the City Council to duplicate the minutes of meet-

ings and other official documents—services formerly performed by Anton Koberger.

The Small Woodcut Passion, Dürer's most extensive series (thirty-seven woodcuts), contains a great many night scenes illumined by candlelight, as well as a spectacular sunrise—the *Noli me tangere*, in which Christ appears to Mary Magdalene in the guise of a gardener—and a brillant *Supper at Emmaus* lighted by Christ's own halo, suggesting the Saviour's eventual disappearance into a cloud of light, to the amazement of His companions.

In the Small Passion, as in Durer's new, fifteen-plate Engraved Passion (1507–1512), dramatic contrasts between light and dark reduced the need for the intricate landscape detail and turbulent drapery which had been the hallmarks of his earlier work. Friedrich the Wise's personal copy of the Engraved Passion (Princeton University Library) shows that this series, which was issued entirely without text, could effectively be bound together with handwritten prayers of the owner's choosing, to form a personalized devotional volume.[4]

Due perhaps to the death of Celtis, or to the failure of the School for Poets, Dürer's prints after the second Italian trip included no mythological or allegorical subjects but were almost exclusively religious in nature. All were protected by the special copyright awarded to Dürer by the Emperor Maximilian in 1511.

# XI

## THE MASTER AND HIS
## JOURNEYMEN

DÜRER'S astonishing technique and his powers of invention had already attracted hordes of would-be imitators on both sides of the Alps well before the end of the fifteenth century. The earliest written record of his having accepted a student, however, dates from 1502. The household expense accounts of Friedrich the Wise of Saxony show that on the Saturday of Passion Week in the spring of 1502, two florins were spent to send a young apprentice painter named Friedrich to Nuremberg. A generous clothing allowance of five florins was paid on the boy's behalf by the Elector's agent in Nuremberg, and a total of fifty-two florins were paid to Albrecht Dürer for his instruction over the course of the next two years. The boy's name—Friedrich—and further generous payments for clothing and spending money, as well as the notation that he was apprenticed to Dürer "by order of His Grace" have suggested to scholars the possibility that he may have been an illegitimate son of Friedrich the Wise. Little more is known of this "scholarship" student: the fact that two of his purchases included a print of St. Sebastian, protector against epidemic disease, and a map of Italy (*ein welsche karten* [*sic*]), and that the substantial sum of twenty florins was paid directly to him by the Elector's agent shortly afterward suggests that he may have set out for Italy, in order to follow Dürer's earlier example.

Meanwhile, it was the master and not the student who had been doing studies from nature: the famous *Wild Hare* of 1502 and *Great Piece of Turf* (1503, both Vienna, Albertina) date from this period. Soon afterward, Dürer himself returned to Italy.

Dürer's letters from Venice reveal that by 1505 his youngest brother, Hanns III, was already a member of the workshop, and his letter to Jacob Heller (October 12, 1509) conveying his brother's thanks for Heller's two-florin tip is an indication that Hanns had assisted with the preparation of the Heller Altar. Since Dürer insisted that no one but himself had painted a stroke on the important central panel, Hanns, who was

nineteen by then, may have been responsible for the grisaille paintings "in stone color" which formed the altar's original wings. Hanns, who had been injured in a fight in early June of 1510, seems to have been sent to Italy in 1511, to judge from a letter addressed to Pirckheimer by Galeazzo de Sanseverino's agent, dated May 26.

By 1503, however, Dürer had three young journeymen, all of whom were also named Hans—one of whom may perhaps have been the subject of Dürer's portrait drawing in Williamstown, a "speaking" likeness.

The first to arrive, Hans Süss from Kulmbach, near Bayreuth (ca. 1480–1522) may have come as early as 1500, and is known to have been involved in the production of the woodcut illustrations for Konrad Celtis's edition of the comedies of Roswitha von Gandersheim, as well as those for the latter's *Quattuor libri amorum*, celebrating the beauties of Germany and Celtis's own love affairs.[1] Hans Süss was joined in 1503 by Hans Schäufelein and Hans Baldung, and all three worked on the illustrations for Ulrich Pinder's *Die beschlossen Gart des Rosenkranz Mariae* (The Closed Garden of Mary's Rosary). By 1511, Hans Süss, who was both a gifted painter and stained glass designer, had obtained Nuremberg citizenship and opened his own workshop. Schäufelein, who had painted the Ober St. Veit Altar from Dürer's design while his master was in Italy, left in 1510 for Augsburg.

Baldung, whom Dürer referred to as "Grienhans" in order to distinguish him from the other three Hanses in the shop, was the most talented of them all. He seems to have come to Nuremberg after receiving his preliminary training elsewhere—probably in Swabia, as Tilmann Falk has suggested. He is thought to have supervised the workshop while Dürer was away in Italy, and he left shortly after Dürer's return, traveling to Halle in 1507 and finally settling in Strassburg, where he took out citizenship in 1509.[2]

Dürer not only taught these young men, and assigned them portions of the workshop projects, but helped them to begin earning independently—Schäufelein, for example, was permitted to sign certain works as his own as early as 1504. Michail Liebmann has noted that the master and his journeymen divided the tasks more or less evenly during these years, with Dürer taking the responsibility for quality control and for the meeting of deadlines.[3] In the case of the book illustrations, none of the woodblocks was signed when an outside publisher was used, whereas, when Dürer acted as his own publisher, he initialed all of the cuts, whether or not he had designed them himself.

In the case of the so-called Ober St. Veit Altar, painted for Friedrich the Wise by Schäufelein using Dürer's drawings, the finished product was not a "Schäufelein" but a product of "The Dürer Workshop." Hans Süss's epitaph for Lorenz Tucher, the Provost of St. Sebald's (1513), was based on a Dürer drawing made in 1511, but qualifies as a Hans Süss von Kulmbach since it was made three years after the artist became an independent master.

Dürer broke with tradition in permitting his journeymen to accept independent commissions as time allowed, even while they were still indentured to him. Baldung, Schäufelein, and Hans Süss von Kulmbach each designed coats of arms, small glass paintings, and other works which they were allowed to sign themselves.

Tradition was broken, as well, when Dürer's students were permitted to develop their own styles, rather than simply being set to copy the work of the master. Hans von Kulmbach, who at one point was much taken with Dürer's Paumgartner Altar and his *Adoration of the Magi* for Friedrich the Wise, nevertheless went on to develop a style which incorporates elements of Albrecht Altdorfer and Hans Burgkmair as well. And Hans Baldung, who had adopted Dürer's practice of making self-portraits and who retained memories of Dürer's tiny engraving of *A Witch Riding Backwards on a Goat* (B.67, ca. 1500), as well as the splendid nudes from the *Fall of Man* (B.1) and the erotic implications of the *Coat of Arms with a Skull* (B.101), went on to enlarge upon themes of witchcraft, sex, and death in the spirit of the *Malleus maleficarum*—the Dominican manual for the inquisition of witches—carrying these matters to a feverish pitch never envisioned by Dürer himself. (The Nuremberg City Council, which was anti-Dominican, refused to take notice of the new mania for witch-hunting stirred up in Cologne and elsewhere.)

By 1512 or earlier, Dürer had already determined to write a manual for young artists, to share his own hard-won knowledge of Euclidian geometry, perspective, the human figure, and color, as well as the information on morals, hygiene, and other personal matters which were to influence subsequent authors of painters' manuals such as Carel van Mander. The projected book was to have been called *Speiss für Malerknaben* (Food for Young Painters). It was never finished—it had turned into an encyclopedia by the time of the artist's death—but a preliminary draft for the introduction to the book, dated 1512, survives in the British Museum.[4] Noting that nobody has ever been harmed by an oversupply of knowledge, Dürer stated in it that, while individual abilities may differ,

"no reasonable man is so crude that he cannot learn what he is by temperament best suited for. Therefore no one is excused from learning something." He also recorded his belief that it is necessary for the common good "that we learn and then pass it on to posterity without keeping it a secret"—quite the opposite of the tradition of the German *Bauhütte*. He went on to claim that sight is the noblest of the senses (unlike Martin Luther, who insisted that hearing was the superior sense), and cited painting for its usefulness in the service of the Church, in "fix(ing) the image of those who have died," and in recording "the extent of earth, of water, and of the stars." He firmly stated his belief that, since the ability to achieve true art is derived from divine inspiration, "those who are not suited to it should not attempt it." He pointedly referred to the great esteem in which the art of painting was held "by mighty kings many centuries ago," and alleged that the art of painting cannot be properly judged by anyone who is not himself a good painter, since the ability to do this "is denied to others, like a foreign language."

Finally, Dürer lamented the loss of the books on art written by the ancients, "Phidias, Praxiteles, Abelles, Polteclus, Parchasias, Lisipus, Protogines, and others," whose works were lost forever due to war, expulsion of peoples, or changes of laws and religion, when art was crudely suppressed by those who thought it the work of the devil, for "this is to be regretted by every man of learning." Noting that he knew of no modern work in print dealing with the subject of art in a responsible way, though "some have written of such things who do not understand them," he pledged to write clearly and succinctly "in order to please the talented youths who prize art more than silver and gold."

An outline for the projected work shows that Dürer had intended to point out the importance of a favorable astrological birth sign for the would-be painter, as well as the appropriate physique and posture. He advocated "that he be kept from women . . . and that he guard himself from all impurity, (for) nothing weakens the understanding more than impurity." The young painter should be brought up in comfortable and pleasant surroundings, and taught "how to read and write well, and be also instructed in Latin so far as to understand certain writings." He should be brought up in the fear of God, and taught to pray to God for "the grace of quick perception."

One entire section of the book was to have been devoted to the usefulness of painting: in addition to the practice of painting as an antidote to idleness—a commonplace from medieval manuals—and its uses for

holy edification, Dürer interjected the Renaissance sentiment that "it is useful because a man gains great and lasting memory by it if he applies it rightly," and "it is useful because God is thereby honored when it is seen that He has bestowed such genius upon one of His creatures in whom is such art." Lastly, he pointed out, "that if you are poor you may by such art come into great wealth and riches."[5]

Dürer enjoyed excellent rapport with the young men who were his first journeymen, and they remained his friends throughout their lives. At times, even after they had "graduated" from his workshop he loaned them his own drawings. He took Hans Baldung's prints to market in the Netherlands in 1520 along with his own, and when he died in 1528 a lock of his hair was sent to Baldung as a memento.

Wolf Traut (1480–1520), the son of the painter Hans Traut of Speyer, had apparently joined the workshop in 1505, since his hand has been discerned among the illustrations for the *Beschlossen Gart*, as well as in the legend of *St. Heinrich and Kunigunde* (1509). He was also responsible for designing parts of the Small Passion. His not inconsiderable talent as a painter can be seen in the Bavarian National Museum's Artelshofen Altar (1514), originally made for the Nuremberg chapel of St. Anne (now destroyed), and in his altar for the Church of St. John in Nuremberg, based on one of Dürer's engravings.

Hans Leu (ca. 1490–1531), the son of a well-known painter from Zürich, had been trained in the Schongauer tradition by his father before coming to Nuremberg. He, too, may have arrived shortly before Dürer's departure for Italy, since he seems to have been influenced almost more by Hans Baldung than by Dürer himself. By 1513 he had returned to Zürich to take over his father's workshop, but he seems to have remained in contact with Dürer, since in the spring of 1519 Dürer saw him again when he visited Zürich in company with Pirckheimer. Leu became a follower of the radical Swiss reformer, Ulrich Zwingli—who later sent greetings to Dürer—and was killed with him in the Battle of Kappel in 1531.

Dürer's new journeymen had come to Nuremberg at a critical time. Wolf Traut and Hans Springinklee, a Nuremberg youth who specialized in miniature painting and woodcut design, were both employed by Dürer in the course of his work for the Emperor Maximilian, which began during or after the Emperor's two-week visit to Nuremberg in February of 1512.

Early in that year, Dürer had been commissioned by the City Council

to paint two idealized portraits of Charlemagne, the first Holy Roman Emperor, and Sigismund, the Emperor who had transferred the Imperial regalia to Nuremberg. The paintings, somewhat larger than life size, were to be hinged to the wall in the Treasure Chamber—the room in a house facing the Market Square where the coronation regalia and relic collection were annually taken for public display (they were kept in locked storage in the chapel at the Hospital of the Holy Spirit during the remainder of the year). Dürer did careful "reconstructions" of the two emperors, each shown with items from the treasure which were believed to have belonged to him. He used a genuine portrait of Sigismund, but for Charlemagne, for whom no reliable portraits were extant, he invented an appropriately Godlike, white-bearded monarch (Charlemagne, it will be recalled, had been canonized in the early Middle Ages and was still regarded as a saint). For his efforts, Dürer was paid the sum of eighty-five florins by the City Council on February 16, 1513, and another sixty florins on June 19.

A letter from Lazarus Spengler, the Municipal Secretary, dated November 30, 1513 describes Maximilian's admiration for the painting of Charlemagne, and records his Imperial wish that "Thürer" should receive "something else" with the help of Kaspar Nützel (one of the most influential members of the City Council, who had frequently represented the city on diplomatic missions).

Dürer did, indeed, receive something else, in the form of a number of commissions from Maximilian himself (Plate 22)—though the impecunious Emperor was never to pay him for his work. Maximilian, as has often been noted, was the first Holy Roman Emperor to understand the power of the press: although he built virtually nothing, with the exception of the occasional hunting lodge, and had little understanding of painting, he was acutely aware of the need to publicize himself and his dynasty, for—as he himself said, "if a man in his lifetime does not provide for his own memory, he will not be remembered after his death, but forgotten with his funeral bell. Thus the money which I spend for the perpetuation of my memory is not lost. On the contrary, to spare such money would be to stifle my future memory." To that end, Maximilian had dictated his autobiography (in Latin) to Willibald Pirckheimer, while the two of them were sailing across Lake Constance during the Swiss War. He had also embarked upon a grandiose sculptural program for his own tomb, featuring an over-life-size procession of bronze ancestors, both real and spurious, and he planned a series of

publications even more ambitious than Dürer's own—a projected list of thirty-three books, seven of which were actually produced. In addition, he required several portraits, an illustrated Book of Hours suitable for mass production, plus a colossal triumphal arch and triumphal procession executed all in woodcut. Albrecht Dürer was chosen to be his art director for these latter undertakings.

The Triumphal Arch, which was finally completed in 1515, was a co-operative enterprise combining the efforts of the court historian and astronomer Johann Stabius, Albrecht Dürer, Wolf Traut, and Hans Springinklee, plus Peter Flötner, Albrecht Altdörfer, and the court painter, Jörg Kölderer. Its 174 blocks, cut by the Nuremberg *Formschneider* Hieronymus Andreae, formed a monumental archway approximately ten square meters in area. (One hundred seventy-one of the original blocks survive and are in the Vienna Albertina.) This curious structure, which was designed in honor of the triumphal arches erected by the Roman emperors but oddly resembles a Nüremberg stove, was ornamented with an elaborate iconographic program celebrating Maximilian's own life and deeds and those of his Hapsburg ancestors. It was printed in an edition of seven hundred copies, in order to be dispatched to all corners of the Empire, where "instant," paper-thin honorific ceremonies could then be staged using the Triumphal Procession—fifty-seven yards of woodcuts, headed by Dürer's Triumphal Chariot (eight separate sheets) bearing the image of Maximilian wearing the Crown of Charlemagne and attended by Victory and the Cardinal Virtues. Dürer also designed a cavalcade of horsemen and a caisson bearing trophies for the procession.[6]

Only the block-cutter, Hieronymus Andreae, was actually paid for this noble undertaking—if somewhat belatedly—in 1526. Albrecht Dürer was forced to complain in a letter to Christoph Kress (July 1515), Nuremberg's Ambassador to the Imperial Court, asking him to "point out to His Imperial Majesty that I have served him for three years at my own expense. . . . I therefore beg His Imperial Majesty to reward me with one hundred guilders," noting that without his supervision the finely detailed work on the Triumph would not have been done properly, and that he had supplied many other designs for Maximilian as well. Implied, but not enumerated, were Dürer's two painted portraits of the Emperor, his designs for a suit of parade armour, and his fifty-six marginal drawings in the Emperor's personal copy of the prayer book printed in Augsburg with custom-made type ("Prayerbook Fraktur"),

which had evidently been intended to serve as modelli for woodcut il-
lustrations. Hans Baldung had also contributed illustrations to the
prayer book, as had Lucas Cranach, Albrecht Altdorfer, Hans
Burgkmair, and Jörg Breu. (Dürer had also illustrated the Emperor's
presentation copy of the *Hieroglyphica* of Horus Apollo, newly trans-
lated by Pirckheimer from Greek into Latin, but presumably had been
rewarded by Pirckheimer for that.) In addition, Dürer had provided the
design for Hans Leinberger's over-life-size bronze statue of Albrecht
von Hapsburg—a knightly figure in elaborate armor—for Maximilian's
neo-Burgundian tomb at Innsbruck.

In his reply from Innsbruck dated September 6, 1515, Maximilian
praised Dürer for his "art, skill, and intelligence," as well as for his loy-
alty, and directed the City Council of Nuremberg that "for the duration
of his life, but not longer, he shall be given, shall be paid, and shall re-
ceive annually and every year, against his receipt, one hundred guilders
Rhenish out of the customary city tax which the . . . Burgomaster and
Council of the City of Nuremberg are obliged to remit and pay annually
and each year to our Treasury." These were fair words, but in point of
fact, the annuity was rarely paid by the City Council, which threatened
to invalidate the arrangement altogether when Maximilian died in Jan-
uary of 1519.

Fortunately, however, Albrecht Dürer had not been entirely depen-
dent upon the Emperor's largesse. During the period 1512–1515, while his
projects for Maximilian were underway, he had a continuing source of
income from the sales of the new editions of his woodcut series, The
Apocalypse, The Large Passion, The Life of Mary, and the Small Pas-
sion, all four of which were published in book form in 1511, as well as
from the proceeds of the Landauer Altar of 1511, and the *Engraved Pas-
sion*, completed in 1512. In addition, he had designed the *St. Jerome in a
Cave* woodcut (B.113, 1512) to serve as the title page for the German
translation of Eusebius's life of St. Jerome prepared by his friend and
neighbor, the Municipal Secretary Lazarus Spengler, and had done a
title border for Willibald Pirckheimer (K.270, ca. 1513). The workshop
also undertook several private commissions for Johann Stabius, includ-
ing celestial maps of the northern and southern heavens and a terrestrial
map of the eastern hemisphere, inspired by Martin Behaim's famous
globe of 1492, a broadsheet of the patron saints of Austria (B.116), a coat
of arms, and a woodcut portrait of Stabius as St. Coloman.

By far the most remarkable achievements of the "Maximilian years,"

however, were the three great engravings, nearly identical in size, which have come to be known as Dürer's "master prints": *The Knight, Death, and Devil* (Plate 23), *St. Jerome in His Study* (1514, B.60), and *Melencolia I* (Plate 24). *The Knight, Death, and Devil*, which Dürer himself referred to simply as *Der Reuter* (the rider, not the knight), has been given several conflicting interpretations, ranging from the personification of Erasmus of Rotterdam's "Christian soldier" as described in the *Enchiridion militis christiani* (Handbook of the Christian Soldier, four editions 1502–1515), who scoffs at Death and the Devil, to that of the grim robber knight who consorts with them both. It has even been suggested that Dürer engraved a deliberately ambiguous image in order to widen his audience.[7] It cannot be denied, however, that the image of the rider is a commanding one, highly reminiscent of such Italian equestrian monuments as Verrochio's *Colleoni* (Venice, completed 1496) or Donatello's *Gattamelatta* (Padua, completed 1453), both of which were familiar to him, and that the thoroughbred horse, a "pacer," is the result of his studies of the proportions of horses dating from 1500 onward. While it is true that, as a townsman Dürer would have had ample reason to fear such wandering knights—his own dealer had been waylaid by one—yet it is also true that, as a not-infrequent visitor to Bamberg, he would certainly have been aware of the "good" image of the medieval, royal Rider of Bamberg Cathedral. Even more to the point, he was surely acquainted with Hans Burgkmair's elegant chiaroscuro woodcut of 1508 depicting Maximilian, "the last knight," in full armor and on horseback. The Emperor's own prowess as warrior and tournament hero, and his dedication to the militant St. George, had inspired a large number of knightly images in both Augsburg and Saxony, as well as on the Danube, between 1505 and 1510. The aristocratic cult of the knight was destined for a tragic end, however, when in 1522 Franz von Sickingen led the rebellious Imperial knights in their disastrous attack on the archbishopric of Trier and artillery proved its superiority over knighthood once and for all.

If Dürer's *Reuter* represents the *vita activa*, whether in the service of God, like Erasmus's Christian soldier, or in the defense of home and hearth, like Willibald Pirckheimer in his dealings with the local robber barons, or—like Maximilian himself—in the attempt to enlarge the Fatherland, then the serene *St. Jerome in His Study* is its very opposite. This true engraver's engraving contains the most subtle effects of light and texture ever committed to copperplate, and depicts the hero of Christian

humanism, the translator of the Vulgate himself, in a setting remarkably similar to one of the upper rooms in Dürer's own house. The good saint is still shown here with his cardinal's hat, however—an accoutrement to which he was not historically entitled, as Erasmus of Rotterdam would soon prove in the definitive biography of St. Jerome which he published in 1517. After his meeting with Erasmus in 1520, Dürer painted a new image of St. Jerome (Lisbon) wearing a proper scholar's beret.

*Melencolia I*, engraved in the year of his mother's death, is the most disturbing of Dürer's prints, as well as the most complex iconographically.[8] The antithesis of the serene and sun-filled *St. Jerome in His Study*, it represents yet a third solution to the problem of human endeavor— the life of the secular scholar, a scientist like Dürer himself, surrounded by the attributes of Geometry, Architecture, Mathematics, and Astronomy, who can grasp only the weights and measures of the material world. Dürer was aware that Aristotle, and after him Marsilio Ficino, had reported that all truly outstanding men suffer from melancholy, and may, through Pirckheimer's good offices, have known something of modern Florentine Neoplatonic philosophy in which melancholy is linked with Plato's theory of the origin of creativity in "divine frenzy." In his outline of the manual for young painters, Dürer takes note that artistic youths are especially prone to melancholy, which may be brought on by overwork, and must be protected from it. Konrad Hoffmann has called attention to the traditional and pejorative symbolism of the bat as the medieval personification of Despair caused by Pride, which flees from the light,[9] while the comet has been interpreted by scholars both as a portent of doom and as a source of enlightenment or evidence of divine presence. In this regard, it should be remembered that Dürer himself had seen a comet, noting the fact in his *Gedenkbuch* without speculating as to its meaning, and that he was now the owner of Bernard Walther's observatory and custodian of the latter's scientific library.

Erwin Panofsky viewed the three *Meisterstiche* as a suite of engravings, with the *Melencolia I* as a "spiritual self-portrait" of Albrecht Dürer. It is worth noting, however, that there is no record of Dürer's having treated the three as a set when he sold or made gifts of his prints on his journey to the Netherlands; he did, however, view the *St. Jerome* and the *Melencolia I* as a pair, as did Anton Tucher of Nuremberg, who sold three pairs of them in 1515.[10]

If *Melencolia I* may be considered a "self-portrait" of Albrecht Dürer,

at least insofar as he saw his situation in 1514, it is no less a spiritual portrait of Maximilian, who is known to have suffered from the creative man's malady.¹¹ And if the three engravings are iconographically related, then their common theme, as Erasmus says in the *Enchiridion*, is that self-knowledge is the beginning of wisdom.

# XII

## SPENGLER, LUTHER, AND
## THE SODALITAS
## STAUPITZIANA

WHEN Albrecht Dürer bought his house in the Zisselgasse in 1509, he became the neighbor of Lazarus Spengler (Plate 25), the man who was destined to implement the Reformation in Nuremberg. Spengler, who lived in the house called "Zum Einhorn" (The Unicorn—No. 19), was a man eight years Dürer's junior. He held the strategically important office of First Secretary to the City Council (*Ratsschreiber*)—a position held by his father before him. This was not simply a clerical post, for Spengler and his co-worker had a pool of six scribes and file clerks at their disposal to handle the routine office work.[1] His own duties included acting as legal counsel to the City Council while it was in session, since the Council's official jurisconsults, ironically, were forbidden to attend Council meetings because of their university degrees. (Spengler had attended the University of Leipzig, but prudently dropped out before becoming tainted with the LL.D., just as Pirckheimer had done from Pavia, on his father's advice.) Spengler was in charge of the Council's library and archive which, thanks in large measure to him, is still a marvel of organization; and it was also his duty to attend sessions of the Imperial Diet and to serve as one of Nuremberg's official representatives at meetings of the Swabian League. In this latter capacity, he had gone to Würzburg with Pirckheimer in 1505. In 1518 he would attend the Augsburg Diet with Kaspar Nützel, Leonhard Groland, and Albrecht Dürer—Dürer's principal function being to make portrait drawings in chalk of Maximilian (W.567), of Cardinal Albrecht von Brandenburg (W.568), who was newly elevated to the purple, of Count Philipp zu Solms (W.570), and of Cardinal Matthäus Lang (W.[1957] Nbg.538). The expense account submitted by Spengler to the City Council for their twenty-one-day stay was three hundred gulden which, according to Spengler's biographer, the historian Harold Grimm, was the equivalent of a year's salary for a high public official.[2]

Despite Spengler's white-collar background, he and Dürer had a number of things in common; the ninth of twenty-one children, he also had had a father who kept a family chronicle. He also came from a family which, despite its entitlement to a coat of arms, was not considered part of the cream of Nuremberg society; and he, like Albrecht Dürer, was to fall victim to the Dance Statute of 1521 which barred attendance at dances held in the City Hall to all but Nuremberg's forty-two patrician families.

It is likely that Spengler and Dürer, through their mutual friendship with Pirckheimer, had known each other for some years before this: however, their friendship was cemented when Dürer was made a *Genannter*, or member of the Great Council, in 1509.

Soon the two men were exchanging comic poetry. As Dürer reported in a document dated 1509, the original of which must have been written during the waning days of the Poets' School, his early efforts at penning couplets in praise of Christ were laughed at by Pirckheimer, who told him that no line of verse should have more than eight syllables. Dürer had then written a poem of eighteen lines in praise of stoicism ("For he will readily be called a wise man / Who is alike indifferent to riches and poverty"). Each line was eight syllables in length, and each rhyme more excruciating than the last, but he was again rebuffed by the fastidious Pirckheimer. Whereupon Dürer appealed to Lazarus Spengler for help, and Spengler replied with eighteen rhyming lines about the wisdom of being able to accept criticism with equanimity, and a comic poem of fifty lines, addressed to Pirckheimer, in which a cobbler attempts to criticize a portrait painted by a famous and bearded artist and is told, in effect, to stick to his last. Dürer, recognizing the parody on Apelles and the cobbler and not to be outdone, then composed a genuinely funny though scarcely more poetic seventy-one lines satirizing a notary who only knew how to use one form, and so was unable to spell his clients' names. Declaring that he wanted to learn something about everything, from writing to the practice of medicine, Dürer then went on to prescribe remedies for sore eyes and ears, stinking breath, flatulence, gout et al., concluding with the unwelcome news that he planned to continue to write poetry despite his friends' unseemly mirth. True to his word, he fired off another comic poem in 1510, this one addressed to a fellow painter, Konrad Merkel of Ulm, who had sent him a funny letter. But for Spengler, as a New Year's greeting for 1511 he produced not a poem but a comic drawing, *The Missive Bakery* (Bayonne, Musée Bonnat: W.623), showing a printer—evidently Spengler himself—at work grind-

ing out useless bureaucratic documents which are then placed directly into the fire by his two assistants, a blacksmith and a baker, played, according to Grimm, by Hieronymus Holzschuher and Kaspar Nützel, respectively. (The latter two had gone off on a diplomatic mission, turning over to Spengler the job of writing reports to the Council.) On the drawing Dürer wrote, "Superb missives are here cast, printed and baked in the year 1511—Dear Lazarus Spengler, I am sending you herewith the cake which for lack of leisure I could not bake before. Enjoy it!"[3]

If Albrecht Dürer, who was preparing to publish his Large Passion, Life of Mary, and his new Small Woodcut Passion, had at first entertained the notion of writing the verses for them himself, it is possible that we owe Lazarus Spengler a very large debt indeed for having dissuaded him. In any case, Dürer's discovery that his poetic talents lay, not in the direction of religious meditations but in burlesque, does not strike one as the usual behavior of a melancholic, and when considered together with his general gregariousness as revealed in both the letters from Venice and the Netherlandish diary, they cast doubt on the oft-drawn picture of Dürer as a habitual melancholic himself.

The years 1513 and 1514, however, did bring sad events: one was the death of his godfather, Anton Koberger, on October 13, 1513, at the age of seventy-three. The other was the serious illness of Dürer's mother, from which she never recovered.

After his mother's death in 1514, Dürer wrote the following lines in his *Gedenkbuch* where he had previously recorded the manner of his father's death:

> Now you must know that, in the year 1513 on a Tuesday before Cross Week [April 26] my poor mother, whom two years after my father's death, because she was quite poor, I took into my care, and after she had lived nine years with me, one morning became so deathly sick that we broke into her room; otherwise she could not open the door and we could not have come to her. So we carried her into a room downstairs, and she was given the sacraments [Communion and Extreme Unction], for everyone thought she would die. Because ever since my father's death she had been in poor health, and spent most of her time in church, and scolded me if I did not do right. And she was always worried about my sins and my brothers', and if I went out or in, she always said "Go in the name of Christ!" And she constantly and diligently gave us pious warnings, and she always had great concern for our souls' health. And I cannot praise enough her good works and the compassion she showed to everyone, and her good character.
>
> This pious mother of mine had borne and brought up eighteen children,

had often had the plague and many other severe and strange illnesses, saw
great poverty, scorn, contempt, mocking words, terrors, and great adver-
sities. Yet she was never vindictive.

From that day, on the aforementioned date when she was taken ill, more
than a year later, in 1514 as they reckon it, on a Tuesday, the 17th day of
May, two hours before nightfall, my mother, Barbara Dürer died a Chris-
tian death with all the sacraments, absolved by Papal power from pain and
sin. But first she gave me her blessing and wished me peace with God, and
exhorted me with beautiful words to keep myself from sin. She also asked
to drink St. John's blessing, which she then did [i.e., drank the consecrated
"St. John's wine" used for love pledges and farewell drinks].

She feared death very much, but she said that she was not afraid to come
before God. Also she died hard, and I noticed that she saw something
frightening; for she asked for the holy water and then said nothing for a
long time. Then her eyes closed. I saw, too, how Death gave her two great
strokes to the heart, and how she closed her mouth and eyes and departed
in pain. I prayed for her. I have such sorrow from this, that I cannot express
it. God be merciful to her.

Item: her greatest delight was always to speak of God and she liked to see
God honored. She was in her sixty-third year when she died.

And I have had her buried honorably, according to my means. God the
Lord grant me that I too may come to a blessed end, and that God with His
heavenly host, my father, mother, and relations may come to my death, and
that almighty God will grant us all everlasting life. Amen. And in her death
she looked more lovely than in life.

Dürer's most expressive drawing is the charcoal portrait that he made
of his mother in 1514 (Plate 26) one day as he sat by her side during her
terminal illness. It shows a woman painfully emaciated and frail. On the
day when he made the drawing, using the same charcoal, he wrote "1514
*an oculy Dz ist albrecht dürers / mutter dy was alt 63 Jor*" (On March 19,
this is Albrecht Dürer's mother, when she was 63 years old). At some
point shortly after her death on May 16 he wrote in ink, "*vnd ist verschi-
den / Im 1514 Jor / am erchtag vor der crewtzwochen / vm zwey genacht*" (and
she passed away in the year 1514 on Tuesday before Cross Week (i.e.,
Rogation), two hours before nightfall).

The theme of mother and child was on his mind a great deal during
that year, for he did a large number of drawings of the Madonna and
Child (W. 527–533, 548), as well as the delicately engraved and apocalyp-
tic *Virgin on the Crescent with a Diadem* (B.33) and the shadowed and
earthbound *Madonna by the Wall* (B.40.), with its glimpse of the Nu-

remberg castle and Luginsland tower seen over the ramparts in the background.

By his own admission, Dürer was deeply moved by his mother's death—and frightened by the fact that she, who had lived what he thought to be a blameless life, had apparently seen a vision of something dreadful at the moment of passing from life to death. His entirely natural depression during and after this event, together with his disappointment over the singularly unrewarding projects he had done for Maximilian by 1515, may have contributed to the "grossen Angsten" from which, a short time later, he felt that Martin Luther had delivered him.

As Dürer's letter from Venice dated August 18, 1506, indicates, he had begun to attend services at the Augustinian Church of St. Veit favored by many of Pirckheimer's friends from the City Council. In 1512 Johann von Staupitz, Vicar-General of the German Congregation of Augustinians, spent two days in the cloister there, giving sermons on the need for a return to Christ's own theology, which were extremely well received.

Staupitz, who as former Dean of the Theological Faculty at the new University of Wittenberg had been Martin Luther's own mentor and confessor beginning in 1511, returned to Nuremberg in the winter of 1516 to give a series of sermons for Advent. His topic was "On True Repentance," and his large and enthusiastic audience included Pirckheimer's entire humanist dining club—Albrecht Dürer, Lazarus Spengler, the Treasurers Hieronymus Ebner and Anton Tucher (the latter a close friend of Friedrich the Wise), the brothers Endres and Martin Tucher (later Burgomaster), Kaspar Nützel, Sigmund and Christoph Fürer, Christoph Scheurl (former counselor and diplomat for Friedrich the Wise, now jurisconsult to the City Council), Jakob Welser, and Hieronymus Holzschuher. The friends also attended his Lenten sermons that spring (1517) and dined with him, and were impressed, as Luther had been, with his emphasis on God's infinite capacity for the forgiveness of sin, on the Passion of Christ as the only true key to salvation, and with his contempt for empty ceremony. It was Staupitz who would later forward Luther's defense of the Ninety-five Theses to Rome, and who finally released the reformer from his Augustinian vows.

So avid was the interest of the Pirckheimer circle in Staupitz's teachings, that they began to call themselves the "Sodalitas Staupitziana"—a compliment both to the Augustinian Vicar-General and to the earlier "Sodalitas Celtica" of Sebald Schreyer's generation. When the younger and more radical Augustinian Prior, Dr. Wenceslaus Linck, Luther's

close friend, was sent from Wittenberg, the friends soon began to call themselves "the Sodalitas Martiniana" (1519). Although by that time Pirckheimer had begun to cede the leadership of the group to Spengler, it is clear that Dürer continued to keep up his ties with the circle, since he purchased presents for a number of the members on his trip to the Netherlands in 1520–1521 (see Chapter XVI).

As a member of this humanist study group in search of clear ethical guidance, Dürer was among the first to read Kaspar Nützel's unauthorized German translation of Martin Luther's Ninety-five Theses in printed form (Luther had neither foreseen nor wished that they be circulated publicly). A letter from Luther to Christoph Scheurl dated March 5, 1518, relays greetings to Dürer and extends thanks for an unspecified gift (*donum insignis viri Alberti Dureri*), presumably a group of his own prints which the artist had sent soon after learning of Luther's work. Possibly he may have sent either the Large Passion or the Small one—surely not his 1513 engraving of the *Sudarium Held by Two Angels* (B.25), which by its very nature was subject to an indulgence of ten thousand years on the authority of Pope John XXII (1316–1324), one of the very abuses against which Luther's theses were directed.

Despite his admiration for Luther, Dürer designed a new Marian woodcut, *The Virgin Mary as Queen of the Angels* (1518, B.101), which recalls the Glorification as part of the Rosary devotion as well as the Easter anthem of the Virgin, *Regina coeli*. In 1518, the year of the Heidelberg Disputation, Luther had not yet formally addressed the problem of the Virgin's theological role, which he only began to take up in 1521, in the commentaries on the *Magnificat*, and in 1522 on the *Hail Mary*.

A letter from Dürer to Georg Spalatin, court chaplain and secretary to Friedrich the Wise, is undated but evidently written early in 1520:

> To the honorable and most learned Mr. Geörgenn Spalentinus, my most gracious lord Duke Friedrich's princely chaplain.
>
> Most worthy dear sir! I have already sent you my thanks in a brief letter after having read only your note. Only afterward, when the little bag that held the book was turned inside out, did I find your real letter, from which I learned that it was my gracious lord himself [Friedrich the Wise] who sent me Luther's little book. Therefore I pray Your Honor to convey my humble gratitude to His Electoral Grace, and beg him humbly that he will protect the praiseworthy Dr. Martin Luther for the sake of Christian truth. It matters more than all the riches and power of this world, for with time everything passes away; only the truth is eternal. And if God helps me to come to Dr. Martinus Luther ["das jch zw doctor Martinus Luther kom"], then

I will carefully draw his portrait and engrave it in copper for a lasting re-
membrance of this Christian man who has helped me out of great distress.
And I beg your worthiness to send me for my money anything new that Dr.
Martin may write in German.[4]

Among the manuscripts in the British Museum is a list, in Dürer's
hand, of sixteen of Luther's early pamphlets, all dating from the years
between 1516–1520. It is not known whether the list was made as an in-
ventory or as a reading list, perhaps made up at the time of his corre-
spondence with Spalatin. The works included are Luther's pamphlet
against indulgences (Wittenberg, 1518?); the *Sermon on Indulgence and
Grace* (Wittenberg, 1518); the sermon on "the ban," that is, excommuni-
cation (Leipzig, 1520); one of the two early pamphlets on the Ten Com-
mandments (1518–1529); two sermons on penitence; the tract on three
kinds of sin; tracts on confession and on receiving the sacrament; on the
meaning of Christ's Passion; on marriage (Leipzig, 1519); a sermon
preached in Leipzig (1519); the explanation of the meaning of the Lord's
Prayer (Leipzig, 1518); Luther's translation of the *Seven Penitential
Psalms* (Leipzig, 1518); an explanation of Psalm 109, addressed to Hie-
ronymus Ebner; and Luther's first proposition debated against Eck at
Leipzig—that Christ, not the Pope, is head of the Church.

Because no portrait of Luther by Dürer's hand has survived, scholars
have assumed that the two men never met; indeed, the previous English
translation of Durer's phrase "das jch zw doctor Martinus Luther kom"
has been "if I meet Dr. . . . . Luther." However, that is not what Dürer
wrote. He wrote "if I *come to*" Luther, which means simply that he was
thinking of making a journey to see the reformer with the object of mak-
ing a portrait engraving; it does not imply that the two had never met.
They had had, at the very least, several near misses. Luther came to Nu-
remberg on October 5, 1518, on his way to his hearing with Cardinal
Cajetan in Augsburg, at which time he met with Spengler, Linck, and
other members of the sodality. Linck accompanied him to Augsburg,
where he met Dürer's friend, Konrad Peutinger. When Staupitz released
him from his vows, Luther fled Augsburg on horseback, stopping in
Nuremberg again on his way home (October 23). This time Luther was
a guest in Pirckheimer's home, where he was staying when he was
shown a copy of Pope Leo's instructions to Cajetan, ordering him to
arrest Luther and excommunicate his followers. In light of these devel-
opments, it is conceivable that, although he could well have met Luther,
Dürer may have decided that the time was not right to distribute the

fugitive's portrait. Before he had made up his mind to meet Luther in Wittenberg, Lucas Cranach's first portrait engraving of Luther (1520), wearing his Augustinian tonsure and cowl, may have come to Dürer's attention.

In the same letter to Spalatin, Dürer went on:

> Item: as you asked about the *schucz pücklein Martini* [i.e., Spengler's tract defending Luther, 1519⁵], be informed that there are no more on hand. They are printing them at Augsburg. When it is ready, I will send you some copies. But you must know that this little book, although printed here, has been condemned from the pulpits as heretical and fit to be burned. They despise the man who published it anonymously. It is reported that Dr. Eck wanted to burn it at Ingolstadt, as was done some time ago to Dr. Reuchlin's book.

Dürer's reference here is to the attack on the work of the pioneering Hebraicist of the early sixteenth century, Johannes Reuchlin, led by the conservative Dominicans of Cologne and at first backed by Maximilian (1513). Pirckheimer and his friend Ulrich von Hutten were among the many Christian humanists who, led by Erasmus of Rotterdam, had come to Reuchlin's defense—Hutten with the anonymously published and hilarious *Letters of the Obscure Men* (*Dunkelmännerbriefe*), a devastating satire on Dominican life and scholarship.⁶ Johann Eck, who was Professor of Theology at Ingolstadt, was one of Luther's foremost opponents. He considered Spengler's *Defense* a personal attack on himself, and was even more incensed when, at the end of February in 1520, still another brilliant and anonymous satire was published against him, *The Corner [Ecke] Planed Smooth* (*Eccius dedolatus*). Eck, Luther, Scheurl, and others assumed that Pirckheimer had written it; Pirckheimer denied it. The author is still unknown. Eck, however, took revenge in a dramatic way when he went to Rome to press charges against Luther and was permitted, with Cardinal Cajetan and others, to draft the papal bull *Exsurge domine* (June 15, 1520), demanding that Luther recant or be excommunicated. It was Eck's privilege to be allowed to name other accused heretics in the bull: among the six whom he named were Spengler and Pirckheimer.

# XIII

## DÜRER'S JOURNEY TO
## THE NETHERLANDS

A LTHOUGH Dürer was only forty-nine years old in the summer of 1520, he had revealed in his letter to Spalatin the fact that, "As I am losing my sight and freedom of hand my affairs do not look well" (Dan so mir ab get am gesicht vnd freiheit der hant, würd mein sach nit wolsten). His failing vision may simply have been due to the onset of presbyopia, one of the normal symptoms of middle age, which today is considered a matter of little consequence. For Dürer, however, whose artistic reputation had been built upon a flood of engravings and woodcuts employing the utmost precision and exquisiteness of detail, the loss or blurring of his near vision must have seemed a tragic matter indeed, as would even the slightest suspicion of hand tremors, which might very well have been symptoms of the onset of serious illness. He was therefore determined to place his petition for the pension promised him by Maximilian, who had died unexpectedly on January 12, 1519, before the new Emperor, Maximilian's grandson, Charles V, since the renewal of the Imperial promise was by no means a foregone conclusion. The impecunious Maximilian, however warm his personal wishes for Dürer's comfort in old age, had, as usual, indulged in creative financing in establishing the pension: it was not to be paid out of his own pocket, nor yet out of the Imperial treasury, but was to be provided by the Nuremberg City Council, which was then empowered to claim it as a tax deduction—a precarious arrangement at best, and one immediately vulnerable to nullification upon the old Emperor's death.

Pirckheimer's notation on a letter to his friend Venatorius, dated January 18, 1519, "Turer male stat" (Dürer is in bad shape) was interpreted by Erwin Panofsky as a reference to spiritual crisis brought on in part by the death of Maximilian—which meant, literally, the end of an era for which Dürer himself had set the artistic style—as well as the preoccupation with the teachings of Luther which was noted by the youthful

Jan van Scorel when he passed through Nuremberg in 1519. (Since, to
Scorel, this meant toying with heresy, he prudently kept moving, and
eventually entered the service of Pope Adrian VI). However, Fedja An-
zelewsky's interpretation of the same passage as a reference to physical
illness is the more likely explanation in view of Dürer's own statement
to Spalatin.

Whether his malady was spiritual, physical, or financial Dürer had, in
any event, sufficiently recovered by July to travel, and planned to attend
the coronation of the new Emperor, Charles V, in Aachen—a project
which he could perfectly well have carried out alone, returning speedily
to Nuremberg once it was over. In point of fact, however, he took with
him both his wife, who had previously handled his sales in Frankfurt,
and their young maid, Susannah, who seems to have functioned both as
laundress and as a companion for Agnes Dürer. He had apparently sent
ahead in his heavy baggage a large stock of his own engravings and
woodcuts for sale, as well as some of the work of his friend and former
journeyman, Hans Baldung. He was to make his headquarters in Ant-
werp—not Aachen—and stay there for an entire calendar year.

In part, Dürer's extended absence from Nuremberg may have been
influenced by the papal bull of June 15 threatening Pirckheimer and
Spengler with excommunication. His departure from home, on July 20,
took place shortly after the news of the contents of *Exsurge Domine*—
which took four months to reach Luther himself—were made known to
Pirckheimer's friend, Ulrich von Hutten, on July 4. It had been known
still earlier at the Fondaco dei Tedeschi in Venice. Dürer was thus in
Antwerp when the bull was actually delivered; on November 12, when
Luther's books were burned in Cologne, he was in Cologne himself,
visiting his cousin Niclas "the Hungarian." He remained in the Neth-
erlands during the Diet of Worms, which opened on January 27, and
was still there on May 17, 1521, when he received the false news that Lu-
ther had been betrayed and perhaps murdered. By the time Dürer and
his traveling party returned to Nuremberg, in July of 1521, the Edict of
Worms had been issued (May 26), and Luther had been placed in pro-
tective custody in the Wartburg by order of Friedrich the Wise.

Dürer's determination to make Antwerp his headquarters was a sound
business decision, for Antwerp by 1520 had replaced Venice as the center
of world commerce, due to the discovery of the New World and the
beginning of an Atlantic economy dominated by the Portuguese. In the
fifteen years which had passed since Dürer's last trip to Venice, the Por-

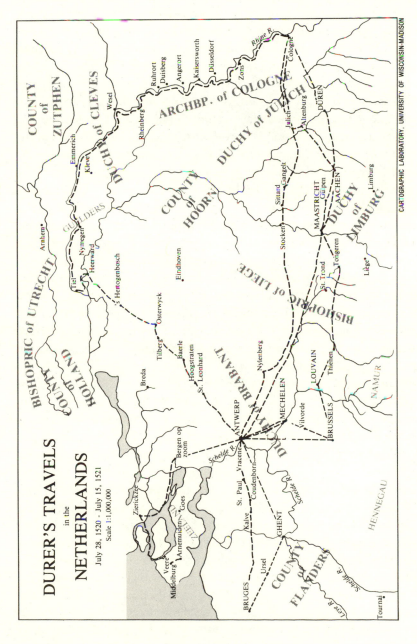

**DURER'S TRAVELS**
in the
**NETHERLANDS**

July 28, 1520 - July 15, 1521
Scale 1:1,000,000

COUNTY
of
ZUTPHEN

DUCHY of CLEVES

BISHOPRIC of UTRECHT

COUNTY
of
HOLLAND

GUELDERS

COUNTY
of
HOORN

ARCHBP. of COLOGNE

DUCHY of JÜLICH

DUCHY of LIMBURG

BISHOPRIC of LIÈGE

DUCHY of BRABANT

COUNTY
of
FLANDERS

HENNEGAU

NAMUR

ZEELAND

Rhine R.

Cologne
Zons
Düsseldorf
Kaisersworth
Angerort
Duisberg
Ruhrort
Wesel
Rheinberg
Emmerich
Kleve
Nymegen
Arnlem
Tiel
Heerward
'S Hertogenbosch
Eindhoven
Osterwyck
Tilberg
Baerle
Hoogstraten
St. Leonhard
Breda
Bergen op zoom
Zierickzee
Veere
Middelburg
Arnemuiden
Goes
Kalve
Ursel
BRUGES
GHENT
Coudenborn
St. Paul
Vracene
ANTWERP
Schelde R.
Schelde R.
MECHELEN
Vilvorde
BRUSSELS
LOUVAIN
Thienen
Nylenberg
St. Trond
Tongeren
Liège
Stocken
Sittard
Gangelt
Stockem
MAASTRICHT
Gulpen
AACHEN
Limburg
Jülich
Altenburg
DÜREN
Tournai
Leye R.
Schelde R.

Dürer's Travels in the Netherlands.

tuguese importers of spices and the German merchants and bankers of Augsburg had created a veritable *Wirtschaftswunder* in what had formerly been a sleepy medieval town. Not only were the firms of Imhoff, Fugger, and Welser now maintaining their headquarters in Antwerp in preference to Venice, but measures were being taken by the local City Council to attract artists to the city as well. Dürer was not only to be wined and dined in Antwerp as a visiting celebrity, but a concrete offer of tax-free status, an annual salary of three hundred gold Philip's gulden and rent-free housing was apparently made to him by the Council in the hope that he might emigrate, as Dürer's letter to the Nuremberg City Council, dated October 17, 1524,[1] reveals.

As he had apparently done on his second trip to Venice, Dürer kept a notebook during the Netherlandish journey in which he maintained a record of his business transactions. Although only a single page of his original manuscript has survived[2]—one of the final pages, on which a tailor's diagram detailing two patterns for Netherlandish women's coats appears—two complete copies of the notebook were made in the late sixteenth or early seventeenth century by professional scribes.[3] The two manuscripts agree in their essentials, but are not completely identical. It is thought that they were both copied from a common source, a third manuscript now missing, which may have been Dürer's original, or simply another and earlier copy of it.

At the time of Dürer's death, his friend Pirckheimer apparently possessed the original diary, for he willed it to his Imhoff heirs. Pirckheimer's grandson, Willibald Imhoff (1519–1580), who himself had lived in Antwerp, and who died a well-known connoisseur and collector, still owned the original at the time of his death. It was last mentioned in 1620.

The diary begins on July 12 and 13, as Dürer and his companions prefaced their journey to the Netherlands with a detour to Bamberg to perform several important functions, the first of which was to obtain a travel pass from the Bishop, Georg III Schenk zu Limburg, exempting them from paying tolls at the many checkpoints along the river Main which were either under his own jurisdiction or were manned by political allies of his. The Bishop was by now an old friend since, as a letter dated October 11, 1517, from Canon Lorenz Beheim to Pirckheimer reveals, Dürer had paid an extended visit to Bamberg, painting the Bishop's portrait and that of his jester (both paintings are now lost), and dining at the head of the Bishop's table.

The travel pass, and three letters of introduction signed by the

Bishop, one of which was addressed to the Margrave of Brandenburg, cost Dürer the goodwill offerings of a Madonna painting (now lost, but still in the episcopal Residenz in Bamberg as late as the nineteenth century) and two of his large woodcut picture books. This actually represented quite a prudent investment for the travelers, as will be seen later.

The complications of continental travel in Dürer's day make modern border-crossings pale by comparison, for not only was highway robbery a fact of life, but the frequent changes of currency and legal jurisdiction encountered by travelers passing from the center of the Holy Roman Empire to Flanders were fraught with opportunities for extortionate tolls and shortchangings to which the unwary might fall prey. During their journey and sojourn in the Netherlands, as Rupprich noted, the Dürers would deal in the following kinds of currency: pfennigs (silver); heller; stuivers (stüber); weisspfennigs (2 heller: 20 weisspfennigs = 24 stuivers = 2.53 g. gold); blanke (2 stuivers); pfund (30 pfennigs); ort (¼ gulden); Rhenish gulden (8 pfund 12 pfennigs); "schlechter" gulden (12 stuivers); Hornish gulden (issued by the Count of Horn); Portuguese gulden; Philipp's gulden (Netherlandish: 25 stuivers); crona (Sonnenkrone: gold pieces worth ca. 1 florin 9 stuivers); anglot (English coins with the image of the Archangel Michael on one side: 2 florins 2 stuivers); rose nobles; Flemish nobles; Hungarian ducats; gold Carolus gulden (1.71 g. gold: 20 stuivers).

> On Thursday after St. Kilian's [July 12, 1520], I, Albrecht Dürer, at my own expense, took my wife from Nuremberg to the Netherlands. And the same day, going by way of Erlangen, we spent the night at Baiersdorff, and spent three pfund minus 6 pfennigs. After that, on Friday, we came to Forchheim [the Bamberg frontier], and there I paid 22 pfennigs for the convoy. From there I went to Bamberg and gave the Bishop a painting of the Virgin Mary, a set of the Marienleben, an Apocalypse, and engravings worth a gulden. He invited me to be his guest, gave me a toll pass and three letters of introduction, and paid my bill at the inn ['Zum Wilden Mann"] where I had spent a gulden. Item: I gave the boatman 6 gold gulden to take me from Bamberg to Frankfurt. Item: Herr Laux Benedict [a Bamberg artist] and Hans the Painter [Hans Wolff] gave me some wine. 4 pfennigs for bread, 13 pf. for tips.[4]

From the episcopal records and other sources we know that Dürer and his party stayed at the inn, "Zum Wilden Mann," and that he made a portrait of Hans Wolff, the Bishop's court painter, at this time. It is also known from the same sources that the Dürers and Susannah made a side trip from Bamberg to the fifteenth-century Chapel of Vierzehnheiligen

(the Fourteen Holy Helpers) in nearby Staffelstein. The small building which Dürer visited, destroyed in the Peasants' War of 1525, was eventually replaced in the eighteenth century by the magnificent church designed by Balthasar Neumann which stands there today. It marks the site where a fifteenth-century shepherd had his two visions of the saintly "helpers in need"—among whom is numbered St. Christopher, the protector against an evil death and favored saint of travelers.

Dürer's failure to mention this side trip to Vierzehnheiligen is curious, in view of the completeness of his description of his itinerary in almost every other respect. His silence on the subject may, of course, have been due to an oversight, or to the fact that his wife and maid had persuaded him to go there, while he himself saw nothing to remark on. However, if he had planned to share the experiences noted in the diary with his friend Pirckheimer, the omission may have been a deliberate one, for the cult of the Fourteen Holy Helpers was one of the aspects of popular piety recently castigated by Pirckheimer's friend, Erasmus of Rotterdam. In *The Praise of Folly*, Erasmus heaps scorn on those who believe in the power of St. Christopher's image to protect them against sudden death, or of St. Barbara's to protect them in battle, as well as of those who believe that lighting candles to St. Erasmus will make them rich: "as, one is good for toothache; another for groaning women; a third for stolen goods; a fourth for making a voyage prosperous; and a fifth, to cure sheep of the rot; and so of the rest, for it would be too tedious to run over all."

It is possible that Dürer went to Vierzehnheiligen only under protest, at the insistence of the redoubtable Agnes—or at the urging of the Bishop, or of his own confessor in Nuremberg. As will be seen later, however, he was by no means immune to the cult of saints and of other Catholic proprieties during his visit to the Coronation, despite the fact that, when left to his own devices in the Netherlands he seems rarely to have attended Mass.

From July 14 to 20 Dürer and his party traveled by boat on the Main from Bamberg to Frankfurt, presenting their toll pass at every station along the way. They were to find that the Bishop of Bamberg's influence extended far beyond the confines of his own territory, for the customs men employed by the Bishops of Würzburg and Eichstätt respected it, as did those of the Archbishop of Mainz at Aschaffenburg.

The travelers spent each night on shore at an inn or guest house and were responsible for procuring their own food. In traveling with a convoy, as with the "package tours" of today, all members of the party were obliged to keep to the route and the schedule established by the convoy

master. Despite a rigorous timetable, however, a journey which today would require only three hours by train consumed six days, due to the leisurely turns and twists of the river Main and the necessity for toll negotiations.

Of the cities and towns through which Dürer passed on this leg of his journey, Miltenberg is the best preserved today, with its medieval fortress, one remaining fifteenth-century house, and Germany's oldest surviving hotel, a half-timbered structure dating from 1590 but closely resembling the architectural style of Dürer's day.

After passing Miltenberg, Klingenberg, and Worth, the travelers came to "Ochsen Purg" (Aschaffenburg), Seligenstadt, Steinheim, and "stayed overnight at Johansen's, who showed us around town and was very friendly." Finally on Friday, July 20, the party reached Frankfurt by way of Kesselstadt, and settled in for the night.

Dürer's old client, Jacob Heller, despite their acrimonious correspondence of 1508 seems to have been sufficiently pleased with his altarpiece to send Dürer and his wife a complimentary gift of wine to be served them at their inn (which was, in all probability, the "Nürnberger Hof," which he owned himself)—though not sufficiently pleased to invite them to dine with him. His attitude stands in noticeable contrast to the hospitality shown the Dürers along the Rhine and in the Netherlands.

Frankfurt, the old Imperial city near the mouth of the Main, was a transfer point for the party, where their passenger and baggage fares had to be renegotiated.

> Then on Sunday I took the early boat from Frankfurt to Mainz, and in that way we came to Höchst, where I showed my toll letter and they let me go. Also I spent 8 Frankfurt pfennigs for landing [with my things] and 14 Frankfurt hellers for the boatman and 18 pf. for the girdle. And I bought passage in the Cologne boat for myself and my baggage for 3 gulden. Also at Mainz I spent 17 weisspfennigs. Item: Peter the Goldsmith from the mint, gave me two bottles of wine. Veit Varnbuhler also invited me but his landlord would take no money from him, but insisted on being my host himself, and they showed me much honor.
>
> And so I took leave of Mainz, where the Main joins the Rhine, and it was on Monday after St. Mary Magdalene [July 23]. Also I gave 10 heller for meat in the boat and 9 hellers for eggs and beer. Also, Leonard the Goldsmith gave me wine and birds in the boat to cook on the way to Cologne. Master Jobst's brother [Jobst de Negker's?] gave me a bottle of wine on the boat.

After leaving Mainz, the party sailed on the Rhine past the vineyards of Eltville and Rudesheim, where their pass was still honored, but at

Schloss Ehrenfels "I had to pay 2 gold gulden. But if within two months I would bring them a pass, the toll taker would give me back the 2 gold florins."

At Bacharach and Kaub, Dürer had to promise in writing that he would bring a letter from the Archbishop's chancery within two months or pay the toll. At St. Goar they let him pass free, after asking how he had been treated elsewhere, and at the Trier toll-bar they made him show "with a little writing under my signet that I didn't have any common merchandise with me."

> Then on St. James's Day [July 25] I left Andernach early for Linz. From there we went to the toll station at Pun (Bonn) where they let me pass free. After that we came to Cologne. And in the boat I paid 9 weisspfennigs and 1 more, and 4 pf. for fruit. At Cologne I paid out 7 weisspfennigs for unloading my things, and 14 heller to the boatmen. And then I gave my black lined coat edged with velvet to my cousin Niclas, and to his wife I gave a florin.
>
> Item: at Cologne, Hieronymus Fugger gave me wine; Johannes Grossenpeck gave me wine. Also my cousin Niclas gave me wine. Also they gave us a meal at the Franciscan cloister, and a monk gave me a handkerchief [*faczolet*: Dürer uses the Italian word for this exotic item]. Herr Johann Grossenpecker gave me 12 measures of the best wine. And I paid 2 weisspfennigs and 2 hellers to the boy. I have spent besides at Cologne 2 florins and 14 weisspfennigs, and I have given away 10 weisspfennigs, paid 3 pf. for fruit. Lastly I gave 1 weisspfennigs at leaving and paid 1 weisspfennig to the messenger.

Dürer's travels from Mainz to Cologne on the Rhine took him past some of Germany's most celebrated vineyards, as well as through some of the most spectacular scenery north of the Alps. In his day, long before the destruction wrought during the Thirty Years' War, the great castles of Ehrenfels and Lahnstein, owned by the Archbishop of Mainz, were still intact, as was the Marksburg at Braubach (bombarded in World War II). If Dürer seems curiously indifferent to the beauties of the Rhine and its castles, it is in part because we ourselves have been conditioned by German mid-nineteenth-century aesthetics of nostalgia for the medieval Rhine as a "German stream" (i.e., not shared with France) which is celebrated in poetry and song.[5]

Presents of honorary measures of wine became more frequent in the Rhine valley, as might be expected, and many of them, it is interesting to note, were given to Dürer by goldsmiths, rather than by painters.

## THE JOURNEY FROM COLOGNE TO ANTWERP:
### JULY 28–AUGUST 2, 1520

After spending several days in Cologne as guests of his cousin Niclas "the Hungarian," whom he would have known well from the days of the latter's apprenticeship to Albrecht Dürer the Elder (he had become a master goldsmith in 1482, and continued to live in Nuremberg until 1505), Dürer and his party left on the final leg of their journey to Antwerp. They went by the most direct route, overland through the peninsula-shaped portion of the Maasland (Limburg) that belongs to the modern-day Netherlands, a region famous in the earlier Middle Ages for its gold and brasswork. They were apparently on horseback, since Dürer mentions at one point that they "traveled over the meadows." They stopped for meals and lodgings in towns, most of which were as unremarkable in 1520 as they are today, since their route would have been determined by their guide, for practical rather than aesthetic reasons.

Dürer does, however, single out Sittard for honorable mention—probably because of its fine thirteenth-century church. He was also favorably impressed by the inn in Stockem, in the diocese of Liège, which is principally known as the home of the fifteenth-century painter, Jan van Stockem.

As they had done upon leaving Nuremberg, the group departed on the feast day of a popular local saint—in this case, St. Pantaleon, one of the patron saints of Cologne, and a member of the Fourteen Holy Helpers, revered in Germany as the patron saint of physicians. They left before breakfast on Sunday, July 28, and spent three nights on the road, crossing the river Maas between Stockem and Martenslind, and arriving in Antwerp on Thursday, August 2.

### ANTWERP: AUGUST 2–20, 1520

Upon arrival in Antwerp, the Dürer party made its way to Jobst Planckfeldt's inn. Planckfeldt (d. 1531), who seems to have been a particularly kindly and obliging man, owned the house called "Engelenborch," at No. 19 Engelsche Straat, in the area between the busy harbor and the main market. Dürer drew both a portrait of Planckfeldt (W.747, Frankfurt) and a view of the harbor (Plate 27).

Within a few days of his arrival, Dürer had been entertained by the Fuggers' factor, or branch manager, and was given a guided tour of the city by Planckfeldt:

On Saturday after the Feast of St. Peter in Chains [August 4] my landlord
took me to see the Burgomaster's house in Antwerp [the house of Arnold
van Liere, d. 1529, known as the "Hof van Liere," in the Prinsenstraat]. It is
newly built and unusually large and well-planned, with extravagantly beau-
tiful big rooms, a splendidly decorated tower, an enormous garden; in sum,
such a noble house, the like of which I have never seen anywhere in German
lands. Also there is an entirely new street, very long, by which one can reach
the house from both sides, which the Burgomaster had constructed to his
own liking and paid for it himself. Item: I gave three st. to the messenger,
2 pf. for bread, 2 pf. for ink.

He was royally entertained by the St. Luke's Guild in their guild hall,
"De Bontemantel," in the Groote Markt. This last event made a partic-
ularly strong impression on him—and, it is to be hoped, on Agnes. As a
citizen of Nuremberg, of course, Dürer was unfamiliar with painters'
guilds, and was almost incredulous at the obvious wealth and power of
the guild in Antwerp, which owned its own silver service and knew how
to entertain in grand style:

> On Sunday [August 5] it was St. Oswald's Day; the painters invited me
> to their rooms, with my wife and maid. All their service was of silver, and
> they had other splendid ornaments and a delicious meal. All their wives
> were also there. And as I was being led to the table the people stood on
> both sides, as if they were leading some great lord. And there were also
> among them men of very high position, who all behaved most respectfully
> toward me with deep bows, and promised to do everything that they could
> that I would like. And as I was sitting in such honor, the Syndic [Adriaen
> Herbouts, the attorney to the City Council] came, with two servants, and
> presented me with four cans of wine in the name of the City Councillors,
> and they had bidden him to say that they wished thereby to show their
> respect for me and to assure me of their good will. Whereupon I returned
> them my humble service. After that came Master Peeter [Pieter Tiels], the
> master carpenter of Antwerp [Tiels was also a sculptor], and presented me
> with two cans of wine, with the offer of his willing service. So when we had
> spent a long, merry time together till late in the night, they accompanied us
> home with lanterns in great honor. And they begged me to be ever assured
> and confident of their good will, and promised that, in whatever I did, they
> would all be helpful to me. So I thanked them and laid me down to sleep.

He was subsequently taken to the workshop in the painters' ware-
house where the decorations were being made for the triumphal entry
of the new Emperor:

> My host took me to the workshop in the painters' warehouse in Antwerp,
> here they are making the decorations for the triumphal entry of King Carl

[Charles V]. They are four hundred arches long, and each is forty feet wide. They are to be set up along both sides of the street, handsomely lined up, and two stories high. The plays are to be acted on them. And this costs, to have the painters and joiners make it, 4,000 florins. Also all this will be fully draped, and the whole work is very splendidly done.

Dürer was also taken to see the house of Quentin Massys, although he apparently never met the artist himself, who may perhaps have been out of the city for an extended period.[6] Massys' associate, the landscape painter Joachim Patinir, did, however, become a close friend of Dürer's, lending him an apprentice and pigments whenever the need arose, and eventually inviting Dürer to his wedding. Dürer repaid his new friend with a florin's worth of prints, and later made Patinir a sheet of St. Christopher drawings which could be used as staffage in the latter's landscapes.

The Antwerp guilds were responsible for staging the Great Procession on the feast day of the Assumption of the Virgin (August 19), described by Dürer in great detail. His eyewitness account is one of our most valuable records of such a sixteenth-century civic festival:

Item: On the Sunday after Our Lady's Assumption [August 19] I saw the Great Procession from the Church of Our Lady in Antwerp, when the whole town of every craft was assembled, each dressed in his best clothes according to his rank. And all the ranks and guilds had their signs, by which they might be known. In the intervals great costly pole-candles were carried, and their long, old Frankish silver trumpets [posaunen]. There were also in the German fashion many pipers and drummers. All the instruments were loudly and noisily blown and beaten.

I saw the Procession pass along the street, the people being arranged in rows, each man some distance from his neighbor, but the rows close behind one another. There were the goldsmiths, the masons, the painters, the embroiderers, the sculptors, the joiners, the carpenters, the sailors, the fishermen, the butchers, the leatherers, the clothmakers, the bakers, the tailors, the shoemakers—indeed, workmen of all kinds, and many craftsmen and dealers who work for their living. Also the shopkeepers and merchants and their assistants of all kinds were there. After these came the shooters with guns, bows, and crossbows, and the horsemen and footsoldiers also. Then followed the Watch of the Lords Magistrates. Then came a fine troop all in red, nobly and splendidly dressed. Before them, however, went all the religious orders and the members of some Foundations very devoutly, all in their different robes. A very large company of widows also took part in this procession. They support themselves with their own hands and observe a special rule. They were dressed all from head to foot in white linen garments, made especially for the occasion, very touching to see. Among them

I saw some very stately persons. Last of all there came the Chapter of Our Lady's Church with all their clergy, scholars, and treasurers. Twenty persons carried the [statue of] Virgin Mary with the Lord Jesus, adorned in the costliest manner to the honor of the Lord God. In this procession many delightful things were shown, most splendidly got up. Wagons were drawn along decorated like ships and other traveling stages. Behind them came the company of Prophets in their order, and scenes from the New Testament, such as the Annunciation and the Three Holy Kings on big camels and other rare animals, very well arranged. Also how Our Lady fled to Egypt— very devout—and many other things, which for shortness I omit. At the end came a great Dragon with St. Margaret and her maidens led by a girdle; she was especially beautiful. Behind her came St. George with his squires, a very handsome knight in armor. In this host also rode boys and maidens most finely and splendidly dressed in the costumes of many lands, representing various saints. From beginning to end the Procession lasted more than two hours before it was gone past our house. And so many things were there that I could never write them all in a book, so I let it alone.

There was particular devotion to the Virgin in Antwerp, where the principal church (later made a cathedral in 1559) was named in her honor. Dürer marveled at the size of this building which is "so very large that many masses are sung in it at one time without interfering with each other." He particularly admired the masonry and the design of the tower, and pronounced the music the best to be had. He likewise admired the rich stonework—some of it Portovenere marble—and carved choirstalls of the wealthy abbey church of St. Michael, remarking that "In Antwerp they spare no expense on such things, for there is enough money."

Dürer was also entertained by Lorenz Staiber, Nuremberg's famous organist, who was on his way to England to be knighted by Henry VIII, and by the Portuguese consul, Joaõ Brandao, whose portrait he drew in charcoal. He was especially befriended by the Italian paymaster to Margaret of Austria, Regent of the Netherlands, "Tomasin" Bombelli, at whose house he was to become a frequent dinner guest, and by the Treasurer of Brabant, Lorenz Sterck, who is thought to be the sitter portrayed in the Prado's famous portrait of a frowning man in a fur cloak with a rolled document in his hand. He drew the portait of Niclas Kratzer, Henry VIII's German astronomer, who later sat for Hans Holbein in London (1527), but who kept in correspondence with Dürer afterward. Kratzer's letter to Dürer from London, dated August 24, 1524, has been preserved.[7] He was in Antwerp on a visit to Erasmus at this

time, and was present when Dürer made his first drawing of Erasmus (W.805).

It is immediately evident that Dürer was keeping rather exalted company. Despite his slight formal schooling, his native intelligence and the informal training in literature, mathematics, and manners which had been made available to him through his friendship with Pirckheimer made him persona grata wherever he went. His wife Agnes, on the other hand, although she was literate and came from a wealthier family than his own, seems to have been attuned entirely toward life's practicalities. Although she was, in effect, his business manager (he frequently says "I have taken 1 fl. for expenses," suggesting that he did not have sole custody of the purse-strings), yet she was unprepared to keep up with Dürer socially. They both seem to have recognized this. As Fedja Anzelewsky has noted, Susannah the maid had been brought along on the journey as much to serve as companion to Agnes as to perform any practical duties. Agnes and Susannah soon began to take their meals together in their suite at the inn, while Dürer dined out with friends or prospective clients, or with his landlord in the public room of the Engelenborch. Agnes's only excursions into Antwerp society seem to have been an occasional dinner at Bombelli's, and the evening parties given by the Painters' Guild, to which the local painters' wives were also invited.

Toward the end of August, Dürer became friendly with "Signor Rodrigo of Portugal," Rodrigo Fernandez d'Almada, First Secretary to the Portuguese Consul, whose portrait drawing (Berlin) is done with the brush in white on paper tinted greyish purple. Many gifts were exchanged: Dürer's artworks for lavish presents of sugar cane, marzipan, and other candies, and a green parrot for Agnes.

> Herr Aegidius [Gillgen], King Carl's porter, has taken for me from Antwerp the *St. Jerome in His Cell*, the *Melencolia I*, the three new *Marys*, the *Anthony*, and the *Veronica* [engravings] as a present for Master Conrad Meit, the good sculptor whose like I have never seen. He is in the service of Lady Margaret, the Emperor's daughter. Also I gave Master Gillgen a *Eustace* and a *Nemesis*.

Having been assured of the goodwill of the local Painters' Guild and of the City Council—again a contrast to the treatment he had received during his early days in Venice—Dürer had begun both to sell and to exchange his stock of prints for luxury items in Antwerp, and to do a thriving business in charcoal portraiture.[8] He also began to do a few oil paintings, making use of Joachim Patinir's studio and apprentice for

color-grinding and panel preparation. Shortly before leaving with his Italian friend Tomasin, Margaret of Austria's paymaster, on a trip to Brussels and Mechelen to have his petition to the new Emperor drawn up, Dürer sent a present to Lady Margaret's court sculptor, Conrad Meit of Worms, whose work he particularly admired.

## The First Trip to Mechelen and Brussels: August 26–September 3, 1520

Item: on Sunday after St. Bartholomew's I went with Herr Tomasin from Antwerp to Mechelen; there we stayed overnight. There I invited Master Conrad [Meit] and a painter with him to supper. And this Master Conrad is the good sculptor who works for Frau Margaret.

On August 26, when he had been living in Antwerp for a little over three weeks, Dürer, leaving Agnes and her maid in Antwerp, made an eight-day trip to Mechelen (Malines) and Brussels, with Margaret of Austria's paymaster, Tomaso Bombelli, as his traveling companion. His primary objective was to secure expert advice and highly placed backers for the petition regarding the extension of his old-age pension which he hoped to present to the new Emperor in an audience to be held shortly after the Coronation in Aachen. The contacts he made were well-placed, and some of them were already well known to him from Nuremberg: these included "my lords," the Nuremberg deputation to the Coronation—Hans Ebner, Leonhard Groland, and Niklas Haller, all members of the City Council, who had been entrusted with the critical task of escorting the Imperial regalia from its normal storage place in the Nuremberg Church of the Heilig-Geist-Spital. There was also Pirckheimer's friend Jacob Banisius (1467–1532), who had been Maximilian's personal secretary and was now one of Charles V's advisers. An important new contact was Johann, Margrave of Brandenburg (1493–1525), "Margrave Hansen," who had served as Charles's Chamberlain and had been his traveling companion on the latter's trip to Spain in 1517 to be crowned king, and who would later marry the Emperor's step-grandmother, Germaine de Foix. Dürer also cultivated the friendship of Margaret of Austria's court sculptor, Conrad Meit of Worms (ca. 1480–ca. 1550), and of one of her painters, Bernard van Orley (1492?–1541), and received assurance from Margaret herself that she would speak favorably to her nephew, the Emperor, on Dürer's behalf.

Dürer also found time to accept a dinner invitation from "the Lady of

Nieuwkerk," apparently one of Margaret's ladies-in-waiting. He had indeed become a master at what it is now fashionable to call networking.

All was not given over to the pursuit of the main chance, however. Dürer's eight days in the twin capitals of Brussels and Mechelen afforded him the opportunity to visit and describe the principal sights (Plate 28), including the Royal Palace with its zoo, and the elegant Town Hall in Brussels, where he saw the four great Justice paintings by Rogier van der Weyden, who had been the official painter to the city until his death in 1464. These mural paintings, destroyed in the siege of 1695, are known today only in the tapestry copies preserved in the Berne Historisches Museum. He also marveled at the treasures in the Count of Nassau's town house and chapel, which included two works by Hugo van der Goes now lost—the *Seven Sacraments* and a Crucifix—as well as the great bed "wherein 50 people can lie," which the Count maintained for his more bibulous dinner guests.

Of particular interest is Dürer's account of his visit to the first exhibition of pre-Columbian art ever held—the objects from "the new golden land" of Mexico, goodwill tokens sent to Charles V in his capacity as King of Spain by Captain Hernando Cortes in July of 1519.[9]

> Also I have seen the things which have been sent to the King from the new golden land [Mexico]: a sun all made of gold, a whole *klaffter* [fathom] wide, and a moon all of silver of the same size. Also two rooms full of the arms of the people there, and all sorts of wonderful weapons of theirs, armor and darts, wonderful shields, strange clothing, bedspreads, and all kinds of wonderful objects of various uses, much more beautiful to me than miracles [*Wunderding*]. These things were all so precious that they have been valued at 100,000 florins. All the days of my life I have seen nothing that has gladdened my heart so much as these things, for I saw amongst them wonderful works of art, and I marveled at the subtle *ingenia* of men in foreign lands. Indeed, I cannot express all that I thought there.

As the son of Kaiser Friedrich III's favored goldsmith, who had practiced the art himself as a novice, Dürer's opinion on the high quality of the objects of silver and gold—most of which are now lost—is invaluable. He was also extremely knowledgeable on the subject of arms and armor, which made up a substantial portion of the booty, as did garments and ceremonial hangings of brilliant and exotic bird feathers—another special interest of Dürer's. He was acquainted, through his friendship with Pirckheimer, with the translator of Cortes's letters, Pietro Savorgnano, whose book would be printed in Nuremberg in 1524, and would take into consideration Cortes's diagram of the Aztec capital

of Tenochtitlan as one of the influences on his own *Treatise on Fortifi-cations* published in 1527.

While on this trip, Dürer made more spur-of-the-moment portrait drawings in charcoal, including one by candlelight—a daring innovation in 1520, but a curious parallel to the method recommended by Leonardo da Vinci of studying the sitter outdoors at twilight, in order to soften the facial expression and bring out the modeling of the head.

> Item: in Brussels there is a most beautiful *Rathaus*, large, and covered with beautiful carved stonework and a noble openwork tower. I drew a portrait at night by candlelight of my host at Brussels, Master Conrad; at the same time I drew Dr. Lamparter's son in charcoal, and also the hostess."

At Brussels I saw many other beautiful things besides, and especially I saw a fishbone there as big as if masons had built it up out of squared stones. It was a fathom long and very thick. It weighs up to fifteen centner [15 × 110 lbs = 1650 lbs], and its form resembles that drawn here: [Dürer's drawing of the whalebone in the original manuscript was not reproduced by either of the copyists]. It stood up behind on the fish's head.

I was also in the Count of Nassau's house, which is very splendidly built and as beautifully decorated. I have again dined twice with my Lords [of Nuremberg].

Item: Madonna Margareta sent after me to Brussels and promised to speak for me to King Carl, and she has shown herself quite exceptionally kind to me. I sent her my engraved Passion and another copy to her Treasurer, Jan Marnix by name, and I have also done his portrait with charcoal. I gave two st. for a buffalo ring; also two st. for opening St. Luke's picture.

When I was in the Nassau house in the chapel there, I saw the good picture Master Hugo [van der Goes] painted. And I saw the two fine halls and treasures everywhere in the house, also the great bed wherein 50 people can lie. And I saw the great stone which the storm cast down in the field near the Lord of Nassau [a meteorite]. The house stands high, and from it there is a most beautiful view at which one cannot but wonder, and I do not believe that in all the German lands the like of it exists.

Item: Master Bernhard the Painter [Bernard van Orley] has invited me and prepared so costly a meal that I do not think ten florins would pay for it. Lady Margaret's Treasurer, whom I drew, and the King's Steward named Meteni [Jehan de Metenye, the former Mayor of Bruges], and the Town Treasurer named Pusleidis [Gillis van Busleyden, Treasurer of Brabant] invited themselves to it, to keep me good company. I gave Master Bernhard an engraved Passion, and he gave me in return a black Spanish purse worth 3 gulden. And I have given Erasmus of Rotterdam a Passion engraved in copper.

> Item: I have drawn the portrait of Master Bernhard [van Orley], Frau Margaret's painter, with the charcoal. I have drawn Erasmus of Rotterdam one

more time [W.805]. I have given Lorenz Sterck a Sitting Hieronymus [probably the *St. Jerome in His Study*] and the *Melencolia*. And I have taken a portrait of my hostess's godmother. Item: six persons have given me nothing, whose portraits I drew at Brussels . . .

So then on Sunday [September 2] after St. Gilgen's Day [St. Giles, September 1] I traveled with Herr Tomasin to Mechelen and took leave of Herr Hans Ebner [of Nuremberg]. He would take nothing for my expenses while I was with him—7 days. I paid 1 st. for Hans Geuder [Pirckheimer's nephew]. One st. I gave to my host's servant for a leaving gift.

And at Mechelen I had supper with the Lady of Nieuwkerke. And early on Monday I left for Antwerp. And I ate early with the Portuguese [Consul Brandaõ]; he gave me three pieces of porcelain,[10] and Rodrigo gave me some feathers from Calicut. I have spent one florin and paid the messenger 2 st. I bought Susannah a mantle for 2 fl. 1 ort.

Dürer's exhilarating experiences in Mechelen, where Lady Margaret maintained her residence, and in Brussels, the splendid diplomatic capital, where he was feted on the expense account of the Nuremberg delegation to the Coronation, and was delighted alike by Renaissance architecture, early Flemish painting, pre-Columbian goldwork and natural wonders, is in sharp contrast to Agnes Dürer's activities as they are hinted at from this last entry:

My wife paid 4 fl. Rhenish for a washtub, a bellows, and for a bowl, my wife's slippers, and for wood for cooking, and knee-hose; also for a parrot cage and for the two jugs and for tips. So my wife has spent for eating, drinking, and other necessities 21 st.

However, this is not to say that Agnes had not enjoyed equally well her golden opportunity to go shopping in the fabled markets of Antwerp, unencumbered by her *rara avis* of a husband, to pick up certain items which would make life truly worth living.

During the month of September 3–October 4, before his departure for the Coronation, Dürer was a frequent guest of two Austrian noblemen, Wilhelm and Wolfgang von Roggendorf, whose coat-of-arms he drew "large, on a woodblock for cutting," for which he was later paid with seven ells of velvet. Wilhelm (1481–1541) was a member of Margaret of Austria's Council of State and was General Stadhouder of Friesland.

Dürer also dined frequently with the Nuremberg delegation, who were now staying in Antwerp, and was taken to dinner at the Fugger mansion. He was also the guest on one occasion of Wolff Haller II, a former Fugger office manager who had resigned in 1519 to accept a court position under Charles V.

He continued to give away as presents, or to trade with other artists, an enormous number of the stock of his own prints which he had brought with him from Nuremberg: some were bread-and-butter presents for those who had shown him their hospitality or were prepared to lend their influence on his behalf at court, while others were his medium of exchange for "Raphael's work"—perhaps prints by Marcantonio Raimondi, or perhaps late drawings by the great Italian painter, who had recently died in Rome (April 6, 1520). Raphael's student, Tomaso Vincidor who was in the Netherlands on commission from Pope Leo X to oversee the weaving of Raphael's tapestry cartoons, sought out Dürer in order to give him a gold ring, and made a portrait of him to send to Rome:

> Item: Raphael's *Ding* [estate? workshop?] is broken up after his death [on April 6, 1520]. But one of his pupils, a good painter by the name of Tomas Polonier ["Tomas of Bologna"—i.e., Tommaso di Andrea Vincidor, d. 1536] wanted to see me. So he came to me and gave me an antique gold ring with a very well-cut stone, worth 5 gulden; I have already been offered twice that amount for it. I gave him 6 gulden worth of my best prints for it . . .
>
> On Monday after Michaelmas [October 1] I gave Tomaso Vincidor a whole set of prints to send for me to Rome to another painter in trade for Raphael's work. . . . The Bolognese [Vincidor] has drawn my portrait. He wants to take the portrait to Rome with him. [Vincidor's portrait of Dürer, now lost, is known from Andreas Stocker's engraved reproduction made in 1629].

Dürer also drew the portrait of the Bruges painter, Jan Provost, with charcoal, and acquired from Dirk Vellert ("Master Dietrich the glasspainter") an interesting new pigment, "the red color that one finds at Antwerp in the new bricks."

Dürer witnessed another great public spectacle—the Triumphal Entry of Charles V into Antwerp—but, having purchased the printed program composed by Peter Gillis and Cornelius Grapheus, he felt it unnecessary to describe the thirteen tableaux which lined the parade route.[110] We know from the program itself, however, that the first of these represented the Genius of Antwerp welcoming Charles, together with the Three Graces, hand in hand, with the golden apple, all on a stage held up by two columns, between which were found the allegorical figures of Faith and Love. Then followed other tableaux featuring Jupiter enthroned between Right and Might; the Emperor accepting Piety and rejecting Impiety; the Emperor accompanied by Prudence, Justice,

Clemency, Truth, and Munificence; Philologia and Mercury (the god of Commerce) with Barbarism and Ignorance at their feet; the young emperor as Hercules at the Crossroads, embracing a woman dressed as Pallas Athena and rejecting Luxury, Indulgence, and Drunkenness; and a palace, wherein Eudoxia, Victoria, Honor, and Majesty paid tribute to the Emperor while trampling on Infamy. A twelfth tableau represented the Apotheosis of the Emperor, with Death in a pit underneath, and finally, in the thirteenth, the Emperor was shown embracing Europa, while holding out a helping hand to Greece (shown dying), while Asia and Africa knelt to plead for freedom; Peace defeated War, and two generals carried the heads of Mohammed and the Sultan on the tips of their lances. Of this spectacle, which Martin Luther was to denounce as an egregious example of Pride, Dürer commented briefly but warmly on the splendid decorations and the beautiful girls, "the like of which I have never seen."

Dürer also undertook a new field of endeavor during this period— architectural design—when he "had to draw a plan for [Margaret of Austria's] physician, for him to build from. For drawing that, I would not take less than ten gulden." He also noted that he had given a complete set of his prints to Margaret herself, and had "drawn her two pictures on parchment, with the greatest pains and care, that are worth 30 gulden."

Dürer also bought both the Condemnation of Martin Luther issued by the Theological Faculty of the University of Cologne, and some Lutheran broadsheets in dialogue form.

And he dined four times with his wife, and Rodrigo gave them another parrot.

> I have seen at Antwerp the bones of the Giant [Brabo]. His thigh is 5½ *werkschuhe* long and extraordinarily heavy and very thick, as are his shoulder blades—a single one is broader than a strong man's back—and the same with his other limbs. And the man was 18 *schuhe* tall, and had ruled at Antwerp and done miraculous things, as is described in an old book written by the city fathers. . . .
>
> Item: I gave Herr Niclaus Ziegler [of Nördlingen, Charles V's Vice Chancellor, who later countersigned Dürer's pension] a Christ lying dead, it is worth 3 gulden. The Portuguese Factor's painted child's head is worth 1 gulden. I gave 10 st. for a buffalo horn. I paid 1 gold gulden for an elk's foot.

# XIV

## THE CORONATION OF
## CHARLES V

ON OCTOBER 3, 1520, Dürer left Antwerp for Aachen, traveling with the Nuremberg delegation to the coronation of Charles V, and leaving Agnes and the maid at Jobst Planckfeldt's inn in Antwerp. The party traveled on horseback by way of Maastricht and Gulpen, reaching its destination in three days. Since the Coronation would not take place until October 23, sixteen days hence, and his living expenses were being taken care of by his traveling companions, this period was, even more than the previous trip to Brussels, a vacation for Dürer. There was plenty of leisure time for sight-seeing in the octagonal palace chapel built by Charlemagne, as well as in the medieval City Hall where the Coronation would take place. Dürer, who was by now something of an authority on Charlemagne, correctly identified the two columns of red and green porphyry brought by the first Holy Roman Emperor from Italy (though not from Rome, as Dürer thought, but from Theodorich's palace in Ravenna), and he noted astutely that they are "correctly made according to Vitruvius's writings" (*De architectura libri* x, Books 3 and 4). He drew the City Hall in his silverpoint sketchbook (W.764), viewing it from the northwest, and from the Throne Room he drew a view of the Palatine Chapel (W.763), which he could see from the window. He also viewed the chapel Treasury with its important collection of holy relics in their medieval reliquaries of gold, silver, crystal, and cloisonné. He was particularly struck by the relics of the Virgin Mary's chemise and girdle, but in a lapse of memory mistook the arm reliquary of Charlemagne for that of the Emperor Henry II, who is entombed in the Bamberg cathedral (both emperors had been elevated to sainthood in the twelfth century).

In view of Dürer's deep respect for Martin Luther, whose opinion on the subject of relics is well known, his inspection of the relic collection at Aachen may seem strange or even hypocritical to the modern reader. He made no mention of having attempted to obtain the indulgences which normally accompanied the viewing of relics, however, and which,

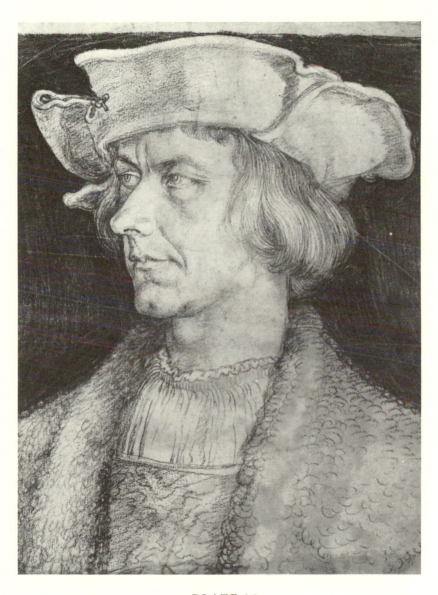

—— PLATE 25 ——

Dürer. *Portrait of a Man* (Lazarus Spengler?). 1518. Charcoal.
London, British Museum.

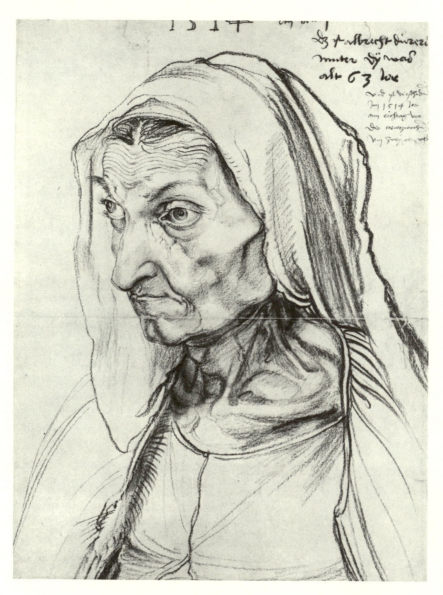

—— PLATE 26 ——

Dürer. *Portrait of the Artist's Mother at the Age of Sixty-three*. 1514. Charcoal.
Berlin, Staatliche Museen Preussischer Kulturbesitz, Kupferstichkabinett.

PLATE 27

Dürer. *Antwerp Harbor.* 1520. Pen and ink. Vienna, Albertina.

PLATE 28

Dürer. *Sketches of Animals and Landscapes.* 1521. Pen and black ink; blue, gray, and rose wash. Williamstown, Mass., The Sterling and Francine Clark Art Institute.

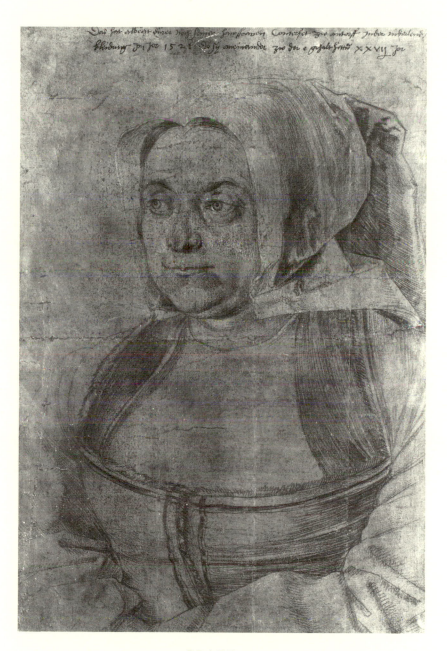

Dürer. *Portrait of Agnes Dürer in Netherlandish Costume*. 1521.
Metalpoint on gray-purple primed paper. Berlin, Staatliche Museen
Preussischer Kulturbesitz, Kupferstichkabinett.

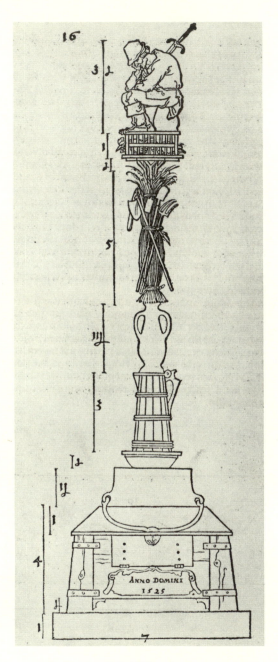

_____ PLATE 30 _____

Dürer. *Design for a Monument to a Dead Peasant*. 1525. Woodcut. Berlin, Staatliche Museen Preussischer Kulturbesitz, Kupferstichkabinett.

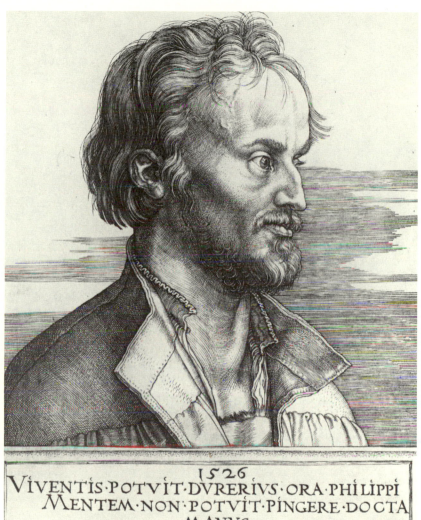

VIVENTIS·POTVIT·DVRERIVS·ORA·PHILIPPI
MENTEM·NON·POTVIT·PINGERE·DOCTA
MANVS

———— PLATE 31 ————

Dürer. *Portrait of Philipp Melanchthon*. 1526. Engraving. The University
of Wisconsin, Madison, Elvehjem Museum of Art.

——— PLATE 32 ———

Dürer's grave, Nuremberg, Cemetery of St. John.

rather than the preservation of the relics themselves, constituted the practice toward which Luther's ire had been directed in the Ninety-five Theses. Indeed, Dürer's reference to the collection at Aachen is extremely brief, in light of the number and nature of items known to have been on view there, and it is entirely possible that his primary objective in visiting the collection was to be seen by the Emperor's men to have done so; it is worth noting that he also bought a rosary during his stay in Aachen, and that a few days later, when the court had moved to Cologne, he viewed the relics of St. Ursula and her eleven thousand virgins there, and gave his rosary to one of his Nuremberg companions after buying a Lutheran pamphlet.

Dürer's activities in Aachen also included making portrait drawings—some of them he drew in silverpoint in his own sketchbook—Paulus Topler and Martin Pfinzing, both of Nuremberg (W.761), and Caspar Sturm of Oppenheim (W.765), whom Charles V was to appoint as Imperial Herald four days after the Coronation and was at present attached to the court of Cardinal Albrecht von Brandenburg. It was he who later accompanied Martin Luther from Wittenberg to attend the Diet at Worms in the spring of 1521, and it is thought that he was the author of an anonymous pamphlet describing Luther's hearing before the Emperor.

Other portraits, done in charcoal, were gifts to the sitters in gratitude for hospitality—like the drawing of twelve-year-old Christoph Groland, evidently a present for his father, and that of Dürer's host, Peter von Enden, a former mayor of Aachen.

One of the chief attractions of Aachen was its wealth of hot sulphur baths, thirty-eight in all, which were thought from Celtic times to have healing powers, and are still sought out by sufferers from rheumatism, gout, and other infirmities. It was these very waters which had attracted Charlemagne himself to the site, and the baths which he constructed beneath his palace, large enough to accommodate the Emperor and one hundred of his bodyguard, were still in use.[1] Dürer and his companions availed themselves of these therapeutic springs on at least two, and probably three occasions. (It is unclear whether his second reference refers to the same bath as the first, although one is recorded in Flemish and the other in Rhenish currency). He also had to send his laundry out, since he was beyond the range of Susannah and her washtub.

Another unaccustomed and daring activity for Dürer was gambling. He mentions with increasing frequency throughout the coming winter,

both on this trip and after his return to Antwerp, the fact that he has lost such and such a sum "at play." (Only once, back in Flanders, does he report having been the winner). He does not disclose the form, or possibly forms, of play at which he was so inept, but games of cards as well as those of dice were current in the early sixteenth century, just as in modern times they are a feature of life in European spas, and Cologne and Wesel were centers of playing-card manufacture. Dürer's decision to participate in games played for money was perhaps a function of his having become the companion of the wealthy "lords of Nuremberg," since there is no earlier reference in his writings to such activity.

## THE CORONATION

Item: on October 23 King Carl was crowned at Aachen. There I saw all manner of lordly splendor, the like of which no man now alive has ever seen—all as it has been described.

As in the case of Charles V's triumphal entry into Antwerp, Dürer here relied on the official published program as his aide-mémoire. He does note, however, that he gave two gulden worth of his prints to a man named Matthes, whom some have sought to identify with Matthias Grünewald, Albrecht von Brandenburg's court painter. And on a side trip to Jülich, he paid four stuivers for "two eyeglasses."

## COLOGNE: OCTOBER 28–NOVEMBER 14

Then on Friday before Sts. Simon and Jude's [October 26] I left Aachen and traveled to Düren, and was in the church where St. Anne's head is. From Düren we went on and came to Cologne on Sunday, Simon and Jude's Day [October 28]. I had lodging, food, and drink at Brussels with my lords of Nuremberg, and they would take nothing from me for it. Likewise I ate with them for three weeks at Aachen, and they have taken me to Cologne with them and will accept nothing in payment for it.

Dürer, who had been the guest of the Nuremberg delegation during the events of the Coronation in Aachen, was taken by them to Cologne where the grand ball and the coronation banquet were to be held in the Imperial "dancing house" (the Gürzenich). While there he seems to have lived for at least a part of the time at the home of his cousin Niclas, since he presented gifts to his cousin's family and servants on leaving,

mentioning that "they have been to a good deal of trouble on my account."

While waiting to receive the Emperor's verdict on his petition for the renewal of his pension, Dürer had time for shopping—another Lutheran pamphlet and a second copy of the University of Cologne's condemnation of Luther were two of his purchases.

> I have bought a tract of Luther's for 5 weisspfennigs. And I spent another weisspfennigs for the Condemnation Lutheri, the pious man. [*Condemnatio doctrinae librorum Martini Lutheri per quosdam magistros Lovanienses et Colonienses facta cum responsione Lutheri*.] Also 1 weisspfennig for a paternoster [rosary]. Also 1 weisspfennig for a belt. Also 1 weisspfennig for 1 pfund of candles. I have changed 1 gulden for expenses. I had to give my large ox-horn to Herr Leonard Groland [one of the "lords of Nuremberg" with whom Durer was traveling]. And to Herr Hans Ebner [another of the "lords"] I had to give my big cedarwood rosary. I gave 6 weisspfennigs for a pair of shoes. I gave 2 weisspfennigs for a little death's head. I spent 1 weisspfennigs for beer and bread. Also 1 weisspfennigs for *enspertelle*. I gave messengers 4 weisspfennigs I gave 2 weisspfennigs to Niclas's daughter [Dürer's niece] for *weckenspitzlein* [a special local pastry baked for All Saints' Day, according to Hans Rupprich].

He "had to give" his prized ox-horn and cedarwood rosary to two of the members of the Nuremberg delegation who had been his hosts in Aachen and who would take no reimbursement.

In Cologne he was staying with his cousin's family, where his role was that of the well-to-do relative. Although Niclas was a goldsmith in a wealthy archiepiscopal city, he was getting on in years (he had been a master goldsmith since 1482), and may never have fully recovered from his misadventure in 1505. Niclas had then lived in Nuremberg, where he owned a home by the Malertore, but spent a great deal of time on the road, selling his goldwares as far away as Lübeck and Magdeburg. In 1505 he had been kidnapped and imprisoned by the henchmen of Graf Asmus von Wertheim while carrying five thousand florins' worth of gems from Nuremberg to Cologne. After his eventual ransom by the Nuremberg City Council, whom he was required to reimburse, he had moved, impoverished, to Cologne. Dürer was sensitive to his cousin's plight, and did his best to be a considerate guest. As we have seen, he had already given Niclas his own black coat on his previous visit.

In Cologne, Dürer drew more portraits, designed a coat-of-arms on a woodblock for Lorenz Staiber, and viewed the sights of Germany's old-

est and largest city. These last included a visit to the City Hall, at which time he paid a small sum to have Stefan Lochner's *Altar of the Patron Saints* opened for viewing. It is only thanks to Dürer's notation that "Master Steffan" had painted this triptych that it was possible for Lochner's life and oeuvre to be reconstructed, since, like the majority of Cologne artists of the late middle ages, Lochner had signed none of his work.

Another famous tourist attraction he visited was the church of St. Ursula, with its vast and macabre treasury of the supposed relics of the martyred princess and her eleven thousand virginal ladies-in-waiting, whose bones line the interior of the sacristy. He also drew the portrait of a nun (Paris, Fondation Custodia) and recorded an unusually large sum for the purchase of candles, although without revealing whether these were for votive use—his petition was still pending, after all—or simply for illumination at his cousin's house.

Finally, on November 12, the Imperial order granting Dürer his pension, signed by Charles V and countersigned by Cardinal Albrecht von Brandenburg, was forwarded to him by way of the lords of Nuremberg. It was perhaps in foreknowledge that Albrecht von Brandenburg's endorsement would be necessary—for, in his capacity as Archbishop of Mainz he was also Chancellor of the Reich—that Durer had taken the precaution in 1519 of making him a present of two hundred impressions of his engraved portrait (The Small Cardinal, B.102), together with the plate, which the Cardinal subsequently used as the frontispiece for his *Halle Relic Book* of 1520.

> Item: Herr Hans Ebner and Herr Niclas Groland would take no payment from me for 8 days at Brussels, 3 weeks at Aachen, and 14 days at Cologne. I have drawn the nun, and given the nun 7 weisspfennigs. I gave her 3 half-sheet engravings.
>
> [November 12] My confirmation [of the pension] from the Emperor came to my lords of Nuremberg for me on Monday after St. Martin's Day in the year 1520, after great trouble and labor. I gave Niclas's daughter 7 weisspfennig at leaving, and have given Niclas's wife 1 gulden and the daughter 1 ort more on leaving, and I started away from Cologne. Before that Staiber had me once as his guest, and my cousin Niclas one time, and the old Wolfgang once, and once more besides I have eaten as his guest. I gave Niclas's man a *St. Eustace* for a leaving present, and his daughter I gave an ort, because they have been to much trouble on my account.
>
> . . . And I left Cologne by ship, early on Wednesday after St. Martin's.

Two days after receiving the good news of the Emperor's favorable decision on renewing his entitlement to an old-age pension, Dürer left Cologne by riverboat, returning to Antwerp by way of the northern Netherlands. Having taken his leave of the Nuremberg delegation to the Coronation, which remained behind in Cologne, he paid his own expenses and made new friends, drawing portraits from time to time.

Dürer's route took him through the "little towns" of Düsseldorf and Duisburg, which were then mere fishing villages, and into the territory corresponding to the east of the modern Netherlands by way of Wesel—the home of the engraver Telman de Wesel "op den dik" ("on the dijk"), an engraver of playing cards and somewhat inept copyist of designs by Dürer—and Emmerich, where the passengers were forced to land because of a dangerous windstorm. He finally reached the ancient Carolingian city of Nijmegen on November 18. From Nijmegen, where Dürer had admired Charlemagne's fortress and its chapel, the route lay westward toward Tiel where, according to Dürer, "we left the Rhine" (he had already left the Rhine above Nijmegen without noticing it, and was now on the river Waal) "and traveled on the Maas to Terawada [Heerwarden]." From there, when another storm arose, Dürer and his companions rented plow-horses to ride to 's-Hertogenbosch ("Pusch").

Although he spent the entire evening in 's-Hertogenbosch—an overnight stop—was feted by the local goldsmiths, and remarked on the excellence of the fortifications as well as the beauty of the Church of St. John, Dürer made no mention of artworks by Hieronymus Bosch, who had died in the summer of 1516. If he was shown the interior of the Church of St. John, which is not unlikely, since it is one of the very few stone churches in the Netherlands built in the Gothic style—he could not have helped but see the stained glass window, chandelier, and several altarpieces by Bosch which were then still in situ.[2] According to seventeenth-century sources, the high altar held a *Creation of the World* by Bosch, and the Mary altar an *Adoration of the Magi*, while a number of Old Testament scenes—probably painted wings for a carved altar—were on the altar of St. Michael. The superb carved wooden altar by Adriaen van Wesel, made in the mid-1470s, would have been in the wealthiest of the side chapels, that of the Confraternity of Our Lady.[3]

Leaving 's-Hertogenbosch by way of the picturesque village of Oisterwijk (still a summer resort today) and Tilburg, the traveling party had evidently settled in for the night at Baerle (whether Baerle-Duc or

Baerle-Nassau is not clear), for Dürer had already made his journal entry detailing his expenses there when his companions got into a disagreement with the innkeeper and either left of their own volition or were ordered to do so. The upshot was that they traveled "in the night" to Hoogstraten, stopping for only two hours' rest before proceeding to Antwerp.

They arrived on November 21, and Dürer discovered that his wife's purse had been cut off by a pickpocket in the Church of Our Lady while he was gone.

The other big news was that an unusually large whale had washed up on the beach at Zierikzee. Dürer set about arranging a trip to Zeeland to see the creature, but before he could do so, on December 10, it had washed out to sea again.

Meanwhile, in Antwerp, Dürer drew more portraits and sold more of his prints, and gave a dinner party for his friends.

On St. Martin's Day [November 11], in Our Lady's Church in Antwerp someone cut off my wife's purse, in which there were two gulden. The purse, besides what was in it, was worth 1 gulden, and some keys were in it, too.

Item: on St. Catherine's eve [November 24] I paid my landlord 10 gold cronen for my bill. I have eaten with the Portuguese this many times: jj. Roderigo gave me 6 Indian nuts, so I have given his boy 2 st. for a trinkgeld. Item: I have paid 19 st. for parchment. Item: I have changed 2 cronen for expenses. I have received 8 florins in all for 2 *Adam and Eves*, a *Meerwunder* [Sea Monster], 1 *Hieronymus*, 1 *Reuther* [Knight, Death and Devil], 1 *Nemesis*, 1 *Eustace*, 1 whole sheet, 17 etchings, 8 quarter-sheets, 19 woodcuts, 7 pieces of the "simple" woodcuts, 2 books, and 10 small woodcut Passions. Item: I gave the three large books for 1 ounce of fine lead-white [*schon loth*]. I have changed a Philipps gulden for expenses. . . .

Item: There is a whale at Zierikzee in Zeeland, blown up on land by a great *Fortuna* and storm wind, that is much more than 100 fathoms long. And no man now alive in Zeeland has ever seen one even a third as long as this is, and the fish cannot get off the land. The folk would gladly see it gone, for they fear the great stink [*den grosen gestanck*]. For it is so large that they think it could not be cut in pieces and boiled down for oil in half a year. Item: Steffan Capello [Margaret of Austria's jeweler] has given me a cedarwood rosary, and so I made his portrait. Item: I paid 4 stuivers for *kesselbraun* [wood soot for making bistre ink?] and a candle snuffer. I gave 3 stuivers for paper. I drew Felix [Hungersperg, W.819, Captain of the Imperial Guard and lutenist] in his book with the pen. Felix gave me 100 *estria* [oysters]. . . .

I have had as guests at dinner Tomasin, Gerhard, Tomasin's daughter, her husband, the glass-painter Honig [Hene Doghens], Jobst and his wife, and Felix. It cost 2 gulden. Item: Tomasin gave me 4 ells of grey damask for a doublet. I have again changed a Philipps gulden for expenses.

## THE TRIP TO ZEELAND: DECEMBER 3–14, 1520

On St. Barbara's Eve [December 3] I rode away from Antwerp toward Perng [Bergen op Zoom, in North Brabant]. I paid 12 st. for the horse and spent 1 gulden 6 st. there. Item: at Bergen I bought my wife a thin Netherlandish cloth for the head; it cost 1 gulden 7 st. I spent 6 st. more for 3 pairs of shoes. A stuiver for eyeglasses, and 6 st. more for an ivory button I gave 2 st. for tips. . . .

I drew Jan de Has [Dürer's landlord in Bergen], his wife, and his two daughters with charcoal, and the girl and the old woman I drew with the silverpoint in my sketchbook [W.771, inscribed "zu Pergen feuertag"].

Early in December Dürer left Antwerp for an eleven-day trip to Bergen op Zoom and the islands of Zeeland. As a native of Germany's most landlocked city, he can scarcely have been expected to realize what an inopportune time of the year this was for such a venture, for it is in the dark days before Christmas that the cold winds and icy rains from the North Sea are at their worst. During this trip he became thoroughly chilled, and had his first severe attack of the sickness which continued to plague him for the remaining eight years of his life. Although he did not report in full on his illness in his journal at this time, he does admit in the entry for April 14–20 that it was at this time that he was first disabled by the combination of "hot fever, great weakness, nausea, and headache." The sickness, which cannot be identified with certainty, has the symptoms of malaria.

On Our Lady's eve [December 7] I started with my companions for Zeeland, and Sebastian Imhoff loaned me 5 gulden. And the first night we lay at anchor in the sea; it was very cold and we had neither food nor drink.

On Saturday [December 8] we came to Goes ["Gus"]; there I drew a girl in her Zeeland costume [*ein Dirn in ihrer Manir*; W.770, Chantilly, Musée Condé]. From there we went to Arnemuiden ["Erma"] and I laid out 15 st. for expenses. We passed by a sunken place and saw the tops of the roofs sticking up out of the water. And we went by the little island of Wolfersdijk and steered for the little town of Kortgene on another nearby island. Zeeland has 7 islands, and Arnemuiden, where I spent the night, is the largest.

From there I went to Middelburg. . . . After that I went to Veere [on the

island of Walcheren] where ships come to port from all lands. It is a very
fine little town.

Dürer had gone to Zeeland by way of Bergen op Zoom, apparently
traveling with a party that included Sebastian and Alexander Imhoff.
After riding on horseback to Bergen, on the shore of the wide arm of
the eastern Schelde which flows past Zierikzee—the site of the beached
whale, which by now had washed away—into the North Sea. Bergen in
Dürer's day was an important trading center, the site of two annual fairs
serving as outlets for unbleached English woollen cloth, which was then
dyed on the spot and transshipped to central Europe. Bergen's financial
fortunes were destined to rise within the next few years under the aegis
of the new Emperor, for Charles V's policies favored Flemish and Dutch
trading cities at the expense of the Hanseatic League.[4]

One of Dürer's first items of business in Bergen was to purchase a
Netherlandish headdress for Agnes; later, on their twenty-sixth wed-
ding anniversary, July 7, as they were leaving for home, he made a metal-
point portrait drawing of her on dark violet-grounded paper, which
shows her wearing the headdress (Plate 29).

Another purchase was a second pair of eyeglasses: had those pur-
chased previously on the trip to Cologne perhaps proved unsatisfactory,
or had Agnes demanded a pair of her own?

Using a broad-beamed Dutch sailing ship as their base of operations,
Dürer and his companions toured the seven islands of Zeeland, stop-
ping to inspect the towns of Goes, Middelburg, and Veere. It was in the
harbor of the island of Arnemuiden that disaster nearly overtook Dürer,
when the unmanned ship broke its mooring line in a sudden gale and
was swept out toward the open sea. Dürer's own presence of mind in
coming to the captain's assistance can be credited with saving the ship
and its remaining passengers from almost certain destruction. (This ad-
venture was later to be compared to Christ's stilling the storm on the
Sea of Galilee in a transparency designed by Dürer's Nazarene followers
of the 1820s.)

But at Arnemuiden, where I landed before, a great misfortune happened
to me. As we were coming in for a landing and throwing out our mooring
rope, a great ship rammed us so hard, and as we were just getting out of the
boat, where in the crush I had let everyone else get out before me, so that
nobody but me, Georg Kunczler [of Nuremberg], 2 old women, and the
skipper with a small boy remained in the boat. When now the other ship
bumped against us, and I was still in the boat with the others named, and

could not get out, our mooring line broke, and in the same moment a
strong stormwind forced our ship backward with great power. We all cried
out for help, but no one would risk himself for us. And the wind carried us
away out to sea. Then the skipper tore his hair and cried aloud, for all his
men had landed and the ship was unmanned. Then we were in fear and
danger, for the wind was great and there were only six people in the ship.
So I spoke to the skipper and said he should take heart and have hope in
God, and think over what was to be done. He said, if he could haul up the
little sail he would try [to see] if we could come to land. So with difficulty
we helped one another and got it at least halfway up and went on again
toward the land. And when the people on shore, who had already given us
up for lost, saw how we helped ourselves, they came to our aid and we came
to land.

At medieval Middelburg (not the town constructed in the fifteenth
century by the largesse of Peter Bladelin, Rogier van der Weyden's cli-
ent) Dürer saw and commented somewhat tartly upon the large altar of
the Deposition painted in 1518–1520 by Jan Gossaert, called Mabuse ("Jo-
hann de Abus"). This work, which was destroyed by fire in 1568, he pro-
nounced "not so good in the drawing as in the coloring"—a verdict
which would surely have pained Gossaert, whose reverence for Dürer's
prints is well known. In 1520 Gossaert was living in Wijk bij Duurstede
as court painter to the Bishop of Utrecht, and there is no record of his
having met Dürer personally; however, Gossaert suddenly took up
printmaking shortly after Dürer's departure from the Netherlands, and
the two men had similar interests in antique sculpture and had a number
of friends and acquaintances in common, including Jacopo dei Barbari,
Bernard van Orley, and Lucas van Leyden.[5] Gossaert, a younger man
than Dürer (thought to have been born between 1478 and 1488), had
already enjoyed the favor of such exalted patrons as Charles V and Mar-
garet of Austria, a fact which may well have come to Dürer's attention.
In any event, Dürer's critical opinion of the Middelburg altarpiece was
not shared by others: an eyewitness account of the destruction of the
Middelburg Abbey and its altarpiece by the iconoclasts alleges that the
painting had taken Mabuse fifteen years to complete, and was reputed
to be the most beautiful picture "in all Europe," valued by the Polish
ambassador at eighty thousand ducats.

But Middelburg is a good town, and has a most beautiful town hall
[newly built, 1512, by Rombout Keldermans]. There is much art shown in
all things there. There is an exquisite choir stall in the Abbey and a splendid
stone gallery, and also a pretty parish church. And besides, the town was

excellent for sketching. Zeeland is pretty and wonderful to see because of the water, for it [the water] stands higher than the land.

. . . And early on Monday morning [December 10] we went back to the ship and left for Veere and Zierikzee. We wanted to see the great fish, but *Fortuna* had carried it away again. [Dürer always thinks of "luck" as Italian.] I paid 2 gulden for fare and expenses and 2 gulden for a koczen [woollen cover]. . . . And we have come back to Bergen. . . .

I gave the guide 3 st. and spent 8 st. and came back to Antwerp to Jobst Planckfeldt's on Friday after St. Lucia's Day, 1520 [December 14]. And for the times I have eaten with him [Jobst] it is paid, and for my wife it is also paid.

# XV

## THE LAMENT FOR
## MARTIN LUTHER

I made the Fuggers' office manager's family a drawing for a mummer's mask, and they gave me an angelot. . . . I made two sheets full of beautiful drawings of mummers' costumes [mummery] for Tomasin. I painted a good Veronica face in oils, that is worth 12 gulden; I gave it to Francisco, the Portuguese Factor. After that I painted S. Fronica [Veronica] in oil colors, better than the previous one, and gave it to the Factor Brandan of Portugal. Franciscus [Pesao] gave the maid [Susannah] 1 Philipps gulden *trinkgeld* for New Year's, and afterward, because of the Veronica, he gave her 1 gulden more.

**D**ÜRER'S journal entries for late December of 1520 and for the first weeks of the new year consist largely of brief references to the expenses of daily life, the receipt of gifts, and to the making of a wide variety of things, from portrait drawings and coats of arms to, late in January, drawings for masquerade costumes for the grand *mardi gras* festivities. As spring approached, he made Tomasin "a drawing to use when he has his house painted."

His most notable art works for this period which can still be identified are the half-length oil painting of *St. Jerome* (Lisbon, Museo del Arte Antigua) which he gave to his Portuguese friend Rodrigo, the drawing of a twenty-year-old black woman (*morin*) named Katherine (Florence, Uffizi), and the oil portrait of the young merchant, Bernhard von Reesen of Danzig (also known, wrongly, as Bernhard von Resten; Dresden, Gemaldegalerie).

Other works, which have been lost, included several small paintings— two of St. Veronica (was this what he did with his drawing of the nun from Cologne?) and one of a child's head, as well as a small painting representing "a duke," which may or may not have been a portrait. Dürer also made a present of "a seated St. Nicolas" to the "largest and richest merchants' guild" in Antwerp—namely, the Haberdashers (for Antwerp was Europe's fashion center in 1520). The Haberdashers owned

the Altar of St. Nicholas in the Antwerp Cathedral, and their guild records indicate that Dürer's St. Nicolas was a design for an altar cloth.[1]

Dürer was quick to make the acquaintance, and the portrait, of the new Portuguese consul, Francesco Pesao, who had arrived in Antwerp to replace Brandao, and dined with "the Portuguese" on seven occasions.

With increasing frequency, Dürer mentions having received gifts of sugar and quince confections, and of sandalwood and "French wood," or Lignum guaiacum, all of which were used for medicinal purposes in the sixteenth century. Quince compote and sandalwood were recommended for the reduction of fever, while "French wood" was regarded as a treatment for syphilis. One of Dürer's Portuguese friends also gave him myrobolans, an East Indian fruit recommended in the *Hortus Sanitatis* for "strengthening the heart, the liver, and the limbs." Dürer's large gift of prints to "doctor Loffen" should probably be interpreted as a medical expense as well. This entry probably refers to Dr. Luppin, who formerly had been the personal physician to the old Emperor, Maximilian.[2]

The highlights of the winter season, in addition to Dürer's sole recorded victory at cards (two gulden, won from Herr Bernhard von Castell), were the banquet of the Goldsmiths' Guild on February 10, to which Dürer and Agnes were invited, and the Shrove Tuesday banquet and masquerade given by Thomas Lopez, the former Factor of Portugal, who was now an Imperial Ambassador. Dürer, who was evidently a last-minute addition to the guest list on Monday night, attended this affair alone.

> [February 10]: Item: On Carnival Sunday the Goldsmiths invited me to an early dinner with my wife. In their company were many gallant people. They had prepared a most splendid meal and did me exceeding great honor. And in the evening the old Bailiff of the town [Gerhard van de Werve] invited me and gave a splendid dinner and did me great honor. Many remarkable mummers came there. I drew Flores [Florent Nepotis], Frau Margaret's organist, with the charcoal.
>
> On Monday night Herr Lupes [Thomas Lopez] invited me to a great banquet on Shrove Tuesday which lasted until 2 o'clock and was very costly. Item: Herr Lorenz Sterck gave me a Spanish fur. And to the above-mentioned feast came many splendid mummers and especially Tomasin Bombelli [whose costume Dürer had designed].
>
> I won two gulden at play. . . . [!—Ed.]
>
> I drew the portrait of Bernhard von Castell, from whom I won the

money, with the charcoal. . . . I made a portrait in black chalk of Master Jan [Jean Mone of Metz], the good marble sculptor who looks like Christoph Kohler [of Nuremberg]. He studied in Italy and comes from Metz.

Another social engagement of no little interest during this period was a dinner with Peter Aegidius and his friend Erasmus of Rotterdam, both of whom Dürer had met soon after his arrival in the Netherlands.

With the arrival of spring, Dürer's spirits seemed to revive. He climbed the newly completed tower of Our Lady's Church of Antwerp, for the sheer joy of viewing the city—a thoroughly humanistic enterprise. He also began to think of returning home, and made a number of purchases which were gifts for Nuremberg friends and their wives, and he found buyers for prints by his former students Hans Schäufelein and Hans Baldung Grien.

Finally, as Easter approached, he paid his confessor ten stuivers in preparation for receiving the obligatory Easter sacrament.

By mid-March, he was sending his excess baggage home, packed in barrels, by way of the Imhoffs.

I have made a good portrait of Cornelius [Cornelius Grapheus], the Secretary of Antwerp, with chalk [*stain kraiden*]. I paid 3 gulden for the 5 silk sashes, which I will give as presents. And 20 st. more for a border [trimming]. I have given the 6 borders [in the bale] to Caspar Nutzell's wife [Clara], Hans Imhoff's wife [Felicitas Pirckheimer], the two Spengler ladies [Ursula, wife of Lazarus Spengler, and Juliana, wife of Georg], the Löffelholzin [Katherina, wife of Thomas Löffelholz, was Agnes Dürer's aunt], and to each a good pair of gloves. I have given Pirckheimer a large beret, an expensive inkstand made of buffalo horn, a silver *Kaiser* [coronation medal], 1 pound of pistachios and 3 sugarcanes. I gave Caspar Nutzell a great elk's foot and 10 large pinecones with pine nuts. I gave Jacob Muffel a scarlet scarf [*prustuch*] an ell long. To Hans Imhoff's child a scarlet embroidered beret and pine nuts; to Kramer's wife [Pirckheimer's widowed neighbor] 4 ells of Italian silk worth 4 gulden; to Lochinger's wife [Hans Lochinger] 1 ell of Italian silk worth 1 gulden; to each of the Spenglers a purse and 3 fine horns; to Herr Hieronymus Holzschuher a huge horn.

I have eaten twice with the Factor. I have eaten with Master Arion [Adriaen Herbouts], the Antwerp Secretary; he gave me the small painted panel that Master Joachim [Patinir] made, it is *Lot and his Daughters*. I have received 12 gulden from art sales. Also, I sold some of Hans [Baldung] Grün's work for 1 gulden. . . .

Item: I painted Bernhard von Resten's portrait in oils. He gave me 8 gulden for it and gave my wife a crona and Susannah 1 gulden, worth 24 st.

I have given 3 st. for the *Swiss War* [the series of engraved panoramas by Master P.W. of Cologne?]. And I paid 2 st. for the ship [either a model or perhaps an engraving of a ship]. Also 3 st. for a case. And 4 st. more for the confessor.

## THE TRIP TO BRUGES AND GHENT: APRIL 6–11, 1521

Dürer's trip by boat to Bruges and Ghent with Hanns Lüber and the painter Jan Provost, although brief, is of particular interest for its value judgments on both contemporary Flemish art and the works of the "old masters—the Van Eyck brothers, Rogier van der Weyden, and Hugo van der Goes—as well as for its revelations about the honors paid to Dürer by the painters and goldsmiths of both cities.

One of Dürer's traveling companions, Hanns Lüber, afterward became a member of the City Council in Ulm. The other, the Flemish painter Jan Provost, despite Dürer's generous description, was really a rather mediocre painter, about six years older than Dürer, whose paintings are a mixture of the styles of Quentin Massys and Gerard David. Thrice married—once to Simon Marmion's widow—he had risen rapidly in the Bruges painters' guild, and had been Dean in 1519. He was destined for still further honors after the death of David (1523). Dürer's silverpoint portraits of Provost and his wife, who put him up overnight in their house in the Oost-Ghistelhofstraat in Bruges, have not survived.

Item: On Saturday after Easter [April 6, 1521] I traveled on the Scheldt with Hanns Lüber [of Ulm] and with Master Jan Prevost [Jan Provost], a good painter born in Bruges, from Antwerp to Bruges ["Prüg"]. . . . it is a noble and beautiful city. I paid 20 and 1 st. for fare and other expenses.

And when I arrived in Bruges, Jan Provost took me to stay at his house, and the same night prepared a delicious meal amd invited many people to meet me. Next day [April 8] Marx [de Glasere] the goldsmith invited me, and gave me a costly meal and invited many people to meet me. After that they took me to the Kaiser's house [the Prinsenhof]. It is large and splendid. There I saw Rudiger's [Rogier van der Weyden's] painted *cappeln* and paintings by a great old master; there I gave the boy 1 st. to open them up.

. . . Then they took me to St. Jacob's and let me see the splendid paintings of Rogier [van der Weyden] and Hugo [van der Goes], who were both great masters.

After that I saw the alabaster *Marienbild* at Our Lady's Church, that Michael Angelo of Rome has made. After that they took me to many churches and let me see all the good paintings, of which there is an overflow there. And when I had seen the Johannes [van Eyck] and the other things, we

came at last to the chapel of the Painters' Guild, where there are good things.

After that they took me to a banquet. And from there I went with them to the guild hall, where they had brought many distinguished people together—goldsmiths and painters and merchants—and they made me have supper with them, gave me gifts and made my acquaintance, and did me great honor. And the two brothers Jacob and Peter Mostaert, the City Councillors, gave me 12 cans of wine, and the whole company, more than 60 persons, led me home with many lanterns. Also I have seen their shooting range with the big fish tank—it is 19 shoes long, 7 shoes high and 7 shoes wide.

Then on Tuesday [April 9] we went away. But before we left I drew Jan Provost and his wife with the silverpoint and gave his wife 10 st. at leaving.

. . .

And when I came to Ghent, the Dean of the Painters' Guild came to me and brought with him the most prominent painters; they showed me great honor, received me most nobly, offered me their good will and service, and ate supper with me. Early on Wednesday morning [April 10] they took me to the tower of St. John's: from up there I saw the great wonderful city, where I, too, had just been regarded as great. After that I saw the *Johannes tafel* [the Ghent Altar]; that is a most precious, thoughtful painting, and especially the Eva, Maria, and God the Father are good.

After that I saw the lions, and drew one with the silverpoint [W.781]. Also I saw on the bridge at the place where people are beheaded, the two statues in honor of a son who beheaded his father.

Ghent is a fine and a wonderful city: four great waters flow through it [the Schelde, Leye, Lieve, and Moere]. I gave 3 st. *trinkgeld* to the sacristan [at St. John's] and the lions' keepers. And I have seen many wonderful things in Ghent besides, and the painters with their Dean did not leave me alone, but have eaten with me night and morning and paid for everything and have been most friendly to me. But I gave 5 st. at the inn at leaving.

But early on Thursday [April 11] I left Ghent and came through some villages to the inn called the "Swan," where we ate breakfast. After that we went through a pretty village and came to Antwerp, and the fare was 8 st.

The sights which Dürer singled out for comment, as before, include exotic animals and belfry views, as well as works of art. As to paintings, he reserved judgment on works by such living painters as Gerard David, whose *Justice of Cambyses and Punishment of Sisamnes* was to be seen in the City Hall in Bruges, and he tactfully refrained from mentioning the work of his host Jan Provost: the only contemporary work he mentions is the alabaster Bruges Madonna by Michaelangelo, which can still be

seen in the church of Notre Dame. His highest praise, however, was bestowed upon the famous Ghent Altar ("the Johannes tafel"), which he saw in the Church of St. John the Baptist in Ghent (now St. Bavon's). He was fortunate enough to see it in morning light, when Jan van Eyck's lighting scheme shows to its best advantage, and was particularly struck by the figures of God the Father and the Virgin Mary. His admiration for these figures is understandable, since they prefigure Dürer's own breathtakingly realistic handling of textures. When it came to the nude figures of Adam and Eve, the future author of the *Four Books of Human Proportion* found the less venturesome figure of Eve superior to the highly detailed and individualized figure of Adam—quite the opposite of modern critical opinion.

## ANTWERP: APRIL 11–MAY 17, 1521

During the third week of April, Dürer suffered an attack of fever, nausea, headache, and debility which he recognized as a recurrence of the "strange sickness" that had overtaken him for the first time in early December, on his trip to Zeeland. He had deliberately omitted any mention of the first attack in the journal, perhaps because he did not wish to cause undue alarm to Agnes, or simply because he assumed that he was well again by the time his journal entries were made. This time, however, he realized the seriousness and the lingering nature of the disease, which signaled the onset of the ill health which would trouble him for the remaining seven years of his life.

> Item: in the third week after Easter [April 14–20] I was seized by a hot fever, great weakness, nausea, and headache. And before, when I was in Zeeland, a strange sickness came over me, such as I have never heard of from any man, and I still have this sickness. . . . I paid the doctor 8 st. and 3 st. to the apothecary. But I changed 1 gulden for expenses. But I spent 3 st. in company. I gave the doctor 10 st. Item: Rodrigo has given me many sweetmeats [*eingemachtes Zucker*] in my illness. I gave the boy 4 st. *trinkgeld*. I have drawn the portrait of Master Joachim [Patinir] with the silverpoint and have also made him another portrait with the silverpoint. But I have changed 1 crona for expenses. I again changed 1 gulden for expenses. Item: I gave the doctor 6 st. Item: 7 st. to the apothecary. I changed 1 gulden for expenses.

A new feature of his expense accounts of late spring and early summer was to be his frequent payments to doctors and apothecaries. The fact

that these are interspersed with references to normal social activities, including banqueting and travel, reinforce the impression that the disease was malaria, in particular, the form of the disease which was known in the sixteenth century as "quartan ague." The blood parasites which cause both forms of malaria are now known to be carried by the bite of the female *Anopheles* mosquito, with an incubation period of about two weeks between the time of the initial infection and the onset of the characteristic chills, fever, and sweating. Although the disease itself is rarely fatal, it causes chronic anemia when left untreated, resulting in increasing ill-health and eventually rendering the sufferer extremely vulnerable to attack by other diseases.

In spite of his illness, or perhaps between recurrences of the fever symptoms, Dürer felt well enough to attend Joachim Patinir's wedding, together with the two plays which were presented, and to draw and paint further portraits, including those of the Treasurer of Brabant, Lorenz Sterck, and of his host, Jobst Planckfeldt. He also dealt with packers and freight handlers who would see to the shipment of another bale of baggage bound for Nuremberg.

Dürer left a revealing account of the complexities involved in dressing well in the sixteenth century, for Antwerp, a city of nearly 200,000, was then the fashion center of Europe, with platoons of tailors and furriers ready to make clothing to measure for the customer who had come there to buy the yard goods for which the Netherlands had become famous.[3] His original drawings for the cloaks he designed for his wife and mother-in-law have survived (London, British Museum), but unfortunately we have no tangible record of his own elegant new "camlet" coat, other than the written account of his payments for the cloth, the thirty-four black pelts of Spanish fur, the velvet and silk trim, and the tailor's and furrier's wages, plus tips.

The entry of most historical interest in this section of the journal, on May 17, is Dürer's lament for Martin Luther,[4] occasioned by the false news of Luther's arrest which had been deliberately circulated in order to conceal the fact that the reformer had actually been kidnapped and placed in protective custody by order of Friedrich the Wise. Dürer was deeply distressed to learn—probably from Spengler, who attended the Diet at Worms as Nuremberg's ambassador—both of the Emperor's condemnation of Luther as a heretic, after the hearing in Worms, and of the rumor that, having been granted a safe-conduct to return to Saxony, he had been betrayed by the Emperor's men and very probably mur-

dered. In an uncharacteristically lengthy eulogy he inveighs against the papacy and calls (in vain, as it turned out) upon Erasmus of Rotterdam, that "aged little man," to sacrifice the remaining few years of his life in order to come to Luther's defense and "attain the martyr's crown." A more un-Erasmian gesture than the pursuit of martyrdom, of course, would be difficult to imagine, and it has often been pointed out that Dürer's disappointment with Erasmus over this issue was probably one of the main reasons for his six-year delay in finishing the engraved portrait of the sage of Rotterdam.[5]

## THE LAMENT FOR LUTHER: MAY 17, 1521

On Friday before Whitsunday in the year 1521 the news came to me in Antwerp that Martin Luther had been so treacherously taken prisoner; for he had trusted Kaiser Carol's herald [Caspar Sturm] with the Imperial safe-conduct. But as soon as the Herald had brought him to an unfriendly place near Eisenach, the Herald told him he no longer needed him, and rode away from him. Immediately there came 10 horsemen and they treacherously carried off the pious man, betrayed into their hands, a man enlightened by the Holy Ghost, a follower of Christ and the true Christian faith. And whether he is still alive, or whether they have murdered him, which I know not, he has suffered this for the sake of Christian truth and because he rebuked the unchristian Papacy, which strives with its heavy load of human laws against the redemption of Christ; and because we are so robbed and stripped of our blood and sweat, and that the same is so shamefully and scandalously eaten up by idle folk, while the poor and the sick die of hunger. . . . Ach, God of Heaven, pity us! O Lord Jesus Christ, pray for Thy people! . . . O God, redeem Thy poor people compelled by heavy ban and edict, which none willingly obeys, continually to sin against its conscience if it disobeys them. Oh God, never hast Thou so heavily oppressed a people with human laws as us poor folk under the See of Rome, who daily long to be free Christians, ransomed by Thy blood. O highest, heavenly Father, pour into our hearts, through Thy son Jesus Christ, such a light, that by it we may know what messenger we are bound to obey, so that with good conscience we may lay aside the burden of others and serve Thee, eternal, Heavenly Father, with light and joyful hearts.

And if we have lost this man, who has written more clearly than any that has lived for 140 years, and to whom Thou hast given such a spirit of the Gospel, we pray Thee, O Heavenly Father, that Thou wouldst again give Thy Holy Spirit to another, that he may gather Thy church anew everywhere together, that we may again live united and in Christian manner, and so, by our good works, all unbelievers as Turks, Heathen, and Calicuts, may

of themselves turn to us and embrace the Christian faith. But, Lord, ere Thou judgest, Thou willest that, as Thy Son, Jesus Christ, had to die by the hands of the priests, and to rise again from the dead and after to ascend up to heaven, so too in like manner it should be with Thy follower Martino Luther, whom the Pope with his money against God treacherously put to death, him wilt Thou also quicken again. And as Thou, O my Lord, ordainest thereafter that Jerusalem should be destroyed for that sin, so wilt Thou also destroy this self-assumed authority of the See of Rome. O Lord, give us then the new beautified Jerusalem, which descendeth out of heaven, whereof the Apocalypse writes; the holy, pure Gospel, which is not darkened by human teaching. May every man who reads Dr. Martin Luther's books see how clear and transparent his teaching is when he sets forth the Holy Gospel. Wherefore his books are to be held in great honor and not to be burned; . . . O God, if Luther is dead, who will henceforth deliver the Holy Gospel to us with such clearness? Ach, God, what might he not still have written for us in ten or twenty years? O all ye Christian men, help me to weep without ceasing for this man, inspired of God, and to pray Him to send us another such enlightened man. O Erasmus of Rotterdam, where will you stand? Behold how the wicked tyranny of worldly power, the might of darkness, prevails! Hear, thou knight of Christ! Ride on by the side of the Lord Jesus! Guard the truth. Attain the martyr's crown! You are such an aged little man. I have heard from you myself that you have but two years wherein you may still be fit to accomplish something. Turn them to good account for the good of the gospel and the true Christian faith, and make yourself heard. . . . O Erasmus, take your stand here so that God Himself may be your praise, even as it is written of David. For then may you accomplish something, and truly you may overthrow Goliath. . . .

Dürer's prayer is a plea for religious toleration, not simply for Luther's personal safety and for official recognition of the need for specific reforms which he had called for, but also for a more enlightened attitude toward the conversion of Turks, East Indians, and newly discovered West Indians. He also hoped for reconciliation of the See of Rome with the Greek and Russian Orthodox branches of Christianity as well. These sentiments, which seem surprisingly modern, are in reality a reflection of the medieval belief that the return of the Messiah would be heralded by the conversion of all the world to belief in Christ.

In view of the fact that Dürer's holograph manuscript has not survived, it has been suggested that liberties may have been taken with this passage by a later and more patently Lutheran writer. However, it must be borne in mind that Dürer was, indeed, one of the most eloquent men of his day, as his publications attest. He had a very intimate knowledge

of Luther's writings to date, as we know from his purchases of current pamphlets, his previous correspondence with Spalatin, and the reading list of Luther's works written in his own hand. He had dined and conversed with Erasmus of Rotterdam on several occasions, was the personal friend of Lazarus Spengler, who was later to persuade the Nuremberg City Council to opt for the Reformation, and was himself the person to whom—in 1521—Karlstadt dedicated his pamphlet on the symbolic interpretation of the Last Supper.[6]

Dürer's numerous references to the language of the Apocalypse come, of course, from the text of the Book of Revelation which was printed on the reverse sides of his own woodcut book, first published in 1498. His many references to Luther's interpretation of "the Gospel" (*Evangelium*) would be more easily explained had they been written after the publication of Luther's translation of the New Testament in September of 1522. It should be recalled, however, that Dürer presumably retained possession of the diary until the time of his own death in 1528, and that it then passed into the hands of his friend Pirckheimer, who had lost his own sympathy for the Reformation after 1525 and spent his last literary energies on an apologia for his sister's convent of St. Clara (*Oratio apologetica monialium nomine*, Nuremberg, 1530).

## ANTWERP: MAY 17–JUNE 7, 1521

During late May and early June, Dürer was still unwell, for he paid a total of four and one-half gulden (90 stuivers) for doctors and medical supplies, including two enemas administered by the apothecary's wife. He was able, however, to attend the Whitsuntide horse fair (May 21), where he seems to have sold prints.

He also mentions having witnessed two of Antwerp's most elaborate religious processions, on May 25 and 30, respectively. These, however, he probably viewed from Jobst Planckfeldt's inn, as he had done in the case of the procession on the day of the Virgin's Assumption, for the parade route led directly past the house. The procession on May 26 was the annual *Besnijdenisommegang* (Circumcision Procession), which honored the most remarkable religious relic in Antwerp, the foreskin of the Infant Jesus. The second procession, four days later, was for the Feast of Corpus Christi, which was a religious holiday of particular significance in Flanders because it had been established through the vision of a medieval Flemish nun—St. Juliana of Mount Cornillon (1193–1258). In

Dürer's day, attendance at both the Mass of Corpus Christi and the procession itself were heavily indulgenced: Dürer's notes show that Agnes must have attended the Mass and received the sacrament, for he paid eight stuivers to "the monk who confessed my wife." He makes no mention of his own confession, or of having gone to church himself.

Artworks which Dürer produced during these weeks included a set of four chiaroscuro drawings (*auff graw papir verhöcht*) of St. Christopher for his friend, the landscape painter Joachim Patinir. It is well known that Patinir, who was the first Netherlandish landscape specialist, sometimes collaborated with figure painters. Patinir painted at least one landscape which features a St. Christopher (El Escorial), but Dürer's four studies "on grey paper, heightened [with white]" have not survived.

At Whitsuntide, Dürer entertained Conrad Meit, Lady Margaret's German sculptor, whom he had met in Mechelen. He also paid a small sum for "Italian art"—probably engravings—and bought a miniature depicting Christ as the Salvator Mundi from Susanna, the talented daughter of Gerard Horenbout, remarking that "it is a great wonder that a woman can do so much." Susanna Horenbout (1503–1545) later emigrated to England, where she became a favorite at the court of Henry VIII, and married the King's Treasurer, John Parker. Dürer's generous impulse in buying the miniature for the substantial sum of one guilder—a fee which he considered appropriate for one of his own charcoal drawings—is somewhat offset by his incredulity here. It is quite possible that his views on women and their supposed abilities, or lack thereof, may help to account for the less-than-enthusiastic reception which Margaret of Austria gave him on June 7.[7]

As Dürer prepared to leave Antwerp, sending further belongings ahead in care of Hans Imhoff, he began to take stock of his business transactions and to realize that, in many instances, people had taken advantage of his good nature, for he had "done many drawings and other things to serve different people, and for the most of my work have received nothing." He was later to discover that Jan, the goldsmith from Brussels had cheated him (June 8), and was to receive the greatest disappointment of all when Margaret of Austria rejected his portrait of her father, the late Emperor.

## THE SECOND TRIP TO MECHELEN: JUNE 6–JUNE 8, 1521

Item: on the sixth day after Corpus Christi [June 6] I traveled to Mechelen with my wife to [call on] Frau Margaret. Item: I took 5 gulden with

me for expenses. At Mechelen I lodged with Master Heinrich, the painter
[Hendrick Keldermanns], at the Inn of the Golden Head. There the paint-
ers and sculptors invited me to be their guest at my inn, and did me great
honor in their gathering. I went also to the house of Poppenreuther, the
gunsmith, and I found wonderful things there.

Dürer's host in Mechelen, the painter Hendrick Keldermanns, owned
the Inn of the Golden Head—a practice which one would have sup-
posed to be more typical of painters in the Dutch Republic in the sev-
enteenth century: Jan Steen and Aert van der Neer come to mind in this
connection. In smaller and less prosperous Mechelen, the painters were
unable to entertain lavishly in their own guild hall, unlike those of Ant-
werp, but they wished nevertheless to honor Dürer, and did so by pay-
ing room and board for Dürer and Agnes at the inn, and by giving what
was apparently a supper party there.

Dürer was also invited to a meal at the home of the German gunsmith,
Hans Poppenreuther of Cologne, who was canon founder and gunsmith
by appointment to Charles V. He may have made the silverpoint draw-
ing of the mortar (W.783), on this occasion; his plans for the book on
fortifications may already have begun to be formulated.[8]

I also went to Frau Margaret's and showed her my *Kaiser*, and I would
have given it to her, but she disliked it so much that I took it away again.
And on Friday [June 7] Frau Margaret showed me all her beautiful things;
among them I saw 40 little panels painted in oils [presumably those by Juan
de Flandes now in the Prado], the like of which for precision and excellence
I have never seen. There I also saw other good things, by Johannes [Jan van
Eyck], Jacob Walch [Jacopo de' Barbari]. I asked my lady for Master Jacob's
little book, but she said she had promised it to her painter [Bernard van
Orley]. Then I saw many other costly things and a costly library. . . .
      On Sunday I returned from Mechelen to Antwerp.

### ANTWERP: JUNE 8–JULY 2, 1521

After his return from Mechelen, Dürer dined at least four times with,
and presented several gifts to, the Augustinian friars who had settled in
the parish of St. Andreas in 1513. Members of Luther's own monastic
order, they were Saxons as well, and Dürer already knew their Vicarius,
Wenceslaus Link, from his membership in the Staupitz study group. It
seems probable that he sought them out in order to keep abreast of any
news concerning Luther's fate. It is possible, too, that as a German and
a known sympathizer with Luther's teachings Dürer may have felt him-

self in a precarious situation in the Netherlands after the reformer's reported arrest, in which case the company of like-minded men still in holy orders might have afforded him a kind of security. Within two years, however, the Augustinians were to be declared heretical and driven out of Antwerp (1523).

## KING CHRISTIAN
## OF DENMARK

> Master Lucas [van Leyden] who engraves in copper has invited me as his guest. He is a little guy [*kleines männlein*], born in Holland, who was at Antwerp. I have eaten with Master Bernhard Stecher. I paid 1½ st. to the messenger. I have received 4 gulden 1 orth from art sales. I have drawn the portrait of Master Lucas with the silverpoint [W.816]. I have lost 1 gulden. . . .

THE most notable event from the art-historical point of view was Dürer's meeting in Antwerp in mid-June with the Dutch painter and printmaker, Lucas van Leyden (1489/1494–1533), who invited him to a meal, and whose own style was to grow appreciably more meticulous after his exchange of prints with the great German artist.[1] Lucas's reasons for coming to Antwerp have not been recorded, but may have included meeting Dürer, whose work he had admired for more than fifteen years, as well as selling prints of his own in the Antwerp market; the records of the Antwerp Painters' Guild also indicate that a certain "Lucas of Holland, painter," took out membership in 1522. Lucas was an engraver famous in his own right by this time, widely admired and copied in Italy for his landscape backgrounds, and, according to Johannes Cochlaeus, more popular with print buyers at the Frankfurt fair than Dürer himself. Commenting on Lucas's small stature, Dürer drew his portrait in silverpoint[2] and later exchanged eight gulden worth of his own prints for Lucas's complete graphic oeuvre—which would have included, among other things, Lucas's intaglio portrait of Maximilian (B.172), dated 1520, based on Dürer's own woodcut of 1519. This work should have been of particular interest to Dürer as the first example of etching and engraving combined on a copper plate (Maximilian's face was engraved, his clothes and background etched—quite the opposite of the procedure to be employed in the Van Dyck studio a century later). Dürer himself had experimented briefly with the newly invented medium of etching, doing half a dozen plates between 1515 and 1518, but

using the iron plates favored by Urs Graf and Albrecht Altdorfer, which were too easily susceptible to corrosion.

IN preparation for the return journey to Nuremberg, Dürer dispatched his trunk, had a traveling-cloak made, accepted many going-away gifts—including a third parrot, which necessitated buying another birdcage—and settled his account with his landlord. Noting ruefully that Frau Margaret had given him nothing for all the things he had presented to her, he was forced to borrow a hundred gold gulden from Alexander Imhoff to finance his journey home.

Paid the doctor 6 st., again 6 st. I gave the Steward of the Augustinian convent at Antwerp a Life of Our Lady, and 4 st. to his servant. I gave Master Jacob an Engraved Passion and a Woodcut Passion and 5 other pieces, and gave 4 st. to his servant. I changed 4 fl. for expenses. I bought 14 fishskins for 2 Philipps fl. I have made portraits in black chalk of Aert Braun and his wife. I gave the goldsmith who appraised the three rings for me 1 gulden [sic] worth of art. Of the three rings which I took in exchange for prints, the two smaller are valued at 15 crona, but the sapphire is worth 25 crona—that makes 54 gulden 8 st. And among other things that the above Frenchman [Jan van de Perre] took are 36 large books: that makes 9 gulden. I bought a screw-knife for 2 st. Item: the man with the rings has cheated me by half: I did not understand it.

I bought a red beret for my god-child for 18 st. Item: I lost 12 st. at play. Drank 2 st. Item: I bought 3 fine little rubies for 11 gulden and 12 st. I changed 1 gulden for expenses. I have eaten one more time with the Augustinians. I ate twice more with Tomasin. I paid 5 st. for brushes made of wild guinea-pig bristles. I bought 6 more brushes for 3 st.

Item: I made the great Anthony Haunolt's [the new Fugger agent] portrait on a royal sheet of paper carefully with black chalk. I made careful portraits of Art Braun and his wife with black chalk on two royal sheets of paper, and I drew him once more with the silverpoint. He gave me an angelot. . . .

. . . I have given Master Joachim [Patinir] Hans Baldung Grien's work [des Grünhanssen ding]. . . . I gave Jobst's wife 4 woodcuts. Gave Friedrich, Jobst's man, 2 books. I gave glazier Hennik's son 2 Books. Rodrigo gave me one of the parrots which are brought from Malaga, and I gave the servant 5 st. trinkgeld. . . . Bought a small cage for 2 st., a pair of long-boots for 3 st., and 8 little boards for 4 st. . . . I gave Master Aert, the glass-painter, a Life of Our Lady, and gave Master Jean Mone, the French sculptor, a whole set of prints. He gave my wife 6 very finely made little glasses, full of rose water. Bought a packing case for 7 st. . . .

Cornelius [Grapheus] the Secretary [of Antwerp] gave me the Lutheran *Babylonian Captivity*. In exchange I gave him my three large books. Item: I have reckoned up with Jobst, and I owe him 31 more gulden. I have paid it to him, deducting the two portraits painted in oils, for which he paid 5 Netherlandish pounds of borax. In all my doings, spendings, sales, and other dealings, in all my business deals with high and low, I have suffered loss in the Netherlands; and especially Frau Margaret gave me nothing for what I made and presented to her. And this settlement with Jobst is made on St. Peter and Paul's Day [June 29]. . . .

I have hired a driver to lead me from Antwerp to Cologne; the fare was 13 light gulden, each worth 24 st., and I shall also provide food and drink for one more person and a boy. . . .

Item: Alexander Imhoff loaned me 100 gold gulden on the eve of Our Dear Lady's Crossing the Mountains, 1521 [July 1]. I gave him my sealed bond for it to repay the money with thanks on delivery of the bond to me at Nuremberg. I paid 6 st. for a pair of shoes. I paid 11 st. to the apothecary. I paid 3 st. for binding cord [for packing]. I gave 1 Philipps gulden to Tomasin's kitchen staff for a leaving present, and gave "Miss Sweetie," his daughter, a gold gulden. I have eaten with him three times. I gave Jobst's wife 1 gulden and also 1 gulden in his kitchen at leaving. Item: paid 2 st. for loading. . . .

Just as his arrangements for departure had been concluded, however, Christian II (1481–1559), King of Denmark, Norway, and Sweden, arrived and sent for Dürer to draw his portrait. Dürer's charcoal drawing of the monarch has disappeared, along with much of King Christian's personal collection of works by Dürer, many of which perished in a fire in the royal palace. Jan Gossaert's pen drawing of Christian (Paris, Institut Neerlandais), based on Dürer's portrait of Maximilian, may give an idea of its original appearance.

In contrast to Margaret of Austria, King Christian not only became his patron, but invited Dürer to dine with him on two occasions, one of which was a state banquet in Brussels [July 7] given for Charles V, Lady Margaret herself, and the dowager Queen of Spain.

[July 2] On Our Lady's Visitation Day, as I was leaving Antwerp, the King of Denmark [Christian II] sent for me to come to him at once to make his portrait. That I did in charcoal. And I also did a portrait of his servant, Anthony [Anton von Metz, the Danish Ambassador to the Germans]. And I was made to dine with the King, and he behaved graciously toward me.

Item: the before-mentioned driver did not take me; I had a disagreement with him.

## The Second Trip to Brussels: July 3–12, 1521

At the request of King Christian, and at the cost of some inconvenience to himself, for he had already bargained with a guide to take his party from Antwerp to Cologne and found the man not amenable to his change in travel plans, Dürer and his companions traveled to Brussels. Christian, who must have been highly pleased with the portrait drawing Dürer had made of him in charcoal, now wanted a formal portrait done in oils. Dürer bought the panel for the portrait on July 4, borrowed an apprentice from "the Master Painter" (perhaps Bernard van Orley's apprentice, Bartholomaus van Conincxloo), and had completed the portrait, framed it, and received full payment for it by July 7. This portrait, too, is lost.

Dürer's assessment of King Christian, the Emperor's brother-in-law, is an interesting one in light of what we know from other sources about this monarch, soon to be deposed, who was widely known as a friend of the middle class and a sympathizer with the Lutheran cause. Dürer was struck by the handsome appearance and physical courage of the forty-year-old ruler of united Scandinavia, who traveled "through his enemies' land with only two attendants." He was also understandably gratified by Christian's generosity and courtesy toward him, which is in striking contrast to the more conservative behavior of Margaret of Austria and her nephew, Charles V. It was probably at King Christian's suggestion that Dürer was admitted as a spectator to the Emperor's banquet in Christian's honor (July 4), and it was at his kind and democratic invitation that Dürer was included among the diners at the reciprocal state dinner given by Christian for Charles V, Margaret of Austria, and Charles's step-grandmother, Germaine de Foix, widow of King Ferdinand of Aragon[3]

Next day [July 3] we traveled to Brussels at the command of the King of Denmark. And I hired a driver, whom I paid 2 gulden. Item: I gave the King of Denmark the best pieces of all my prints; they are worth 5 gulden. I changed 2 more gulden for expenses. Paid 1 st. for a dish and baskets.

I noticed how the people of Antwerp wondered greatly when they saw the King of Denmark, that he was such a manly, handsome man who came through his enemies' land with only two attendants. I saw, too, how the Emperor rode out from Brussels to meet him and received him honorably with great pomp. Then I saw the noble, costly banquet which the Emperor and Frau Margaret held in his honor the next day [July 4]. I paid 2 st. for a pair of gloves.

Item: Herr Anthony [Anton von Metz] gave me 12 Hornish gulden. I gave 2 Hornish gulden of it to the painter for the panel to paint the portrait on and for having the colors ground for me. The other 8 gulden I used for expenses.

Item: on Sunday before St. Margaret's Day [July 7] the King of Denmark held a great banquet for the Emperor, Frau Margaret, and the Queen of Spain, and he invited me and I dined there also. I paid 12 st. for the King's frame, and I painted the King's portrait in oil. He has given me 30 gulden. Item: I gave 2 st. to the boy by the name of Bartholomae [van Conincxloo?] who ground the colors for me. I paid 2 st. for a little glass jar that once belonged to the King. I gave 2 st. *trinkgeld*. Paid 2 st. for the engraved goblets.

. . . I also gave the Master-Painter's boy an Apocalypse and 4 half-sheets. The Bolognese [Tommaso Vincidor] gave me an Italian work of art or two. Item: I paid 1 st. for artwork. Master Jobst the *schneuder* [Jobst de Negker?] has invited me. I ate supper with him.

I paid 32 st. for rent in Brussels for eight days. I gave an engraved Passion to the wife of Master Jan the Goldsmith, with whom I have eaten three times. I gave another Life of Our Lady to [Bartolmeh] the painter's apprentice. I have eaten with Herr Niclaus Ziegler and have given 1 st. to Master Jan's servant.

I had to stay over two days longer in Brussels because I couldn't get a driver. I bought a pair of socks for 1 st.

## The Journey from Brussels to Cologne:
### July 12–15, 1521

On July 12, having finally succeeded in securing a *Fuhrmann*, Dürer and his party left Brussels for the return journey to Nuremberg. Their first day's ride took them as far as Thienen, by way of Louvain. On the second day they rode to Maastricht, where they spent the night, paying "watch money" to have their baggage guarded. On the third day, when their guide became lost, they got only as far as Altenburg, southeast of Jülich, where they spent the night. On Monday, the travelers finally reached the familiar city of Cologne, the home of Dürer's cousin Niclas. While in Cologne, Dürer used the back of his drawing of the lions of Ghent (W.781) to make a silverpoint sketch of a young girl in a Cologne headdress (*Cölnisch gepend*)—his niece, perhaps? Shortly afterward on the river journey bound for Mainz, he sketched Agnes beside her on the same sheet, remarking "*awff dem rin mein weib pey popart*" (on the Rhine, my wife, at Boppard)—a charming river port which in Dürer's day was

a toll station for the Archbishop of Trier. Neither Dürer's diary nor his sketchbook record the Lorelei rock a few miles to the south, which, of course, was only to acquire its mystique in the nineteenth century in Clemens Brentano's *Lore Lay* (1800) and Heinrich Heine's lyric *Ich weiss nicht was soll es bedeuten* (1823) with its vision of the golden-haired temptress who lures poor boatmen to their doom.

Dürer retained his record of his travels, together with his silverpoint sketchbook containing costume studies and drawings of important people and architectural landmarks. Since the diary was not a simple record of expenses, but a travelogue of great interest to others than himself, it is possible that his note-taking may have been inspired by the recent publication of Pausanias's *Description of Greece*, the most famous travel guide of the ancient world.

# XVII

## THE LAST YEARS

THE Dürers returned to Nuremberg from the Netherlands slightly more than a year after their departure, arriving home about the end of July. Agnes Dürer's mother was taken ill on August 18 and died on September 29, as is noted in the family history.

The records of the City Council show that Dürer was in town on August 3 to receive the payment of two hundred florins, "in accordance with the Emperor's award," representing the balance due him on his pension for the years 1519 and 1520. Henceforth he was to be paid the sum of one hundred florins annually on St. Martin's day (November 12), beginning with the current year. The pension was to be deducted from city tax money payable to Charles V, and was to be placed in escrow with Friedrich the Wise, who would see to it that Dürer actually received it.

It is perhaps not entirely coincidental that a week after Dürer's receipt of the two hundred florins, on August 11, the City Council resolved to redecorate the newly renovated City Hall "according to designs by Albrecht Dürer." An unused preliminary drawing, apparently for this project, is in the Morgan Library[1]—a gracefully satirical tribute to the Power of Women, showing Samson and Delilah, David and Bathsheba, and Aristotle and Phyllis—perhaps done, as Erwin Panofsky suggested, in honor of the fact that the Great Hall of the *Rathaus* was used for dancing. The subjects actually painted in the salon, however, were apparently chosen in accord with Nuremberg's new role as an Imperial capital and seat of the Supreme Court: the *Triumphal Chariot of Maximilian*, after the woodcut originally made for the late Emperor; and two justice pictures—the *Calumny of Apelles*, a subject recommended in Alberti's manuscript on painting, and *The Continence of Scipio*. The Council's records show that the work was finished, and that Dürer had been asked to submit his bill, by December 5; he had been asked to keep a record of "the time spent by the painters engaged in this task," and was paid one hundred florins on the following March 22. Unfortunately, no record

was kept of the identities of the painters he employed; scholars have proposed the names of Hans Springinklee, Hans von Kulmbach, and Georg Pencz in this connection. Pencz seems a particularly likely candidate, in view of his later illusionistic ceilings.

Dürer's murals, which seem to have been done in an unstable mixture of oil and tempera similar to that used by Leonardo da Vinci as a substitute for fresco, were in such poor condition by 1613 that, like Leonardo's own mural in the Florentine city hall, they had to be painted out. All hope of recovering the stylistic evidence perished when the *Rathaus* itself was destroyed in an air raid in 1944; the present City Hall, which occupies the original site, is a totally modern structure.

The refurbishing of the City Hall by Dürer and the architect Hans Behaim the Elder was completed just as Nuremberg began to fulfill its new and more prominent role as a seat of Imperial administration, which was to make its acceptance of the Reformation a matter of more than usual complexity. Nuremberg could scarcely afford to alienate Charles V, who had declared at Worms that both his sympathies and his duty lay with the support of orthodoxy ("I am descended from a long line of Christian emperors of this noble German nation. . . . They were all faithful until death to the church of Rome. . . . A single friar who goes counter to all Christianity for a thousand years must be wrong. . . . I will proceed against [Luther] as a notorious heretic.").[2]

The City Council, however, took a justifiable pride in Nuremberg's municipal rights, and had been both disturbed and angered when Pirckheimer and Spengler were threatened by the Pope with excommunication without a hearing. Fresh in their minds, too, was the memory of the great scandal of 1515 surrounding the discovery of a passionate love affair between Johannes Hänlein, prior of the local Dominican monastery, and Barbara Schleiffer, a nun at the nearby cloister of Engelthal, which also involved the complicity of Hänlein and the city Treasurer, Anton Tetzel, in graft and influence peddling. In contrast to the Dominicans, the local Augustinian community—through which Luther's teachings had been introduced to the city—was considered the very model of modern piety, and was especially highly regarded for its openness to humanism. However, many of Nuremberg's most influential citizens, including Lazarus Spengler, characterized their religious convictions in 1521, not as belief in Luther's doctrine, but as belief in the Gospel and the teachings of St. Paul.

Contrary to custom, Charles V's first Diet as the new Emperor had

been held in Worms, due to the continued epidemic of plague in Nuremberg. The Emperor himself did not attend the second or the third Diets, which were presided over by his nineteen-year-old brother, the Archduke Ferdinand. Influential members of the Council of Regency who did attend included Friedrich the Wise, who came to the 1522 and 1523 meetings with Spalatin, and Friedrich II, Count Palatine, Charles V's representative, who brought with him his chaplain, Martin Bucer—all four of whom were sympathetic to Luther. In April of 1521, Bucer had been released from his Dominican vows; by May of 1523 he would become a reformer in Strassburg, which was now the home of Hans Baldung Grien.

In 1522, Dürer did a portrait drawing and woodcut of Ulrich Varnbühler, Pronotary of the Imperial High Court; a silverpoint drawing and engraved portrait of his old client, Friedrich the Wise, now Luther's protector (1524); and a silverpoint profile of Friedrich II of the Palatinate (1523). Evenhandedly, however, he also did new portraits of Cardinal Albrecht von Brandenburg, and designed a throne for Cardinal Matthäus Lang von Wellenburg, the new Archbishop of Salzburg who had been Maximilian's former secretary and was now one of the leading opponents of Luther.[3] Cardinal Albrecht von Brandenburg's personal Missal (Aschaffenburg, Schlossbibliothek) contains several miniatures based on Dürer's designs, including one which shows him celebrating the Mass.

Was Albrecht Dürer a Catholic or a Protestant? A great many publications were devoted to this pseudo-issue during the past century—it seemed a matter of particular importance during and after Bismarck's *Kulturkampf* (ca. 1871–1887)—the Iron Chancellor's reaction against the dogma of Papal Infallibility and the publication of the *Syllabus* of Pope Pius IX in 1864. At that time repressive laws were passed making civil marriage compulsory, banning the Jesuit order from the German empire, and abolishing the Catholic section of the Prussian ministry of culture and education. Albrecht Dürer, whose graphic oeuvre included a complete Life of Mary series, as well as illustrations of penitential self-flagellation and of the indulgenced *Sudarium*, had revealed in his diary and correspondence a lively and knowledgeable interest in the teachings of Martin Luther. Which was the "real" Albrecht Dürer?

The question is both unanswerable and anachronistic.[4] Like the majority of Nuremberg's substantial citizens, Albrecht Dürer was inter-

— PLATE 33 —

Carl Hoff. *Dürer and Raphaël before the Throne of Art.* 1811. Engraving after the lost drawing by Franz Pforr.

—— PLATE 35 ——

Christian Rauch. Albrecht Dürer Monument. 1825–1840. Bronze.
Nuremberg, Albrecht Dürer Platz.

—— PLATE 36 ——

Cover, *Volk und Rasse* (Folk and Race). February 1942. Reproduction
of Dürer, *Self-Portrait*, 1493, Paris, Louvre.

**Sieg oder Unsieg ruht in Gottes Hand/ Der Ehre sind wir selber Herr und König!**

—— PLATE 37 ——

Georg Sluyterman von Langeweyde. *Victory or Defeat Rests in God's Hand: Of Honor We Ourselves Are Lord and King*. Ca. 1936. Woodcut.

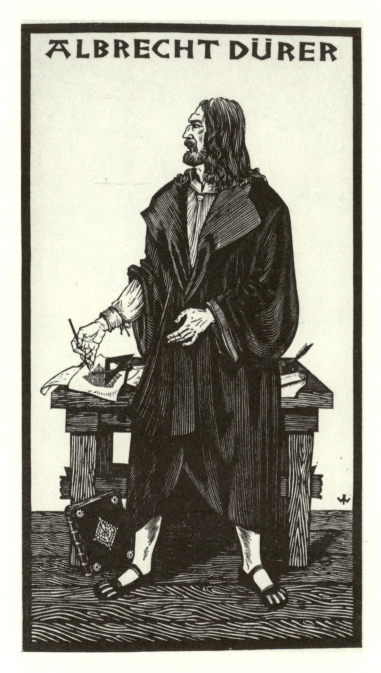

ALBRECHT DÜRER

_____ PLATE 38 _____

Josef Weisz. *Albrecht Dürer*. Ca. 1936. Wood engraving.

_____ PLATE 39 _____

Walter Schreiber. *Rabbit Hutch*. 1970. Mixed media.

PLATE 40

Warrington Colescott. *Dürer at Twenty-three, in Venice, in Love, His Bags
Are Stolen.* 1977. Color etching. Collection of the author.

ested in Luther's teachings and in their implications for both clerical reform and for a "back to basics" approach to the Christian liturgy. He cannot, however, have been a Protestant in the modern sense, since he died two years before the Augsburg Confession, which established an official alternative to Catholicism, was published (1530). After 1530, as Cardinal Albrecht von Brandenburg put it, "there is now no hope of unanimity in the faith." Before that time there were a great many people, including Erasmus, Willibald Pirckheimer, Albrecht Dürer, and even their friend Philip Melanchthon—the author of the Augsburg Confession—who assumed that, once the desired reforms had been accomplished, the reconciliation of all Christians would automatically follow.

On All Saints' Day (November 1), 1521, Andreas Bodenstein von Karlstadt, the professor of theology and jurisprudence who had taken over in Wittenberg during Luther's absence, published his tract *On the Adoration and Veneration of the Symbols of the New Testament*, reaffirming Luther's call for the reception of both the bread and the wine of communion by the laity, who were normally given only the host. He dedicated the pamphlet, his second on the subject, to his "dear protector [*günner*] Albrecht Dürer, . . . in order to pay homage to you . . . [because] your good deeds have put me under obligation to serve you." It seems likely from the rest of the dedicatory paragraph, which deals with malicious gossip being spread elsewhere about the goings-on in Wittenberg, that Dürer had spoken up in defense either of Luther or Karlstadt at some point.

It has often been suggested that Dürer's woodcut of the *Last Supper* B.53, 1523, and the drawing that preceded it[6] must refer to Karlstadt's advocacy of the right of the laity to receive the communion in both kinds. However, it has gone unnoticed that Dürer emphasized in both cases, not the administering of the Eucharist, but the venerable medieval mystic theme of the *Johannesminne*, in which St. John the Evangelist "reclines on the Lord's bosom"—that is, falls asleep at the table, leaning on Christ. This marks the woodcut as still primarily targeted for convent and monastery use, like another scene from the projected Horizontal Passion—the Frankfurt drawing of Christ in the Garden of Gethsemane, prostrate on the ground with arms outstretched in the form of a cross, like a new priest at his ordination or a nun taking her vows.[7]

On Christmas Day in 1521, Karlstadt administered communion in both kinds to the laity—two thousand of them—who had gathered in the Castle Church at Wittenberg. He wore only a plain black robe, and

he explained in his sermon that only their faith was needed as preparation for receiving the communion: fasting and confession were not necessary. He recited the Mass in Latin, leaving out the references to sacrifice, but addressed the communicants in German as they received the bread and wine. Soon afterward the town council issued an ordinance authorizing the communion to be celebrated as Karlstadt had done it. By Holy Week, 1523, the new practice had spread to Nuremberg, where it was first celebrated by the new Augustinian prior, Wolfgang Volprecht. By May of the following year, Volprecht was reading the Mass in German.

Dürer, who may have been flattered initially by Karlstadt's unsolicited dedication, must have found that association increasingly embarrassing as Karlstadt, who was banished from Saxony in 1524, went on to advocate the removal of religious images from the churches, as well as the banning of religious music. In this, as in much else, Nuremberg did not follow suit. While Karlstadt's words led to orgies of image-breaking in other cities from Wittenberg to Zürich, Nuremberg's works of religious art either were quietly removed by their donors, or, since those donors were often prominent members of the City Council, were left unmolested in the churches for which they were designed. Veit Stoss's famous *Angelic Greeting*, newly installed in 1517 in the ceiling of the Church of St. Lorenz, was simply muffled in its enormous Lenten dust cover by order of its donor, the senior City Treasurer Anton Tucher.

In 1525 Luther himself took a stand in opposition to Karlstadt's iconoclasm in the tract *Against the Heavenly Prophets in the Matter of Images and Sacraments*, in which he declared that images "for memorial and witness, such as crucifixes and images of saints," should be tolerated, since "they are praiseworthy and honorable as the witness stones of Joshua and of Samuel."[8]

Dürer, who during 1522 had been devoting himself almost exclusively to the preparation of his *Four Books on the Theory of Human Proportion* for the printer, became increasingly alarmed, as did Luther, Pirckheimer, and the members of the Nuremberg City Council, over the violent and fanatical behavior of some of the radical groups which were beginning to attach themselves to the Reformation. On an impression of Michael Ostendorfer's large woodcut (Coburg) depicting the ecstatic rites of the pilgrims to the shrine of the Beautiful Virgin of Regensburg he wrote:

> 1523: This spectre [*Gespenst*] has risen at Regensburg against Holy Scripture and is permitted by the Bishop because it turns a profit. God help us

that we not dishonor his mother in this fashion, but honor Jesus Christ. Amen.

The shrine stood on the site where the Regensburg Synagogue had been razed in 1519.

Even more distressing for Dürer must have been the arrest of a man whom he had sponsored, or perhaps stood godfather to ("Albrecht Dürers gevatter"), who had been begging without a license (February 27, 1522), contrary to the city ordinance imposed for purposes of distinguishing Nuremberg's own poor from the wandering vagrants—many of whom were now former monks who had left their monasteries. The man was permitted to continue begging after having obtained the required metal identification tag proving his Nuremberg residency.

Most devastating to Dürer's self-esteem however, would surely have been the arrest and interrogation in the torture chamber (though not under torture) in January 1525, of his three former journeymen, the Beham brothers and Georg Pencz, for their radical social and religious views. Barthel Beham, when questioned about his alleged pronouncements advocating a general work stoppage, to last until all property should be redistributed evenly, and his declaration that he found the civil authorities no longer worthy of respect, stated simply that he recognized no authority other than God's.

Georg Pencz, when asked whether he believed in God, replied that he did, but "what he should take to be this God he cannot say." He denied believing in Christ, the Scripture, baptism, the real presence of Christ in the bread and wine of the Sacrament, and the authority of the Nuremberg City Council.

The three young men, all in their early twenties, had been apprehended during the course of the Münzerite scare, when it was discovered that the pre-communistic writings of the radical Anabaptist, Thomas Münzer, had converted Hans Denck, the schoolmaster at St. Sebald's, and that Münzer himself had secretly visited the city. Münzer's tracts were seized and destroyed; Denck was banished permanently, and the three "godless" young painters were expelled from Nuremberg, but were quietly readmitted again in November, after the City Council had openly broken with the papacy (March 3–14).[9]

In the same year, Dürer's *Formschneider,* Hieronymus Andreae was incarcerated in the city jail for having supported the rebellious peasants during the *Bauernkrieg*. Dürer's own views on the Peasants' War are nowhere expressed in writing, and his design for a monument commemorating the uprising, which culminates in a seated peasant stabbed in the

back with a sword (Plate 30), has been interpreted both as a sign of sympathy for the peasant cause and as a mockery of it. The diagram appeared as one of the illustrations in his book, *The Teaching of Measurement*, published in Nuremberg in 1525. A monument to the victors over the peasants was actually erected in Mainz in 1526.[10]

Although Dürer's portrait drawing of Hieronymus Andreae's young wife[11] may have been made as an expression of sympathy for the *Formschneider*'s predicament, and though the readmission of the three young painters to the city may well have been done with his advice and consent, it should be noted that the majority of men whose opinions Dürer valued were horrified by the revolts of the peasants which had flared up in Franconia, Swabia, and Saxony beginning in May 1524 and continuing into the summer of 1525. Luther himself issued a pamphlet on May 5, *Against the Robbing and Murdering Hordes of Peasants*, shortly before Münzer was captured and executed (May 25). On June 4, Dürer had a frightening dream of a cloudburst which deluged the earth, and was so disturbed by it that he painted a watercolor of it afterward (Vienna, Albertina), with a full description of the nightmare underneath.

At about that time, he also was drawing the portrait likenesses of the joint managers of the Fugger Trading Company, Raymond (W.916, Darmstadt) and Anton Fugger (W.915, Coburg); and of the wife and the sister of the Margrave Casimir of Brandenburg-Ansbach, Margarete von Brandenburg-Ansbach[12] and Susanna of Bavaria.[13] The Margrave was the brutal suppressor of the peasant revolts in nearby Bamberg and Würzburg.

The Nuremberg City Council had warned the peasants within its own jurisdiction that armed revolt would be swiftly and severely punished by the Swabian League, and had tried for a while to moderate between the peasants and the League in regard to some of the peasants' demands which it believed to be just, but flatly refused to support the peasant cause against Casimir. During this period, much thought was given to the strengthening of the city's fortifications and internal security—issues which Dürer was to take up in his treatise on fortifications (*Befestigungslehre*) published in 1527, a scientific discussion of purely defensive military architecture and troop deployment dedicated to the embattled King of Hungary.

After the suppression of the peasants, the Nuremberg Council on July 14, 1526, passed a resolution banning the work of Karlstadt and of Dürer's Swiss acquaintance, Ulrich Zwingli, as well, and forbidding the celebration of the Lord's Supper as a purely symbolic ritual.

In July, Albrecht Dürer, after more than a year of long-distance hinting by Erasmus to Pirckheimer, completed the long-awaited engraved portrait of Erasmus of Rotterdam (B.107), whose reluctance to espouse Luther's cause had once offended him. And in October, he made a present to the Nuremberg City Council of the large painting of *The Four Holy Men*—Sts. John, Peter, Mark, and Paul—with its written admonition against belief in false prophets (Munich, Alte Pinakothek). Dürer, who had given the two large panels comprising the painting to the Council "as a remembrance" was reimbursed 112 Rhenish florins for it.

The work, which has become known inaccurately as "The Four Apostles," depicts a St. John the Evangelist holding a Bible open to Luther's 1522 translation of his own Gospel ("In the beginning was the Word . . ."). Below the painted images of Sts. John, Peter, Mark, and Paul are lengthy quotations, also in Luther's German, from Revelations (22:18 ff.), the second Epistle of Peter (2:1–2), I John (4:1–3), St. Mark's gospel (12:38–40), and St. Paul's epistle to Timothy (3:1–7). The quotations were inscribed by Johannes Neudorffer, who indicated in his later biography of Dürer that the four holy men were intended to represent the four humors—a sanguine, a choleric, a phlegmatic, and a melancolic. St. Paul, the New Testament author of most fundamental importance for Luther, is the gifted melancholic, and is clearly predominant over the choleric St. Peter, the apostle who became the first Bishop of Rome, and therefore the first Pope.

Late in 1525, and again in May of 1526, Philipp Melanchthon (1497–1560) came to Nuremberg in the capacity of official consultant to the City Council on the issues of the dissolution of monasteries and of establishing a new secular *Gymnasium*, or high school, and Spengler was sent to Wittenberg to consult Luther himself. Melanchthon was offered the job of Rector of the new school, but declined, recommending his young friend Joachim Camerarius in his stead. Albrecht Dürer became friendly with both Melanchthon and Camerarius, as well as with the new teacher of literature and rhetoric, Eoban Hess.

Dürer had probably known Melanchthon, who was a close friend of Pirckheimer's, since his first visit to Nuremberg in 1518.[14] His engraved portrait of the man who became known as the "Praeceptor Germaniae" for his contributions to the development of secular education dates from 1526 (Plate 31). It was probably Pirckheimer who composed the flattering Latin inscription, "Dürer was able to depict Philip's features as if living, but the practiced hand could not portray his soul." After Dürer's death, Melanchthon in his rhetoric textbook of 1531 was to compare Dürer's art

to the highest level of rhetoric as defined by the Greeks. His son-in-law, Kaspar Peucer (1525–1602), later wrote that Melanchthon had often been present at Pirckheimer's dinner parties when Albrecht Dürer, "who was a very subtle disputant," would get the best of Pirckheimer in arguments over matters affecting Nuremberg's churches and schools.[15] It seems clear that Melanchthon owned an important, and perhaps complete set of Dürer's prints, as his letter of March 15, 1533, to Camerarius shows. It is also probable that he owned the plate for his portrait, which is still preserved in the Gotha Museum.

Dürer's late engraved portraits, including those of Friedrich the Wise, Pirckheimer, Erasmus, and Melanchthon, all have rather valedictory inscriptions in classical Roman lettering centered on tablets designed to resemble the Roman army tombstones which were among the most numerous archeological finds in Germany. When Pirckheimer later composed Dürer's Latin epitaph, he had the plaque cast in the same Roman format.

When Dürer died, on April 6, 1528, Eoban Hess composed a lengthy obituary poem, and Joachim Camerarius a brief but invaluable biography of Dürer, which includes his physical description, praising his physique and profile ("what the Greeks would call perfect") as appropriate to his magnificent spirit, pleasant manner of conversation, stature as a publishing scientist, and sense of honor and justice. Martin Luther, who had received a death notice and obituary poem from Eoban Hess, the rhetoric instructor at the Nuremberg *Gymnasium*, wrote graciously: "It is natural and right to weep for so excellent a man . . . ; still you should rather think him blessed, as one whom Christ has taken in the fullness of his wisdom and by a happy death from these most troublous times, and perhaps from times even more troublous which are to come, lest one who was worthy to look on nothing but excellence, should be forced to behold things most vile. May he rest in peace. Amen."[16]

During the last years, Pirckheimer's correspondents, including Erasmus of Rotterdam and Canon Lorenz Beheim, had phrased frequent questions and comments about Dürer's health in a way that suggests that the recurring fever contracted in the Netherlands continued to trouble him. His death, however, seems to have caught him unprepared, for he left no will, and was unable to finish proofreading the *Four Books of Human Proportion*. Published posthumously by Agnes Dürer, they were seen through the press by Pirckheimer, to whom Dürer had dedicated the work.

In a bitterly worded letter written a month before his own death in
1532, Pirckheimer accused Agnes of having caused her husband's death
by her ill temper and insatiable greed, which had forced Dürer to over-
work during his illness. While it is certainly possible that Pirckheimer
knew whereof he spoke, it is worth noting, however, that he did not
mail the letter, that he had never liked Agnes in the first place—a feeling
that was probably reciprocated—and that his own physical suffering
from gout and kidney stones at this time can hardly have improved his
disposition. His pique seems to have been exacerbated by the fact that
Agnes had failed to give him any of her husband's things. Pirckheimer's
nephew, Georg Geuder, must also have been disappointed, for he had
written in 1527 attempting to cajole his uncle into asking Dürer to sign
the one-hundred-florin pension over to him, promising that he, Georg,
then living in Spain, would reimburse Dürer promptly during his life-
time, and he could then keep receiving the pension after Dürer's death.

Dürer's estate at the time of his death totalled 6,874 florins—a quite
substantial sum, which qualified him as one of Nuremberg's wealthier
citizens. Agnes inherited all of his property, and continued to live in the
great house in the Zisselgasse until her own death in 1539. In her will,
written in 1538 after Hanns Dürer's unexpected death in Poland and filed
in the *Testamentenbuch* in the municipal library,[17] she endowed a schol-
arship fund to enable a craftsman's son to study liberal arts and theol-
ogy. Endres Dürer was to receive all of Dürer's printed work, including
the blocks and plates, his books, and his goldsmith's masterwork as well;
this legacy passed to a niece of Endres's stepdaughter, Regina Hirnko-
fen (d. 1560).

Dürer's official mourners, however, were his many friends and ac-
quaintances in the humanities and theology, all of whom wrote obituary
poetry or letters of condolence to Pirckheimer and Camerarius rather
than to Agnes. And his legatees, as he had planned all along, were the
young artists of the future. His manual on measurement called attention
to the native ability of young German artists, but deplored their lack of
proficiency in geometry, perspective, proportion, and the theoretical
side of art, as well as their ignorance of the history of art from Greek
and Roman times. His own writings constitute the first scientific
publications in the German language on these subjects, and they were
to be quoted dutifully by future authorities—if not avidly read by the
young themselves. (A letter from Caritas Pirckheimer to her brother, for
example, reveals that while the nuns at St. Clara's had enjoyed Dürer's

book "which is dedicated to you, our paintress says she can paint just as well without it.")

Dürer's graphic oeuvre was destined to serve as a permanent academy of design for such young artists as Van Dyck, Rubens, Terbrugghen, Rembrandt, El Greco, and a host of native craftsmen in the New World who were employed by Spanish missionaries to create altarpieces and were given Dürer's prints to use as modelli.[18] And with the collapse of the Holy Roman Empire in the early nineteenth century, Dürer would be treated to an apotheosis that exceeded even Pirckheimer's wildest dreams for the future of German art.

# XVIII

## THE CELEBRATED
## ALBRECHT DÜRER

ALBRECHT DÜRER of Nuremberg is, in the strictest sense of the term, the most thoroughly celebrated artist who ever lived. An annual Albrecht Dürer Day, like the feast day of a saint, was observed by German artists from 1815 until the end of the nineteenth century, while national and even international centenary festivals have been obligatory since 1828, the three hundredth anniversary of his death. The Dürer bibliography compiled by Matthias Mende of Nuremberg in 1971 in honor of the artist's five hundredth birthday contained more than ten thousand carefully cross-indexed entries—and that was nearly a generation ago. A new and much-needed detailed study of Dürer's post-humous reputation was published in West Germany in 1986 by Jan Bialostocki.[1]

Dürer's lasting fame was no accident. It was a goal that Konrad Celtis, Willibald Pirckheimer, and Anton Koberger had urged him to pursue in life, for the sake of German art as well as for his own. It was to that end that he channeled his principal efforts into the graphic arts, scrupulously signed and dated his mature and late works, and employed a professional agent to promote them abroad. It was to that end that he played the "professional German" when he was in Italy—as witness the Rosary Altar painted for the national church of the Germans in Venice, signed "Albertus Durer Germanus," in which his own image appears, several shades more blond than in any of his previous self portraits and swathed wonderfully in furs against the intemperate Italian climate. It was also to that end that he forbade the hapless Jacob Heller of Frankfurt to have his new altarpiece sprinkled with holy water—an outrageous demand in 1509, particularly since Heller was planning to be buried beneath it— "that it may remain clean and fresh for 500 years." Eloquent testimony to the success of these measures are the facts that Dürer's engravings and woodcuts were being widely forged and copied in Italy by both painters

and printmakers before he was thirty-five years old and that he was the
subject of a festival in his own lifetime when, on August 5, 1520, the
Antwerp Painters' Guild gave a banquet in his honor, under the joint
sponsorship of the City Council, as a gesture of welcome to the city
evidently made in the hope that he might settle there permanently. His
unprecedented series of self-portraits and his written history of his fam-
ily are clear indications of the fully developed self-esteem which is the
most essential prerequisite of Renaissance man.

When Dürer died prematurely in 1528, aged fifty-seven, only Raphael
and Michelangelo were more famous than he. An unprecedented quan-
tity of obituary poetry was produced by his many humanist friends to
commemorate his untimely demise, and his tomb (Plate 32) in the newly
laid-out cemetery of St. John (1518) was inscribed with a moving Latin
epitaph composed by his lifelong friend Willibald Pirckheimer: "What-
ever was mortal of Albrecht Dürer is covered by this tomb. Departed
(*emigravit*) April 6, 1528."

The cult of Albrecht Dürer began a symbolic three days after the exe-
quies when, according to Christoph Scheurl, a group of artists exhumed
his body to make his death mask—an ancient Roman funerary practice
lately revived in Renaissance Italy (where, to be sure, it was customary
to perform this service *before* the burial). On the second day after his
death, the famous lock of the great master's hair was spirited away, to
be treasured by an unbroken succession of artists and collectors of Dü-
rer's work, from Hans Baldung to Goethe's friend Heinrich Hüsgen and
the Nazarene painter Edward Steinle, until it came to rest at last in the
Vienna Academy in 1873 enclosed in a silver-bound "reliquary."

The veneration of both Dürer's art and his earthly remains may have
been performed partly in deference to the artist's own Neoplatonic be-
lief that artistic genius is a divine gift, comparable as a creative force only
to that of God Himself, but it flourished in the late sixteenth-century
approbation of Cardinal Paleotti and the Council of Trent. (Dürer, who
had belonged to a Lutheran study group but had published the famous
woodcut series of The Life of Mary, was in the fortunate position of
being praised in perpetuity by both the Protestants *and* the Catholics.)
Paleotti (1582) praised Dürer for his piety, and called him a guardian of
public morality for his purity of thought and his refusal to print any-
thing obscene or sinful. As a result, Dürer's graphic art figured promi-
nently in the curriculum of Denys Calvaert's School for Artists (1575 ff.),
where Domenichino, Guido Reni, and Albani were trained, and was
promoted in Spain by Francisco Pacheco, chief censor of art for the

Spanish Inquisition and father-in-law of Velasquez, in his *Arte de la pintura* (1649).

Dürer's graphics, which were used in Spain in lieu of life models so as not to endanger the immortal soul of the young painter, were therefore considered appropriate fare for Spanish missionaries and their converts in the New World as well. His paintings and drawings, at the same time, were eagerly sought out by princely Catholic collectors, chief among them being the Elector Maximilian I of Bavaria (1573–1651), head of the Holy League in the Thirty Years' War, and the Holy Roman Emperor Rudolph II, who sponsored an entire Dürer-Renaisssance at his court in Prague. Rudolph, who bought the Rose Garland Altar and had it hand-carried over the Alps from Venice to Prague, also amassed the great collection of Dürer's drawings and watercolors which resides today in the Albertina in Vienna, and was the employer of Hans Hofmann, some of whose careful nature studies in watercolor have since been mistaken for genuine Dürers.[2]

Dürer's own pointedly Christlike self-portrait of 1500, with which Bettina von Arnim belatedly fell in love,[3] undoubtedly added to the general odor of sanctity: it served as the model for the head of Christ in J. G. Fischer's *Christ and the Adulteress* (Munich, Bayerische Staatsgemäldesammlungen No. 1411). Both the Counter-Reformation and the Romantic impressions of Dürer as a plaster saint were certainly exacerbated by the fact that the great master had obligingly died during Holy Week, as had his supposed friend and counterpart Raphael of Urbino, the Good Friday fatality of 1520, who was widely believed to have been in line for a cardinal's hat, and some of whose altarpieces were beginning to be credited with miraculous powers.

Despite the fact that after 1550 Dürer's grave was cleared and re-used for the burial of a succession of clergymen from the Heilig-Geist-Spital, his last resting place has continued to exert a morbid fascination.[4] His tomb was renovated in 1681 at the personal expense of the art historian Joachim von Sandrart, who purchased the grave plot and deeded it to the newly founded Nuremberg Academy—the first German academy of art. It was Sandrart who provided both the coats of arms and the more fulsome epitaph referring to Dürer as "Prince of Painters"—an Italianate turn of phrase destined to set the tone for the great painters of the Wilhelmian era—and calling him an artist without peer in "many arts" ("Hier ruhe, Künstler-fürst! du mehr als grosser Mann! In viel Kunst hat es dir noch keiner gleich gethan").

Dürer's tomb was opened yet again in 1811—this time in the name of

phrenology, in the hope of retrieving his skull as palpable evidence of his genius. Regrettably, the grave yielded up only an engraver named Bärenstecher, some three hundred years Dürer's junior and only recently deceased, together with an unceremonious heap of skulls of sundry assorted sizes. The spirit of scientific enquiry, however, had as a side effect a chronic inflammation of the lachrymal glands, first manifested in Britain in the form of elegiac verse, and in France as a vogue for salon paintings depicting the deathbeds of such famous Renaissance artists as Masaccio and Leonardo da Vinci.

In Nuremberg it attracted a late eighteenth-century generation of self-appointed mourners to Albrecht Dürer's tomb—some of them only lately recovered from the grievous loss of young Werther. Among others, it brought the youthful Christian Daniel Friedrich Schubart (1739–1791), who in his autobiography, written in prison in 1774, recalled having paid repeated visits to weep over Dürer's grave as a schoolboy. In the 1790s there were Wilhelm Wackenroder (1773–1798), his friend Ludwig Tieck (1773–1853), and the latter's creation, the fictitious Franz Sternbald. Wackenroder and Tieck, evidently having neglected to fortify themselves with any of the three eighteenth-century monographs on Albrecht Dürer,[5] and seemingly unaware of the vogue for the collection of Dürer engravings and woodcuts which existed in the Goethe circle—or of Hüsgen's catalogue raisonné of Dürer's graphic art, published in 1778—were responsible for popularizing the extraordinary notion that Albrecht Dürer had been forgotten.[6]

In point of fact, no Western artist has been more consistently admired than Dürer who, unlike Raphael, Rembrandt, and others, has never suffered a period of stylistic eclipse. His versatility in handling classical subjects endeared him to the humanists of his own age, while his nature studies have been more widely appreciated at other times, and his handling of the fantastic and the melancholic earned him the approbation of Victor Hugo, Delacroix, Baudelaire, and Jean Paul Sartre. His publications on mathematics, human proportion, and fortification have carried him through such periods of artistic drought as the Thirty Years' War, and were widely quoted by such subsequent authors of treatises as Lomazzo, Van Mander, Nicolas Hilliard, and Sir Joshua Reynolds.

It was the expatriate Nazarenes who first struck upon the idea of celebrating regularly scheduled Dürer festivals, the first of which was held in Rome on May 20, 1815, in Peter Cornelius's room at the Nazarene headquarters in the former monastery of San Isidoro. The details of this

affair were described by Friedrich Overbeck in a letter to Joseph Sutter, dated July 17, which tells how a portrait of the "immortal Master" was hung up and crowned with a thick oak wreath, in which the tools of the various arts which he practiced were placed as attributes: palette and brush, burin, chisel, compass and square, pen, and so on. On a table beneath this arrangement lay "the best of his engravings and woodcuts that we all had collected." Also, Overbeck reveals, there was a biography of Dürer at hand "which was read to the great joy and edification of all." Later, "to the tinkle of glasses," they thought of their absent friends, and decided to celebrate this memorable day every year, to "kindle inspiration in German hearts anew. . . . as well as to stimulate a new German art."[7]

Both the patriotic and crypto-Catholic features of this simple but effective rite are readily traceable to the influence of Wackenroder's *Herzensergiessungen eines kunstliebenden Klosterbruders* (Confessions of an Art-loving Monk, 1797), with its sacramental view of art. Likewise the emotional appeal for a return to a truly national German art, which would be taken up afterward by Fichte and Friedrich Schlegel, is expressed in the oak wreath—symbolic both of the *Altgermanen* and of the War of Liberation, as were the *altdeutsch* costumes normally worn by the Nazarenes. It is worth noting, too, that the idea for the *Dürerfest* came from J. E. Scheffer von Leonhardshoff, a new member of the Brotherhood as of 1815 and the only army veteran in the group, who had served in the War of Liberation at age fourteen.

May 20, 1815 was a totally unremarkable anniversary for Albrecht Dürer—his three hundred forty-forth birthday—but it was an auspicious date indeed for those who hoped for German unification, since it coincided with the deliberations of the Congress of Vienna, which had itself "kindled inspiration in German hearts anew"—prematurely, as it turned out.

In 1816 the Albrecht Dürer Verein was founded in Nuremberg, directly stimulated by the new concern for the preservation of historic monuments begun in 1815 by Karl Friedrich Schinkel, the Prussian state architect, and taken up in January of 1818 in the Rhineland by order of Ludwig X, the Grand Duke of Hesse. The Dürer Verein immediately set about raising funds for the restoration of Dürer's grave and the purchase of his house in the Zisselgasse from its private owner.[8] Beginning in 1820 the membership held simple graveside services in the Johannisfriedhof annually on St. John's Day (June 22), featuring the laying of an oak

wreath on Dürer's tomb and, by 1823, the singing of an anthem, "An Albrecht Dürer's Ruhestätte" (At Albrecht Dürer's Resting Place). After 1837 when the Albrecht Dürer Verein, whose membership had been made up exclusively of artists, was merged with the older Nürnberger Verein von Künstlern und Kunstfreunden (Artists and Friends of Art), the resulting organization, called simply the Dürer-Verein, also held regularly scheduled exhibitions of contemporary art at the Dürer Haus. But these were private, members-only ceremonies. A national epidemic of Dürer-festivities in 1828 marked the three hundredth anniversary of the master's death, when celebrations were held in Nuremberg, Berlin, Dresden, Bamberg, Breslau, and elsewhere.[9]

The Nuremberg festival, planned and directed by a coalition of artists and city officials, attracted a crowd of some ten thousand people, including a large number of visitors to the city. Plans were begun two years in advance when the Director of the Kunstschule (the former Nuremberg Academy), the engraver Albert Christoph Reindel, published an open invitation to all German artists, whether living at home or abroad, to donate examples of their work to a permanent public collection being assembled in Nuremberg in honor of the Dürer anniversary. In response to his rallying-cry, a total of some 130 works in all media were submitted by artists ranging in age from twenty-three to seventy-three, and running the stylistic gamut from Rococo to Biedermeier. Participation in the project was thus not a function of age, training, or stylistic preference; the artists had in common with each other—and with Dürer—only their German birth, the desire to call attention to their work, and their collective hope for a brighter future for the arts in Germany.

Some of the more memorable contributions to the collection, which was partially reassembled by Matthias Mende and Inge Hebecker at the Dürer Haus in honor of Dürer's five-hundredth birthday,[10] were Caspar David Friedrich's watercolor view of the *Heldenstein*, executed with a clarity that would have delighted Dürer himself; a watercolor by the Nazarene painter, Joseph Wintergerst, *The Apotheosis of Albrecht Dürer*, featuring a palpable Gothic shrine shown sprouting from the Master's tomb as his soul is borne heavenward to join an Augustinian company of the Blessed; Carl Heinrich Rahl's very topical *Allegory of the Consequences of the Invention of Lithography for the Engraver* (an engraving showing a hapless copperplate artist immobilized beneath the weight of six litho stones); and Matthias Christoph Hartmann's enchanting tempera painting representing himself and his two young sons paying hom-

age to a colossal marble bust of Albrecht Dürer, perhaps the one sub-
mitted by Ernst Mayer. The collection was housed in a room in the
former Imperial castle, and was apparently the world's first public mu-
seum devoted exclusively to contemporary art. Sad to say, however, rel-
atively few of the festival-goers found their way to the exhibition, and
within five years the collection was placed in storage.

One reason for the general public indifference (other than the usual
reasons for indifference to contemporary art) was that the modern ex-
hibition had been upstaged by Ludwig I of Bavaria, who insisted with
royal conviction that the proper way to honor Albrecht Dürer was with
a life-size bronze statue.[11] He himself insisted upon selecting the sculp-
tor—Christian Rauch of Berlin—and made a handsome contribution
toward the monument's cost, specifying that the remainder of the nec-
essary funds should be solicited from the public. This was both an inter-
esting prefiguration of the modern matching-funds grant and a stroke
of political genius.

Nuremberg, once the capital of the Reich and repository of the coro-
nation regalia, had been annexed by Bavaria only in 1806 with the dis-
solution of the Holy Roman Empire itself, at which time its area was
exactly the same as in Dürer's lifetime and its population smaller by four
thousand souls. Its medieval and renaissance buildings, and its tradition
of handicrafts, were still perfectly preserved in the early nineteenth cen-
tury for the very good reason that there had been almost no economic
growth there since the Thirty Years' War.[12] Though annexation by Ba-
varia was to prove an enormous economic success after 1835, when Nu-
remberg became Germany's first railhead, the loss of independence was
perceived by many Nurembergers as a loss of status, and there had been
a certain amount of ill feeling between Nuremberg and Munich with
regard to such matters as taxes, military conscription, citizenship for
Catholics, and compulsory education during the reign of Ludwig's fa-
ther, King Maximilian I Joseph. Ludwig, who in 1819 had been persona
grata at the soirées of the Nazarenes in Rome and was now the employer
of Peter Cornelius, had inherited the throne only in 1825, barely a year
before announcing his plan for the Dürer monument, which was to be
the first in the world erected in honor of an artist. King Ludwig's pro-
posal was received with tremendous enthusiasm—by everyone except
the sculptors of Nuremberg, who were understandably annoyed at hav-
ing been passed over in favor of a member of the Berlin Academy.

The site chosen for the monument was the former Milk Market—re-

christened Albrecht Dürer Platz—and the laying of the cornerstone by the senior burgomaster was made the focal point of the celebration. Since Rauch's statue would not be ready in time for the festivities, a number of temporary decorations, all of them stressing the Romantic image of the Christological Dürer, were created for the occasion. A fifty-foot-tall painting on transparent material lighted from the back, was erected between Dürer's house and the Tiergärtnertor by a team of Nuremberg artists. It represented a colossal statue of the Master standing in a gothic shrine silhouetted against the rising sun. On its base was inscribed, "Father Dürer, give us thy blessing, that like thee we may truly cherish German art; be our guiding star until the grave!" [13]

In the main auditorium of the City Hall, where Friedrich Schneider's oratorio *Christus der Meister* was to be performed on Easter Sunday as a benefit concert for the Dürer Haus Fund, a cycle of seven transparencies was installed to resemble stained-glass windows. These each stood a bit over six feet tall and had been painted during the week preceding the festival by a group of more than thirty of Peter Cornelius's pupils, who had come to Nuremberg on foot from Munich for the purpose. Six of the subjects represented were scenes from Dürer's life as set forth in Friedrich Campe's tricentennial edition of Dürer's autobiographical writings, chosen for their value as typological parallels to the life of Christ—Dürer at his mother's deathbed and Dürer calming the storm in Zeeland were two of the more memorable. A seventh scene, included at the insistence of Cornelius, represented *Dürer and Raphael before the Throne of Art*—a Wackenroderish subject first portrayed by the late Franz Pforr in 1811 during the halcyon days of the Nazarene brotherhood in Rome (Plate 33).

The festival program itself was an interesting mixture of the patriotic, the sacrilegious, and the purely convivial, in which poetry, music, drama, and the figurative arts were mingled in a grandly pre-Wagnerian potpourri. The late-evening reception for out-of-town guests held at the Dürer Haus survives in the lively descriptions of Sulpiz Boisserée and Ludwig Emil Grimm (Plate 34).[14] A musical sunrise service was held at Dürer's grave on Easter morning, featuring the official festival song, "Wie schön leucht't uns der Morgenstern," by Ernst Förster (son-in-law of the popular writer, Jean Paul Richter), and a lengthy address by Friedrich Campe, the reigning Dürer scholar—too lengthy by half, as some complained. Although the wreath was made of ivy rather than of German oak, as Grimm tells us, the worshippers included many artists

from the most distant parts of Germany, "for once united at this grave."
A number of them were resplendent in long hair and the *altdeutsch* cos-
tumes outlawed by the Carlsbad Decrees—though they had left their
swords at home in compliance with the festival regulations set down by
the Nüremberg city government. (On the chance that the Dürer festival
might take a violent turn, as had the 1817 Luther festival at the Wartburg,
the arrangements for the cornerstone laying included a double cordon
of militia to seal off the entire Dürer Platz during the ceremony.)

The featured event of the evening was a performance of A. W. Grie-
sel's eminently forgettable play, *Albrecht Dürer* (pub. 1820), one of a
number of nineteenth-century dramas devoted to Dürer's adventures,
both real and imagined. (A livelier one, *Albrecht Dürer in Venedig*, was
written by Eduard von Schenk for the celebration in Munich: in it, Al-
brecht Dürer takes Agnes and an imaginary niece, Anna, to Venice. Ag-
nes haggles over prices at every opportunity, Giorgione fritters his time
away playing the lute, and Marcantonio Raimondi apologizes for copy-
ing Dürer's prints.)

The Dürer Haus guest book shows that an imposing number of the
great and near-great had come to Nurenberg to honor Dürer, but there
was one who was conspicuous by his absence. The venerable Goethe,
who in his youth had advocated Dürer's "wood-carved manliness" as an
antidote for the *geschminkte Puppenmaler* (dandified doll painters) of the
Rococo, excused his absence from the festival on the grounds of old age
and precarious health in a letter dated March 18, 1828. Although these
were undoubtedly legitimate reasons for his having remained in Wei-
mar, an even more fundamental reason is suggested by the following
lines from *Wilhelm Meister*, penned in 1829: "There is no patriotic art
and no patriotic science. Both belong, like all higher things, to the
whole world."[15]

In contrast to the public and popular character of the four-day Nu-
remberg celebration, the Berlin one was both elitist and mercifully
brief.[16] It was not the impecunious Künstlerverein, but the Berlin Acad-
emy—and more specifically its director, Gottfried Schadow—who took
charge of the affair and who, moreover, controlled the supply of eight
hundred tickets. Guests of honor at the festival, which was held in the
*Singakademie*, were the Prussian crown prince and his family, and the
ancient war hero, Field Marshall August Count Neidhardt von Gnei-
senau. The setting for the festival address and for the oratorio—com-
posed by the nineteen-year-old Felix Mendelssohn—was designed by

the Geheime Oberbaurat Friedrich Schinkel himself. Its focal point was a great altarpiece crowned by a painted copy of Dürer's 1511 woodcut of the Holy Trinity, with pedestals below on which were placed life-size plaster statues draped in actual garments of white linen: a standing Albrecht Dürer, with stylus and tablet in hand, flanked by classical female figures representing Scenography, Painting, Sculpture, and "Architectura Militaris," or Fortification. Interestingly, there was no representation of the graphic arts, which were Dürer's real forte, while sculpture, to which he had at best a dubious claim, was accorded the place of honor at his left—no doubt in deference to Schadow and his protégé, Christian Rauch.

The admission of military architecture to Parnassus was both a tribute to Dürer's treatise on fortification (*Befestigungslehre*), newly reprinted in Berlin in 1823, and a compliment to the venerable Field Marshall Gneisenau and the educational reform of the Prussian Officer Corps. Berlin's institutions of higher learning at this time included, after all, not only an eighteen-year-old university and academies of art and music, but a newly founded Superior Military Academy as well, where small groups of officers were sent for "spiritual advancement."[17] Prussian officers, and later those of the Imperial army, would continue to study Dürer's *Befestigungslehre* until 1917.

The Künstlerverein, which had been given no role in the day's official events, retired to its own quarters in the evening for a private party featuring a colossal bust of Albrecht Dürer crowned with laurel, a number of songs written especially for the occasion by Friedrich Wilhelm Gubitz—the reviver of the woodcut technique—and a generous supply of alcohol. Jocund references were made to the sanctimonious Nazarenes—never great favorites in Berlin outside the Schadow household—as well as to the shortcomings of Dürer's wife Agnes.[18] The generally irreverent flavor of the occasion persisted in later Berlin anniversaries, and is best remembered from Adolf Menzel's lithographed invitation card from the 1830s, showing a Dürer-Pantocrator presiding over a gigantic punchbowl.

In 1840, Christian Rauch's long-awaited bronze statue of Dürer (Plate 35) was finally ready for installation in Nuremberg's Milk Market—completed literally in the nick of time, a mere nine days before the newly liberated Belgians were scheduled to dedicate their own monument to cultural separatism—a statue of Peter Paul Rubens (Antwerp, May 30, 1840: the Dutch, of course, were forced to retaliate in 1847 with a mon-

ument to Rembrandt). Thus Albrecht Dürer's reputation as cultural hero was saved: he remained both the first artist in history to be commemorated by a public monument, as well as the earliest artist to be so honored.

Dürer's reputation as a paragon of virtue, on the other hand, had been irreparably damaged by the publication in 1828 of the unexpurgated Dürer papers—including the fateful letters from Venice. This, together with the waning of Wackenroder's influence and the dramatic improvement in Nuremberg's economic situation, helps to account for the more worldly tone of this and later nineteenth-century festivities.[19] There was, to be sure, a performance of Haydn's *Creation*, followed by a two-hundred-torch parade to Dürer's grave for a brief musical service; there was also a new cantata ("Euer Vorbild, euer Führer, Künstler, bleibe Albrecht Dürer," by Georg Neumann). But at the unveiling of Rauch's monument, there were tributes to King Ludwig's new Danube–Main Canal, and the city was awash in its first tidal wave of Dürer kitsch: from little metal copies of the Dürer statue, to sheet music (the *Albrecht-Dürer-Marsch*, by Valentin Hamm), stickpins, hairpins, shirt studs, pipe-stoppers, wine glasses, and special Albrecht-Dürers-Torte and Albrecht-Dürers-Lebkuchen at the local pastry shops.

The play was Friedrich Wagner's *Albrecht Dürer*, performed at the new city theater, and there was a festival ball, inspired by the Albrecht Dürer masquerade held in Munich during the previous Fasching season, a description of which survives in Gottfried Keller's *Der Grüne Heinrich*. The masked ball, held in the Munich Residenz, had focussed upon Dürer's relationship to the Emperor Maximilian, and in particular upon the supposed granting of the artist's coat of arms in perpetuity, an anecdote first told by Karel van Mander in the *Schilderboek* (1604). The Bavarian court was portrayed as having fostered an idyllic and symbiotic relationship between nobility and bourgeoisie in which the arts were permitted to flourish—imagery which was to be transferable with ease from Ludwig I of Bavaria to Kaiser Wilhelm in the late nineteenth century, where it provided themes for such painters as Carl Jäger, Wilhelm Koller, and Hans Makart.

The four-hundredth anniversary of Dürer's birth, however, came as something of an anticlimax, since the birthday itself—May 21, 1871—came only eleven days after the signing of the Peace of Frankfurt, but more importantly because the longing for German unity which had spawned the Dürer celebrations in 1815 now suddenly found itself satis-

fied. Consequently, the play presented was only a re-run of *Albrecht Dürer in Venice*; the anniversary volume appeared a year late and without pretensions to serious scholarship; the speeches and poems struck a new low in literary merit, being replete with references to *Kaiser, Reich, Vaterland, Sieg, Heldengräber, Adler*, and *Volk*; and the obligatory visit to Dürer's grave was rescheduled from dawn to the more civilized hour of 7:30. The concert program featured substantial nineteenth-century fare: Schiller's *Festgesang an die Künstler*, arranged for men's chorus by Mendelssohn; Max Bruch's *Lied vom deutschen Kaiser*; Beethoven's Seventh Symphony, and the Hallelujah Chorus from Handel's *Messiah*. However, the guests arrived by rail, and the toasts were "telegraphed" from Nuremberg to other celebrations all over the country, and the exhibition at the new Germanisches Nationalmuseum was the first in Nuremberg history to be devoted—*mirabile dictu*—to Dürer's own work. Since the best of Dürer's paintings, drawings, and watercolors had long ago been sold from Nuremberg to such interested parties as Rudolph II and Maximilian I of Bavaria, and the great *Self-Portrait* of 1500 had been stolen from the City Hall and replaced with the forgery by A. W. Küfner as recently as 1805, the exhibition was heavily dependent on works borrowed from Vienna, and from private collectors in Frankfurt and Aachen.

In the rhetoric of 1871, Dürer (whose father and uncles were, after all, Hungarian) began to be referred to as "the most German of German masters" by Julius Hübner in his speech at the Albrechtsburg in Meissen,[20] and in Nuremberg the Burgomaster Christoph Seiler issued a clarion call in his speech at the foot of the Dürer monument for a full-fledged cultural crusade to be undertaken in Dürer's name and on a national scale—the re-Germanizing of the Alsace being one of its major goals.[21]

Thus the foundation was laid for the Albrecht Dürer image of the Second Reich: an amalgam of the Christological Dürer of the Romantic period, who continued to inspire by his personal example but was freed at last from his enforced association with Raphael of Urbino, and the militaristic Albrecht Dürer of the victorious Prussian army, whose officer corps would produce four new studies of the *Befestigungslehre* between 1867 and 1889.[22]

The theme of *Dürer als Führer* was taken up in earnest by Julius Langbehn (1904),[23] who described Dürer's art, somewhat incongruously, as "a two-handed sword" fit for slaying those twin dragons of French Im-

pressionism and Art for Art's Sake; and Dürer became the unwitting arbiter of German middle-class taste through the all-encompassing activities of Ferdinand Avenarius's *Dürerbund* (1902 ff.). The Dürerbund, which at its peak had 300,000 members, including Max Liebermann and Heinrich Wölfflin, was formed for the avowed purpose of promoting a "healthy" culture.[24] As such it took the field against smut, decadence, and bad taste, producing its own traveling exhibitions, pre-packaged entertainments for do-it-yourself celebrations of cultural heroes, children's books, communion cards, toys, manuals for bird-watching, nature conservancy, and sex education, and inexpensive reproductions of "Meisterbilder" suitable for framing—for a newly domesticated Albrecht Dürer had been revealed to the public for the first time through photographic reproductions of his watercolors and easel pictures (the *Wild Hare* became a public favorite), and his woodcuts and engravings had been made available in the late nineteenth century in inexpensive facsimiles from the *Reichsdruckerei*. The Dürerbund also served as a quality control for design-approved artifacts of every sort, from table silver to tombstones. Though the Dürerbund itself failed to survive World War I, its root system remained viable, and most of its ideals were destined to bloom again after 1933.

By 1928, the four-hundredth anniversary of his death, Albrecht Dürer was so indispensable a member of every middle-class household and so powerful a political ally that a simple two- or three-day festival no longer seemed adequate: both 1928 and 1971, in consequence, were officially designated "Dürer Years," like Papal Jubilees. April 6, 1928, fell on Good Friday, and was celebrated in Berlin by a special session of the Reichstag, while in Nuremberg there was the obligatory visit to Dürer's grave—portrayed somewhat irreverently on the cover of *Simplicissimus* by Thomas Theodore Heine, who depicted a group of academicians belatedly bestowing the title of Professor on the departed. The keynote address and anniversary volume this time were by Geheimrat Prof. Dr. Heinrich Wölfflin of Zürich, and the Festspiel was Wagner's *Meistersinger*.

Added attractions were the opening of the newly restored Dürer Haus, fully stocked with period furnishings through the generosity of the Albrecht-Dürerhaus-Stiftung, established in 1871; the performances of *Faust* and of eleven plays by Roswitha von Gandersheim, Burkart Waldis, and Hans Sachs; and revivals of the medieval *Büttnerstanz* and *Schembartlauf*. There was also a special Youth Day (July 7) for Nurem-

berg schoolchildren and Erlangen University students, and separate
weeks devoted to the cultures of Franconia, Oberpfalz, and Austria.

The crowning achievement of the Dürer Year, however, and the per-
sonal triumph of Nuremberg's Democratic mayor, Dr. Hermann
Luppe, was the splendid Dürer exhibition on view at the Germanisches
Nationalmuseum. This was the first exhibition of international impor-
tance to be held in a German museum, and one of the world's first major
monographic exhibitions. Thanks to Gustav Stresemann's conciliatory
"Spirit of Locarno," and to the fact that Nuremberg's commercial im-
portance had made it a strategic center for foreign consulates, Luppe
was able to arrange the temporary return to Nuremberg for the first time
in history of many of Dürer's important paintings and drawings which
had found their way to foreign countries. Once it became evident that
Paris, Lisbon and Rome had agreed to lend works to the exhibition,
Luppe was even able to secure the partial cooperation of the major Ger-
man museums—some of which had previously refused to honor his re-
quests.[25] There was even an Albrecht Dürer *Ostpolitik*, with festivals in
Budapest and in Gyula, the birthplace of Albrecht Dürer, Sr., where a
historic marker was unveiled. Relations with the Horthy government
became so cordial that Luppe was made an honorary citizen of Gyula
and was presented with the Hungarian Order of Merit; Luppe recipro-
cated by adding Hungarian Week to the Dürer Year.

The great exhibition of 1928 was the source of tremendous interna-
tional publicity for Nuremberg and attracted a record 200,000 visitors.
With its unprecedented problems in security and insurance, it repre-
sented a daring advance in museology, as well as a celebration of the
apparent return of the German economy to a state of stability after the
disastrous inflation of the postwar years. Dürer Year seemed an effective
antidote for the reactionary *Deutscher Tag* of 1923, Nuremberg's celebra-
tion of the anniversary of the 1870 victory over the French at Sedan with
its militaristic parades of S.A. ( Nazi Storm Troopers) and *Stahlhelm*
(World War I veterans of the German Army), and for the National So-
cialist Party Congress of 1927. Only five years later, however, in 1933,
Mayor Luppe was placed under arrest by the new master of Nuremberg,
Julius Streicher, who would bring notoriety to the city with the pro-
mulgation of the Nuremberg Laws.[26]

Although Albrecht Dürer had been declared so racially pure as to be
featured on the cover of the Nazi publication *Volk und Rasse* (Plate 36),
he had no centenary during the Third Reich, and even his annual days

of remembrance were supplanted by a new *sacre du printemps*—April 20, the birthday of Adolph Hitler. The taste for public spectacle was amply fulfilled by the annual *Reichsparteitage* which, like the public celebrations of the victory over the French in 1871 (*Sedan-Feiern*), were held in early September. Nuremberg was now called "the most German of German cities," in Hitler's phrase, and her Imperial glory was restored by the return of the crown jewels from Vienna, as well as by the mammoth new architectural program projected by Albert Speer for the city's outskirts.

It was in this new role that Nuremberg was described in an R.A.F. Bomber Command report of 1943 as "a political target of the first importance, and one of the Holy Cities of the Nazi creed," and that it was subsequently marked for destruction by Air Chief Marshall Sir Arthur Harris in the raids of 1944 and 1945, in which the aiming point was the medieval city center rather than the industrial suburbs.[27] It was in this capacity that Nuremberg was selected as the site of the war criminals' trials, and was *not* selected to be the new capital of the Federal Republic.

As if by a miracle, Albrecht Dürer's tomb and monument survived the holocaust unscathed; his house, like his reputation however, had suffered serious, though not irreparable damage. During the twelve years of the Thousand Year Reich, Albrecht Dürer was daily celebrated in thousands of ways, exerting a powerful influence on contemporary graphic art (Plate 37), for Adolf Hitler, who had painstakingly copied a color reproduction of Dürer's *Pond House* watercolor as an art student manqué in his Vienna days, was known to harbor a particular fondness for the work of the "most German of all German artists." Copies after, and forgeries of, the *Knight, Death and Devil* were at an all-time high; cited out of context by Friedrich Nietzsche in *The Birth of Tragedy* as the harbinger of Schopenhauer, Dürer's master engraving was soon transformed in the work of Willibald Hentschel, Ernst Bertram, and Hans F. K. Gunther into the symbol of the Volkish hero; and finally, in the poetry of Eberhard Wolfgang Moeller and—in the enormous painting by the Tyrolean zealot, Hubert Lanzinger, which once hung over Albert Speer's desk—into the image of Hitler himself.[28]

The aesthetic preferences of the Dürerbund lived on in the work of modern printmakers (Plate 38) and in the lists of "approved" reproductions for domestic decoration. Such a list published in the official Party women's magazine *N.S. Frauenwarte* in 1937, for example, offered a selection of 122 works by 53 artists—one-fourth of them by Albrecht Dü-

rer.[29] It was, of course, in 1937 that the German museums were purged of their "degenerate" works of modern art, and the ghosts of Albrecht Dürer, Lucas Cranach, and Albrecht Altdorfer were invoked to fill the resulting void.

Against a background of such memories as these, and in the teeth of the craze for op, pop, and concept art, for blue jeans and happenings, for anti-heroes and counterculture, the lengthiest and most expensive Dürer festival in history was staged in 1971, in honor of the artist's five-hundredth birthday. Three years and six million marks in the planning, it began with an "Advent" ceremony in December of 1970, on Willibald Pirckheimer's birthday. The official delegation to Dürer's grave, where non-partisan chrysanthemums were substituted for the wreath of oak, was led by Prof. Dr. Carlo Schmidt of Bonn, who asserted that Nuremberg was not only the city of Pirckheimer, Dürer, and the Imperial regalia, but also that of the *Reichsparteitage*, which must be taken into account whenever the "fame and honor" of the city were mentioned, and that this fact must be recognized in order to put the "German Dürer" and the "German Nuremberg" into perspective. Both Schmidt and the Dürer-Year Kuratorium were vilified in the press, where the catch phrase *"Dürer statt Führer"* soon became the unofficial leitmotif of 1971 and where, on the far left, Schmidt's reference to Nuremberg's "fame and honor" was perceived as a deliberate *double entendre*.[30]

In many ways the basic structure of Dürer Year 1971 was simply a more expensive version of 1928. Despite the loss of several of Dürer's most brilliant watercolors, including the *View of Nuremberg*, from the Bremen Museum in 1945, the most splendid Dürer exhibition ever assembled brought five thousand people *per day* to the Germanisches Nationalmuseum. To augment it, there were seventeen smaller exhibitions in the city's other musuems and exhibition halls, and a cultural smorgasbord of concerts, lectures, films, operas, and plays was offered—some of which, like Brecht's *Galileo*, Reiner Werner Fassbinder's *Blut am Hals der Katze*, and Arnold Schönberg's *Moses und Aron* had quite tenuous connections, if any, with Albrecht Dürer. Others, such as Günther Grass's lecture, *Vom Stillstand im Fortschritt -Variationen zu Albrecht Dürers "Melencolia I,"* were not only beautifully crafted but relevant as well.

The loss of the city's architectural heritage in World War II was only too evident, however, and was merely made more poignant by a folk fair

and by the continuing presence of the United States Army a quarter-century after the war. A 1.75-million-mark multi-media show, *Noricama*, produced by Josef Svoboda of Prague, offered a fifteen-minute history of Nuremberg in which projections of Albrecht Dürer's Apocalypse woodcuts were juxtaposed with film footage of the air raids of 1945.

For schoolchildren there were free Dürer books, an art competition to identify the "Albrecht Dürers of tomorrow," and an essay contest ("What Albrecht Dürer means to us today"). There were one-week crash courses in Albrecht Dürer for the city's policemen, and a "Name Dürer's Animals" contest for visitors to the Nuremberg zoo. For the thirty winners of the Municipal Dürer Quiz, there was a luncheon with Gustav Heinemann.[31] In the true spirit of 1840, no attempt was made to prevent the commercialization of the Dürer image—indeed, Albrecht Dürer and West German currency have been quite literally synonymous since the paper marks of the Weimar Republic, where one found, for example, the portrait of the *Venetian Woman by the Sea* on the twenty million mark note and the supposed portrait of Jacob Fugger (now thought to represent the Treasurer, Lorenz Sterck) on the five thousand.

As was duly noted in the leftist press, the Dürer Kuratorium numbered among its members, in addition to Willy Brandt and the highest officials of the Bonn government, representatives of the mass media, and such captains of industry as Max Grundig and Ernst von Siemens, but not a single artist. At the municipal level, the city of Nuremberg published an appeal for "Verbundpartner" for its advertising campaign—that is, for firms willing to design their own advertising around the Dürer Year theme. The prize-winning design for the official Dürer Year poster was that of the Dresdner Bank—a selection which some viewed as highly symbolic.

But there were in 1971, of course, *two* Germanies, each claiming custody of Albrecht Dürer's cultural legacy. If the Federal Republic in its haste to destroy the false Dürers of the second and third Reichs had failed to provide a suitable substitute, as some journalists claimed, this could hardly be said of the Democratic Republic where, due to Friedrich Engels's admiration for him (*Dialektik der Nature*, 1874), Dürer is more highly revered than any other artist—despite his West German birthplace. When the war on formalism was officially declared by the Democratic Republic in 1951, it was, after all, not the Saxon court painter Lucas Cranach, but Albrecht Dürer whose works were recommended for study, and to whom the first issue of the new social-realist

periodical *Bildende Kunst* (1953) was devoted. Consequently, while Lucas Cranach's five hundredth birthday in 1972 was left to be commemorated in capitalist Basel, Albrecht Dürer's anniversary elicited an international symposium and two volumes of papers produced under the auspices of the Karl Marx University in Leipzig.[32] The symposium was supplemented by a small exhibition of sixteenth-century German drawings from the Dessau Museum, and was attended by teachers, artists, students, party functionaries, and by a delegation of factory workers from the Leuna Werke "Walter Ulbricht." Forty papers were presented by visiting art historians from Russia, Czechoslovakia, Poland, Bulgaria, Rumania, Italy, Sweden, West Germany, and France, as well as from the D.D.R.

The Albrecht Dürer who emerged from Leipzig was Engels's basic intellectual giant and man of action, now viewed in the context of the new post-Ulbricht East German concern for the development of a public sense of heritage, and in the particular context of the so-called "Early Bourgeois Revolution." To no one's surprise, he was a leftist pictured as having shared Thomas Münzer's and Michael Gaismeier's vision of a "society without masters and servants." Dürer was also praised for having developed his own national consciousness "free of any chauvinism," while the Federal Republic was castigated for having abused Dürer's humanistic legacy in order to hide the supposedly inhuman character of capitalism, and as having reserved the works of art of the past for elitist aesthetic pleasure.

As Wolfgang Stechow noted, however, it would seem that it was the West German Albrecht Dürer and his big business *Verbundpartner* who were the real victors over elitism.[33] Whatever one's personal reaction to advertisements inaccurately describing Dürer as "Deutschlands erster Hippie" (the Dorland Agency); or to the Albrecht-Dürer-Platte at the Gasthof Pillhofer with a large AD monogrammed in mayonnaise, there is no denying the fact that 360,000 people visited the superb exhibition at the Germanisches Nationalmuseum, and that, thanks to the unobtrusive use of advertising from publishers and art dealers by way of a colophon, the beautiful scholarly catalogue of the exhibition could be sold for fifteen marks, well within the range of the "*Malerknaben*" for whom Dürer himself wrote. As a result, 73,000 copies were sold.

Contributions from business and industry also figured prominently in funding two of the exhibitions of modern art arranged by the Albrecht-Dürer-Gesellschaft. *Mit Dürer Unterwegs*, financed by Roland Graf Fa-

ber-Castell, featured the work of six young German artists who had been given travel grants to retrace some of Dürer's steps: Matthias Prechtl created a delightful Netherlandish sketchbook, as well as an updated view of the *Weissensee* with a junked automobile in the middle of it (mixed media), and a bemused Dürer sketching a nude in a Venetian gondola which has knowing overtones of both Thomas Mann and Errol Flynn.

Nuremberg's other modern exhibition of 1971, *Albrecht Dürer zu ehren*, featured well-established artists from both hemispheres: Picasso, Graham Sutherland, Marino Marini, Salvador Dali, Joseph Albers, and Max Bill, among many others, and Otto Dix, who had chosen four early drawings for the exhibition shortly before his death. One of the most timely entries, Walter Schreiber's *Hasenstall*, was a high-rise rabbit hutch featuring identical reproductions of Dürer's famous hare in identical settings of genuine wood, wire, and carrots (Plate 39).

In 1971 the rhetoric of German unification, however, was conspicuous by its absence, as each of the two Germanies laid claim to Dürer's own political sympathies: the Münzerite Dürer presented in Leipzig resurfaced in 1974 in a radio play by Günter Kunert, *Mit der Zeit ein Feuer*, and was countered in 1975 in Martin Walser's *Sauspiel* by a more reactionary Dürer whose treatise on fortifications was described as a bulwark against the radical peasants, rather than against the Turkish menace, as has been assumed.[34]

There was, however, agreement on both sides of the border that Albrecht Dürer, the Renaissance man, European traveler, and educator of the young should take precedence over the more single-minded and xenophobic Albrecht Dürers of past celebrations. This was the theme developed by Wolfgang Stechow in his opening address, *Albrecht Dürer: Praeceptor Germaniae*, at the Nuremberg exhibition. His lecture was doubly meaningful, first as it disclosed an unfamiliar facet of Albrecht Dürer—his reception in the New World. Secondly, the speaker himself, who had left his position as *Extraordinarius* at the University of Göttingen in 1936 to escape the Third Reich, by his presence in Nuremberg on Dürer's five-hundredth birthday symbolized the final reconciliation of German-born art historians on two continents.

Meanwhile, the truly international Dürer was celebrated as well in Britain, the United States, and the Soviet Union with important exhibitions and scholarly catalogues prepared in London, Boston, Washington, and Leningrad. New Dürer catalogues and monographs continue

to appear on both sides of the Atlantic and in Eastern Europe, as do new
works of art inspired by Dürer and his adventures: Warrington Cole-
scott, with tongue firmly in cheek, has recast the case of *Dürer v. Marcan-
tonio Raimondi* in contemporary terms in two color etchings, both titled
*Albrecht Dürer at Twenty-three: In Love, In Venice, His Bags Are Stolen*
(1977), from his satirical *History of Printmaking* series (Plate 40). The
Dürer prints, although completed a year later than some of the other
plates in Colescott's series of colored collage-etchings dealing with such
printmakers as Picasso, Toulouse-Lautrec, Goya, and Rembrandt, were
nevertheless the first to be sold out.

Goethe, whose opinions on certain other issues are now routinely
ignored, has been vindicated at least in regard to his belief that "there is
no patriotic art and no patriotic science. Both belong, like all higher
things, to the whole world."

# NOTES

## Chapter I

1. Dürer's original manuscript has been lost. The Nuremberg book dealer and antiquarian, Friedrich Campe (1776–1846), editor of the tricentennial edition of Dürer's autobiographical writings (1828) had access to a manuscript, also now lost, which had belonged to the Imperial goldsmith Hans Petzold (1550–1632). It is not known whether Petzold's manuscript was Dürer's original, or simply an early copy. Surviving copies in manuscript are the two transcribed by Nicolaus Paul Helffreich (d. 1684), a member of the Nuremberg City Council and the city's official pawnbroker: Bamberg, Staatliche Bibliothek, J.H. Msc. art. 50, III. 12, and Nuremberg Stadtbibliothek, Will-Nor. III 915b and 916 fol. Pap. Both of these were copied from the same archetype. The Bamberg manuscript came from the estate of Joseph Heller, author of the first modern catalogue raisonné of Dürer's work, who bought it in Nuremberg in 1821. It bears the signature of a previous owner, Christopher Jacob Waldstrom von Reichelsdorf, and the date 1718. (See Hans Rupprich, ed., *Dürer: Schriftlicher Nachlass*, 3 vols. [Berlin, 1956], vol. I, pp. 27–34.)

2. See Emerich Lukinich, "Albrecht Dürers Abstammung," *Ungarische Jahrbuecher*, vol. IX (1929), 104–110. (Prof. Lukinich at the time of writing was the Director of the Sechenyi-Bibliothek of the Hungarian National Museum.) See also Gerhard Hirschmann, "Albrecht Dürers Abstammung und Familienkreis," in Nuremberg, *Albrecht Dürers Umwelt: Festschrift zum 500. Geburtstag Albrecht Dürers am 21. Mai 1971,* Nürnberger Forschungen, 15 (Nuremberg, 1971), pp. 35–54.

3. ". . . honorabilis dominus Johannes, plebanus ecclesie sancte crucis in civitate Waradiensi fundate . . . procurator nobilis Nikolai de Doboka." (Egon Erwin Kisch, "Nachforschungen nach Dürers Ahnen," in *Der rasende Reporter* [Berlin, 1925], pp. 256–163, quoted in Hirschmann, "Albrecht Dürers Abstammung und Familienkreis.")

4. Nürnberg, Staatsarchiv (Siebenfarbiges Alphabet, Akten Nr. 28). See A. Gümbel, "Zur Biographie Albrecht Dürers des Älteren," *Repertorium für Kunstwissenschaft*, vol. XXXVII (1915), pp. 210–213.

5. Fedja Anzelewsky, *Dürer: His Art and Life* (1980; rpt. New York: 1981), p. 15. Hermannstadt is modern Sibiu (Rumania). Dr. Anzelewski is Director Emeritus of the Kupferstichkabinett in West Berlin and author of the standard catalogue of Dürer's paintings.

6. Quoted in August Buck, "Enea Silvio Piccolomini und Nürnberg," in Nuremberg, *Albrecht Dürers Umwelt*, p. 25 (translation mine).

7. On the display of the *Reichskleinodien* in Nuremberg, see Jeffrey Chipps Smith, *Nuremberg: A Renaissance City, 1500–1618* (Austin, Texas, 1983), pp. 28–29, and New York, Metropolitan Museum of Art, *Gothic and Renaissance*

*Art in Nuremberg 1300–1550*, exhibition catalogue (New York and Nuremberg, 1986), no. 47, pp. 179–181.

8. A full account of this and other spectacles can be found in Richard Vaughan, *Philip the Good* (London, 1970), chap. 5; see also Oskar Cartillieri, *Am Hofe der Herzöge von Burgund* (Basel, 1926).

9. Elizabeth Caesar, "Sebald Schreyer," *Mitteilungen des Vereins für die Geschichte der Stadt Nürnberg*, vol. LVI (1969), pp. 1–213, cited in Anzelewsky, *Dürer: His Art and Life*, pp. 15–16.

10. On the Schlüsselfelder ship, see New York, *Gothic and Renaissance Art in Nuremberg*, no. 81, pp. 224–227.

11. Nuremberg, Staatsarchiv, Ratsverlässe 235 fol. IIv.

12. Nuremberg, Germanisches Nationalmuseum Archive.

13. Merry E. Wiesner, *Working Women in Renaissance Germany* (New Brunswick, N.J., 1986), pp. 170–171.

14. Berlin, Kunstgewerbe-Museum; Munich, Schatzkammer der Residenz; Vienna, Kunsthistorisches Museum; Amsterdam, Rijksmuseum. On the relationship between Endres Dürer and Wenzel Jamnitzer, see Christoph Gottlieb von Murr, *Journal zur Kunstgeschichte und zur allgemeine Literatur*, vol. 2 (1776), p. 232, and Rupprich, *Dürer*, vol. I, pp. 8–9, esp. note 6.

15. Konrad Celtis, Libri odarum quattuor III. 23.

16. June 14, 17, and 18, Nuremberg Stadtarchiv, Ratsverlässe 1510, III, IIb, 12b, 13a.

17. Hans Dürer's murals are partially illustrated in Jan Bialostocki, *The Art of the Renaissance in Eastern Europe* (Phaidon, Oxford 1976), plates 70, *The Tabula Cebetis* (1532), and 71, *Tournaments* (painted in collaboration with Master Antoni from Wroclaw, ca. 1533).

18. Nuremberg Stadtbibliothek, Pirckheimer-Papiere ad 375.8.

19. The detailed record of actions taken by the Nuremberg City Council in regard to goldsmiths, brass workers, painters, sculptors, and other artisans is published in Theodor Hampe, *Nürnberg Ratsverlässe über Kunst und Künstler im Zeitalter der Spätgotik und Renaissance*, Quellenschriften zur Kunstgeschichte und Kunsttechnik, N.F. XI, vol. I (Vienna and Leipzig, 1904). The documents referring to Hans Frey's case are found on pp. 53–55 of the Nuremberg Staatsarchiv, documents 369 (1488, VI, IIa), 370 (IIb), and 375 (1488, VII, 9a).

## Chapter II

1. Ulrich Wagner (d. 1490), *Rechenbuch*, published June 16, 1482, in Bamberg by Heinrich Peczensteiner. See also Klaus Leder, "Nürnbergs Schulwesen an der Wende vom Mittelalter zur Neuzeit," in Nuremberg, *Albrecht Dürers Umwelt*, pp. 29–34.

2. Rupprich, *Dürer*, vol. I, p. 113, noted in Klaus Leder, "Nürnbergs Schulwesen an der Wende vom Mittelalter zur Neuzeit," in Nuremberg, *Albrecht Dürers Umwelt*, pp. 29 ff.

3. Camerarius, in the preface to his Latin translation of Dürer's *Four Books of Human Proportion*, posthumously published in 1532.

4. On silverpoint, see James S. Watrous, *The Craft of Old Master Drawings* (Madison, Wis., 1957), pp. 3–24.

5. Ochenowski (1911), Bauch (1932), Panofsky (1943), Tietze (1951), Strieder (1981). See Matthias Mende, *Dürer-Bibliographie* (Wiesbaden, 1971). Wolfgang Stechow was also convinced of the correctness of the attribution to Dürer's father.

6. Munich, Alte Pinakothek, 663, 670, 664, 666.

7. See in particular Leonhard Sladeczek, *Albrecht Dürer und die Illustrationen zur Schedelchronik* (Baden-Baden, 1965); Franz J. Stadler, *Michael Wolgemut und der nürnberger Holzschnitt im letzten Viertel des 15. Jahrhunderts* (Strassburg, 1913); Willy Kurth, *Albrecht Dürer: Sämtliche Holzschnitte* (Munich, 1927); Eduard Flechsig, *Albrecht Dürer, sein Leben und seine künstlerische Entwicklung*, 2 vols., vol. II (Berlin, 1931), pp. 507–516; Leonie von Wilkens, "Begegnungen: Nürnberg," in *Albrecht Dürer 1471–1971*, exhibition catalogue (Nuremberg, 1971), pp. 60–73; Walter L. Strauss, *The Woodcuts and Woodblocks of Albrecht Dürer* (New York, 1980), pp. 1–36.

## CHAPTER III

1. Albrecht Dürer the Elder's portrait is in the Uffizi in Florence. The portrait of his mother, considered lost since the seventeenth century, was identified by the late Lotte Brand Philip in 1978, on the basis of the inventory number from the collection of Willibald Pirckheimer's Imhoff heirs, as that of the *Unknown Woman in a Coif* previously attributed to Master W.B. (Germanisches Nationalmuseum, Nuremberg). See L. B. Philip, *Das neuentdeckte Bildnis von Dürers Mutter*, Renaissance Vorträge, vol. VII (Nuremberg, 1981). An earlier version, with research and comment by Fedja Anzelewsky, was published in English in *Simiolus*, vol. X (1978/79), pp. 5–18. The identification has not been universally accepted. (See Peter Strieder, *Albrecht Dürer: Paintings–Prints–Drawings* (New York, 1981), p. 226.)

2. Christoph II, Scheurl, *Commentarii de vita et obitu reverendi patris Dni. Anthonii Kressen* (Nuremberg, 1515). See also Jakob Wimpfeling, *Epithoma Germanorum Jacobi wimpfelingii* (Strassburg, 1505).

3. Munich, Alte Pinakothek 1027: the date has been read both as 1453 and as 1483.

4. Colmar, *Bezirksarchiv, Urbar des St. Martinstiftes*, fol. 58r., quoted in Julius Baum, *Martin Schongauer* (Vienna, 1948), p. 70, note 12.

5. I am indebted to Willibald Sauerländer for this observation.

6. Carel van Mander, *Het Schilderboeck* (Haarlem, 1604); Joachim von Sandrart, *Teutsche Akademie der Bau-, Bild- und Mahlerey-Künste* (Nuremberg, 1675).

7. Kupferstichkabinett, KdZ.4174: W.30.

8. On Master A.G. see Alan Shestack, *Fifteenth Century Engravings of Northern Europe from the National Gallery of Art* (Washington, D.C., 1967), nos. 121–122, and Jane C. Hutchison, *Early German Artists*, commentary, volume IX of *The Illustrated Bartsch* (New York, 1990). The basic research is the un-

published Ph.D. dissertation by Ursula Petersen, *Der Monogrammist A.G.*, Freiburg-im Breisgau, 1953.

9. On this artist, see *The Master of the Amsterdam Cabinet or the Housebook Master*, compiled by J. P. Filedt Kok (Princeton, 1985).

10. W.16, formerly Bremen, Kunsthalle until 1945.

11. British Museum; see John Rowlands, *The Age of Dürer and Holbein: German Drawings 1400–1550* (Cambridge, 1988), pp. 60–61, no. 35.

12. W.30, Berlin, and W.25, Erlangen, University Library.

13. W.41, formerly Rotterdam, Museum Boymans van Beuningen until 1941.

14. Frankfurt, Städelsches Kunstinstitut, Inv. 334, 335. The engraver Master W.B. has been identified as Wolfgang Beurer, or Peurer, in a recent article by Fedja Anzelewsky, who now reattributes the paintings to Anton Beurer. (F. Anzelewsky, "Eine Gruppe von Malern und Zeichnern aus Dürers Jugendjahren," *Jahrbuch der Berliner Museen*, vol. XXVII [1985], pp. 35–59.)

15. Illustrated in Filedt Kok, *Master of the Amsterdam Cabinet*, fig. 40, and cat. nos. 116 a–b. On Master W.B. see also Alan Shestack, *Master LCz and Master W.B.* (New York, 1971).

16. Ludwig Grote, "Dürer-Studien," *Zeitschrift des deutschen Vereins für Kunstwissenschaft*, vol. XIX (1965), p. 162.

17. University Library, B 155v.

18. Zucker, Mark J., "Raphael and the Beard of Pope Julius II," *The Art Bulletin*, vol. LIX (1977), pp. 524–533.

## CHAPTER IV

1. Dürer's horoscope is contained in a letter from Lorenz Beheim to Willibald Pirckheimer, dated May 23, 1507 (Nuremberg, Stadtbibliothek, Pirckheimer-Papiere ad 375.8). Rupprich, *Dürer*, vol. I, p. 254; vol. III, p. 455.

2. Walter L. Strauss, *The Complete Drawings of Albrecht Dürer*, vol. 1 (New York, 1974), p. 212.

3. Christoph II, Scheurl, *Libellus de laudibus Germaniae et Ducum Saxoniae* (Leipzig, 1508). (Rupprich, *Dürer*, vol. I, pp. 290–291.)

4. W.75, Frankfurt, Städelsches Kunstinstitut.

5. Arnold von Harff and Canon Pietro Casola, quoted in H.F.M. Prescott, *Friar Felix at Large: A Fifteenth-Century Pilgrimage to the Holy Land* (1950; rpt., New Haven, 1960), pp. 83–84.

6. Ibid.

7. Berlin, Kupferstichkabinet, KdZ 15 346; KdZ 15 344; KdZ 15 343.

8. Formerly Bremen, Kunsthalle, before 1945.

9. W.67, W.68, both Vienna, Albertina.

10. W.95, London, British Museum.

11. W.96, formerly Bremen, Kunsthalle, until 1945.

12. W.97, ex coll. von Hirsch.

13. W.94, Paris, Louvre.

14. W.99, Oxford, Ashmolean.

## Chapter V

1. Celtis, *Norimberga*, vol. XII, in Albert Werminghoff, ed., *Conrad Celtis und sein Buch über Nürnberg* (Freiburg im Breisgau, 1921). On Willibald Pirckheimer, see also Hans Rupprich, *Wilibald Pirckheimer und die erste Reise Dürers nach Italien* (Vienna, 1930); Nuremberg Stadtbibliothek, *Willibald Pirckheimer 1470–1970*, exhibition catalogue (Nuremberg, 1970); Christoph von Imhoff, *Berühmte Nürnberger aus neun Jahrhunderten* (Nuremberg, 1984).

2. New York, Ian Woodner collection.

3. E. Rosenthal, "Dürers Buchmalereien für Pirckheimers Bibliothek," *Jahrbuch der preussischen Kunstsammlungen*, vol. XLIX (1928), Beiheft, p. 1, quoted in Veronika Birke and Friedrich Piel, eds., *Die Sammlung Ian Woodner*, exhibition catalogue (Vienna, 1986), no. 48.

4. Salo W. Baron, *A Social and Religious History of the Jews*, 2nd ed., vol. XIII (New York, 1969), p. 169, note 11. I am grateful to Ellen W. Meyer for this reference.

5. Oskar Hase, *Die Koberger*, 3rd ed. (Amsterdam and Wiesbaden, 1967); see also Baron, *A Social and Religious History of the Jews*. I am grateful to Ellen Meyer for this and reference material on Nuremberg's Jewish community.

6. On Dr. Johannes Pirckheimer, see Arnold Reimann, *Die älteren Pirckheimer: Geschichte eines Nürnberger Patriziergeschlechtes im Zeitalter des Frühhumanismus (bis 1501)* (Leipzig, 1944); Christoph von Imhoff, *Berühmte Nürnberger*; Rupprich, *Wilibald Pirckheimer*.

7. See Erwin Panofsky, "Jan van Eyck's Arnolfini Portrait," *Burlington Magazine*, vol. LXIV (1934), pp. 177 ff., and *Early Netherlandish Painting*, 2 vols. (Cambridge, Mass., 1953), vol. I, pp. 202–203.

8. London, British Museum, Cod. Arundel 175.

9. Cf. Rupprich, *Wilibald Pirckheimer*; see also Franz Winzinger, *Dürer* (Hamburg, 1983), pp. 52–55.

10. On Charitas (Caritas) Pirckheimer, see W. Loose, *Aus dem Leben der Charitas Pirckheimer—Äbtissin zu St. Clara in Nürnberg. Nach Briefen* (inaugural dissertation), Dresden, 1870; Christoph von Imhoff, *Berühmte Nürnberger*; L. Kurras and F. Machilek, *Caritas Pirckheimer—1467–1532* (Munich, 1982); G. Deichstetter, ed., *Caritas Pirckheimer: Ordensfrau und Humanistin— Vorbild für die Oekumene—Festschrift zum 450. Todestag* (Cologne, 1982).

11. Jan Bialostocki, "Myth and Allegory in Dürer's Engravings," in *Tribute to Wolfgang Stechow, Print Review*, vol. V (1976), pp. 24–34.

12. Vienna, Albertina, 3062.

13. Hamburg, Kunsthalle, 23006.

14. Cf. Fedja Anzelewsky, *Dürer-Studien* (Berlin, 1983), pp. 45–56. The tale was later the subject of a song as well as a prose account by Hans Sachs (1552).

15. Erwin Panofsky, *Hercules am Scheidewege*, Studien der Bibliothek Warburg, 18 (Leipzig and Berlin, 1930), p. 166. See also W. Strauss, *The Intaglio Prints of Albrecht Dürer* (New York, 1976), no. 24.

16. On Hercules Alemannus, see Frank L. Borchardt, *German Antiquity in Renaissance Myth* (Baltimore, 1971).

17. Borchardt. *German Antiquity*, pp. 18, 45.
18. Anzelewsky, *Dürer-Studien*, pp. 66 ff.

## CHAPTER VI

1. Nürnberg, Stadtarchiv, Lib. Cons. K, fol. 132v.
2. Rupprich, *Dürer*, vol. III, p. 448.
3. Rupprich, *Dürer*, vol. I, p. 244. Hans Arnold became a Nuremberg citizen in 1489. Heinrich Zyner, Rupprich suggests, may have been a relative of Dürer's brother-in-law, Martin Zinner, who had married Agnes Dürer's only sister.
4. Cf. Frans von Juraschek, "Der Todsündendrache in Dürers Apokalypse," *Jahrbuch der preussischen Kunstsammlungen*, vol. LVIII (1937). See also Strauss, *The Woodcuts and Woodblocks of Albrecht Dürer*, no. 40, pp. 153–155.
5. Nuremberg, Peypus, 1501.
6. See Harold Joachim, "Review of Friedrich Winkler's *Dürer und die Illustrationen zum Narrenschiff*," *Art Bulletin*, vol. XXXV (1953), p. 66.
7. George Szábo, of the Lehman Collection, Metropolitan Museum, N.Y., in a paper delivered at the annual meeting of the College Art Association of America, Chicago, Ill., 1971. Published as "Dürer and Italian Majolica: Four Plates with 'The Prodigal Son and the Swine,' " in *American Ceramic Circle Bulletin* (1972–1973), pp. 5–28.
8. Berlin, Staatliche Museen Preussischer Kulturbesitz.
9. 1521, Madrid, Prado.
10. Drawing, 1520–1521, Berlin, Kupferstichkabinett.
11. Silverpoint, 1520, Chantilly, Musée Condé.
12. 1505, London, British Museum.
13. Berlin, Staatliche Museen Preussischer Kulturbesitz.
14. Kassel, Gemäldegalerie. The portraits of Hans (V) Tucher and his wife have been returned to the Weimar Museum by the private New York collector, Eliot Elisofon, who had purchased them after World War II.
15. Munich, Alte Pinakothek, where it was severely, perhaps irreparably, damaged in 1988 by a vandal who drenched it in acid.

## CHAPTER VII

1. Erwin Panofsky, *The Life and Art of Albrecht Dürer*, 4th ed. (Princeton, 1955), p. 43; Franz Winzinger, "Albrecht Dürers Münchner Selbstbildnis," *Zeitschrift für Kunstwissenschaft*, vol. VIII (1954), pp. 43 ff.
2. Kassel, Landesbibliothek.
3. Dieter Wuttke, "Dürer und Celtis: Von der Bedeutung des Jahres 1500 für den deutschen Humanismus: Jahrhundertfeier als symbolische Form," *Journal of Medieval and Renaissance Studies*, vol. X (1980), pp. 73 ff.
4. See also Jan Bialostocki, "Vernunft und Ingenium in Dürers kunsttheoretischem Denken," *Zeitschrift des deutschen Vereins für Kunstwissenschaft*, vol. XXV (1971), 107–114.
5. See Ernst Gombrich, *The Heritage of Apelles: Studies in the Art of the Renaissance* (Ithaca, N.Y., 1976), p. 17.

6. Rupprich, *Dürer*, vol. III, p. 295.

7. Formerly in Bremen, until 1945.

8. Konrad Celtis, *Odes* IV, 5 (Ode to Apollo), in Lewis W. Spitz, ed., *The Northern Renaissance* (Englewood Cliffs, N.J., 1972), pp. 14–15.

9. Anzelewsky, *Dürer: His Art and Life*, p. 61. See also Elisabeth Caesar, "Sebald Schreyer," pp. 1–213.

10. Ludwig Grote, "Die 'Vorder-Stube' des Sebald Schreyer. Ein Beitrag zur Rezeption der Renaissance in Nürnberg," *Anzeiger des germanischen Nationalmuseum Nürnberg* (1954–1959), pp. 43–67, cited in Anzelewsky, *Dürer: His Art and Life*, p. 61.

11. The best of the Roman copies is in the Vatican; the statue was also reproduced on Roman coins of Cnidos struck during the reign of Caracalla. Cf. Margarette Bieber, *The Sculpture of the Hellenistic Age*, rev. ed. (New York, 1967), p. 19 and fig. 25. See also Bernard Ashmole, "Praxiteles," *Encyclopedia of World Art*, vol. XI (London, 1966), cols. 562–565.

12. W.263, Berlin, Staatliche Museen Preussischer Kulturbesitz, Kupferstichkabinett; W.261, London, British Museum; W.262, New York, Metropolitan Museum.

13. Charles Scillia, "Dürer's *Adam and Eve*: Two Classical Canons," paper delivered at the conference, Tradition and Innovation in the study of Northern European Art, University of Pittsburgh, October 1985.

14. British Museum MS., vol. II. 43.

15. See Jay A. Levenson, "Jacopo de' Barbari," in Jay A. Levenson, Konrad Oberhuber, and Jacquelyn L. Sheehan, eds., *Early Italian Engravings from the National Gallery of Art* (Washington, D.C., 1973), pp. 341–381, especially note 19, p. 345.

## Chapter VIII

1. Franz Winzinger, *Albrecht Dürer* (Reinbek bei Hamburg, 1971), p. 54. Winzinger speculates that Sanseverino may previously have visited Nuremberg as a guest at Pirckheimer's wedding in the fall of 1495.

2. Munich, Alte Pinakothek, no. 706.

## Chapter IX

1. Nuremberg Stadtbibliothek, Pirckheimer-Papiere 394.1.

2. George Szábo, "Dürer and Italian Majolica I, pp. 5–28.

3. See Miriam Beard, *A History of Business*, 2 vols. (Ann Arbor, 1962), vol. 1, pp. 85–87, on social life at the Fondaco dei Tedeschi.

4. *The Pilgrimage of Arnold von Harff Knight . . . 1469–1499*, trans. Malcolm Letts (London, 1946).

5. Fedja Anzelewsky, "War Dürer in Kärnten?" in *Dürer-Studien: Untersuchungen zu den ikonographischen und geistesgeschichtlichen Grundlagen seiner Werke zwischen den beiden Italienreisen* (Berlin, 1983), pp. 169–178.

6. Ibid.

7. British Museum, St. 1505/28.

8. Anzelewsky, "War Dürer in Kärnten?" pp. 169–178.

9. Panofsky, *The Life and Art of Albrecht Dürer*, p. 110.

10. Ibid.

11. (Blessed) Cardinal Giovanni Dominici (1350–1420), *Regola del governo di cura familiare*, written 1400–1405. (See *Regola del governo di cura familiare dal Beato Giovanni Dominici*, ed. D. Salve, Florence, 1860.) Leon Battista Alberti, *Libri della famiglia* (completed 1441), ed. G. Mancini (Florence, 1908).

12. Panofsky, *The Life and Art of Albrecht Dürer*, p. 114.

13. Jan Bialostocki, "Opus quinque dierum: Dürer's 'Christ among the Doctors' and Its Sources," *Journal of the Warburg and Courtauld Institutes*, vol XXII (1959), pp. 17, 34.

14. Nuremberg Stadtbibliothek, Pirckheimer-Papiere 396.

15. Dürer is undoubtedly referring here to Pirckheimer's alleged wild oats from his student days in Italy.

16. Nuremberg Stadtbibliothek, Pirckheimer-Papiere 394, 7.

17. Thought to be either the *Madonna with the Siskin* (Berlin-Dahlem) or, alternatively, the *Christ among the Doctors* (Lugano, Thyssen-Bornemisza Collection), also dated 1506. The latter work is now believed to have been painted in Rome (Anzelewsky, *Dürer: His Art and Life*, p. 129).

18. These very probably included the painted portrait of an unknown woman by the sea (Berlin-Dahlem: Preussischer Kulturbesitz: once erroneously identified as Agnes Dürer because of the intials "A.D." inscribed on her bodice), as well as some portrait drawings. The Vienna portrait of a Venetian woman (Kunsthistorisches Museum, 6440), which is dated 1505, must already have been painted soon after Dürer's arrival in Venice. Although her costume is actually Milanese, this work can only have been painted in Venice, and was left unfinished (Leonie von Wilckens, ed., *Albrecht Dürer*, exhibition catalogue [Munich, 1971], no. 531).

19. Mentioned in Konrad Celtis's *Norimberga* as a Hungarian garment (Pannoniae hasucum; cf. Rupprich, *Dürer*, vol. I, p. 57, note 12).

20. London, British Library, Sloane Collection, Harl. 4935, fol. 41.

21. Hans Zamasser, a local Nuremberg rowdy, was a particular favorite of Pirckheimer's *Herrenstube*. One of Dürer's early portrait clients, Oswolt Krel, had been jailed by the city magistrates in 1497 for ridiculing Zamasser as a Fool in a carnival play (Rupprich, *Dürer*, vol. I, p. 59, note 8).

22. London, British Library, Sloane Collection, Harl. 4935, fol. 41.

## CHAPTER X

1. Translation, Walter L. Strauss.

2. Translations based on Conway as amended by Panofsky and Stechow (*Northern Renaissance Art 1400–1600* [Englewood Cliffs, N.J., 1966], pp. 91–94).

3. I am indebted to Sister Mary Carla Huebner, S.S.N.D., for this observation.

4. See Charles Talbot, ed., *Dürer in America* (Washington, D.C., 1971), pp. 138–142.

## CHAPTER XI

1. On Hans Süss, see Sigrid Walther, *Hans Süss von Kulmbach* (Dresden, 1981).

2. On Hans Baldung Grien, see Gert von der Osten, *Hans Baldung Grien— Gemälde und Dokumente* (Berlin, 1983); James H. Marrow and Alan Shestack, eds., *Hans Baldung Grien: Prints and Drawings*, exhibition catalogue, National Gallery of Art, Washington, D.C., and Yale University Gallery (New Haven, 1981).

3. M. J. Liebmann, "Dürer und seine Werkstatt," in Ernst Ullmann, Günter Grau, and Rainer Behrends, *Albrecht Dürer: Zeit und Werk* (Leipzig, 1971).

4. Sloane Collection, 5230/24.

5. Walter L. Strauss, ed., *Albrecht Dürer: The Painter's Manual* (New York, 1977), passim.

6. On Maximilian, see Gerhard Benecke, *Maximilian I (1459–1519): An Analytical Biography* (London, 1982). I am grateful to Loni Hayman for this and other references to Maximilian. Diane Strickland, *Maximilian as Patron: The Prayerbook*, Ph.D. diss., University of Iowa, 1980; Karl Giehlow, *Kaiser Maximilian I. Gebetbuch und Zeichnungen von Albrecht Dürer und anderen Künstlern*, facsimile edition (Vienna and Munich, 1907), and "Urkundenexegese zur Ehrenpforte Maximilians I," in *Beiträge zur Kunstgeschichte* (Vienna, 1903), pp. 91–110; Larry Silver, "Prints for a Prince: Maximilian, Nuremberg and the Woodcut," in Jeffrey Chipps Smith, ed., *New Perspectives on the Art of Renaissance Nuremberg* (Austin, Texas, 1985), pp. 7–21.

7. On the *Knight, Death, and Devil*, see Heinrich Theissing, *Dürers Ritter, Tod und Teufel: Sinnbild und Bildsinn* (Berlin, 1978); Ursula Meyer, "Political Implications of Dürer's 'Knight, Death and Devil,' " *Print Collector's Newsletter*, vol. IX, no. 2 (May–June 1978), pp. 35–39; Hans Schwerte, *Faust und das Faustische. Ein Kapitel deutscher Ideologie* (Stuttgart, 1962), chap. VIII, "Dürers 'Ritter, Tod und Teufel' "; I am grateful to Reinhold Grimm for this reference.

8. The literature is too lengthy to list in full. Essential works include Erwin Panofsky and Fritz Saxl, *Dürers Kupferstich 'Melencolia I.' Eine quellen- und typengeschichtliche Untersuchung*, Studien der Bibliothek Warburg, vol. II (Leipzig and Berlin, 1923); Raymond Klibansky, Erwin Panofsky, and Fritz Saxl, *Saturn and Melancholy* (London, 1964); Konrad Hoffmann, "Dürers 'Melencolia'," in W. Busch, R. Hausherr, and E. Trier, eds., *Kunst als Bedeutungsträger. Gedenkschrift für Günter Bandmann* (Berlin, 1978), pp. 251–279, and "Dürer's 'Melencolia I,' " *Print Collector's Newsletter*, vol. IX, no. 2 (May–June 1978), pp. 33–35; Philip L. Sohm, "Dürer's *Melencolia I*: The Limits of Knowledge," *Studies in the History of Art*, vol. IX (1980), 13–32; Hartmut Böhme, *Albrecht Dürer—"Melencolia I"—Im Labyrinth der Deutung* (Frankfurt a.M., 1989), I am grateful to Jost Hermand for this reference; and Peter Klaus Schuster, *"Melencolia I": Dürers Denkbild*, 2 vols. (Berlin, 1989).

9. Hoffmann, "Dürers 'Melencolia.' "

10. Rupprich, *Dürer*, vol. I, pp. 156 and 295, cited in Sohm, "Dürer's *Melencolia I*," p. 13.

11. Karl Giehlow, "Dürers Stich 'Melencolia I' und der maximilianische Humanistenkreis," *Mitteilungen der Gesellschaft für vervielfältigende Künste*, vol. XXVI (1903), pp. 29–41, and vol. XXVII (1904), pp. 6–28, 57–78.

## Chapter XII

1. On Spengler, see Harold J. Grimm, *Lazarus Spengler: A Lay Leader of the Reformation* (Columbus, Ohio, 1978).
2. Grimm, *Lazarus Spengler*, p. 20.
3. Gerhard Pfeiffer, "Albrecht Dürer und Lazarus Spengler," in Dieter Albrecht et al., eds., *Festschrift für Max Spindler* (Munich, 1969); and Strauss, *The Complete Drawings of Albrecht Dürer*, vol. III, p. 1290.
4. Basel, Universitätsbibliothek, Mscr. G. I. 31, p. 41.
5. Schutzred vnnd christenliche antwort ains erbarn liebhabers götlicher warhait der heiligen geschrifft, auff etlicher widersprechen, mit anzaigunge, warumb Doctor Martini Luthers leer nit sam unchristlich verworffen, sonder mer als Christenlich gehalten werden sol. *Apologia* 1519.
6. Complete text in *On the Eve of the Reformation: Letters of Obscure Men*, intro. by Hajo Holborn (New York, Evanston, and London, 1964).

## Chapter XIII

1. Nürnberg Stadtarchiv.
2. London, British Museum, Hs. Add. 5229 fol. III.22.
3. Bamberg, Staatliches Bibliothek, 246, J.H. Msc. art. I, III.18, and Nürnberg Stadtarchiv, S.I., L.79, No. 15, Fas. 18.
4. Excerpts from Dürer's Netherlandish diary are based in part on the Conway translation, as amended by Stechow in *Northern Renaissance Art*, pp. 96–107, and in part on my own reading of Rupprich's definitive German edition with its extensive historical notes.
5. A useful survey is "Zersungenes Erbe: Zur Geschichte des *Deutschlandliedes*," in Jost Hermand's *Sieben Arten an Deutschland zu leiden* (Königstein, 1979), pp. 62–74.
6. On Quentin, or Quinten, Massys, and on Antwerp in this period, see Larry Silver, *The Paintings of Quinten Massys* (Montclair, N.J., 1984).
7. Rupprich, *Dürer*, vol. I, p. 54.
8. On Dürer's gifts and sales of artworks in the Netherlands, see Julius Held, *Dürers Wirkung auf die niederländische Kunst seiner Zeit*, Ph.D. diss., The Hague, 1931.
9. Hernando Cortes, *Five Letters: 1519–1526*, trans. F. Bayard Morris (New York, 1929); Hugh Honor, *The New Golden Land* (New York, 1975); Vienna, Museum für Volkerkunde, *Die mexikanische Sammlung* (1965). For these and other references I am grateful to Linda Duychak. For further information on the pre-Columbian art seen by Dürer, see her M.A. thesis, *Dürer and Vera Cruz*, University of Wisconsin–Madison, 1989.
10. According to Rupprich (*Dürer*, vol. I, p. 185, note 221) this must have been Chinese porcelain, acquired by Portuguese traders in India.
11. See J. Jacquot, ed., *Les fêtes de la Renaissance*, vol. II, *Fêtes et ceremonies au*

*temps de Charles Quint* (Paris, 1960), cited in Silver, *Quinten Massys*; and Hans Rupprich, "Die Beschreibungen niederländischer Prozessionsspiele durch Dürer und Hieronymus Köler der Ältere," *Maske und Kothurn*, vol. 1 (1955), pp. 88 ff.

## CHAPTER XIV

1. On Aachen, see Richard E. Sullivan, *Aix-la-Chapelle in the Age of Charlemagne*, 2nd prtg. (Norman, Okla., 1974).
2. On the Church of St. Jan, see C.J.A.C. Peeters, *De Sint Janskathedraal te 's Hertogenbosch* (The Hague, 1985). I thank Thomas Gombar for this reference.
3. On Adriaen van Wesel, see the exhibition catalogue, *Adriaen van Wesel: een Utrechtse beeldhouwer uit de late middeleeuwen*, Amsterdam, Rijksmuseum, 1981, particularly the article by W. Halsema-Kubes on the Mary Altar for the Confraternity of Our Lady, pp. 34–44.
4. On Bergen, see Fernand Braudel, *The Perspective of the World*, Civilization and Capitalism 15th–18th Century, vol. 3 (1979; New York, 1982), p. 149.
5. On Gossaert, see Max J. Friedländer, *Early Netherlandish Painting*, vol. VIII (Brussels and Leiden, 1972), pp. 1–50 and editor's note pp. 114–115; and H. Pauwels, H. R. Hoetink, and S. Herzog, *Jan Gossaert genaamd Mabuse*, exhibition catalogue (Brussels and Rotterdam, 1965).

## CHAPTER XV

1. See Léon de Burbure, *Bulletins de l'Academie royale de Belgique*, 2nd. series, vol. XXVII (1869), cited in Rupprich, *Dürer*, vol. 1, p. 193, note 498.
2. Rupprich, *Dürer*, vol. 1, p. 192, note 460, also spelled "Lupin."
3. For this and other information on Dürer's fashions, I am grateful to Loni Hayman.
4. On Dürer and Luther see especially Gottfried Seebass, "Dürers Stellung in der reformatorischen Bewegung," in Nuremberg, *Albrecht Dürers Umwelt*, pp. 101–131; Heinrich Lutz, "Albrecht Dürer in der Geschichte der Reformation," *Historische Zeitschrift*, vol. CCVI (1968), pp. 32 ff.; Andreas Bodenstein von Karlstadt, *Von anbetvng vnd der erbietvng der zeychen des newen Testaments* (Augsburg: Melchior Remminger, 1521), dedicated to Dürer.
5. (M.105). See letter from Erasmus to Willibald Pirckheimer dated January 8, 1525, excerpted in Rupprich, *Dürer*, vol. 1, p. 271, no. 79. The full text of the letter can be found in the standard edition of Erasmus's letters, P. S. and H. M. Allen, *Opus epistolarum Desiderii Erasmi Roterodami* (Oxford, 1906–1947), vol. VI (1926), p. 2 f., No. 1536.
6. Bodenstein von Karlstadt, *Von anbetvng vnd der erbietvng der zaychen des newen Testaments*.
7. I am grateful to Pamela H. Decoteau for this observation, and for bibliographical references regarding Margaret of Austria and her court.
8. Albrecht Dürer, *Etliche vnderricht, zv befestigung der Statt, Schloss, vnd flecken* (Nuremberg, Hieronymus Anreae, 1527). The silverpoint drawing of a mortar, on pink-grounded paper, was formerly in the Bremen Kunsthalle (until

1945.) It is the verso of a silverpoint drawing of two female heads, one wearing a crown (W.782).

## Chapter XVI

1. On Lucas van Leyden's graphic art, see Ellen S. Jacobowitz and Stephanie L. Stepanek, *The Prints of Lucas van Leyden and His Contemporaries*, exhibition catalogue, National Gallery of Art (Washington, D.C., 1983); J. P. Filedt Kok, *Lucas van Leyden—Grafiek*, exhibition catalogue, Rijksprentenkabinet (Amsterdam, 1978); Rik Vos, "The Life of Lucas van Leyden by Karel van Mander," in *Lucas van Leyden Studies, Nederlands Kunsthistorisch Jaarboek*, vol. XXIX (1978), pp. 459–508.

2. Dürer's silverpoint is popularly believed to be the drawing in the Musée Wicar, Lille (W.816), although another drawing in the British Museum, attributed to Dürer, bears the inscription "effegies Lucae Leidensis" (W.809).

3. It has been suggested (Jan Veth and Samuel Müller, *Albrecht Dürers niederländische Reise* (Berlin and Utrecht, 1918), p. 28, cited in Rupprich, *Dürer*) that the crowned woman drawn in profile in the silverpoint drawing W.782 (formerly Bremen Kunsthalle, until 1945) may represent Germaine de Foix. Flechsig, Winkler, and Panofsky, however, were convinced that both female heads in the lost drawing were sketched after paintings, rather than done from life. The literature is discussed in Strauss, *The Complete Drawings of Albrecht Dürer*, vol. IV, p. 2084, no. 1521/46. The present writer knows the drawing only from reproductions, but is inclined to agree with the latter opinion.

## Chapter XVII

1. W.921, New York, Pierpont Morgan Library, *ex coll*. Sir Peter Lely.

2. *Deutsche Reichstagsakten*, II, 595–596 (1896), cited in Roland H. Bainton, *Here I Stand: A Life of Martin Luther* (New York, 1950), p. 145.

3. *Portrait of Ulrich Varnbühler* (W.908), Vienna, Albertina (life drawing for the woodcut, B.155); *Portrait of Friedrich the Wise* (W.897), silverpoint drawing, Paris, École des Beaux Arts, study for the engraved portrait B.104 (1524); *Portrait of Friedrich II of the Palatinate* (W.903), London, British Museum; *Portrait of Cardinal Albrecht von Brandenburg* (W.896), Paris, a study for the engraving B.103 ("The Large Cardinal"), dated 1523; *Design for a Throne* (W.920), Braunschweig, Herzog Anton Ulrich-Museum, dated 1521.

4. Seebass, "Dürers Stellung," pp. 101–131.

5. Bodenstein von Karlstadt, *Von anbetvng vnd der erbietvng der zeychen des newen Testaments*.

6. W.889, Vienna.

7. W.798, Frankfurt, Städelsches Kunstinstitut, 1521.

8. *Wider die himmlischen Propheten, von den Bildern und Sakrament*, Weimar Luther edition, vol. XVIII, pp. 62 ff.

9. On the Behams and Pencz, see Herbert Zschelletzschky, *Die "Drei gottlosen Maler" von Nürnberg* (Leipzig, 1975).

10. On the design for a monument to a dead peasant, see Hans-Ernst Mittig,

*Dürers Bauernsäule: Ein Monument des Widerspruchs* (Frankfurt a.M., 1984). On the war itself, see also Bob Schreiber and Gerhard Benecke, *The German Peasant War—1525—New Viewpoints* (London, Boston, and Sydney, 1979).

11. London, British Museum, W.899.

12. W.913, British Museum.

13. W.914, Cambridge, Mass., Fogg Museum.

14. On Melanchthon, born Johann Schwarzerd, see Clyde Manschreck, *Melanchthon, the Quiet Reformer* (New York, 1958).

15. Kaspar Peucer, *Tractatus historicus de Phil. Melanchthonis* . . . (Amberg, 1596). Quoted in Rupprich, *Dürer*, vol. I, p. 306.

16. Heinz Lüdecke and Susanne Heiland, *Dürer und die Nachwelt* (Berlin [DDR], 1955), pp. 41–42 (translation mine).

17. Nürnberg, Staatsarchiv, Losungsamt, vol. 70, p. 384. This reference, discovered by Hirschmann (in Nuremberg, *Albrecht Dürers Umwelt*, p. 49 and note 75) was unknown to Rupprich.

18. I am grateful to Louisa R. Stark for this observation.

## Chapter XVIII

1. Jan Bialostocki, *Dürer and His Critics*, Baden-Baden, 1986.

2. Fritz Koreny, *Albrecht Dürer und die Tier- und Pflanzenstudien der Renaissance*, exhibition catalogue (Munich, 1985).

3. See Bettina von Arnim's letter to Goethe, from Munich, dated June 16, 1809 (Lüdecke and Heiland, *Dürer und die Nachwelt*, pp. 147–149).

4. See Moriz Thausing, "Hüsgen's Dürersammlung und das Schicksal von Dürers sterblichen Überresten," *Zeitschrift für bildende Kunst*, vol. IX (1874), pp. 321–323.

5. Heinrich Conrad Arend (1728—in honor of the two-hundredth anniversary of Dürer's death); David Gottfried Schöber (1769); Johann Ferdinand Roth (1791).

6. See Dieter Bänsch, "Zum Dürerbild der literarischen Romantik," *Marburger Jahrbuch*, vol. XIX (1974), pp. 259–274.

7. Lüdecke and Heiland, *Dürer und die Nachwelt*, pp. 168–169.

8. Georg Freiherr Kress von Kressenstein, *Albrecht Dürers Wohnhaus und seine Geschichte* (Nuremberg, 1896), p. 50.

9. See Karl Heinz Schreyl, *Nürnberger Dürerfeiern 1828–1928* (Nuremberg, 1971).

10. Matthias Mende and Inge Hebecker, *Das Dürer-Stammbuch von 1828*, exhibition catalogue 4, Dürer-Haus (Nuremberg, 1973).

11. See Matthias Mende, "Das Dürer-Denkmal," in Volker Plagemann and Hans-Ernst Mittig, eds., *Denkmäler im 19. Jahrhundert* (Munich, 1971), pp. 163–181.

12. Bänsch, "Zum Dürerbild," pp. 259–274.

13. "O gieb uns, Vater Dürer, deinen Segen, / Dass treu, wie du, die deutsche Kunst wir pflegen; / Sei unser Stern, bis an das Grab!"

14. Sulpiz Boisserée, letter to his brother Melchior, dated April 6, 1828 (Lüdecke and Heiland, *Dürer und die Nachwelt*, pp. 196–199, and Grimm, *Lazarus Spengler*, pp. 191–196).

15. Johann Wolfgang von Goethe, *Schriften zur Kunst* (dtv-Ausgabe), vol. 34 (Munich, 1972), p. 259.

16. See Georg Galland, *Eine Dürer-Erinnerung aus dem romantischen Berlin*, Strassburg, 1912.

17. Gordon A. Craig, *The Politics of the Prussian Army 1640–1945*, 2nd ed. (1964; Oxford, rpt., 1972), p. 45; Bernhard Schwertfeger, *Die grossen Erzieher des deutschen Heeres* (Potsdam, 1936), p. 15.

18. A sample of the evening's verse, which does not translate well: "Freunde, wir sind hier versammelt, / Dürers eingedenk zu sein, / Und das Hirn wär uns verrammelt / Täten wir es nicht beim Wein."

19. See Berthold Hinz, *Dürers Gloria: Kunst, Kult und Konsum* (Berlin, 1971).

20. Julius Hübner, *Albrecht Dürer: Festrede am Tage der Dürerfeier der Dresdner Kunstgenossenschaft den 25. Juni 1871 . . . im Prunksaale der Albrechtsburg zu Meissen* (Dresden, 1871), p. 10.

21. Schreyl, *Nürnberger Dürerfeiern*, p. 111.

22. C.v.d. Goltz, "Albrecht Dürers Einfluss auf die Entwicklung der deutschen Befestigungskunst," in Herman Grimm, ed., *Über Künstler und Kunstwerke*, vol. 2 (Berlin, 1867), pp. 189–203; G. von Imhof, *A. Dürer in seiner Bedeutung für die moderne Befestigungskunst* (Nördlingen, 1871); M. Jahns, *Handbuch einer Geschichte des Kriegswesens* (Leipzig, 1880), pp. 1183–1189; and M. Jahns, *Geschichte der Kriegswissenschaft*, vol. 1 (Munich and Leipzig, 1889), pp. 783–792.

23. Julius Langbehn and Momme Nissen, *Dürer als Führer*, rev. ed. (Munich, 1928), pp. 8 ff.

24. Gerhard Kratzsch, *Kunstwart und Dürerbund* (Göttingen, 1969), p. 336 and passim.

25. Luppe's unpublished memoirs, cited in Schreyl, *Nürnberger Dürerfeiern*, pp. 117–120.

26. See Gerhard Hirschmann and Hans Hubert Hofmann in Gerhard Pfeiffer, ed., *Nürnberg: Geschichte einer europäischen Stadt* (Munich, 1971), esp. pp. 445–465; and Fritz Nadler, *Eine Stadt im Schatten Streichers* (Nuremberg, 1969).

27. On wartime Nuremberg, see Erhard Mossack, *Die letzten Tage von Nürnberg* (Nuremberg, 1952); and Martin Middlebrook, *The Nuremberg Raid* (London, 1973).

28. See George L. Mosse, *The Crisis of German Ideology* (New York, 1972), pp. 240 ff.; Schwerte, *Faust und das Faustische*, pp. 243–278; Reinhold Grimm, "Vom sogenannten Widerstand gegen die Völkischen: Ein Nachtrag zum Thema 'Ritter, Tod und Teufel,' " in Lawrence Baron et al., *Ideologiekritische Studien zur Literatur: Essays II* (Bern and Frankfurt a.M.), 1975, pp. 73–84.

29. *N.S. Frauenwarte: Die einzige parteiamtliche Frauenzeitschrift*, vol. III, no. 6, (1937), p. 85. I am grateful to the late Walter Strauss, who procured a copy of this publication for me.

30. *Tendenzen*, vol. XII, 75/76 (June–July 1971), pp. 126–127.

31. On the 1971 celebration, see the extensive coverage in *Der Spiegel*, vol. XI (1971), pp. 153–178.

32. Ernst Ullmann, Günter Grau, and Rainer Behrends, eds., *Albrecht Dürer: Zeit und Werk*, Leipzig, 1971; Ernst Ullmann, ed., *Albrecht Dürer: Kunst im Aufbruch*, Leipzig, 1972.

33. Wolfgang Stechow, "Recent Dürer Studies," *Art Bulletin*, vol. LVI (1974), pp. 259–270.

34. Günther Kunert, published in Günter Rücker, *Portrait einer dicken Frau* (Berlin [DDR], 1974); Martin Walser, *Das Sauspiel: Szenen aus dem 16. Jahrhundert* (Frankfurt a.M.), 1975. I am grateful to Reinhold Grimm and Jost Hermand for these references.

# SELECTED BIBLIOGRAPHY

Alte Pinakothek, Munich. *Altdeutsche Malerei* (Catalogue II). Munich, 1963.

Anzelewsky, Fedja. *Albrecht Dürer: Das malerische Werk*. Berlin, 1971.

————. *Dürer: His Art and Life*. New York, 1980.

————. *Dürer-Studien: Untersuchungen zu den ikonographischen und geistesge-schichtlichen Grundlagen seiner Werke zwischen den beiden Italienreisen*. Berlin, 1983.

————. "Eine Gruppe von Malern und Zeichnern aus Dürers Jugendjahren." *Jahrbuch der Berliner Museen*, vol. XXVII (1985), pp. 35–39.

Ashmole, Bernard. "Praxiteles." In *Encyclopedia of World Art*. Vol. XI. London, 1966. Cols. 562–565.

Baier, Helmut. *600 Jahre Ostchor St. Sebald—Nürnberg 1379–1979*. Nürnberg, 1979.

Bainton, Roland. *Here I Stand: A Life of Martin Luther*. New York, 1950.

Bänsch, Dieter. "Zum Dürerbild der literarischen Romantik." *Marburger Jahrbuch*, vol. XIX (1974), pp. 259–274.

Baron, Salo W. *A Social and Religious History of the Jews*. 2nd ed. Vol. XIII. New York, 1969.

Bauch, Kurt. *Martin Schongauer und die deutschen Kupferstecher des fünfzehnten Jahrhunderts*. Forschungen zur Geschichte der Kunst am Oberrhein, Band 5 (Sonderheft). Freiburg im Breisgau, 1941.

Baum, Julius. *Martin Schongauer*. Vienna, 1948.

Baxandall, Michael. *The Limewood Sculptors of Renaissance Germany*. New Haven and London, 1980.

Beard, Miriam. *A History of Business*. 2 vols. Ann Arbor, 1962.

Beck, Herbert, and Peter C. Bol. *Dürers Verwandlung in der Skulptur zwischen Renaissance und Barock* (exhibition catalogue). Frankfurt a.M.: Liebighaus, 1981.

Bell, William. "Manuscripts of Albert Dürer in the Library and Print-Room of the British Museum, and Elsewhere." *The Art Journal* (1861), pp. 106–107.

Benecke, Gerhard. *Maximilian I (1459–1519): An Analytical Biography*. London, 1982.

Beth, Ignaz. "Hans Dürer." In Thieme and Becker, *Allgemeines Lexikon*, vol. X (1914), p. 71.

Bialostocki, Jan. "Opus quinque dierum: Dürer's 'Christ Among the Doctors' and its Sources." *Journal of the Warburg and Courtauld Institutes*, vol. XXII (1959), pp. 17–34.

————. "Vernunft und Ingenium in Dürers kunsttheoretischem Denken." *Zeitschrift des deutschen Vereins für Kunstwissenschaft*, vol. XXV (1971), pp. 107–114.

————. "Myth and Allegory in Dürer's Engravings." In *Tribute to Wolfgang Stechow*. *Print Review*, vol. V (1976), pp. 24–34.

————. *The Art of the Renaissance in Eastern Europe*. Oxford, 1976.

————. *Dürer and His Critics 1500–1971*. Baden-Baden, 1986.

Bieber, Margarete. *The Sculpture of the Hellenistic Age*. Rev. ed. New York, 1967.

Birke, Veronika, and Friedrich Piel, eds. *Die Sammlung Ian Woodner* (exhibition catalogue, Albertina). Vienna, 1986.

Bodenstein von Karlstadt, Andreas. *Von anbetvng vnd der erbietvng der zeychen des newen Testaments*. Augsburg: Melchior Remminger, 1521.

Böhme, Hartmut. *Albrecht Dürer—"Melencolia I"—Im Labyrinth der Deutung*. Frankfurt a.M., 1989.

Bongard, Willi, and Matthias Mende. *Dürer Today*. Munich, 1970.

Borchardt, Frank L. *German Antiquity in Renaissance Myth*. Baltimore and London, 1971.

Bott, Gerhard, and Bernd Moeller, eds. *Martin Luther und die Reformation in Deutschland* (exhibition catalogue, Nuremberg, Germanisches National-museum). Frankfurt a.M., 1983.

Brandi, Karl. *The Emperor Charles V*. Atlantic Highlands, N.J., 1980.

Braudel, Ferdinand. *The Perspective of the World*. Civilization and Capitalism. Vol. 3. 1979; New York, 1982.

Buchwald, G. *Luther-Kalendrium*. Leipzig, 1929.

Buck, August. "Enea Silvio Piccolomini und Nürnberg." In Nuremberg, *Albrecht Dürers Umwelt*.

Burckhardt, Daniel. *Die Schule Martin Schongauers am Oberrhein*. Basel, 1888.

———. "Martin Schongauer und seine Brüder in ihre Beziehungen zu Basel." *Jahrbuch der Preussischen Kunstsammlungen*, vol. XIV (1893), pp. 158 ff.

Caesar, Elisabeth. "Sebald Schreyer." *Mitteilungen des Vereins für die Geschichte der Stadt Nürnberg*, vol. LVI (1969), pp. 1–213.

Cartillieri, Oskar. *Am Hofe der Herzöge von Burgund*. Basel, 1926.

Celtis, Konrad. *Norimberga*. In Albert Werminghoff, ed., *Conrad Celtis und sein Buch über Nürnberg*. Freiburg im Breisgau, 1921.

———. "Ode to Apollo" and "A Public Oration" (Celtis's inaugural address, University of Ingolstadt, August 31, 1492). In Lewis W. Spitz, ed., *The Northern Renaissance*. Englewood Cliffs, N.J., 1972. Pp. 13–27.

Chiapelli, Fredi, ed. *First Images of America*. 2 vols. Berkeley, Ca., 1976.

Christensen, Carl C. *Art and the Reformation in Germany*. Athens, Ohio, 1979.

Conway, William Martin. *Literary Remains of Albrecht Dürer*. Cambridge, 1889.

———. *The Writings of Albrecht Dürer*. New York, 1958.

Cortes, Hernando. *Praeclara de Nova maris Oceanii Hyspania Narratio . . .* Trans. Petrus Savorgnanus. Nuremberg, 1524.

———. *Five Letters: 1519–1526*. Trans. F. Bayard Morris. New York, 1929.

Craig, Gordon A. *The Politics of the Prussian Army 1640–1945*. 2nd. ed. Oxford, 1964. Rpt. 1972.

Cremer, Erika. "Dürers verwandschaftliche Beziehungen zu Innsbruck." In *Festschrift Nikolaus Grass*. Vol. 2. 1975. Pp. 125–130. Cited in Anzelewsky, *Dürer: His Art and Life*.

Davies, Martin. *Rogier van der Weyden*. London, 1972.

Deichstetter, G., ed. *Caritas Pirckheimer: Ordensfrau und Humanistin—Vorbild für die Oekumene—Festschrift zum 450. Todestag*. Cologne, 1982.

Delacroix, Eugene. *Journal*. Ed. Andre Joubin. 3 vols. Paris, 1932.

Dürer, Albrecht. *Etliche vnderricht, zu befestigung der Statt, Schloss, vnd flecken.* Nuremberg: Hieronymus Andreae, 1527.

"Dürer: Anliegen der Nation." *Der Spiegel,* vol. XI (December 1971), pp. 153–178.

Duychak, Linda. *Dürer and Vera Cruz: Some Speculations Regarding Albrecht Dürer's Response to a 1520 Display of Pre-Columbian American Artifacts.* M.A. thesis, University of Wisconsin–Madison. 1989.

Eberlein, Johann Konrad. "Dürers Melencolie-Stich—Analyse eines Beispiels." In Hans Belting, Heinrich Dilly et al., eds., *Kunstgeschichte: Eine Einführung.* Berlin, 1986.

Eco, Umberto. *Art and Beauty in the Middle Ages.* New Haven and London, 1986.

Endres, Rudolf. "Zur Einwohnerzahl und Bevölkerungsstruktur Nürnbergs im 15. und 16. Jahrhundert." *Mitteilungen des Vereins für die Geschichte der Stadt Nürnberg,* vol. LVII (1970), pp. 242–271.

Evers, Hans Gerhard. *Dürer bei Memling.* Munich, 1972.

Filedt Kok, J. P. *Lucas van Leyden-Grafiek* (exhibition catalogue, Rijksprentenkabinet). Amsterdam, 1978.

Filedt Kok, J. P., comp. *The Master of the Amsterdam Cabinet or the Housebook Master* (exhibition catalogue, Amsterdam, Rijksmuseum). Princeton, 1985.

Finke, Ulrich. "Dürers 'Melancholie' in der französischen und englischen Literatur und Kunst des 19. Jahrhunderts." *Zeitschrift des deutschen Vereins für Kunstwissenschaft,* vol. XXX (1976), pp. 67–85.

———. *Französische und englische Dürer-Rezeption im 19. Jahrhundert.* Renaissance Vorträge 4/5. Nuremberg, 1976.

Friedländer, Max J. *Die altniederländsiche Malerei.* 14 vols. Berlin and Leiden, 1924–1937. English edition, Leiden, 1967–1976.

Galland, Georg. *Eine Dürer-Erinnerung aus dem romantischem Berlin.* Strasbourg, 1912.

Geisberg, Max. "Martin Schongauer." In Thieme and Becker, *Allgemeines Lexikon,* vol. XXX (1936), pp. 249–254.

Genthon, Istvan. *Kunstdenkmäler in Ungarn.* Budapest, 1974.

Germanisches Nationalmuseum. *Reformation in Nürnberg—Umbruch und Bewehrung* (exhibition catalogue). *Schriften des Kunstpädagogischen Zentrums im Germanischen Nationalmuseum,* 9. Nuremberg, 1979.

———. *Martin Luther und die Reformation in Deutschland* (exhibition catalogue). Nuremberg, 1983.

Giehlow, Karl. "Dürers Stich, 'Melancholia I' und der maximilianische Humanistenkreis." *Mitteilungen der Gesellschaft für vervielfältigende Künste,* vol. XXVI (1903), pp. 29–41; XXVII (1904), pp. 6–18, 57-78.

———. "Urkundenexegese zur Ehrenpforte Maximilian I." In *Beiträge zur Kunstgeschichte.* Vienna, 1903. Pp. 91–110.

———. *Kaiser Maximilian I. Gebetbuch und Zeichnungen von Albrecht Dürer und anderen Künstlern.* Facsimile edition. Vienna and Munich, 1907.

Goethe, Johann Wolfgang von. *Schriften zur Kunst.* dtv-Ausgabe. Vol. 34. Munich, 1972.

Goltz, Colmar, Freiherr von der. "Albrecht Dürers Einfluss auf die Entwicklung

der deutschen Befestigungskunst." In Herman Grimm, ed., *Über Künstler und Kunstwerke*. 2 vols. Berlin, 1867. Vol. 2. Pp. 189–203.

Gombrich, Ernst. "The Earliest Description of Bosch's *Garden of Earthly Delights*." *Journal of the Warburg and Courtauld Institutes*, vol. XXX (1967), pp. 403–406.

———. *The Heritage of Apelles: Studies in the Art of the Renaissance*. Ithaca, N.Y., 1976.

Götz, Wolfgang. "Historismus: Ein Versuch zur Definition des Begriffes." *Zeitschrift des deutschen Vereins für Kunstwissenschaft*, vol. XXIV (1970), pp. 196–212.

Grimm, Harold J. *Lazarus Spengler: A Lay Leader of the Reformation*. Columbus, Ohio, 1978.

Grimm, Reinhold. "Vom sogenannten Widerstand gegen die Völkischen: Ein Nachtrag zum Thema 'Ritter, Tod und Teufel.' " In Lawrence Baron et al., *Ideologiekritische Studien zur Literatur: Essays II*. Bern and Frankfurt a.M., 1975. Pp. 73–84.

Gümbel, Albert. "Zur Biographie Albrecht Dürers des Älteren." *Repertorium für Kunstwissenschaft*, vol. XXXVII (1915), pp. 210–213.

Hagen, Oskar. "War Dürer in Rom?" *Zeitschrift für Bildende Kunst*, new series, vol. XXVIII, no. 5 (1916/1917), pp. 254–265.

Hale, John Rigby. *Renaissance Fortification*. London, 1977.

Hampe, Theodor. *Nürnberger Ratsverlasse über Kunst und Künstler im Zeitalter der Spätgotik und Renaissance*. Quellenschriften zur Kunstgeschichte und Kunsttechnik, N.F. XI. Vol. 1. Vienna and Leipzig, 1904.

———. "Albrecht Dürer der Ältere." In Thieme and Becker, *Allgemeines Lexikon*, vol. X (1914), pp. 70 ff.

Hartmann, Wolfgang. *Kaiser Maximilian I. und Albrecht Dürer: Ein Künstlerfest der Spätromantik und sein Anspruch*. Nuremberg, 1976.

Hase, Oskar. *Die Koberger: Eine Darstellung des buchhändlerischen Geschäftsbetriebes in der Zeit des Überganges von Mittelalter zur Neuzeit*. 3rd ed. Amsterdam and Wiesbaden, 1967.

Hay, Denys, ed. *The New Cambridge Modern History*. Vol. I: *The Renaissance 1493–1520*. Planned by G. R. Potter. Cambridge, 1957.

Hegel, K. "Der Einzug Karls V. in Antwerpen." *Historische Zeitschrift*, vol. XLIV (1880).

Held, Julius. *Dürers Wirkung auf die niederländische Kunst seiner Zeit*. Ph.D. diss. The Hague, 1931.

Hinz, Berthold. *Dürers Gloria: Kunst, Kult und Konsum*. Berlin, 1971.

Hirschmann, Gerhard. "Albrecht Dürers Abstammung und Familienkreis." In Nuremberg, *Albrecht Dürers Umwelt*.

Hirschmann, Gerhard, and Hans Hubert Hofmann. *Nürnberg: Geschichte einer europäischen Stadt*. Munich, 1971.

Hoffmann, Konrad. "Dürers 'Melencolia.' " In W. Busch, R. Hausherr, and E. Trier, eds., *Kunst als Bedeutungsträger. Gedenkschrift für Günther Bandmann*. Berlin, 1979. Pp. 251–277. And in *Print Collector's Newsletter*, vol. IX, no. 2 (May–June 1978), pp. 33–35.

Hoffmann, Werner, ed. *Luther und die Folgen für die Kunst* (exhibition catalogue, Hamburg, Kunsthalle). Munich, 1983.

Honor, Hugh. *The European Vision of America* (exhibition catalogue). Cleveland, Ohio, 1975.

———. *The New Golden Land*. New York, 1975.

Hübner, Julius. *Albrecht Dürer: Festrede am Tage der Dürerfeier der Dresdner Kunstgenossenschaft den 25. Juni 1871 . . . im Prunksaale der Albrechtsburg zu Meissen*. Dresden, 1871.

Hugelshofer, Walter. *Swiss Drawings: Masterpieces of Five Centuries* (exhibition catalogue, Smithsonian Institution). Washington, D.C., 1967.

Hugo, Victor. "À Albert Dürer." In Hugo, *Oeuvres complets. Poesie. VI. Les Voix interieures*. Paris, 1837. Pp. 125–127.

Huizinga, Johann. "Dürer in die Nederlanden." *De Gids*, vol. LXXXIV (1920), pp. 470–484.

———. *Erasmus and the Age of Reformation*. New York, 1967.

Hutchison, Jane Campbell. "Der vielgefeierte Dürer." In Reinhold Grimm and Jost Hermand, eds., *Deutsche Feiern*. Athenaion Literaturwissenschaft, 5. Wiesbaden, 1977.

———. *Graphic Art in the Age of Martin Luther* (exhibition catalogue, University of Wisconsin, Elvehjem Museum). Madison, Wis., 1983.

Hutten, Ulrich von, et al. *On the Eve of the Reformation: Letters of Obscure Men*. Intro. Hajo Holborn. New York, Evanston, and London, 1964.

Imhof, G. von. *A. Dürer in seiner Bedeutung für die moderne Befestigungskunst*. Nördlingen, 1871.

Imhoff, Christoff, Freiherr von. *Berühmte Nürnberger aus neun Jahrhunderten*. Nuremberg, 1984.

Ivins, William M. "Notes on Three Dürer Woodblocks." *Metropolitan Museum Studies*, vol. IX (1929), pp. 102–111.

Jahns, M. *Handbuch einer Geschichte des Kriegswesens*. Leipzig, 1880.

———. *Geschichte der Kriegswissenschaft*. Vol. 1. Munich and Leipzig, 1889.

Joachim, Harold. "Review of Friedrich Winkler's *Dürer und die Illustrationen zum Narrenschiff*." *Art Bulletin*, vol. XXXV (1953), pp. 66–67.

Kahsnitz, Rainer, ed. *Veit Stoss in Nürnberg* (exhibition catalogue, Germanisches Nationalmuseum). Nuremberg, 1983.

Kauffmann, Thomas da Costa. "Hermeneutics in the History of Art: Remarks on the Reception of Dürer in the Sixteenth and Early Seventeenth Centuries." In Jeffrey Chipps Smith, ed., *New Perspectives on the Art of Renaissance Nuremberg*. Austin, Texas, 1985. Pp. 23–40.

Koch, Robert A. *Joachim Patinir*. Princeton, 1968.

Kohlhaussen, Heinrich. *Nürnberger Goldschmiedekunst des Mittelalters und der Dürerzeit, 1240 bis 1540*. Berlin, 1968.

Koreny, Fritz. *Albrecht Dürer und die Tier- und Pflanzenstudien der Renaissance* (exhibition catalogue, Vienna, Albertina). Munich, 1985.

Koschatzky, Walter. *Albrecht Dürer: The Landscape Watercolors*. New York, 1973.

Kratzsch, Gerhard. *Kunstwart und Dürerbund*. Göttingen, 1969.

Kress von Kressenstein, G. Freiherr von. *Albrecht Dürers Wohnhaus und seine Geschichte*. Nuremberg, 1896.

Kunert, Günther. "Mit der Zeit ein Feuer." In G. Rücker, *Porträt einer dicken Frau*. Berlin (DDR), 1974.

Kurras, L., and F. Machilek. *Caritas Pirckheimer—1467–1532*. Munich, 1982.

Langbehn, Julius, and Momme Nissen. *Dürer als Führer*. Rev. ed. Munich, 1928.

Leder, Klaus. "Nürnbergs Schulwesen an der Wende vom Mittelalter zur Neuzeit." In Nuremberg, *Albrecht Dürers Umwelt*, pp. 29–34.

Lehfeldt, Paul. *Luthers Verhältnis zu Kunst und Künstlern*. Berlin, 1892.

Lehrs, Max. *Geschichte und kritischer Katalog des deutschen, niederländischen und französischen Kupferstichs im fünfzehnten Jahrhundert*. Vol. v, *Martin Schongauer*, Vienna, 1925.

Levenson, Jay. "Jacopo dei Barbari." In Jay Levenson, Konrad Oberhuber, and Jacquelyn L. Sheehan, eds. *Early Italian Engravings from the National Gallery of Art* (exhibition catalogue, National Gallery of Art). Washington, D.C., 1973. Pp. 341–380.

Liebmann, Michail J. "Dürer und seine Werkstatt." In Ernst Ullmann, Günther Grau, and Rainer Behrends, eds., *Albrecht Dürer: Zeit und Werk*. Leipzig, 1971.

Lightbown, Ronald W. "Dürer and the Goldsmith's Art." *Apollo*, new series, vol. xciv, no. 13 (July 1971), pp. 24–35.

Loose, W. *Aus dem Leben der Charitas Pirckheimer—Äbtissin zu St. Clara in Nürnberg. Nach Briefen* (inaugural dissertation). Dresden, 1870.

Lortz, Joseph. *Die Reformation in Deutschland*. 6th ed. Freiburg im Breisgau, 1982.

Lüdecke, Heinz, and Susanne Heiland. *Dürer und die Nachwelt*. Berlin (DDR), 1955.

Lukinich, Emerich. "Albrecht Dürers Abstammung." *Ungarische Jahrbuecher*, vol. ix (1929), pp. 104–110.

Lutz, Heinrich. "Albrecht Dürer in der Geschichte der Reformation." *Historische Zeitschrift*, vol. ccvi (1968), pp. 22–44.

Maas, Herbert. *Nürnberg—Geschichte und Geschichten*. Nuremberg, 1985.

MacKendrick, Paul. *Romans on the Rhine: Archaeology in Germany*. New York, 1970.

Madou, M.J.H. "Notes on Costume." In Filedt Kok, *The Master of the Amsterdam Cabinet or the Housebook Master*, pp. 293 ff.

Mende, Matthias. "Das Dürer-Denkmal." In Volker Plagemann and Hans-Ernst Mittig, eds., *Denkmäler im 19. Jahrhundert*. Munich, 1971.

———. *Dürer-Bibliographie*. Wiesbaden, 1971.

———. *Albrecht Dürer: Zum Leben, zum Holzschnittwerk*. Munich, 1976.

Mende, Matthias, and Inge Hebecker. *Das Dürer-Stammbuch von 1828* (exhibition catalogue, Dürer-Haus). Nuremberg, 1973.

Meyer, Ursula. "Political Implications of Dürer's 'Knight, Death and Devil.' " *Print Collector's Newsletter*, vol. ix, no. 2 (May–June 1978), pp. 35–39.

Middlebrook, Martin. *The Nuremberg Raid*. London, 1973.

Minott, Charles. *Martin Schongauer*. New York, 1971.

Mittig, Hans-Ernst. *Dürers Bauernsäule: Ein Monument des Widerspruchs*. Frankfurt a.M., 1984.

Mossack, Erhard. *Die letzte Tage von Nürnberg*. Nuremberg, 1952.

Mosse, George L. *The Crisis of German Ideology*. New York, 1972.

Nadler, Fritz. *Eine Stadt im Schatten Streichers*. Nuremberg. 1969.

Nagler, G. K. "Veit Stoss (Stuos) in Krakau und seine Ankunft in Nürnberg." *Kunstblatt*, vol. XXVIII (1847), pp. 141–144.

*N. S. Frauen-Warte: Die einzige parteiamtliche Frauenzeitschrift*, vol. III, no. 6 (1937).

New York. Metropolitan Museum of Art. *Gothic and Renaissance Art in Nuremberg 1300–1550*. Comp. Rainer Kahsnitz and William D. Wixom. New York and Nuremberg, 1986.

Norman, A.V.B. "Albrecht Dürer: Armour and Weapons." *Apollo*, new series, vol. XCIV, no. 113 (July 1971), pp. 36–39.

Novotny, K. A. *Mexikanische Kostbarkeiten aus Kunstkammern der Renaissance* (exhibition catalogue, Museum für Volkerkunde). Vienna, 1960.

Nuremberg. Verein für Geschichte der Stadt Nürnberg. *Albrecht Dürers Umwelt: Festschrift zum 500. Geburtstag Albrecht Dürers am 21. Mai 1971*. Nürnberger Forschungen, 15. 1971.

Nuremberg Festcomité. *Gedenkbuch der vierhundertjährigen Geburtstagsfeier Albrecht Dürers*. Nuremberg, 1871.

Nuremberg Stadtbibliothek. *Willibald Pirckheimer 1470–1970* (exhibition catalogue). Nuremberg, 1970.

Oehler, Lisa. "Das Dürermonogramm auf Werken der Dürerschule." *Städel-Jahrbuch*, new series, vol. IV (1973), pp. 37–80.

Offenbacher, Emil. "La bibliothèque de Wilibald Pirckheimer." *La Bibliofilia*, vol. XL (1938), pp. 241–263.

Osten, Gert von der. *Hans Baldung Grien*. Berlin, 1983.

Ozment, Steven E. *The Reformation in the Cities: The Appeal of Protestantism to Sixteenth-Century Germany and Switzerland*. New Haven and London, 1975.

Panofsky, Erwin. *Hercules am Scheidewege und andere antike Bildstoffe in der neueren Kunst*. Studien der Bibliothelk Warburg, 18. Leipzig and Berlin, 1930.

———. "Albrecht Dürer and Classical Antiquity." In his *Meaning in the Visual Arts*. Garden City, N.J., 1955. Pp. 236–285.

———. *The Life and Art of Albrecht Dürer*. 4th ed. Princeton, 1955.

———. "Virgo et Victrix. A Note on Dürer's *Nemesis*." In Carl Zigrosser, ed., *Prints*. New York, 1962. Pp. 13–38.

Panofsky, Erwin, and Fritz Saxl. *Dürers Kupferstich 'Melencolia I.' Eine quellen- und typengeschichtliche Untersuchung*. Studien der Bibliothek Warburg. Vol. 2. Leipzig and Berlin, 1923.

Parshall, Linda B., and Peter Parshall. *Art and the Reformation: An Annotated Bibliography*. Boston, 1986.

Parshall, Peter, "Camerarius on Dürer—Humanist Biography as Art Criticism." In F. Baron, ed., *Joachim Camerarius (1500–1574)*. Munich, 1978. Pp. 11 ff.

Pauwels, H., H. R. Hoetink, and S. Herzog. *Jan Gossaert genaamd Mabuse* (exhibition catalogue). Brussels and Rotterdam, 1965.

Peeters, C.J.A.C. *De Sint Janskathedral te 's Hertogenbosch*. The Hague, 1985.

Petersen, Ursula. *Der Monogrammist A. G.: Studien zur Schule Martin Schongauers*. Ph.D. diss. Albert-Ludwigs-Universität Freiburg im Breisgau, 1953.

Pfaff, Annette. *Studien zu Albrecht Dürers Heller-Altar. Nürnberger Werkstücke zur Stadt- und Landesgeschichte*. Vol. 7. Nuremberg, 1971.

Pfeiffer, Gerhard. "Albrecht Dürer und Lazarus Spengler." In Dieter Albrecht et al., eds., *Festschrift für Max Spindler*. Munich, 1969.

Philip, Lotte Brand. *Das neuentdeckte Bildnis von Dürers Mutter*. Renaissance Vorträge. Vol. VII. Stadt Nürnberg Stadtgeschichtliche Museen, 1981. Pp. 3–33.

Prescott, H.F.M. *Friar Felix at Large: A Fifteenth-Century Pilgrimage to the Holy Land*. New Haven, 1950.

Reimann, Arnold. *Die älteren Pirckheimer: Geschichte eines nürnberger Patriziergeschlechtes im Zeitalter des Frühhumanismus*. Leipzig, 1944.

Rowlands, John. *The Age of Dürer and Holbein: German Drawings 1400–1550*. Cambridge, 1988.

Rupprich, Hans. *Willibald Pirckheimer und die ertse Reise Dürers nach Italien*. Vienna, 1930.

————. "Die Beschreibungen niederländischer Prozessionsspiele durch Dürer und Hieronymus Köler der Ältere." *Maske und Kothurn. Vierteljahrsschrift für Theaterwissenschaft*, vol. I (1955), pp. 88 ff.

————. "Willibald Pirckheimer. Beiträge zu seiner Wesenserfassung." *Schweizer Beiträge zur allgemeinen Geschichte*, vol. XV (1957), pp. 64–110.

Rupprich, Hans, ed. *Dürer: Schriftlicher Nachlass*. 3 vols. Berlin, 1956.

Saville, Marshall H. "The Earliest Notices Concerning the Conquest of Mexico by Cortes in 1519." *Indian Notes and Monographs* (New York), vol. IX, no. 1 (1920), pp. 1–54.

————. *The Goldsmith's Art in Ancient Mexico*. New York, 1920.

Schade, Werner, et al. *Kunst der Reformationszeit* (exhibition catalogue, Berlin [DDR], Staatliche Museen). Berlin (BRD), 1983.

Scheurl, Christoph II. *Commentarii de vita et obitu reverendi patris Dni. Anthonii Kressen*. Nuremberg, 1515.

Schreyl, Karl Heinz. *Nürnberger Dürerfeiern 1828–1928*. Nuremberg, 1971.

Schultheiss, Werner. "Albrecht Dürers Beziehungen zum Recht." In Nuremberg, *Albrecht Dürers Umwelt*, pp. 220–254.

Schultz, F. T. "Michael Wolgemut." In Thieme and Becker, *Allgemeines Lexikon*, vol. XXXVI (1947), pp. 175 ff.

Schwerte, Hans. *Faust und das Faustische*. Stuttgart, 1962. Esp. Chap. VIII: "Dürers 'Ritter, Tod und Teufel': Eine ideologische Parallele zum Faustischen." Pp. 243–278.

Schwertfeger, Bernhard. *Die grossen Erzieher des deutschen Heeres*. Potsdam, 1936.

Scillia, Charles. "Dürer's *Adam and Eve*: Two Classical Canons." Paper delivered at the conference, Tradition and Innovation in the Study of Northern European Art, University of Pittsburgh, October 1985.

Scribner, Bob, and Gerhard Benecke. *The German Peasant War 1525: New Viewpoints*. London, Boston, and Sydney, 1979.

Seebass, Gottfried. "Dürers Stellung in der reformatorischen Bewegung." In Nuremberg, *Albrecht Dürers Umwelt*, pp. 101–131.

Shestack, Alan. *Fifteenth Century Engravings of Northern Europe from the National Gallery of Art* (exhibition catalogue, National Gallery of Art). Washington, D.C., 1967.

———. *Master LCz and Master W.B.* New York, 1971.

Silver, Larry. *The Paintings of Quinten Massys.* Montclair, N.J., 1984.

———. "Prints for a Prince: Maximilian, Nuremberg and the Woodcut." In Jeffrey Chipps Smith, ed., *New Perspectives on the Art of Renaissance Nuremberg.* Austin, Texas, 1985. Pp. 7–21.

Simon, Erika. "Das Werk: Die Rezeption der Antike." In *1471–Albrecht Dürer–1971* (exhibition catalogue). Nuremberg, 1971.

Smith, Jeffrey Chipps. *Nuremberg: A Renaissance City, 1500–1618.* Austin, Texas, 1983.

Spitz, Lewis W., ed. *The Northern Renaissance.* Englewood Cliffs, N.J., 1972.

Stechow, Wolfgang. "Justice Holmes' Notes on Albert Dürer." *Journal of Aesthetics and Art Criticism,* vol. VIII (1949), pp. 119 ff.

———. *Northern Renaissance Art 1400–1600.* Sources and Documents in the History of Art. Englewood Cliffs, N.J., 1966.

———. *Dürer and America.* Washington, D.C., 1971.

———. "Alberti Dureri Praecepta." *Studies in the History of Art.* Washington, D.C., National Gallery of Art, 1971–1972.

———. "Recent Dürer Studies." *Art Bulletin,* vol. LVI (1974), pp. 259–270.

Strauss, Gerald. *Sixteenth-Century Germany: Its Topography and Topographers.* Madison, Wis. 1959.

———. *Luther's House of Learning: Indoctrination of the Young in the German Reformation.* Baltimore and London, 1978.

Strauss, Walter L. *The Complete Drawings of Albrecht Dürer.* 6 vols. New York, 1974.

———. *The Intaglio Prints of Albrecht Dürer.* New York, 1976.

Strauss, Walter L., ed. *Albrecht Dürer. The Painter's Manual.* New York, 1977.

———. *The Woodcuts and Woodblocks of Albrecht Dürer.* New York, 1980.

Strickland, Diane C. *Maximilian as Patron: The Prayerbook.* Ph.D. diss., University of Iowa. 1980.

Strieder, Peter. *Meister um Albrecht Dürer* (exhibition catalogue, Germanisches Nationalmuseum). Nuremberg, 1971.

———. *Albrecht Dürer: Paintings–Prints–Drawings.* New York, c. 1981.

Stromer, Wolfgang, Freiherr von. "Nürnberg's wirtschaftliche Lage im Zeitalter der Fugger." In Nuremberg, *Albrecht Dürers Umwelt.*

Szábo, George. "Dürer and Italian Majolica I: Four Plates with 'The Prodigal Son amid the Swine.'" *American Ceramic Circle Bulletin* (1970–1971), pp. 5–28.

Talbot, Charles, ed. *Dürer in America: His Graphic Work* (exhibition catalogue, National Gallery of Art). Washington, D.C., 1971.

*Tendenzen,* vol. XII, no. 75/76 (June–July 1971), pp. 126–127.

Thausing, Moriz. "Hüsgen's Dürersammlung und das Schicksal von Dürers sterblichen Überresten." *Zeitschrift für bildende Kunst,* vol. IX (1874), pp. 321–323.

———. *Albert Dürer, His Life and Works.* 2 vols. London, 1882. German edition, *Albrecht Dürer: Geschichte seines Lebens und seiner Kunst.* Leipzig, 1884.

Theissing, Heinrich. *Dürers Ritter, Tod und Teufel: Sinnbild und Bildsinn*. Berlin, 1978.

Thieme, Ulrich, and Felix Becker, eds. *Allgemeines Lexikon der bildenden künstler*. 37 vols. Leipzig, 1908–1950.

Ullmann, Ernst, ed. *Albrecht Dürer: Kunst im Aufbruch*. Leipzig, 1972.

Ullmann, Ernst, Günter Grau, and Rainer Behrends, eds. *Albrecht Dürer: Zeit und Werk*. Leipzig, 1971.

Vaughn, Richard. *Philip the Good*. London, 1970.

Verspohl, F. "Zur Kritik der Künstlerideologie in der ersten Hälfte des 19. Jahrhunderts." *Marburger Jahrbuch*, vol. XIX (1974). Esp. p. 286.

Vey, Horst. "Nicolas Hilliard and Albrecht Dürer." In *Mouseion. Studien aus Kunst und Geschichte für Otto H. Förster*. Cologne, 1960. Pp. 155–168.

Vienna. Museum für Volkerkunde. *Die mexikanische Sammlung*. 1965.

Vos, Rik. "The Life of Lucas van Leyden by Karel van Mander." In *Lucas van Leyden Studies, Nederlands Kunsthistorisch Jaarboek*, vol. XXIX (1978), pp. 459–508.

Waetzoldt, Wilhelm. *Dürer und seine Zeit*. Vienna, 1935.

Walser, Martin. *Das Sauspiel: Szenen aus dem 16. Jahrhundert*. Frankfurt a.M., 1975.

Walther, Sigrid. *Hans Süss von Kulmbach*. Dresden, 1981.

Warnke, Martin. *Cranachs Luther*. Frankfurt a.M., 1984.

Watrous, James S. *The Craft of Old Master Drawings*. Madison, Wis., 1957.

Weyrauther, M. *Konrad Peutinger und Willibald Pirckheimer in ihren Beziehungen zur Geographie*. Munich, 1907.

White, Christopher. "The Travels of Albrecht Dürer." *Apollo*, new series, vol. XCIV, no. 113 (July 1971), pp. 14–23.

Wiederanders, Gerlinde. *Albrecht Dürers theologische Anschauungen*. Berlin (DDR), 1975.

Wiesner, Merry E. *Working Women in Renaissance Germany*. New Brunswick, N.J., 1986.

Willibald-Pirckheimer-Kuratorium. *Willibald Pirckheimer, 1470/1970*. Nuremberg, 1970.

Wimpfeling, Jakob. *Epithoma Germanorum Jacobi wimpfelingii*. Strassburg, 1505.

Winkler, Friedrich. *Die Zeichnungen Albrecht Dürers*. 4 vols. Berlin, 1936–1939.

Winzinger, Franz. "Albrecht Dürers Münchner Selbstbildnis." *Zeitschrift für Kunstwissenschaft*, vol. VIII (1954), pp. 43 ff.

———. *Albrecht Dürer*. Reinbek bei Hamburg, 1971.

Wuttke, Dieter. "Dürer und Celtis: Von der Bedeutung des Jahres 1500 für den deutschen Humanismus: Jahrhundertfeier als symbolische Form." *Journal of Medieval and Renaissance Studies*, vol. X (1980), pp. 73–129.

Zschelletzschky, Herbert. *Die "Drei gottlosen Maler" von Nürnberg: Sebald Beham, Barthel Beham und Georg Pencz. Historische Grundlagen und ikonologische Probleme ihrer Graphik zur Reformations- und Bauernkriegszeit*. Leipzig, 1975.

# INDEX